SILVER, ART GLASS, PAINTINGS, AND DECORATIVE ART

HERITAGE SIGNATURE AUCTION #608
OCTOBER 30 – 31, 2004 | DALLAS

Bryan Abbott, Director | Ext 320 | BryanA@HeritageGalleries.com
Heritage Galleries & Auctioneers — Auction Room
3500 Maple Avenue, 17th floor | Dallas, Texas 75219

LOT VIEWING
Wednesday, October 27 & Thursday, October 28
9:00a.m. — 5:00p.m.

Friday, October 29, 2004
by appointment only
Earlier lot viewing available by appointment

Heritage Galleries & Auctioneers
3500 Maple Avenue, 17th floor
Dallas, Texas 75219
800.872.6467

ABSENTEE BIDS BY FAX
Deadline: Wednesday, October 27, 2004
12:00 noon CST | fax: 214.443.8425

ABSENTEE BIDS BY INTERNET
www.HeritageGalleries.com
bid@HeritageGalleries.com
Bids close at 10:00pm CST prior to each session

LIVE TELEPHONE BIDDING
Must be arranged on or before Friday, October 29, 2004
800.872.6467 | Kathy Eilers (ext. 392)

AUCTION SESSIONS
Session I: Silver
Saturday Morning, October 30, 2004 at 10:00am CST
Lots 18001 — 18525

Session II: Art Glass and Fine Art
Saturday Evening, October 30, 2004 at 6:00pm CST
Lots 19001 — 19321

Session III: Pottery and Ceramics
Sunday Afternoon, October 31, 2004 at 1:00pm CST
Lots 20001 — 20339

AUCTIONEERS
Sam Foose, TX License #00011727
Leo Frese, John Petty, Scott Peterman

AUCTION RESULTS
Immediately available at: www.HeritageGalleries.com
For faxed results, call our automated service:
1.866.835.3243, Auction #608

LOT PICK UP
There will be no lot pickup Sunday, October 31
Lot pickup Monday, November 1, 9:00am — 5:00pm,
by appointment only

Catered meals will be served on Saturday and Sunday
Lots are sold at an approximate rate of 80 — 100 lots per hour

View lots online at www.HeritageGalleries.com

HERITAGE
Galleries & Auctioneers

3500 Maple Avenue, Seventeenth Floor
Dallas, Texas 75219-3941
214.528.3500 | 800.872.6467 | 214.443.8416 (fax)

Catalogued by: Bryan Abbott, Karen Fedri, Noelle DeSantis, Nan Chisholm, Don Darnell
Production and Design by: Cindy Brenner, Carlos Cardoza, Keith Craker, Cathy Hadd, Mary Hermann,
Matt Pegues, Michael Puttonen, Marsha Taylor, Carl Watson
Catalog and Internet Photography by: Jamie Graham

Steve Ivy
CEO
Co-Chairman
of the Board

Jim Halperin
Co-Chairman
of the Board

Bryan Abbot
Director

Karen Fedri
Consignments

Greg Rohan
President

Ed Jaster
Consignments

HERITAGE
Galleries & Auctioneers

3500 Maple Avenue, Seventeenth Floor
Dallas, Texas 75219-3941
214.528.3500 | 800.872.6467 | 214.443.8416 (fax)

HERITAGE
Galleries & Auctioneers

Dear Fellow Collectors,

It is my sincere pleasure to greet you once again, quite proudly, after our exceptional inaugural auction in spring of this year. Our May auction was a landmark sale of Silver, Art Glass and Fine Art, realizing $1.2 million. I thank those returning bidders for their continued enthusiasm, and I hope to reward your interest with the wonderful selection of silver, porcelain, art glass, fine art and pottery compiled herein.

We are excited to bring you the following rare items and collections:

- An outstanding array of Silver tableware, including rare 19th Century flatware patterns and an important five-piece Gorham Martelé tea service (circa 1905).
- Many beautiful pieces of 19th Century American holloware.
- An assortment of lamps bearing the marks of Tiffany, Handel, Moe Bridges, Muncie, Weller, and a particularly fine Fulper Vasekraft lamp.
- Numerous pieces of Tiffany Studio glass.
- An extensive collection of art pottery crafted by Rookwood, Roseville, Weller, Newcomb and Teco.
- An array of 19th and 20th Century French art glass including fine examples of Gallé, Daum Nancy and Webb among many other makers.
- A collection of 19th and 20th Century porcelain including Sevres, Limoges, Dresden and Meissen.
- Many fine art paintings including works by Henry Ryland, William Etty, Georges Rouault, Gustave Castan and Augustus Dunbier.

We would especially like to thank and recognize two notable silver enthusiasts, collectors and authors for their consignments to this sale. Dr. William Hood and Dr. Dale Bennett have both provided a selection of lots from their personal collections.

We have truly enjoyed assembling this remarkable auction, and we thank our consignors for their contribution to this event. We hope that you are equally delighted in the offerings of this catalog.

Best regards,

Bryan Abbott

TERMS AND CONDITIONS OF SALE

AUCTIONEER AND AUCTION:

1. This auction is presented by Heritage Numismatic Auctions. Inc. or its subsidiary Currency Auctions of America, Inc. or their affiliate, Heritage Auctions, Inc. through its divisions Heritage Comic Auctions, or Heritage Sports Collectibles Auctions, as identified with the applicable licensing information either on the title page of the catalog or on the Internet site (the "Auctioneer"). The auction is conducted under these Terms and Conditions of Auction and applicable state and local law.

BUYER'S PREMIUM:

2. On bids placed through Heritage, a Buyer's Premium of fifteen percent (15%) for Heritage Numismatic Auctions Inc, Heritage-CAA, and Heritage Comics Auctions or nineteen and one-half percent (19.5%) for Heritage Sports Collectibles, Heritage-Odyssey and Heritage Galleries & Auctioneers of the hammer price will be added to the successful bid. If the bid is placed through eBay Live a Buyer's Premium equal to the normal Buyer's Premium plus an additional five percent (5%) of the hammer price will be added to the successful bid. There is a minimum Buyer's Premium of $6.00 per lot.

AUCTION VENUES:

3. Exclusively Internet, CurrencyAuction.com, Amazing Comics Auctions, and Bullet Auctions are auctions conducted on the Internet. Signature auctions accept bids on the Internet first, followed by a floor bidding session. Bids may be placed prior to the floor bidding session by Internet, telephone, fax, or mail.

BIDDERS:

4. Any person participating in or who registers for the auction agrees to be bound by and accepts these Terms and Conditions of Auction ("Bidder(s)").

5. All Bidders must meet Auctioneer's qualifications to bid. Any Bidder who is not a customer in good standing of the Auctioneer may be disqualified at Auctioneer's sole option and will not be awarded lots. Such a determination may be made by Auctioneer in its sole and unlimited discretion, at any time prior to, during, or even after the close of the auction.

6. If an entity places a bid, then the person executing the bid on behalf of the entity agrees to personally guarantee payment for any successful bid.

7. Auctioneer reserves the right to exclude any person it deems in its sole opinion is disruptive to the auction or is otherwise commercially unsuitable.

CREDIT REFERENCES:

8. Bidders who do not have established credit with the Auctioneer must either furnish satisfactory credit information including two collectibles-related references well in advance of the auction date or supply valid credit card information. All Bidders must meet Auctioneer's qualifications to bid. Any Bidder who is not a customer in good standing at Auctioneer may be disqualified and will not be awarded lots. Auctioneer reserves the right to disqualify any Bidder even after the close of the auction. Bids placed through our Interactive Internet program will only be accepted from pre-registered Bidders. Bidders who are not members of HeritageGalleries. com should pre-register at least two business days before the first session to allow adequate time to contact references.

BIDDING OPTIONS:

9. Bids may be placed for a Signature Sale as set forth in the printed catalog section entitled "Choose your bidding method." For Exclusively Internet, CurrencyAuction. Com, Amazing Comics Auctions, and Bullet auctions see the alternatives shown on each website. Review at HeritageCoin.com/Auctions/howtobid.asp.

10. The Auctioneer cannot be responsible for your errors in bidding, so carefully check that your bid is entered correctly. When identical mail or FAX bids are submitted, preference is given to the first received; Internet bids are evaluated as received first. The decision of the Auctioneer and declaration of the winning Bidder is final. The Auctioneer is not responsible for executing mail bids or FAX bids received on or after the day the first lot is sold, nor Internet bids submitted after the published closing time; nor is the Auctioneer responsible for proper execution of bids submitted by telephone, mail, FAX, e-mail, Internet, or in person once the auction begins. To ensure the greatest accuracy, your written bids should be entered on the standard bid sheet form and be received at the Auctioneer's place of business at least two business days in advance of the auction date. Internet bids may not be withdrawn until your written request is received and acknowledged by Auctioneer (FAX: 214-443-8425); such requests must state the reason, and may constitute grounds for withdrawal of bidding privileges. Lots won by mail Bidders will not be delivered at the auction unless prearranged in advance.

CONDUCTING THE AUCTION:

11. Notice of the consignor's liberty to place reserve bids on his lots in the auction is hereby made in accordance with Article 2 of the Texas Uniform Commercial Code. A reserve is an amount below which the lot will not sell. THE CONSIGNOR OF PROPERTY MAY PLACE WRITTEN RESERVE BIDS ON HIS LOTS IN ADVANCE OF THE AUCTION. ON LOTS SUBJECT TO A RESERVE, IF THE LOT DOES NOT MEET THE RESERVE THE CONSIGNOR MAY PAY A REDUCED COMMISSION ON THOSE LOTS. Reserves are generally posted online about 3 days prior to the auction closing on Internet-Only auctions, and 7 days prior to the auction on Signature auctions. IF THERE IS AN UNMET RESERVE BID POSTED ON A LOT, THE CURRENT BID DISPLAYED ONLINE WILL AUTOMATICALLY BE SET AT ONE INCREMENT BELOW THE RESERVE BID. The Auctioneer will not knowingly accept (and reserves the right to reject) live telephone or floor bids from consignors. Any successful bid placed by a consignor on his consigned lot on the auction floor or by telephone during the live session, or after the reserves for an auction have been posted, will be considered an unqualified bid, and in such instances the consignor agrees to pay full Buyer's Premium and Seller's Commissions on the lot(s) even if (s)he buys them back.

12. The highest qualified Bidder shall be the buyer. In the event of any dispute between floor Bidders at a Signature Sale, the Auctioneer may at his sole discretion put the lot up for auction again. The Auctioneer's decision shall be final and binding upon all Bidders.

13. The Auctioneer reserves the right to refuse to honor any bid or to limit the amount of any bid which, in his sole discretion, is not submitted in "Good Faith," or is not supported by satisfactory credit, numismatic references, or otherwise. A bid is considered not made in "Good Faith" when an insolvent or irresponsible person, or a person under the age of eighteen makes it. Regardless of the disclosure of his identity, any bid by a consignor or his agent on a lot consigned by him is deemed to be made in "Good Faith".

14. All items are to be purchased per lot as numerically indicated and no lots will be broken. The Auctioneer reserves the right to withdraw, prior to the close, any lot or lots from the auction. Bids will be accepted in whole dollar amounts only.

15. No "buy" or "unlimited" bids will be accepted. Bidders will be awarded lots at approximately the increment of the next highest bid. No additional commission is charged for executing bids other than the Buyer's Premium applied to all successful bids. Off-increment bids may be accepted by the Auctioneer at Signature auctions.

16. Estimates will be given upon written request. It is recommended that Bidders approach or exceed the estimates in order to increase the chances of bidding successfully.

17. Auctioneer reserves the right to rescind the sale in the event of nonpayment, breach of a warranty, disputed ownership, auctioneer's clerical error or omission in exercising bids and reserves, or otherwise.

18. Outage Policy: Auctioneer occasionally experiences Internet and/or Server outages during which Bidders cannot participate or place bids. If such outage occurs, we may at our discretion extend bidding for the auction up to 24 hours. At our discretion, Auctioneer may consider two outages that occur very closely to one another to be one outage when extending such auction. This policy applies only to widespread outages and not to isolate problems that occur in various parts of the country from time to time.

19. Scheduled Downtime: Auctioneer periodically schedules system downtime for maintenance and other pu poses; this scheduled downtime is not covered by the Outage Policy.

20. The Auctioneer or affiliates may consign items to be sold in this auction, and may place reserve bids on tho items or any other in the auction. The Auctioneer or affiliates expressly reserve the right to modify any su reserve bids on these items or any others at any time prior to the live auction or the online closing based up data made known to the Auctioneer or its affiliate.

21. The Auctioneer may extend advances, guarantees, or loans to certain consignors, and may extend financing other credits at varying rates to certain Bidders in the auction.

PAYMENT:

22. All sales are strictly for cash in United States dollars. Cash includes: U.S. currency, bank wire, cashier check travelers checks, and bank money orders, all subject to reporting requirements. Credit Card (Visa or Mast Card only) payments may be accepted up to $10,000 from non-dealers at the sole discretion of the auctio eer, subject to the following limitations: a) sales are only to the cardholder, b) purchases are shipped to t cardholder's registered and verified address, c) Auctioneer may preapprove the cardholder's credit line, d) credit card transaction may not be used in conjunction with any other financing or extended terms offer by the Auctioneer, and must transact immediately upon invoice presentation, e) rights of return are govern by these Terms and Conditions, which supersede those conditions promulgated by the card issuer, f) flo Bidders must present their card. Personal or corporate checks may be subject to clearing before delivery of t purchases.

23. Payment is due upon closing of the auction session, or upon presentment of an invoice. The Auctione reserves the right to void a sale if payment in full of the invoice is not received within 7 days after the close the auction.

24. Lots delivered in the States of Texas, California, or other states where the auction may be held, are subject all applicable state and local taxes, unless appropriate permits are on file with us. In the event that sales tax not properly collected due to an expired, inaccurate, inappropriate tax certificate or declaration or any oth reason, bidder agrees to pay Auctioneer the actual amount of tax due. Lots from different auctions may not aggregated for sales tax purposes.

25. In the event that a Bidder's payment is dishonored upon presentment(s), Bidder shall pay the maximum stat tory processing fee set by applicable state law.

26. If the auction invoice(s) submitted by the Auctioneer is not paid in full when due, the unpaid balance will be interest at the highest rate permitted by law from the date of invoice until paid. If the Auctioneer refers th invoice(s) to an attorney for collection, the buyer agrees to pay attorney's fees, court costs, and other collecti costs incurred by the Auctioneer. If Auctioneer assigns collection to its in-house legal staff, such attorne time expended on the matter shall be compensated at a rate comparable to the hourly rate of independe attorneys.

27. In the event a successful Bidder fails to pay all amounts due, the Auctioneer reserves the right to resell th merchandise, and such Bidder agrees to pay for the reasonable costs of resale, including a 10% seller's commi sion, and also to pay any difference between the resale price and the price of the previously successful bid.

28. The Auctioneer reserves the right to require payment in full in good funds before delivery of the merchandi to the buyer.

29. The Auctioneer shall have a lien against the merchandise purchased by the buyer to secure payment of th auction invoice. Auctioneer is further granted a lien and the right to retain possession of any other property the buyer then held by the Auctioneer or its affiliates to secure payment of any auction invoice or any oth amounts due the Auctioneer from the buyer. With respect to these lien rights, the Auctioneer shall have all th rights of a secured creditor under Article 9 of the Texas Uniform Commercial Code. In addition, with respe to payment of the auction invoice(s), the buyer waives any and all rights of offset he might otherwise ha against the Auctioneer and the consignor of the merchandise included on the invoice.

30. If a Bidder owes Auctioneer or its affiliates on any account, the Auctioneer and its affiliates shall have the rig to offset such unpaid account by any credit balance due Bidder, and it may secure by possessory lien any unpa amount by any of the Bidder's property in their possession.

31. Title shall not pass to the successful Bidder until all invoices are paid in full. It is the responsibility of the buy to provide adequate insurance coverage for the items once they have been delivered.

RETURN POLICY:

A. MEMORABILIA

32A. A MEMORABILIA lot (Autographs, Sports Collectibles, or Music, Entertainment, Political, American and/or Pop Culture memorabilia) when the lot is accompanied by a Certificate of Authenticity, or its equiv lent, from an independent third party authentication provider, has no right of return. Under extremely limite circumstances, not including authenticity (e.g. gross cataloging error), a purchaser, who did not bid from th floor, may request Auctioneer to void a sale. Such request for evaluation must be made in writing detaili the alleged gross error, and submission of the lot to the Auctioneer must be pre-approved by the Auctionee A bidder must notify the appropriate department head (check the inside front cover of the catalog or o website for a listing of department heads) in writing of the purchaser's request and such notice must be maile within three (3) days of the mail bidder's receipt of the lot. Any lot that is to be evaluated for return must l received in our offices with 30 days. AFTER THAT 30 DAY PERIOD, NO LOT MAY BE RETURNED FC ANY REASONS. Lots returned must be in the same condition as when sold and must include the Certifica of Authenticity, if any. No lots purchased by floor bidders may be returned (including those bidders acting agents for others). Late remittance for purchases may be considered just cause to revoke all return privileges

B. COINS, CURRENCY, COMICS AND SPORTSCARDS

32B. COINS, CURRENCY, COMICS AND SPORTSCARDS Signature Sales: The auction is not on approva No certified material may be returned because of possible differences of opinion with respect to the gra offered by any third-party organization, dealer, or service. There are absolutely no exceptions to this polic Under extremely limited circumstances, (e.g. gross cataloging error) a purchaser, who did not bid from th floor, may request Auctioneer to void a sale. Such request for evaluation must be made in writing detaili the alleged gross error, and submission of the lot to the Auctioneer must be pre-approved by the Auctionee A bidder must notify Ron Brackemyre, (ext. 312) in writing of the bidder's request and such notice must mailed within three (3) days of the mail bidder's receipt of the lot. Any lot that is to be evaluated must be our offices within 30 days. Grading or method of manufacture do not qualify for this evaluation process n do such complaints constitute a basis to challenge the authenticity of a lot. AFTER THAT 30-DAY PERIO NO LOTS MAY BE RETURNED FOR REASONS OTHER THAN AUTHENTICITY. Lots returned mu be housed intact in the original holder. No lots purchased by floor Bidders may be returned (including tho Bidders acting as agents for others). Late remittance for purchases may be considered just cause to revoke a return privileges.

33. Exclusively Internet, CurrencyAuction.com, Amazing Comics Auctions™ and Bullet auctions: THREE (DAY RETURN POLICY. All lots (Exception: Third party graded notes are not returnable for any reaso whatsoever) paid for within seven days of the auction closing are sold with a three (3) day return privilege

You may return lots under the following conditions: Within three days of receipt of the lot, you must first notify Auctioneer by contacting Customer Service by phone (1-800-872-6467) or e-mail (Bid@HeritageGalleries.com), and immediately mail the lot(s) fully insured to the attention of Returns, Heritage, 3500 Maple Avenue, 17th Floor, Dallas TX 75219-3941. Lots must be housed intact in their original holder and condition. You are responsible for the insured, safe delivery of any lots. A non-negotiable return fee of 5% of the purchase price ($10 per lot minimum) will be deducted from the refund for each returned lot or billed directly. Postage and handling fees are not refunded. After the three-day period (from receipt), no items may be returned for any reason. Late remittance for purchases revokes all Return-Restock privileges.

34. All Bidders who have inspected the lots prior to the auction will not be granted any return privileges, except for reasons of authenticity.

DELIVERY:

35. Postage, handling and insurance charges will be added to invoices. Please either refer to Auctioneer's web site HeritageGalleries.com for the latest charges or call Auctioneer.

COMPLETE SHIPPING AND HANDLING CHARGES

36. Auctioneer is unable to combine purchases from other auctions or Heritage Rare Coin Galleries into one package for shipping purposes. Successful overseas Bidders shall provide written shipping instructions, including specified customs declarations, to the Auctioneer for any lots to be delivered outside of the United States.

37. All shipping charges will be borne by the successful Bidder. Any risk of loss during shipment will be borne by the buyer following Auctioneer's delivery to the designated common carrier.

38. Regardless of domestic or foreign shipment, risk of loss shall be borne by the buyer following Auctioneer's delivery to a shipper.

39. Any claims for undelivered packages must be made within 30 days of shipment by the auctioneer.

40. In the event an item is damaged either through handling or in transit, the Auctioneer's maximum liability shall be the amount of the successful bid including the Buyer's Premium.

CATALOGING:

41. The descriptions provided in any catalog are intended solely for the use of those Bidders who do not have the opportunity to view the lots prior to bidding.

42. Any description of the lots contained in this auction is for the sole purpose of identifying the items.

43. In the event of an attribution error, the Auctioneer may, at the Auctioneer's sole discretion, correct the error on the Internet, or, if discovered at a later date, to refund the buyer's money without further obligation. Under no circumstances shall the obligation of the Auctioneer to any Bidder be in excess of the purchase price for any lot in dispute.

WARRANTIES AND DISCLAIMERS:

44. NO WARRANTY, WHETHER EXPRESSED OR IMPLIED, IS MADE WITH RESPECT TO ANY DESCRIPTION CONTAINED IN THIS AUCTION. Any description of the items contained in this auction is for the sole purpose of identifying the items, and no description of items has been made part of the basis of the bargain or has created any express warranty that the goods would conform to any description made by the Auctioneer.

45. Auctioneer is selling only such right or title to the items being sold as Auctioneer may have by virtue of consignment agreements on the date of auction and disclaims any warranty of title to the coins.

46. Auctioneer disclaims any warranty of merchantability or fitness for any particular purposes.

47. Auctioneer disclaims all liability for damages, consequential or otherwise, arising out of or in connection with the sale of any property by Auctioneer to Bidder. No third party may rely on any benefit of these Terms and Conditions and any rights, if any, established hereunder are personal to the Bidder and may not be assigned. Any statement made by the Auctioneer is a statement of opinion and does not constitute a warranty or representation. Any employee of Auctioneer may not alter these Terms and Conditions, and, unless signed by a principal of Auctioneer, any alteration is null and void.

48A. **COINS, CURRENCY, COMICS AND SPORTSCARDS** - Coins sold referencing a third-party grading service ("Certified Coins") are sold "as is" without any express or implied warranty, except for a guarantee by Auctioneer that the Certified Coins are genuine. Certain warranties may be available from the grading services and the Bidder is referred to the following services for details of any such warranties: ANACS, P.O. Box 182141, Columbus, Ohio 43218-2141; Numismatic Guaranty Corporation (NGC), P.O. Box 4776, Sarasota, FL 34230; Professional Coin Grading Service (PCGS), PO Box 9458, Newport Beach, CA 92658 and ICG, 7901 East Belleview Ave., Suite 50, Englewood, CO 80111. Comic books sold referencing a third-party grading service ("Certified Comics") are sold "as is" without any express or implied warranty, except for a guarantee by Auctioneer that the Certified Comics are genuine. Certain warranties may be available from the grading services and the Bidder is referred to the following services for details of any such warranties: Comics Guaranty Corporation (CGC), P.O. Box 4738, Sarasota, FL 34230. Sportscards sold referencing a third-party grading service ("Certified Sportscards") are sold "as is" without any express or implied warranty, except for a guarantee by Auctioneer that the Certified Sportscards are genuine. Certain warranties may be available from the grading services and the Bidder is referred to the following services for details of any such warranties: Professional Sports Authenticator (PSA), P.O. Box 6180 Newport Beach, CA 92658; Sportscard Guaranty LLC (SGC) P.O. Box 6919 Parsippany, NJ 07054-6919; Global Authentication (GAI), P.O. Box 57042 Irvine, Ca. 92619; Beckett Grading Service (BGS), 15850 Dallas Parkway, Dallas TX 75248. Currency sold referencing a third-party grading service ("Certified Currency") are sold "as is" without any express or implied warranty, except for a guarantee by Auctioneer that the Certified Currency are genuine. Certain warranties may be available from the grading services and the Bidder is referred to the following services for details of any such warranties: Currency Grading & Authentication (CGA), PO Box 418, Three Bridges, NJ 08887.

48B. **MEMORABILIA** - Auctioneer does not warrant authenticity of a memorabilia lot (Autographs, Sports Collectibles, or Music, Entertainment, Political, Americana and/or Pop Culture memorabilia), when the lot is accompanied by a Certificate of Authenticity, or its equivalent, from an independent third party authentication provider. Bidder shall solely rely upon warranties of the authentication provider issuing the Certificate or opinion. For information as to such authentication provider's warranties the bidder is directed to: SCD Authentic, 4034 West National Ave., Milwaukee, WI 53215 (800) 345-3168; JO Sports, Inc., P.O. Box 607 Brookhaven, NY 11719 (631) 286-0970; PSA/DNA; 130 Brookshire Lane, Orwigsburg, Pa. 17961; Mike Gutierrez Autographs, 8150 Raintree Drive Suite A, Scottsdale, AZ. 85260; or as otherwise noted on the Certificate.

49. All non-certified coins and comics and currency are guaranteed genuine, but are not guaranteed as to grade, since grading is a matter of opinion. Grading is an art, not a science, and therefore the opinion rendered by the Auctioneer or any third party grading service may not agree with the opinion of others (including trained experts), and the same expert may not grade the same coin with the same grade at two different times. Auctioneer has graded the non-certified items, in the Auctioneer's opinion, to their current interpretation of the American Numismatic Association's standards as of the date the catalog was prepared. There is no guarantee or warranty implied or expressed that the grading standards utilized by the Auctioneer will meet the standards of ANACS, NGC, PCGS, ICG, CGC, CGA or any other grading service at any time in the future.

50. Auctioneer offers no opinion as to the validity of a grade assigned by any third-party grading service. Since we cannot examine C.G.A. encapsulated notes or Comics Guaranty Corporation (CGC) encapsulated comics, they are sold "as is" without our grading opinion, and may not be returned for any reason. Auctioneer shall not be liable for any patent or latent defect or controversy pertaining to or arising from any encapsulated collect-

ible. In any such instance, purchaser's remedy, if any, shall be solely against the certification service certifying the collectible.

51. Due to changing grading standards over time and to possible mishandling of items by subsequent owners, the Auctioneer reserves the right to grade items differently than shown on certificates from any grading service that accompany the items. For the same reasons as stated above, the Auctioneer reserves the right to grade items differently than the grades shown in the catalog should such items be reconsigned to any future auction.

52. Although consensus grading is employed by most grading services, it should be noted as aforesaid that grading is not an exact science. In fact, it is entirely possible that if a lot was broken out of a plastic holder and was resubmitted to another grading service or even the same service, the lot could come back a different grade. Certification does not guarantee protection against the normal risks associated with potentially volatile markets.

53. The degree of liquidity for certified coins and collectibles will vary according to general market conditions and the particular lot involved. For some lots there may be no active market at all at certain points in time.

RELEASE:

54. In consideration of participation in the auction and the placing of a bid, a Bidder expressly releases Auctioneer, its affiliates, the Consignor, or Owner of the Lot from any and all claims, cause of action, chose of action, whether at law or equity or any arbitration or mediation rights existing under the rules of any professional society or affiliation based upon the assigned grade or a derivative theory, breach of warranty express or implied, representation or other matter set forth within these Terms and Conditions of Auction or otherwise, except as specifically declared herein; e.g., authenticity, typographical error, etc., and as to those matters, the rights and privileges conferred therein are strictly construed and is the exclusive remedy. Purchaser by non-compliance to its express terms of a granted remedy, shall waive any claim against Auctioneer.

DISPUTE RESOLUTION AND ARBITRATION PROVISION:

55. By placing a bid or otherwise participating in the auction, such person or entity accepts these Terms and Conditions of Auction, and specifically agrees to the alternative dispute resolution provided herein. Arbitration replaces the right to go to court, including the right to a jury trial.

56A. COINS & CURRENCY; If any disputes arise regarding payment, authenticity, grading or any other matter pertaining to the auction, the Bidder or a participant in the auction and/or the Auctioneer agree that the dispute shall be submitted, if otherwise mutually unresolved, to binding arbitration in accordance with the rules of the Professional Numismatists Guild (PNG) or American Arbitration Association (A.A.A.). The A.A.A. arbitration shall be conducted under the provisions of the Federal Arbitration Act with locale in Dallas, Texas. If an election is not made within ten (10) days of an unresolved dispute, Auctioneer may elect either PNG or A.A.A. Arbitration. Any claim made by a Bidder has to be presented within one (1) year or it is barred. An award granted in arbitration is enforceable in any court. No claims of any kind (except for reasons of authenticity) can be considered after the settlements have been made with the consignors. Any dispute after the settlement date is strictly between the Bidder and consignor without involvement or responsibility of the Auctioneer.

56B. ALL OTHER AUCTIONS; If any dispute arises regarding payment, authenticity, grading, description, provenance or any other material pertaining to the auction, the Bidder or the participant in the auction and/or the Auctioneer agree that the dispute shall be submitted, if otherwise mutually unresolved, to unbinding arbitration in accordance with the commercial rules of the American Arbitration Association (A.A.A.). The A.A.A. arbitration shall be conducted under the provisions of the Federal Arbitration Act with locale in Dallas, Texas. The prevailing party may be awarded his reasonable attorney's fees and costs. An arbitrator's award is enforceable in any court of competent jurisdiction. Any claim made by a Bidder has to be presented within one (1) year or it is barred. Any claim as to provenance or authenticity must be first transmitted to Auctioneer by credible and definitive evidence and there is no assurance such presentment that Auctioneer will validate the claim. Authentication is not an exact science and other contrary opinions may not be recognized by Auctioneer. Auctioneer in no event shall be responsible for consequential and incidental damages and the value of any item is determined by its high bid, which is Auctioneer's maximum liability. Provenance and authenticity are not guaranteed by the Auctioneer, but rather are guaranteed by the consignor. Any action or claim shall include the consignor with Auctioneer acting as interpleador or nominal party. While every effort is made to determine provenance and authenticity, it is up to the Bidder to arrive at that conclusion prior to bidding.

57. In consideration of his participation in or application for the auction, a person or entity (whether the successful Bidder, a Bidder, a purchaser and/or other Auction participant or registrant) agrees, that all disputes in any way relating to, arising under, connected with, or incidental to these Terms and Conditions and his purchases or default in payment thereof shall be arbitrated pursuant to the arbitration provision. In the event that any matter including actions to compel arbitration, construe the agreement, actions in aid or arbitration or otherwise needs to be litigated, such litigation shall be exclusively in the Courts of the State of Texas, in Dallas County, Texas, and if necessary the corresponding appellate courts. The successful Bidder, purchaser, or Auction participant also expressly submits himself to the personal jurisdiction of the State of Texas.

MISCELLANEOUS:

58. Agreements between Bidders and consignors to effectuate a non-sale of an item at auction, inhibit bidding on a consigned item to enter into a private sale agreement for an item, or to utilize the Auctioneer's auction to obtain sales for non-selling consigned items subsequent to the auction are strictly prohibited. If a subsequent sale of a previously consigned item occurs in violation of this provision, Auctioneer reserves the right to charge Bidder the applicable Buyer's Premium and consignor a Seller's Commission as determined for each auction venue and by the terms of the seller's agreement.

59. Acceptance of these terms and conditions qualifies Bidder as a Heritage customer who has consented to be contacted by Heritage in the future. In conformity with "do-not-call" regulations promulgated by the Federal or State regulatory agencies, participation by the Bidder is affirmative consent to being contacted at the phone number shown in his application and this consent shall remain in effect until it is revoked in writing. Heritage may from time to time contact Bidder concerning sale, purchase and auction opportunities available through Heritage and its affiliates and subsidiaries.

60. Storage of purchased coins: Purchasers are advised that certain types of plastic may react with the coin's metal and may cause damage to the coins. Caution should be used to avoid storage of coins in materials that are not inert.

STATE NOTICES:

61. Notice as to an Auction Sale in California. Auctioneer has in compliance with Title 2.95 of the California Civil Code as amended October 11, 1993 Sec. 1812.600, posted with the California Secretary of State its bonds for it and its employees and the auction is being conducted in compliance with Sec. 2338 of the Commercial Code and Sec. 535 of the Penal Code.

CHOOSE YOUR BIDDING METHOD

Mail Bidding At Auction

Mail bidding at auction is fun and easy and only requires a few simple steps.

1. Look through the catalog, and determine the lots of interest.
2. Research their market value by checking price lists and other price guidelines.
3. Fill out your bid sheet, entering your maximum bid on each lot using your price research and your desire to own the lot.
4. Verify your bids!
5. Mail Early. Preference is given to the first bids received in case of a tie. **When bidding by mail, you frequently purchase lots at less than your maximum bid.**

Bidding is opened at the published increment above the second highest mail or Internet bid; we act on your behalf as the highest mail bidder. If bidding proceeds, we act as your agent, bidding in increments over the previous bid. This process is continued until you are awarded the lot or you are outbid.

An example of this procedure: You submit a bid of $100, and the second highest mail bid is at $50. Bidding starts at $51 on your behalf. If no other bids are submitted, you purchase the lot for $51. If other bids are placed, we bid for you in the posted increments until we reach your maximum bid of $100. If bidding passes your maximum: if you are bidding through the Internet, we will contact you by e-mail; if you bid by mail, we take no other action. Bidding continues until the highest bidder wins.

Auction #608

Interactive Internet™ Bidding

You can now bid with Heritage's exclusive Interactive Internet™ program, available only at our web site: www.heritagegalleries.com. It's fun, and it's easy!

1. Register on-line at http://www.heritagegalleries.com/common/register.php.
2. View the full-color photography of every single lot in the on-line catalog!
3. Construct your own personal catalog for preview.
4. View the current opening bids on lots you want; review prices realized archive.
5. Bid and receive immediate notification if you are the top bidder; later, if someone else bids higher, you will be notified automatically by e-mail.
6. The Interactive Internet program opens the lot on the floor at one increment over the second highest bid. As the high bidder, your secret maximum bid will compete for you during the floor auction, and it is possible that you may be outbid on the floor after internet bidding closes. Bid early, as the earliest bid wins in the event of a tie bid.
7. After the sale, you will be notified of your success.

It's that easy!

Telephone Bidding

To participate by telephone, please make arrangements at least one week before the sale date with Kathy Eilers, 1-800-872-6467, Ext. 392.

We strongly recommend that you place preliminary bids by mail, Fax, or Internet, even if you intend to participate by telephone. On many occasions this dual approach has helped reduce disappointments due to telephone problems, unexpected travel, late night sessions and time zone differences, etc. We will make sure that you do not bid against yourself.

Condition Reports

Bidders may be interested in specific information not included in the catalog description of an item. Upon written request Heritage will, time permitted, as a service to our clients, attempt to provide additional information on any lot in this sale for the guidance and convenience of the bidder. Heritage may not be able to respond to all requests. Please note Condition Reports are written opinions of the sale catalogers describing the condition of property noting their opinions of damage or restoration of an item. Condition Reports are not to be relied on as statements of fact, representations, warranties or our assumption of any liability of any kind. Condition Reports do not extend the Limited Warranties provided in the catalog. Regardless of the issuance of a Condition Report, all bidders are reminded that each lot is sold "As Is". It is the bidder's responsibility to either personally evaluate each lot or have a knowledgeable consultant inspect the lot on the bidder's behalf. A reference to specific condition issues does not imply the lot is free from defects or the absence of other condition issues such as but not limited to age, wear, damage, restoration, alterations, or imperfections created during the making of the object.

1. Name, Address, City, State, Zip

Your address is needed to mail your purchases. We need your telephone number to communicate any problems or changes that may affect your bids.

2. References

If you have not established credit with us from previous auctions, you must send a 25% deposit, or list dealers with whom you have credit established.

3. Lot Numbers and Bids

List all lots you desire to purchase. On the reverse are additional columns, you may also use another sheet. Under "Amount" enter the maximum you would pay for that lot (whole dollar amounts only). We will purchase the lot(s) for you as much below your bids as possible.

4. Total Bid Sheet

Add up all bids and list that total in the appropriate box.

5. Sign Your Bid Sheet

By signing the bid sheet, you have agreed to abide by the Terms of Sale listed in the auction catalog.

6. Fax Your Bid Sheet

When time is short submit a Mail Bid Sheet on our exclusive Fax Hotline. There's no faster method to get your bids to us instantly. Simply use the **Heritage Fax Hotline number 214-443-8425.**

> When you send us your original after faxing, mark it "Confirmation of Fax" (preferably in red!)

MAIL/FAX BID SHEET

HERITAGE
Galleries & Auctioneers

Heritage Galleries & Auctioneers
1-800-872-6467
3500 Maple Avenue
Dallas, TX 75219-3941
(All information must be completed.)

> HG&A Auction
> Submit Your Bids By Fax
> FAX HOTLINE: 214-443-8425

NAME **WILLIAM STARK** CUSTOMER # (if known) _____

ADDRESS **4739 - B BRADFORD DRIVE** _____

CITY/STATE/ZIP **DALLAS, TX 75219** _____

DAYTIME PHONE (**214**) **555-8109** EVENING PHONE (**214**) **528-3500**

YOUR E-MAIL ADDRESS _____
(E-MAIL bids MUST be sent to Bid@HeritageGalleries.com) Would you like a FAX or e-mail confirming receipt of your bids? If so, please print your FAX # or e-mail address here: _____

REFERENCES: New bidders who are unknown to us must furnish satisfactory trade references or a credit card in advance of the sale date.

Dealer References (City, State)
DESIGNS BY DAVID
SMITH'S FINE PAINTINGS

(Bid in whole dollar amounts only.) You are authorized to release payment history information to other dealers and auctioneers so that I may establish proper credit in the industry. (Line out this statement if you do not authorize release.)

LOT NO.	AMOUNT	LOT NO.	AMOUNT	LOT NO.	AMOUNT	LOT NO.	AMOUNT
143	200	3210	325				
221	75						
1621	125						
2416	625						

PLEASE COMPLETE THIS INFORMATION:

1. IF NECESSARY, PLEASE INCREASE MY BIDS BY:
 ☑10% ☐ 20% ☐ 30% ☐ 50%
 Lots will be purchased as much below bids as possible.

2. ☐ I HAVE BOUGHT ANTIQUES/ART FROM YOU BEFORE (references are listed above)

William Stark
(Signature required) Please make a copy of your bid sheet for your records.

On all successful bids, I agree to pay an additional twenty percent (20%) Buyer's Premium and all mailing and shipping charges. I have read and agree to all of the Terms and Conditions of Sale: inclusive of paying interest at the lesser of 1.5% per month (18% per annum) or the maximum contract interest rate under applicable state law from the date of sale (if the account is not timely paid), and the submission of disputes to arbitration.
REV. 4/26/04

SEE OTHER SIDE

SUBTOTAL	1475
TOTAL from other side	
TOTAL BID	1475

The official prices realized list that accompanies our auction catalogs is reserved for bidders and consignors only. We are happy to mail one to others upon receipt of $1.00. Written requests should be directed to Kathy Eilers.

We would like to draw special attention to the Silver Collections of Dr. William P. Hood, Jr. and Dr. Dale Bennett.

The Dr. William P. Hood, Jr. Collection

Lots 18051 - 18068

Begins on page 10

Dr. Hood, a retired cardiologist, authored the definitive text on Tiffany flatware, entitled *Tiffany Silver Flatware—1845-1905: When Dining Was an Art*. He is now working on several magazine articles on flatware and has started another book, *An Annotated Bibliography of Flatware*.

The Dr. Dale Bennett Collection

Lots 18187 - 18219

Begins on page 47

Dr. Bennett, now retired from his physician practice, has authored many articles for Silver Magazine and has served as curator for the San Antonio Museum of Art's Silver Show. Dr. Bennett has devoted his major focus to tracing and documenting the development of American and English serving pieces.

SESSION ONE — SILVER
Public-Internet Auction #608
Saturday, October 30, 2004, 10:00 a.m., Lots 18001-18525
Dallas, Texas
A 19.5% Buyer's Premium Will Be Added To All Lots
Visit <u>HeritageGalleries.com</u> to view scalable images and bid online.

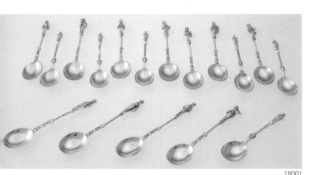
18001

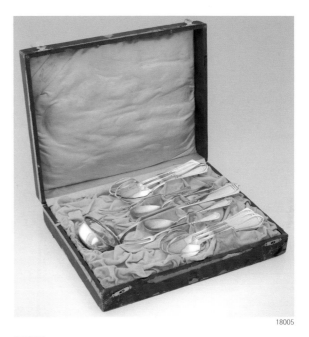
18005

18001

SEVENTEEN SILVER APOSTLE SPOONS
Various marks, England and Germany, c.1910

The spoons with apostle finials and twist handles, *marked reverse of bowls*
6.5in. the longest

18002

A DANISH SILVER LOBSTER PICK
Mark of George Jensen, Denmark, c.1950

Two-pronged lobster pick with dueling prawns on handle, *marked reverse*
7.3in. long, 1.25oz

18003

THREE DANISH SILVER PYRAMID PATTERN SALT SPOONS
Mark of Georg Jensen, Copenhagen, c.1945

No monogram, light patina *marked reverse of bowl*
2.0in. long (Total: 3)

18005

A CONTINENTAL SILVER ART DECO BOXED SERVING SET
H. Wurm, Braunschweig, Germany, c.1920

Consisting of six tablespoons, two gilt serving spoons, two serving forks and one parcel gilt soup ladle, in their original fitted case, *marked undersides*
13.8in. the soup ladle (Total: 11 Items)

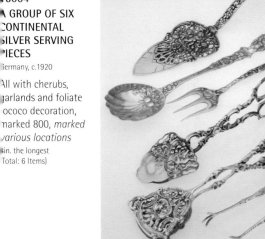
18004

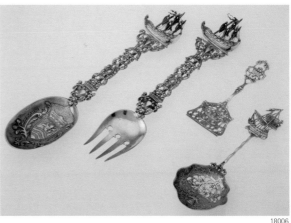
18006

18004

A GROUP OF SIX CONTINENTAL SILVER SERVING PIECES
Germany, c.1920

All with cherubs, garlands and foliate rococo decoration, marked 800, *marked various locations*
9in. the longest
(Total: 6 Items)

18006

A GROUP OF FOUR CONTINENTAL SILVER NAVAL MOTIF SERVERS
Various makers, c.1900

First, a round bowl reticulated bonbon spoon with a ship finial; second, a reticulated ship motif bonbon shovel; third, a salad serving fork with cast rocaille handles and warship finial with three masts and a flag; fourth, the matching salad serving spoon to the fork, *marked interior of bowls*
the longest, 10.75in. (Total: 4 Items)

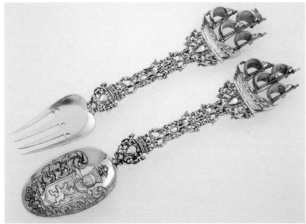

18007

A PAIR OF SILVER FIGURAL NAVAL MOTIF SALAD SERVERS

Continental, c.1920

The handles with open work and putti, finials of large naval ships, *marked reverse of bowls*

10.7in. long (Total: 2 Items)

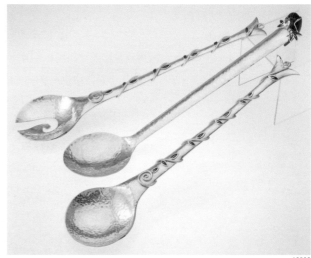

18008

THREE HAMMERED AND INLAID SILVER PLATE SERVING SPOONS

Los Castillo

The spoons of hammered silver, two with a vine motif in turquoise paste, one with a turquoise paste and lapis parrot

15in. long (Total: 3)

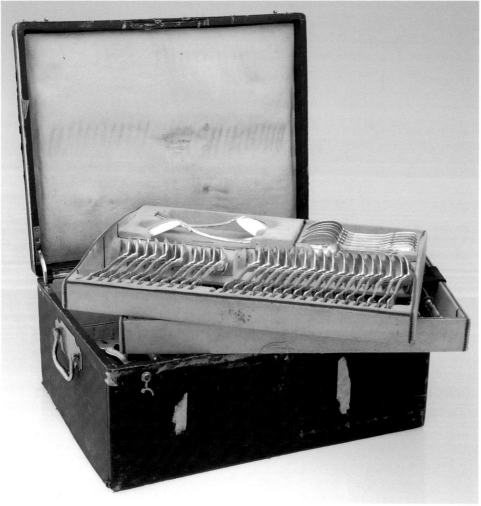

18009

18009

A ONE-HUNDRED-NINETEEN PIECE CONTINENTAL SILVER FLATWARE SERVICE IN A FITTED CANTEEN

Mark of Heinrich Fries, sold by W. Grebner, Wien, Austria, c.1910

Each with a heraldic crest, marked 'H. Fries' and the Vienna Austria inspection mark for import silver dated 1902 to 1921, the service consisting of:
Eighteen teaspoons
Eleven dessert spoons
Seventeen tablespoons
Ten dessert forks
Eleven dessert knives
Twenty-one dinner forks
Twenty-one dinner knives
Two large serving spoons
Fish serving knife and fork
A roast carving fork and knife
A soup ladle
A pair of sugar tongs
Two gravy ladles

166oz. weighable silver (Total: 119 items)

18010

A GROUP OF SIX AMERICAN SILVER PLATE HOLLY PATTERN DEMITASSE SPOONS

Mark of E.H.H. Smith, Bridgeport, Connecticut, c.1910

Decorated with holly leaves, vines and berries, excellent condition, *marked reverse of handle*

4.2.in long (Total: 6)

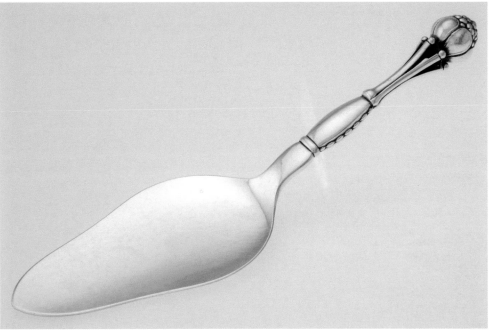

18013

18013
A DANISH SILVER #38 PATTERN FLAT SERVER
Mark of Georg Jensen, Copenhagen, Denmark, c.1940

Known as pattern #38, featuring a stylized blossom set upon six beaded supports, oval beading on the side of handle, hammer marks evident on finish, unusual 'Georg Jensen limited silversmiths' mark, *marked reverse of handle*
10.5in. long, 4.7oz

18014
AN AMERICAN SILVER FIGURAL FLORAL BON BON SPOON
Mark of Shreve Treat & Eacret, San Francisco, California, c.1915

The handle with floral openwork spelling 'San Francisco', a parcel gilt poppy bowl, *marked reverse of handle*
5.2in. long

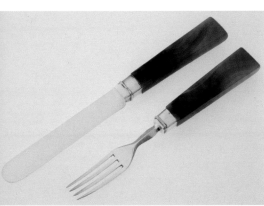

18011

18011
A PAIR OF MEXICAN SILVER SPOONS, HECTOR AGUILAR
Mark of Hector Aguilar, Taxco, Mexico, c.1945

One a shovel, one a spoon, *marked reverse of handles*
5in. the longest

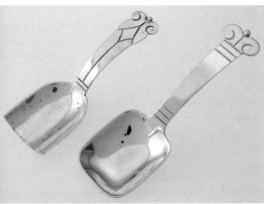

18012

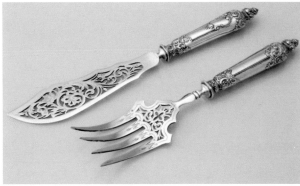

18015

18015
A FRENCH SILVER BOXED FISH SERVING KNIFE AND FORK
France, c.1880

Rococo style handles, blade of knife and surface of fork with extensive open-cut work, decorative engraving also, original silk lined box, *marked on handle*
12.5in. long, the knife (Total: 2 Items)

18012
AN ENGLISH SILVER AGATE HANDLE KNIFE AND FORK
Maker unknown, London, England, c.1897

The handles square, grey agate, the blades and ferrules of sterling silver, trademark 'TB', *marked on blade*
8.5in. the knife (Total: 2 Items)

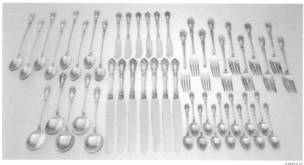

18016

A FIFTY-PIECE GROUP OF AMERICAN SILVER CHATEAU ROSE PATTERN FLATWARE

Mark of Alvin, Providence, Rhode Island, c.1940

No monogram, the group consisting:
Seven hollow-handle knives
Six butter knives
Four forks
Seven salad forks
Eight iced tea spoons
Five soup spoons
Thirteen demitasse spoons

(Total: 50 Items)

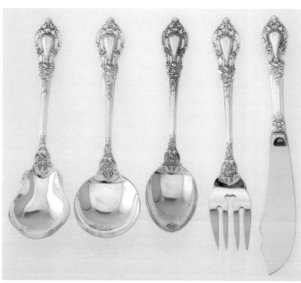

18017

A THIRTY-ONE-PIECE GROUP OF AMERICAN SILVER ELOQUENCE PATTERN FLATWARE

Mark of Lunt, Greenfield, Massachusetts, c.1953

Each piece without monogram, some sealed in the original factory sleeve stamped 'Lunt Sterling,' the group comprising:
Three teaspoons
Eighteen soup spoons
Seven iced tea spoons
A salad fork
A master butter knife (stainless steel blade)
A sugar shell

(Total: 31 items)

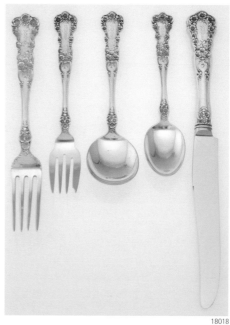

18018

AN AMERICAN SILVER BUTTERCUP PATTERN FLATWARE SERVICE

Mark of Gorham, Providence, Rhode Island, c.1910

An older service with period monograms, eight 9.6in knives, eight 7.5in. forks, eight salad forks, eight cream soup spoons, eight ice tea spoons, twelve teaspoons, a sugar shell and butter knife, crisp pattern, excellent condition, *marked reverse of handles*

(Total: 53)

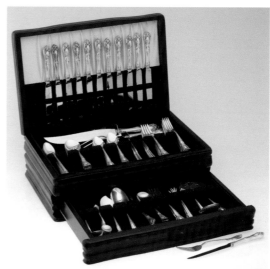

18019

A ONE HUNDRED THIRTEEN-PIECE GROUP OF AMERICAN SILVER CHATEAU ROSE PATTERN FLATWARE

Mark of Alvin, Providence, Rhode Island, c.1940

Unmonogrammed, the group consisting:
Twelve hollow-handle knives
Twelve butter knives
Twelve forks
Twelve salad forks
Twelve teaspoons
Twelve iced teaspoons
Twelve soup spoons
Twelve demitasse spoons
A carving set
A sauce ladle
A serving spoon
A preserve spoon
A lemon fork
Two olive forks
Two sugar shells
Two cold meat forks
Two master butter knives
Two gravy ladles
A tomato server

(Total: 113 items)

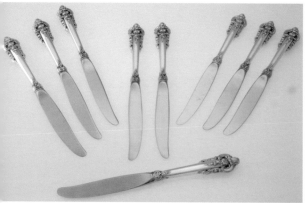

18020

A NINE-PIECE GROUP OF AMERICAN SILVER GRAND BAROQUE PATTERN KNIVES
Mark of Wallace, Wallingford, Connecticut, c.1941

Hollow-handle knives, unmonogrammed, *marked reverse of handles*
Each 9in. long
(Total: 9 Items)

18021

AN ELEVEN-PIECE GROUP OF AMERICAN SILVER GRAND BAROQUE PATTERN SPOONS
Mark of Wallace, Wallingford, Connecticut, c.1941

Unmonogrammed group of ten teaspoons, together with a demitasse spoon, *marked reverse of handles*
(Total: 10 Items)

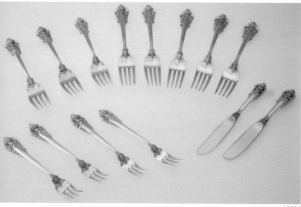

18022

A FOURTEEN-PIECE GROUP OF AMERICAN SILVER GRAND BAROQUE PATTERN FLATWARE
Mark of Wallace, Wallingford, Connecticut, c.1941

Unmonogrammed, the group consisting:
Five forks
Three salad forks
Four cocktail forks
Two hollow-handle butter knives
(Total: 14 items)

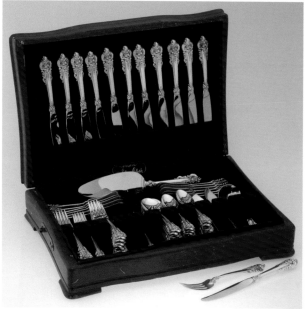

18023

A NINETY-FOUR-PIECE AMERICAN SILVER GRAND BAROQUE PATTERN FLATWARE GROUP
Mark of Wallace, Wallingford, Connecticut, c.1941

Unmonogrammed, the group consisting:
Twelve hollow-handle knives
Twelve butter knives
Twelve forks
Twelve salad forks
Two lemon forks
Twelve soup spoons
Twenty-four teaspoons
A preserve spoon
A bonbon spoon
A sugar shell
A sauce ladle
A master butter knife
A pie server
A serving spoon
A cold meat fork

(Total: 94)

18024

FOURTEEN AMERICAN SILVER CENTURY PATTERN STEAK KNIVES
Mark of Tiffany & Co., New York, c.1945

Each with Tiffany stainless blades, pointed and very sharp, eight with a period 'S' monogram, six with a period 'JMF' monogram, *marked on ferrule*
8.5in. each
(Total: 14 Items)

18025
FOURTEEN AMERICAN SILVER CENTURY PATTERN SPOONS
Mark of Tiffany & Co., New York, c.1945

Eight with a period 'S' monogram, six with a period 'JMF' monogram, a great art deco pattern for the 100th anniversary of Tiffany & Co., *marked reverse of handle*

6in. each (Total: 14 Items)

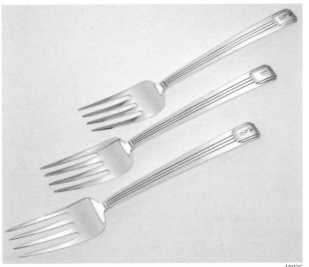

18026

18026
THREE AMERICAN SILVER CENTURY PATTERN SERVING FORKS
Mark of Tiffany & Co., New York, c.1945

Three serving forks in the art deco 'Century' pattern by Tiffany, excellent condition, all with period monograms, two matching, *marked reverse of handles*

8.7in. long (Total: 3 Items)

18027
A PAIR OF AMERICAN SILVER CENTURY PATTERN SERVING SPOONS
Mark of Tiffany & Co., New York, C.1940

Both with large oval bowls, an art deco 'ALC' monogram, this pattern made in 1939 to commemorate Tiffany's 100th anniversary, one of the spoons with a star for the year 1943, *marked reverse of handle*

9in. long each, 7.2oz gross weight (Total: 2 Items)

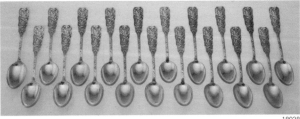

18028

18028
A GROUP OF NINETEEN AMERICAN SILVER ST. CLOUD PATTERN SPOONS
Mark of Gorham, Providence, Rhode Island, c.1890

Seven with monograms, twelve without, very good condition throughout, *marked reverse of handles*

5.9in. each (Total: 19 Items)

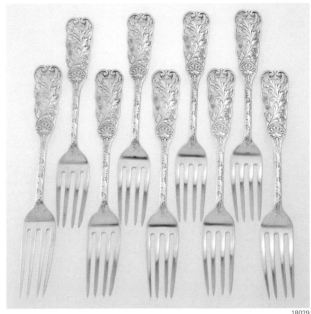

18029

18029
A GROUP OF NINE AMERICAN SILVER ST. CLOUD PATTERN FORKS
Mark of Gorham, Providence, Rhode Island, c.1900

Full length tines with no cutting on backside, each with a period monogram 'Aldrich' on reverse, *marked reverse of handle*

7.6in. long each (Total: 9 Items)

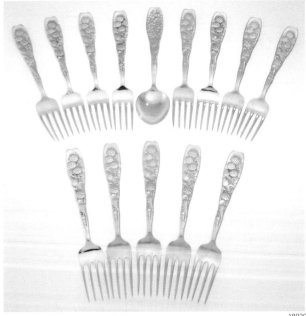

18030

18030
A GROUP OF FOURTEEN AMERICAN SILVER BERRY PATTERN ITEMS
Mark of Whiting, Providence, Rhode Island, c.1890

Thirteen forks and one dessert spoon, all with script 'Oakley' monogram, *marked reverse of handles*

6.8in long, the forks (Total: 14 Items)

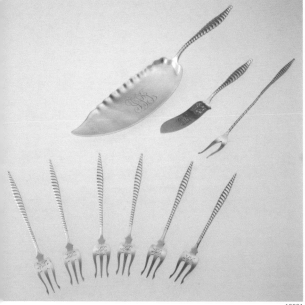

18031

A GROUP OF AMERICAN SILVER OVAL TWIST PATTERN FLATWARE

Mark of Whiting, Providence, Rhode Island, c.1890

A fish slice, olive spear, master butter knife and six seafood forks, *marked reverse of handles*

11in. the fish knife (Total: 9 Items)

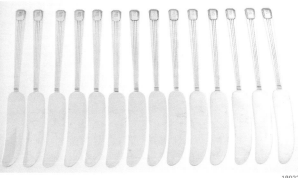

18032

FOURTEEN AMERICAN SILVER CENTURY PATTERN BUTTER SPREADERS

Mark of Tiffany & Co., New York, c.1945

Eight with a single 'S' monogram, six with a three letter 'JMF' monogram, the six with the 'star' WWII date mark, *marked reverse of handles*

6.1in. long each (Total: 14)

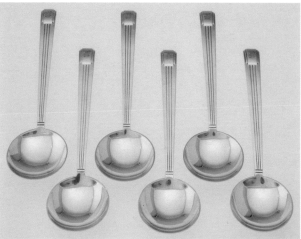

18033

A GROUP OF SIX AMERICAN SILVER CENTURY PATTERN SOUP SPOONS

Mark of Tiffany & Co., New York, c.1945

Each with star date mark, superb original condition, matching 'JMF' monograms, *marked reverse of handles*

6.7in. long (Total: 6 Items)

18034

FOUR AMERICAN SILVER CENTURY PATTERN FORKS

Mark of Tiffany & Co., New York, c.1945

This pattern made to commemorate the 100th anniversary of the founding of Tiffany & Co., a period deco 'JMF' monogram, *marked reverse of handle*

7.2in. long (Total: 4 Items)

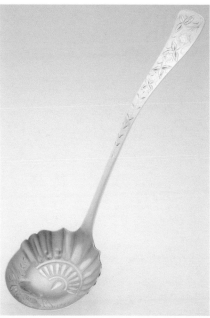

18035

AN AMERICAN SILVER AESTHETIC MOVEMENT SOUP LADLE

Mark of Towle, Newburyport, Massachusetts, c.1890

Parcel gilt, the fluted bowl and handle with engraved floral decoration, *marked reverse of handle*

13.2in. long

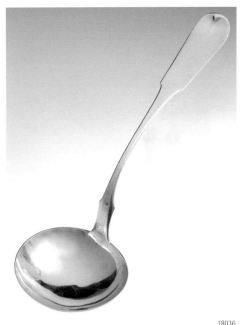

18036

A KENTUCKY COIN SILVER SOUP LADLE

William Kendrick, Louisville, Kentucky, c.1845

A superb Kentucky ladle in excellent condition, natural soft grey patina with no monogram or removals, 'Tipt' pattern

12.7in. long

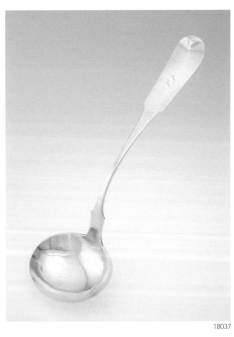

18037

A KENTUCKY COIN SILVER SOUP LADLE

Mark of William Kendrick, Louisville, Kentucky, c.1850

The Tipt pattern ladle with a two letter period script 'LP' monogram, clearly marked 'Wm. Kendrick', *marked reverse of handle*

12.7in. long

18038

A GROUP OF TEN TWIST HANDLE DEMITASSE SPOONS

Mark of Whiting, Providence, Rhode Island, c.1890

Each with matte finish bowl and twist handles, *marked reverse of handles*

4in. long each

(Total: 10 Items)

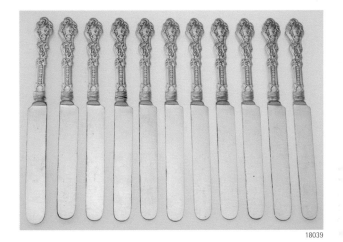

18039

A GROUP OF ELEVEN AMERICAN SILVER VERSAILLES PATTERN KNIVES

Mark of Gorham, Providence, Rhode Island, c.1900

Original silver plated 'blunt' shaped knife blades, plating mostly intact, each with a period 'W' monogram, sterling silver handles, *marked on handles*

9.7in. long

(Total: 11 Items)

18040

A PAIR OF AMERICAN SILVER STRAWBERRY PATTERN ITEMS

Attributed to Durgin, Concord, Massachusetts, c.1860

A master butter knife and sugar shell, the knife with elaborate engraving on the blade, the sugar shell with fluted bowl, sugar with fancy script monogram, *marked reverse of handles*

7in. the longest

(Total: 2 Items)

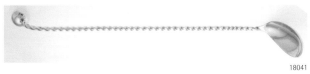

18041

AN AMERICAN SILVER TWIST HANDLE CLARET LADLE

Maker unknown, c.1880

A ball top twist handle claret ladle in the style of George Sharp, script monogram 'MDW' on ball, *marked sterling underside*

14in. long

18042

AN AMERICAN COIN SILVER BERRY SPOON

Mark of N. Harding, Boston, c.1865

The pointed handle with ivy leaves, the gold washed bowl with engraved strawberries, leaves and vines, *marked reverse of handle*

9.25in. long, 2.15oz

18043

AN UNUSUAL AMERICAN SILVER VERSAILLES PATTERN SPOON

Mark of Gorham, Providence, Rhode Island, c.1890

The bowl with ornate cloud background and floating cherub heads with wings, the handle with rococo style scrolls and shells, *marked reverse of bowl*

5.25in. long

18044

AN AMERICAN SILVER STRAINING SPOON

Mark of Shiebler, New York, c.1890

The large bowl pierced, the plain handle with a script monogram, retailed by 'Bigelow Kennard', *marked reverse of handle*

6.4in. long

18045
AN AMERICAN SILVER MILAN PATTERN BERRY SCOOP

Mark of Gorham, Providence, Rhode Island, c.1885

Hand chased decoration in the bowl, the handle with palms and heart shaped cartouche, *marked reverse of handle*

9in. long

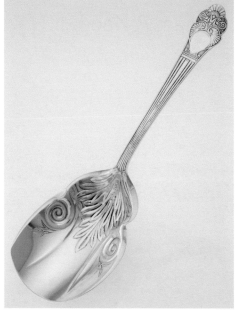

18045

18046

18046
A KENTUCKY COIN SILVER TABLESPOON

Mark of Asa Blanchard, Louisville, Kentucky, c.1810

An excellent well struck mark, the narrow elongated handle slightly tipt back, the bowl with a full square lip, period script 'M' monogram, a superb example of the quality workmanship of Asa Blanchard, *marked reverse of handle*

8.7in. long

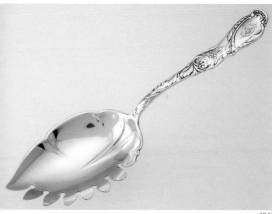

1047

18047
AN AMERICAN SILVER ROUEN PATTERN MACARONI SERVER

Mark of Gorham, Providence, Rhode Island, c.1890

An uncommon foliate rococo pattern, the bowl with flaring tines, stamped 'pat. apld. for,' obverse engraved decoration, *marked reverse of handle*

9.2in. long

18048
AN AMERICAN SILVER IRVING PATTERN ICE CREAM SLICE

Mark of Wallace, Wallingford, Connecticut, c.1900

The original silver plated blade in excellent condition, with rococo style handle, *marked edge of handle*

12in. long

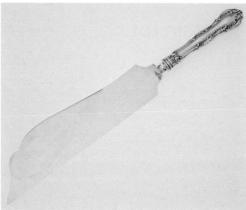

18048

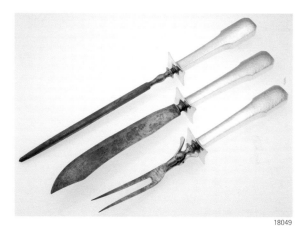

18049

18049
AN AMERICAN SILVER NORMAN HAMMERED PATTERN CARVING SET

Mark of Shreve & Co., San Francisco, California, c.1905

Roast size, each with an applied Old English style monogram, all with original carbon steel fittings, knife blade marked Shreve & Co., *marked on guards*

13.2in. long, the knife (Total: 3 Items)

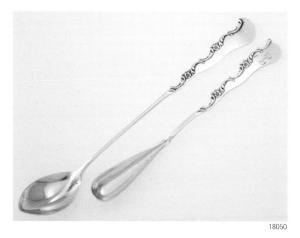

18050

18050
TWO NINETEENTH CENTURY AMERICAN SILVER SERVING PIECES

Mark of Shiebler, New York, c.1890

Matching pattern, each with floral rococo edge, an olive spoon and a rare horseradish spoon, period script 'AH' monogram on radish spoon, *marked reverse of handles*

8.3in. long the olive spoon (Total: 2 Items)

Visit HeritageGalleries.com to view scalable images and bid online.

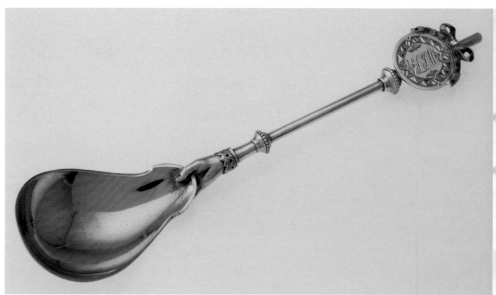

18051

18051

A PARCEL GILT AMERICAN SILVER LADIES PATTERN SUGAR SHELL

Mark of Gorham, Providence, c.1868

Now often written as 'Lady's', the name appears in Gorham's original costing book as 'Ladies'. Monogrammed 'LJM' within the bright-cut, ribbon-adorned medallion, uncommon, *marked reverse of handle*

6in. long

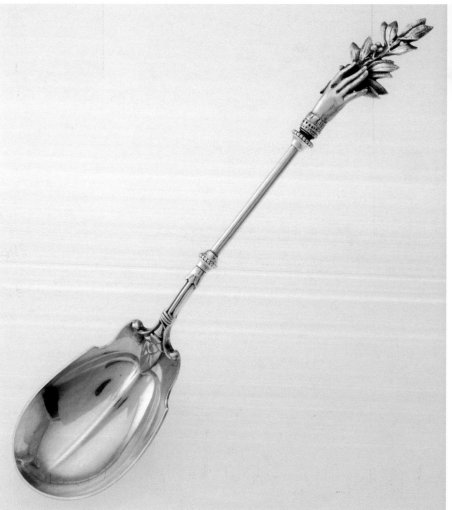

18052

18052

A PARCEL GILT AMERICAN SILVER OLIVE BRANCH PATTERN JELLY SPOON

Mark of Gorham, Providence, c.1869

Often confused with Gorham's Ladies pattern, which it resembles in its cylindrical stem and lady's hand, rare, *marked on handle*

6.8in. long

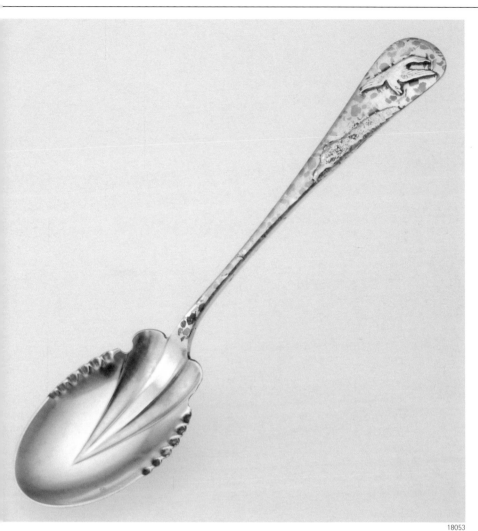

18053

**A PARCEL GILT AMERICAN
SILVER AND MIXED METAL CAIRO
PATTERN ICE CREAM SPOON**

Mark of Gorham, Providence, c.1879

Originally named 'Curio' pattern, with a shaped
and ribbed matte parcel gilt bowl, the handle
with applied rock and bird in flight, very rare
piece, *marked reverse of handle: 'sterling &
other metals'*

6.1in. long

18053

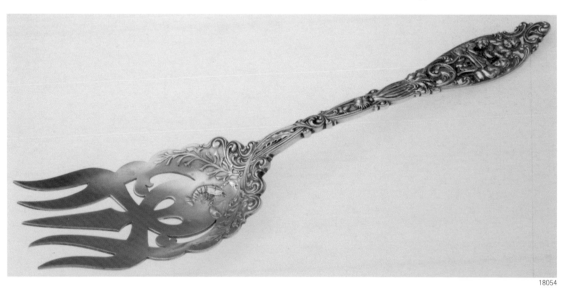

18054

18054

AN AMERICAN SILVER LABORS OF CUPID SALAD SERVING FORK

Mark of Dominick & Haff, New York, c.1900

The hand cut tines with Old English style monogram 'M.H.D.' on reverse, the hand sawn reticulated design with two cupids at a table
and one serving, *marked reverse of handle*

9.3in. long

Publication: *Silver Magazine*, May/June 2001, p.32, fig.18

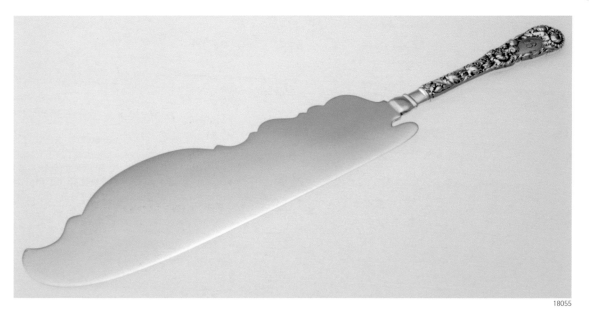

18055

AN AMERICAN SILVER CHRYSANTHEMUM PATTERN ICE CREAM SLICE

Mark of Durgin, Concord, New Hampshire, c.1893

While this item does not appear in Durgin's catalogue for Chrysanthemum pattern, it appears in its catalogue for the Iris pattern under ice cream slicer no. 3, this piece with script monogram 'B' in the obverse cartouche, very uncommon piece, *marked reverse of handle*

12.6in. long

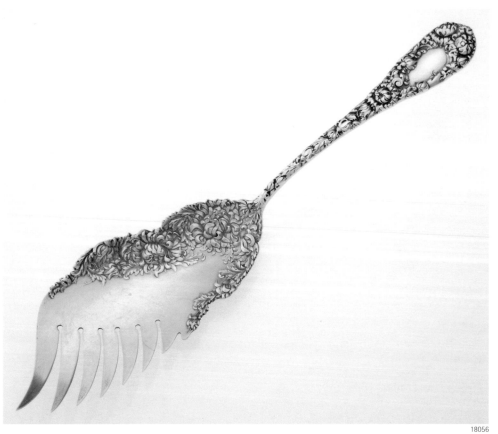

18056

A PARCEL GILT AMERICAN SILVER CHRYSANTHEMUM PATTERN TOMATO SERVER

Mark of Durgin, Concord, New Hampshire, c.1893

The tines resembling those found on a macaroni knife, and its design in terms of tomato servers unique to Durgin, a rare piece, *marked reverse of handle*

9.8in. long

Publication: Appeared in an article on this pattern in *Silver Magazine,* May/June 2002, p.27, fig.16; a similar piece illustrated in *Tiffany Silver Flatware 1845-1905: When Dining Was an Art,* by William P. Hood, Jr., c.1999, p.158, fig.232

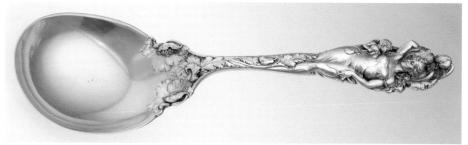
18057

A PARCEL GILT AMERICAN SILVER LOVE DISARMED PATTERN LARGE BERRY SPOON

Mark of Reed & Barton, Taunton, Massachusetts, c.1901

Patented on December 5, 1901, this is an outstanding example of the pattern in near-original mint condition, silver flowers creeping into the gilt bowl, cupid clutching the maiden's gown with one hand and an arrow in the other, his mouth opened as if engaged in dialogue, the maiden gazing down at cupid and holding his bow in hand, with period script monogram reverse of handle, marks include trademark, pat. apped for, sterling, *marked reverse of handle*

10.6in. long

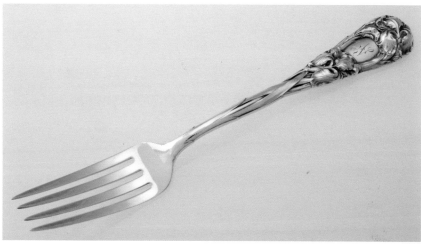
18058

AN AMERICAN SILVER NEW ART PATTERN SERVING FORK

Mark of Durgin, Concord, New Hampshire, c.1899

Of iris motif, with script monogram 'N' to obverse cartouche, one of the rarest pieces in the New Art pattern, *marked reverse of handle*

8.6in. long

Similar server appeared in an article on this pattern in *Silver Magazine,* July/August 2002, p.30, fig.14

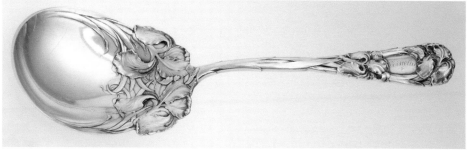
18059

AN AMERICAN SILVER NEW ART PATTERN BERRY SPOON

Mark of Durgin, Concord, New Hampshire, c.1899

The shaped bowl with intertwined irises, the obverse cartouche with period floral engraving 'Cornelia', an uncommon piece, *marked reverse of handle*

9.75in. long

18060

AN AMERICAN SILVER LABORS OF CUPID PATTERN LETTUCE FORK

Mark of Dominick & Haff, New York, c.1900

The shaped and hand sawn reticulated tines and design depicting cupid drinking tea, *marked reverse of handle*

8.6in. long

Publication: *Silver Magazine*, May/June 2001, p.31, fig.4

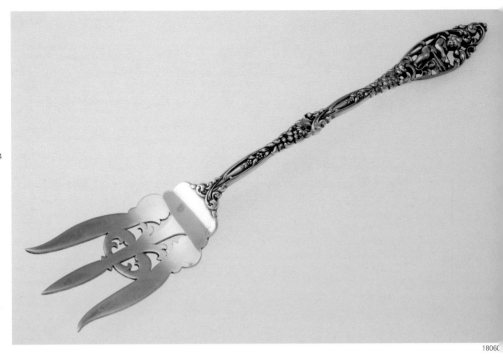

18060

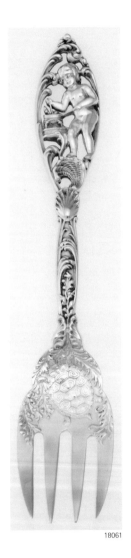

18061

18061

AN AMERICAN SILVER LABORS OF CUPID PATTERN TERRAPIN FORK

Mark of Dominick & Haff, New York, c.1900

The tines with die-struck seaweed and swimming turtle, leading to a hand sawn reticulated design of cupid stirring a chafing dish, very rare piece, *marked reverse of handle*

5.6in. long

Publication: *Silver Magazine*, May/June 2001, p.32, fig.19

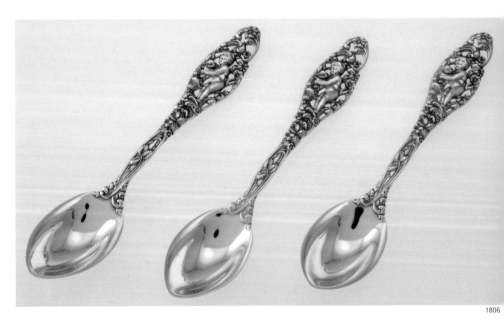

1806

18062

THREE AMERICAN SILVER LABORS OF CUPID PATTERN ORANGE SPOONS

Mark of Dominick & Haff, New York, c.1900

The shaped bowls with identical hand sawn reticulated designs depicting cupid gathering fruit, *marked reverse of handles*

each 5.75in. long

Publication: *Silver Magazine*, May/June 2001, p.32, fig.12

18063
FOUR AMERICAN SILVER RAPHAEL PATTERN OYSTER FORKS

Mark of Alvin, Providence, Rhode Island, c.1902

Narcissus motif, original french-gray finish within the recesses of the pattern, two with matching art nouveau script monogram 'G' reverse of handles, two without monograms, a rare pattern, *each marked reverse of handles*

each 5.6in. long (Total: 4 Items)

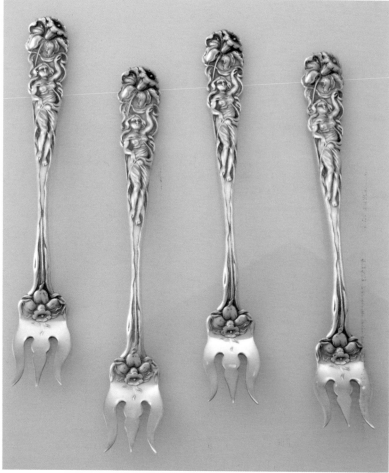

18063

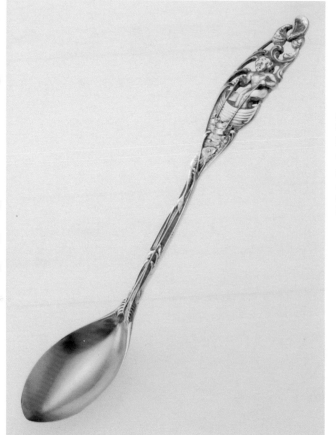

18064

18064
A PARCEL GILT AMERICAN SILVER LABORS OF CUPID PATTERN MUSTARD LADLE

Mark of Dominick & Haff, New York, c.1900

With hand sawn reticulated design depicting cupid dredging for oysters, a very rare piece, *marked reverse of handle*

5.6in. long

Publication: *Silver Magazine*, May/June 2001, p.32, fig.13

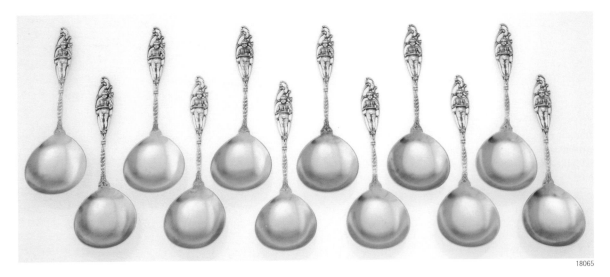

18065

A SET OF TWELVE PARCEL GILT AMERICAN SILVER LABORS OF CUPID PROBABLE SHERBERT SPOONS

Mark of Dominick & Haff, New York, c.1900

The hand sawn reticulated design depicting cupid serving coffee, *each marked reverse of handle*

each 4.75in. long

(Total: 12 Items)

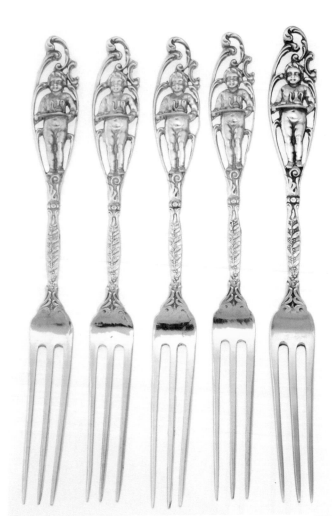

18066

FIVE PARCEL GILT AMERICAN SILVER LABORS OF CUPID BERRY FORKS

Mark of Dominick & Haff, New York, c.1900

Each with identical hand sawn reticulated design of cupid serving coffee, *each marked reverse of handle*

each 4.8in. long

Publication: *Silver Magazine,* May/June 2001, p.31, fig.11

(Total: 5 Items)

18067

AN AMERICAN SILVER LABORS OF CUPID DESSERT SPOON

Mark of Dominick & Haff, New York, c.1900

The bowl with script monogram 'SC', the hand sawn reticulated design depicting cupid gathering fruit with basket, *marked reverse of handle*

7in. long

Publication: *Silver Magazine,* May/June 2001, p.31, fig.5

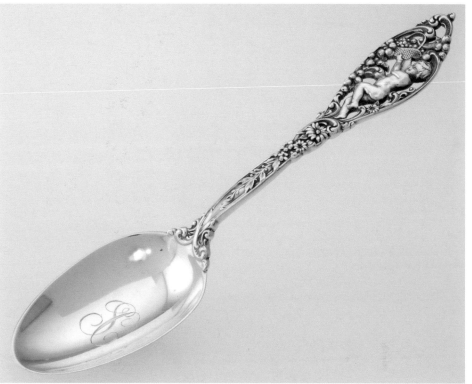

18067

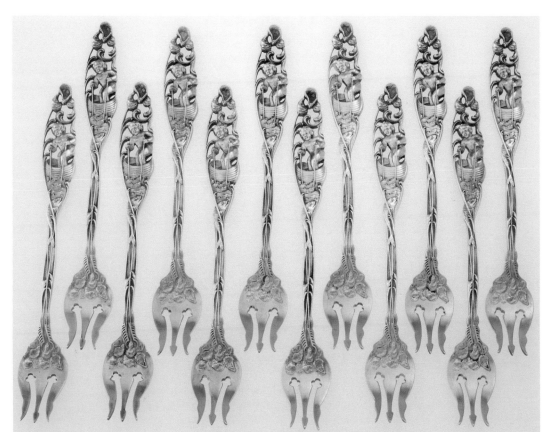

18068

18068

A SET OF TWELVE AMERICAN SILVER LABORS OF CUPID PATTERN OYSTER FORKS

Mark of Dominick & Haff, New York, c.1900

The parcel gilt shaped and hand cut tines with hand sawn reticulated designs each depicting cupid dredging for oysters, *marked reverse of handles*

each 5.5in. long

Publication: *Silver Magazine*, May/June 2001 p.32, fig.13

(Total: 12 Items)

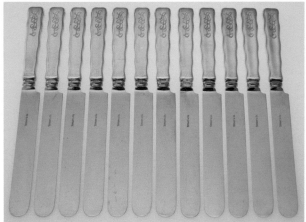

18069

TWELVE AMERICAN SILVER LAP-OVER-EDGE PATTERN KNIVES

Mark of Tiffany & Co., New York, c.1910

The matching group in excellent condition, Tiffany stainless steel replacement blades, 'ABL' monogram, lower case 'm' date mark,

10.2in. long (Total: 12 Items)

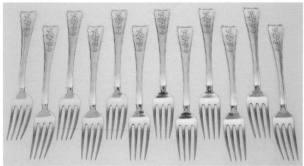

18070

A SET OF TWELVE AMERICAN SILVER LAP-OVER-EDGE FORKS

Mark of Tiffany & Co., New York, c.1910

Lap over front, 'ABL' monogram on obverse, lower case 'm' date mark, *marked reverse of handles*

7.6in. long (Total: 12 Items)

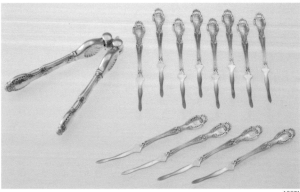

18071

AN AMERICAN SILVER NUT CRACKER AND PICKS IN THE RICHELIEU PATTERN

Mark of Tiffany & Co., New York, c.1895

Twelve nut picks with a matching nut cracker, excellent condition, a period script 'SL' monogram, 'T' date mark, *marked reverse of handles*

5in. the nut picks, 5.2in. the cracker (Total: 13 Items)

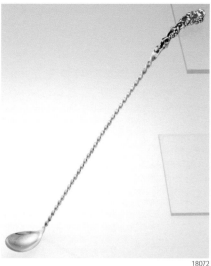

18072

AN AMERICAN SILVER GRAPE MOTIF CLARET LADLE

Mark of Dominick & Haff, New York, c.1880

A heavy cast handle with grapes, leaves and vines, twist handle and small curved bowl, *marked reverse of handle*

13.7in. long

18073

AN AMERICAN SILVER CORONET PATTERN ICE CREAM SLICE

Marked Knowles, Providence, Rhode Island, c.1880

The handle with Moorish design, elaborate Japanese style engraved blade, *marked reverse of handle*

12in. long

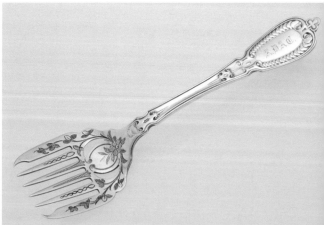

18074

AN AMERICAN SILVER JOHN POLHAMUS ARMOR PATTERN SARDINE FORK

Mark of John Polhamus, New York, c.1865

A difficult piece to find in any pattern and even less common from the middle 19th century, tines engraved with flower, leaf and vine motif, a period 'ADAC' monogram, retailed by Tiffany & Co., *marked reverse of handle*

5.6in. long

8075

A GROUP OF AMERICAN SILVER FLATWARE ITEMS

Various Makers, c.1900

A Towle Old English pattern pea server, a Whiting violet pierced olive spoon, an International edgewood pattern cold meat fork and an Alvin majestic pattern long handled olive spoon, *marked reverse of handles*, (One not Illustrated)

.9in. the longest item (Total: 4 Items)

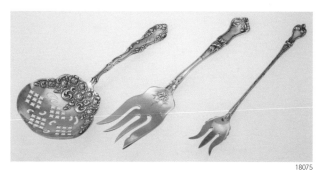

18075

18076

8076

A PARCEL GILT AMERICAN SILVER ACID ETCHED BERRY SPOON

Mark of Gorham, Providence, Rhode Island, c.1880

The handle with acid cut back depicting leaves, vines, and flowers, and period script monogram 'MLA' with radiating fluted bowl, *marked reverse of handle*

in. long

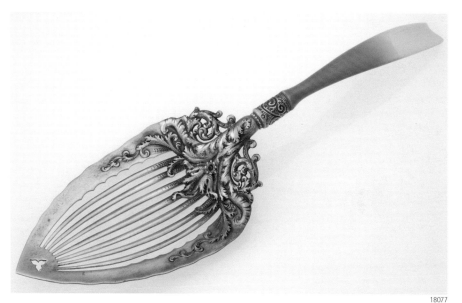

18077

18077

AN AMERICAN SILVER IVORY PATTERN PIE SERVER

Mark of Whiting, Providence, Rhode Island, c.1890

Multi-piece construction with a carved, engraved and tinted ivory handle, part of a group with outstanding original condition, a 'conditional rarity', this piece will prove to be one of the finest examples known of this pattern in the years to come, *marked under tines*

10.7in. long

18078

AN AMERICAN SILVER JAPANESE STYLE MIXED METAL CHEESE SCOOP

Mark of Dominick & Haff, New York, c.1885

Parcel gilt, the handle with hammered surfaces, an applied bird in flight and leafy branch, *marked reverse of handle*

8.5in. long

18078

18079

A GROUP OF TEN AMERICAN SILVER MEDALLION PATTERN EGG SPOONS

Mark of Wood & Hughes, New York, c.1870

Gilt egg shaped bowls, a classic bust of a woman wearing a tiara at the top of handle, the group in excellent condition, *marked reverse of handle*

5.5in. long (Total: 10 Items)

18080

A PARCEL GILT AMERICAN SILVER IVY PATTERN JELLY TROWEL

Mark of Gorham, Providence, Rhode Island, c.1870

The elongated bowl with classical terminus ivy decoration, *marked reverse of handle*

9.6in. long

18081

THREE AMERICAN SILVER SPOONS BY GEORGE SHARP

Unmarked, c.1870

Egg shaped, engraved finials, six sided handles, gold washed bowls, marked only 'Sterling', some light wear to the gold was on the heal of spoons, one ball ding, *marked reverse of handles*

4.5in. long each (Total: 3 Items)

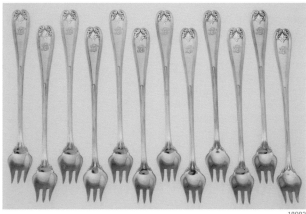

18082

A SET OF TWELVE AMERICAN SILVER COLONIAL SILVER SEAFOOD FORKS

Mark of Tiffany & Co., New York, c.1908

Each engraved on the back of the gilt bowls '1908', each with an 'SLW' period script monogram, *marked reverse of handles*

5.9in. long (Total: 12 Items)

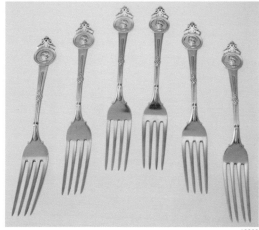

18083

A GROUP OF SIX AMERICAN SILVER MEDALLION PATTERN FORKS

Mark of Gorham, Providence, Rhode Island, c.1865

Two with reverse script monograms and retailed by San Francisco jeweler, J.W. Tucker, four with no monogram and retailed by New Orleans jeweler I.C. Levi, *marked reverse of handle*

7.5in. long each (Total: 6 Items)

18084

A PAIR OF AMERICAN SILVER MEDALLION PATTERN SERVERS

Shulz & Fischer, San Francisco, California, c.1870

A mustard ladle and a sugar shell with gold washed, bright cut engraved bowl, each with San Francisco retail marks

6.7in. the sugar shell (Total: 2 Items)

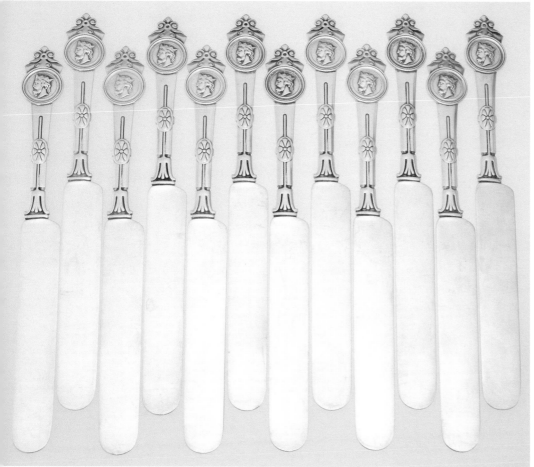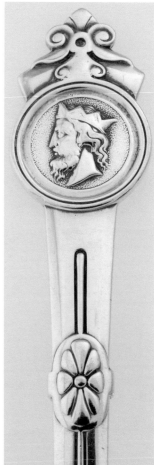

18085

A SET OF TWELVE AMERICAN SILVER MEDALLION PATTERN KNIVES

Mark of Gorham, Providence, Rhode Island, c.1870

Retailed by Tiffany & Co., these highly unusual knives have a rare 'Kings Head' medallion, in excellent condition and have a period 'B' monogram on the reverse of each handle, *marked on blades*

8.4in. long

(Total: 12 Items)

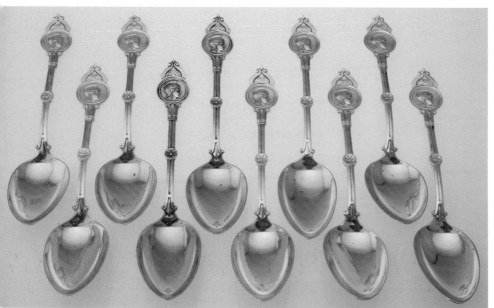

18086

A GROUP OF TWELVE AMERICAN SILVER MEDALLION PATTERN TABLESPOONS

Shulz & Fischer, San Francisco, California, c.1870

Crisp pattern, each marked coin, two marked 'Weyl bros.' a San Francisco retailer, six with matching period script monograms, the other four with various period script monograms, a very well matched group, *marked reverse of handles*

8.5in. long each

(Total: 10 Items)

Visit HeritageGalleries.com to view scalable images and bid online.

Session One, Auction #608 • Saturday, October 30, 2004 • 10:00 a.m.

21

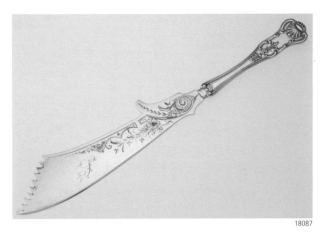

18087

AN AMERICAN SILVER KINGS PATTERN SERVING KNIFE

Maker unknown, c.1860

Possibly a cheese knife, the curved blade with serrated end, bright cut floral engraving, a script 'S' monogram on blade, *marked on blade*

9.5in. long

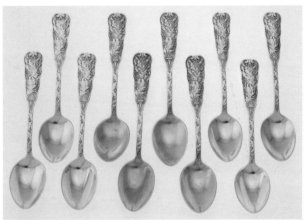

18088

A GROUP OF TEN AMERICAN SILVER ST. CLOUD PATTERN DEMITASSE SPOONS

Mark of Gorham, Providence, Rhode Island, c.1890

Four with parcel gilt bowls, *marked underside*

4.3in. long (Total: 10 Items)

18089

A PAIR OF AMERICAN SILVER CUPID PATTERN SERVING SPOONS

Mark of Shiebler, New York, c.1880

Each with trumpeting angel motif, *marked reverse of handles*

8.2in. long each (Total: 2 Items)

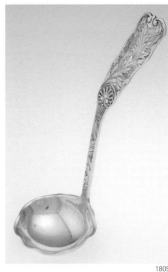
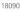

18090

AN AMERICAN SILVER ST. CLOUD PATTERN LADLE

Mark of Gorham, Providence, Rhode Island, c.1885

The bowl with ruffled edges, an Old English style H monogram, *marked underside*

7in. long

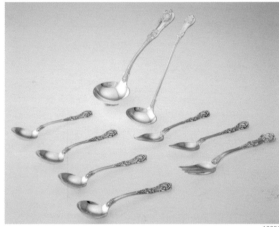

18091

A GROUP OF AMERICAN SILVER ENGLISH KING PATTERN FLATWARE

Mark of Tiffany & Co., New York, c.1900

Consisting of a gravy ladle, sauce ladle, four bouillons, a salad fork and two citrus, one with monogram, *marked reverse of handles* (Total: 9 Items)

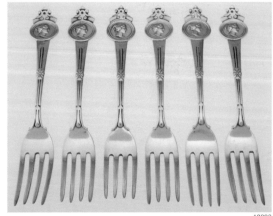

18092

A GROUP OF SIX AMERICAN SILVER MEDALLION PATTERN FORKS

Mark of Gorham, Providence, Rhode Island, c.1870

Each with a classic bust of a woman, excellent condition, *marked reverse of handle*

6.7in. long (Total: 6 Items)

18093

**AN AMERICAN SILVER ATLANTAS
PATTERN SUGAR SHELL**

Mark of Tiffany, New York, c.1890

The art nouveau pattern with fluted bowl and patent marked
1899, script monogram 'G', *marked reverse of handle*

7in. long

18095

A PARCEL GILT AMERICAN SILVER MEDALLION PATTERN POACHED EGG SERVER

Mark of Gorham, New York, c.1864

Die struck construction, the ovoid shaped bowl leading to a heavy handle with a Greco-Roman
deity in the terminus, a period monogram reverse of handle, retailed by Tiffany & Co., *marked
reverse of handle*

8.9in. long; 3.5oz

Literature: A similar server illustrated in *Tiffany Silver Flatware*, by William P. Hood, Jr., Roslyn Berlin, Edward Wawrynek,
c.2003, p.28, fig.22

18096

AN AMERICAN SILVER PALM PATTERN LADLE

Marked for Gorham, Providence, Rhode Island, c.1875

The handle decorated with palm leaves, the hooded bowl
with elaborate reticulate work, *marked reverse of handle*

18097

**A GROUP OF AMERICAN SILVER
EGLANTINE PATTERN FLATWARE**

Mark of Gorham, Providence, Rhode Island, c.1880

Consisting of a gravy ladle with gilt bowl and chased
strawberries, a sauce ladle with chased strawberries, and
an entirely gilt butter knife with engraved blade, *marked
reverse of handles*

7.3in. long, the gravy ladle, 5.30oz gross weight (Total: 3)

18094

A RARE AMERICAN SILVER ENGRAVED ANTIQUE PATTERN FISH SLICE

Mark of Tiffany & Co., New York, c.1910

The handle deeply engraved with floral patterns, the blade chased and
engraved similarly, an open cartouche at the top of the handle but has not
been engraved, *marked reverse of handle*

12.2in. long

18098

**A GROUP OF SIX AMERICAN SILVER
LAP-OVER-EDGE PATTERN KNIVES**

Mark of Tiffany & Co., New York, c.1880

Hammered handles, period script 'ACW' monograms, *marked on blades*

10.6in. long (Total: 6 Items)

18100

A GROUP OF SIX AMERICAN SILVER LAP-OVER-EDGE KNIVES

Mark of Tiffany & Co., New York, c.1885

Hammered finish with 'ACW' period monogram, blades original but pitted and plated, *marked on ferrules*

9.2in. long (Total: 6 Items)

18099

**A SET OF TWELVE AMERICAN SILVER
LAP-OVER-EDGE PATTERN FORKS**

Mark of Tiffany & Co., New York, c.1885

Lap over front, each with a script obverse 'worth' monogram, upper case 'M' date mark, *marked reverse of handles*

7.9in. long (Total: 12 Items)

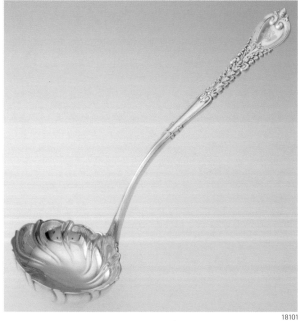

18101

AN AMERICAN SILVER FLORENTINE PATTERN OYSTER LADLE

Mark of Tiffany & Co., New York, c.1900

The twist fluted bowl leading to a scrolled handle in the Florentine pattern with script monogram in the terminal cartouche, stamped 'pat. 1900', *marked reverse of handle*

11in. long, 6.3oz

18102

A PAIR OF PARCEL GILT AMERICAN SILVER FIGURAL TONGS

Mark of Gorham, Providence, Rhode Island, c.1885

The figure a monkey as a jester swinging from two snakes in hoop shapes, attributed to Gorham. partially marked, *marked inside figure*

a similar lot sold May 21, 2004 for $798 with premium

.2in. long

18104

AN AMERICAN SILVER AESTHETIC MOVEMENT SOUP LADLE

Mark of Whiting, Providence, Rhode Island, c.1885

An acid-cut-back scene featuring three birds in flight darting above a body of water, one appearing to be feeding from the water, a gold washed bowl, *Marked reverse of handle*

12.7in. long

18103

AN AMERICAN SILVER JAPANESE PATTERN ICE CREAM SLICE

Mark of Gorham, Providence, Rhode Island, c.1875

The shaped blade with bright-cut oriental style patterns, the handle with a bird in flight holding a floral branch, a stylized blossom in the terminus, *marked reverse of handle*

0.5in. long

18105

AN AMERICAN SILVER IVORY PATTERN LETTUCE FORK

Mark of Whiting, Providence, Rhode Island, c.1890

Multi-piece construction with a carved, engraved and tinted ivory handle, part of a group with outstanding original condition, the top of the handle scrimshawed with the name 'Celia', *marked under tines*

9in. long

18106

A MATCHING PAIR OF MEDALLION PATTERN GRAVY LADLES

Mark of Gorham, Providence, Rhode Island, c.1870

Matching 'BM' monograms on the reverse of handles, retailed by Howard & Co. of New York, each with a classic helmeted male bust, *marked reverse of handles*

7.7in. long each (Total: 2 Items)

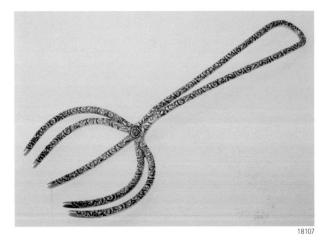

18107

AN AMERICAN SILVER FLORAL ASPARAGUS FORK

Maker unknown, c.1880

Obverse handle entirely chased with roses, three piece construction, retailed J.H. Johnston, *marked reverse of handle*

7.7in.

18108

AN AMERICAN COIN SILVER MEDALLION PATTERN PIE SERVER

John Wendt, New York, c.1865

The rounded heart shaped blade with raised join elaborate foliate engraving, retailed by Braverman & Levy, marked *coin*, period monogram 'C', *marked reverse of handle*

9.1in. long

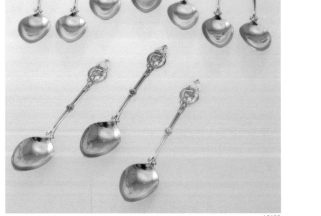

18109

A GROUP OF TEN AMERICAN SILVER MEDALLION PATTERN SPOONS

Shulz & Fisher, San Francisco, California, c.1870

All except one with matching reverse monogram, marked only 'coin', very good condition, *marked reverse of handle*

6in. long (Total: 10 Items)

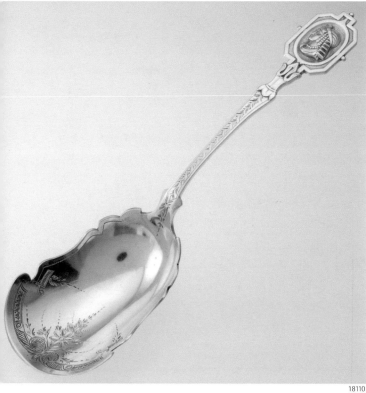

18110

AN AMERICAN SILVER EGYPTIAN MOTIF BERRY SCOOP

Mark of Kidney & Johnson, c.1870

The terminus with a square medallion featuring a pharaoh head in high relief, shovel shaped bowl with elaborate bright cut engraving, *marked reverse of handle*

9.5in. long

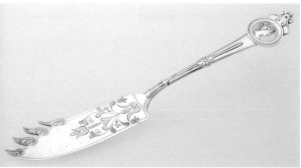

18111

AN AMERICAN SILVER MEDALLION PATTERN CHEESE KNIFE

Mark of Gorham, Providence, Rhode Island, c.1865

The blade with four tines, bright cut engraved, classic female bust, *marked reverse of handle*

8.4in. long

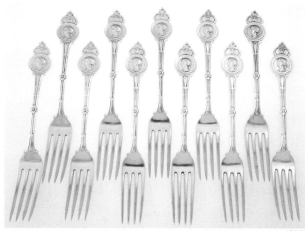

18112

A GROUP OF ELEVEN AMERICAN SILVER MEDALLION PATTERN FORKS

Mark of Koehler & Ritter, San Francisco, California, c.1870

Each with a classic female bust wearing a tiara, various period monograms, matching medallions, size and condition, *marked reverse of handles*

7in. each (Total: 11 Items)

18113

A SET OF TWELVE AMERICAN SILVER LAP-OVER-EDGE PATTERN SALAD FORKS

Mark of Tiffany & co., New York, c.1910

The group in excellent condition, no monograms or removal, lower case 'm' datemark, *marked reverse of handles*

6.7in. long each (Total: 12 Items)

18114

A GROUP OF TWELVE AMERICAN SILVER LAP-OVER-EDGE PATTERN SPOONS

Mark of Tiffany & Co., New York, c.1882

Dessert spoons, six with one script style 'FFN' monogram and the other six with a different script 'FFN' monogram, all have the lap over the front of the pattern, all have upper case 'M' date marks, six engraved on the top reverse of handle 'Xmas 1882', excellent condition, *marked reverse of handles*

7.2in. long (Total: 12 Items)

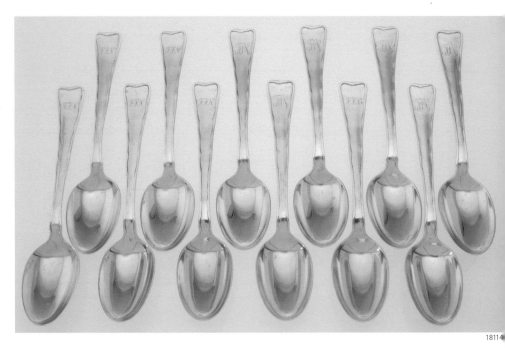

18114

18115

AN AMERICAN SILVER SLICE

Mark of Wood & Hughes, with pseudo hallmarks, c.1870

The spade form blade with open cut design and engraved blossoms, strawberries and leaves, the handle with script monogram 'M. Wilkinson', *marked reverse of handle*

11in. long, 3.82oz

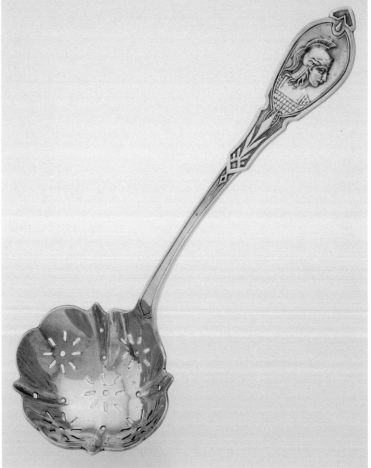

18116

18116

A PARCEL GILT AMERICAN SILVER IVANHOE PATTERN SUGAR SIFTER

Mark of Albert Coles, New York, c.1870

The fluted bowl with elaborate openwork, *marked reverse of handle*

7.5in.

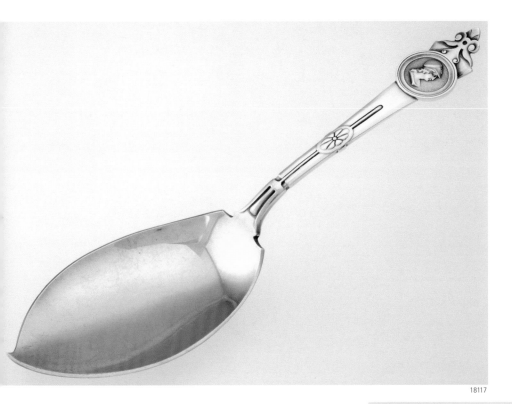

18117

8117

N AMERICAN SILVER MEDALLION PATTERN ICE CREAM SLICE

Mark of Gorham, Providence, Rhode Island, c.1865

arcel gilt, retailed by Tiffany & Co., superb original condition, *narked reverse of handle*

.25in. long

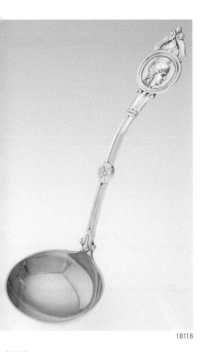

18118

8118

N AMERICAN COIN SILVER MEDALLION PATTERN GRAVY LADLE

hulz & Fischer, San Francisco, California, c.1870

arcel gilt, retailed by 'C.H. Hain & Co.' San Francisco, period script 'HH' nonogram on reverse of handle, *marked reverse of handle*

n. long

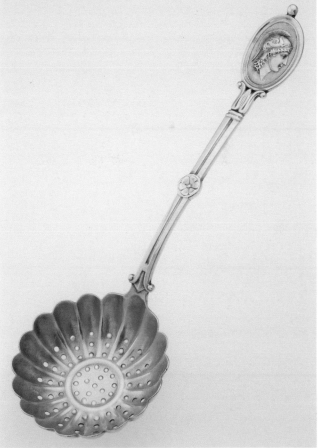

18119

18119

AN AMERICAN SILVER MEDALLION PATTERN SUGAR SIFTER

John Wendt, New York, c.1865

The matte finish fluted bowl with elaborate openwork, retailed by Ball Black & Co., *marked reverse of handle*

8in. long

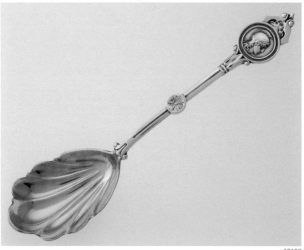

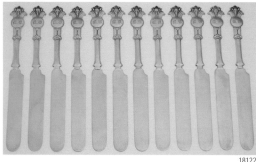

18120

18120

AN AMERICAN SILVER MEDALLION PATTERN SUGAR SHELL

Shulz & Fischer, San Francisco, California, 1870

The scalloped bowl gold washed, crisp pattern, unmarked, no monogram, *unmarked*

7in. long

18122

18122

A SET OF TWELVE GILT AMERICAN SILVER KNIVES

Mark of Ball Black & Co., New York, c.1870

The pattern features a mythical horned beast finial and a circular cartouche, monogrammed with 'MW' *marked on blades*

7.9in. long (Total: 12 Items)

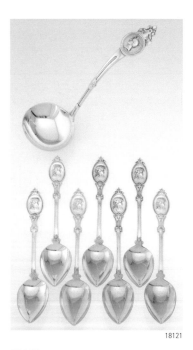

18121

18123

18121

A GROUP OF EIGHT AMERICAN SILVER MEDALLION ITEMS

Various makers, c.1870

Seven teaspoons by Hotchkiss & Shreuder, one gravy ladle by Gorham, retailed by Tiffany & Co., *marked reverse of handles*

7.2in. long the ladle (Total: 8 Items)

18123

AN ASSEMBLED AMERICAN SILVER GRECIAN PATTERN YOUTH SET

Mark of Whiting, Providence, Rhode Island, c.1860

Each handle surmounted with a rams head, grotesque mask at mid handle, various script monograms, *marked reverse of handles*

7.2in. the knife (Total: 3 Items)

18124

18124

A SET OF TWELVE AMERICAN SILVER KING PATTERN FISH KNIVES

Mark of Dominick & Haff, New York, c.1890

Retailed by Howard & Co. of New York, each with a single letter old English 'H' monogram, superb original condition, *marked on handles*

7.7in. long (Total: 11 Items)

18125

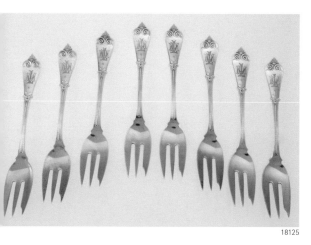

GROUP OF EIGHT TIFFANY BEEKMAN PATTERN OYSTER FORKS

ark of Tiffany & Co., New York, c.1869

matching set of eight oyster forks in Tiffany Beekman pattern, each with period 'MOL' monogram, gold washed tines, lower case 'm' date mark, *arked reverse of handle*

n. long (Total: 8 Items)

18127

AN UNCOMMON SET OF TEN JENNY LIND PATTERN SEAFOOD FORKS

Mark of Shiebler, New York, c.1870

Each with a period script 'HSR' monogram, the pattern by Albert Coles but made after the merger with Shiebler, seafood forks very uncommon in this pattern, *marked reverse of handles*

6.3in. long (Total: 10 Items)

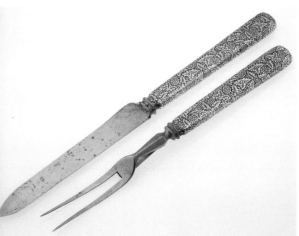

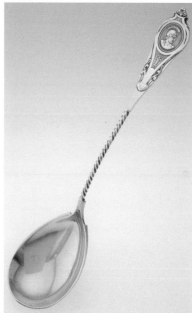

18128

AN AMERICAN COIN SILVER MEDALLION PATTERN PLATTER SPOON

Mark of Albert Coles, New York, c.1870

This most unusual server with the dimensions of a soup ladle but a shallow bowl and no curve in the handle, a classic helmeted bust of a male figure at the top of the handle, an 'S' monogram reverse of handle, *marked reverse of handle*

12.5in. long

8126

N AMERICAN SILVER GRAPE MOTIF CARVING SET

ark of Tiffany & Co., New York, c.1890

he rectangular hollow handles entirely covered in grapevine decoration, orn carbon steel blade and tines, *marked on edge of handles*

e longest 11.5in. (Total: 2 Items)

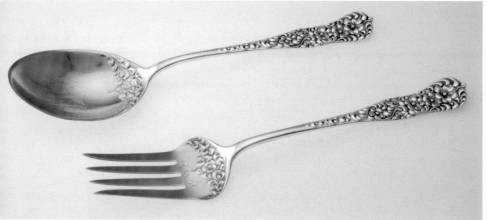

18129

AN AMERICAN SILVER ROCOCO PATTERN LONG HANDLED SALAD SET

Mark of Dominick & Haff, New York, c.1890

The floral rococo pattern crisp with dark patina in the recessed areas, parcel gilt with a period script monogram in the bowls, *marked reverse of handles*

11.5in. long the spoon
(Total: 2 Items)

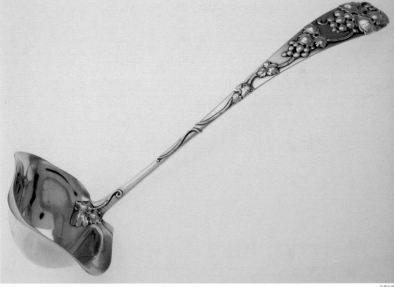

1813

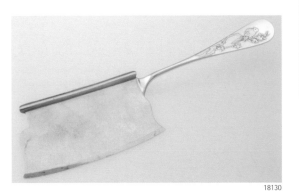

18130

18130

A PARCEL GILT AMERICAN SILVER JAPANESE STYLE ICE CREAM HATCHET

Mark of Whiting, Providence, Rhode Island, c.1880

Reverse tipped, obverse acid cut back decorated with a bird resting upon a leafy branch, *marked reverse of handle*

8.5in. long

18132

A PARCEL GILT AMERICAN SILVER GRAPE PATTERN PUNCH LADLE

Mark of Frank Smith, Gardner, Massachusetts, c.1900

The handle with cast and applied grapes, vines and leaves, double lipped parcel gilt bowl, *marked reverse of handle*

13.75in. high

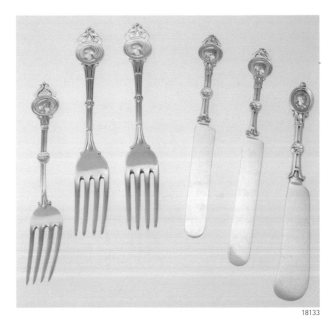

18133

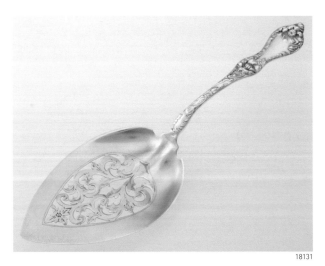

18131

18131

A PARCEL GILT AMERICAN SILVER AMER LES CINQ FLEUR PATTERN JELLY CAKE SERVER

Mark of Reed & Barton, Taunton, Massachusetts, c.1910

Engraved and reticulated flat serving area, *marked reverse of handle*

8.9in. long

18133

A GROUP OF SIX AMERICAN SILVER MEDALLION PATTERN ITEMS

Various makers, c.1870

Marks on backs of handles include Ball Black, Shulz & Fischer, Koehler & Ridder and H. Zacharias, three knives and three forks, fork tines in good shape, five coin silver, one sterling, *marked reverse of handles*

7.6in the longest (Total: 6 Items)

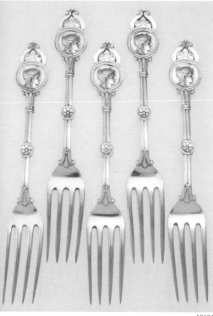

18134

IVE AMERICAN COIN SILVER MEDALLION PATTERN FORKS

hulz & Fischer, San Francisco, California, c.1870

ach with a classic helmeted bust of male, matching period script 'H&C' monograms, *marked reverse of handles*

.5in. long

(Total: 5 Items)

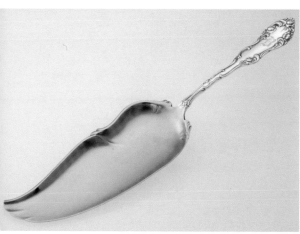

18135

AN AMERICAN SILVER OLD ENGLISH PATTERN FISH SERVER

Mark of Towle, Newburyport, Massachusetts, c.1895

Parcel gilt, period 'B' monogram, retaining virtually all of its original gold wash, the pattern crisp, *marked reverse of handle*

1in. long

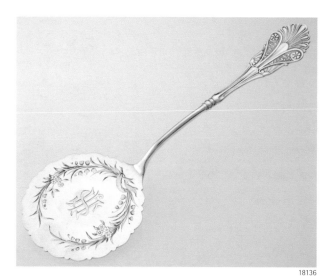

18136

18136

AN AMERICAN SILVER CORINTHIAN PATTERN WAFFLE SERVER

Mark of John Polhemus, New York, c.1870

Retailed by Tiffany & Co., the pie crust flat serving area engraved with a lily of the valley floral wreath, *marked reverse of handle*

8.4in. long

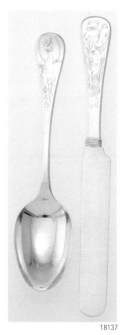

18137

AN AMERICAN SILVER ACID-CUT-BACK YOUTH KNIFE AND SPOON

Mark of Tiffany & Co., New York, c.1890

Each with the upper case 'M' date mark, the spoon with a rooster dancing and swinging a hoop on its arm, the knife with frog riding on the shoulders of a duck, both animated and cartoon like, *marked on reverse of handles*

7.2in. the knife

(Total: 2 Items)

18137

18138

TWO AMERICAN SILVER MEDALLION PATTERN ITEMS

Maker unknown, c.1870

A three tine fork and a sugar shell, medallion somewhat worn on the sugar shell, one marked 'coin' probably both San Francisco makers, *marked reverse of handle*

6.2in. long the fork

(Total: 2 Items)

18139

A GROUP OF SIX MATCHING PARCEL GILT AMERICAN SILVER MEDALLION PATTERN COFFEE SPOONS

Mark of Gorham, Providence, Rhode Island, c.1865

Gold washed from bowl to mid-handle, each with a period 'GB' monogram, Sacramento, California retailer 'H. Wachhorst' stamped to each, a matching classical helmeted Greco-Roman figure, *marked reverse of handles*

each 4.9in. long (Total: 6 Items)

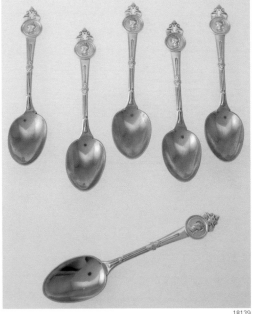
18139

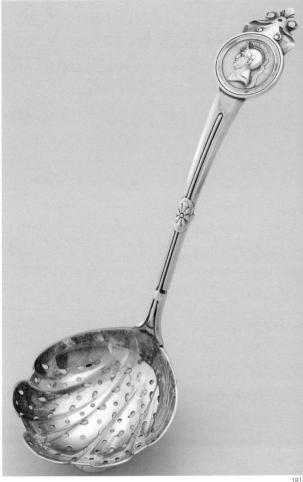
1814

18141

A PARCEL GILT AMERICAN SILVER MEDALLION PATTERN SUGAR SIFTER

Mark of Gorham, Providence, Rhode Island, c.1865

The fluted bowl with elaborate openwork, boldly struck pattern, retailed by Tiffany & Co., *marked reverse of handle*

7.7in.

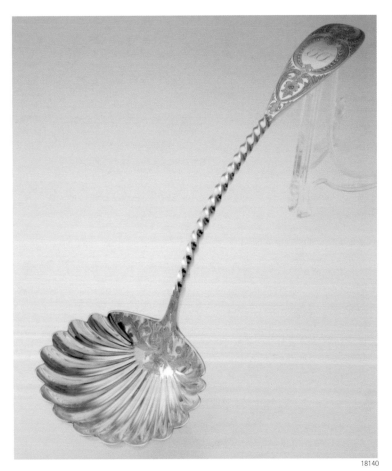
18140

18140

AN AMERICAN SILVER PUNCH LADLE WITH ORIGINAL BOX

Mark of George Sharp, Philadelphia, c.1870

Retailed by Bailey & Co. with original felt and silk lined box the surfaces deeply engraved and chased, the handle twisted, the bowl scalloped and engraved, a period 'EHT' monogram, elaborately hallmarked by Bailey, *marked reverse of handle*

13.8in. long

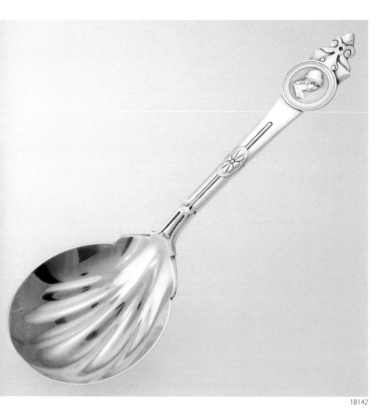

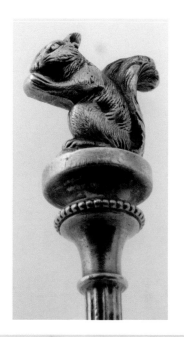

18142

18142
A PARCEL GILT AMERICAN SILVER MEDALLION
PATTERN BERRY SPOON
Mark of Gorham, Providence, Rhode Island, c.1865

With a fluted bowl, retailed by Tiffany & Co., *marked reverse of handle*
8.2in. long

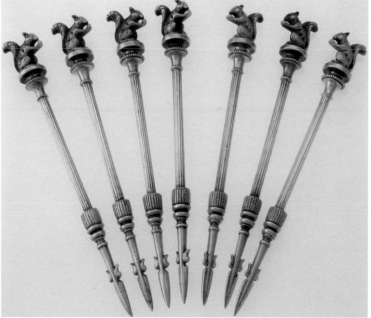

18144

18144
A GROUP OF AMERICAN COIN SILVER FIGURAL NUT PICKS
Unmarked, c.1860

Likely Georg Sharp or Ball Black, each handle in the form of a ceremonial spear with pommel, a cast and applied squirrel finial on each, *unmarked*
4.9in. long each (Total: 7 Items)

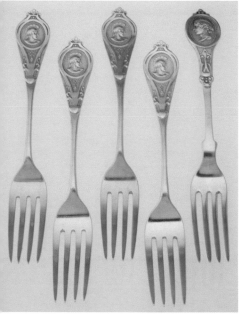

18143

18143
FIVE AMERICAN SILVER MEDALLION PATTERN FORKS
Albert Coles, New York, c.1860

Four by Albert Coles, one marked K.C.& J for Kidney Cann & Johnson, excellent condition, *marked reverse of handles*
7.8in. long (Total: 6 Items)

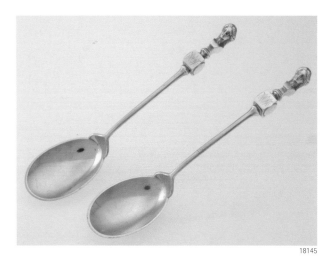

18145

A PAIR OF AMERICAN BUST PATTERN ICE CREAM SPOONS

Each handle with a cast and applied bust of a woman, tubular handle and a gilt bowl, *marked reverse of handles*

5.9in. long, each

(Total: 2 Items)

18146

AN AMERICAN COIN SILVER GOTHIC PATTERN KNIFE

Mark of Gale & Hayden, New York, c.1850

An exceedingly rare American coin silver pattern, an illegible period monogram reverse of handle, marked 'G&H Patented 1847', this piece with some wear to the pattern, *marked reverse of handle*

7.2in long

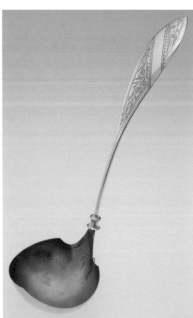

18147

A PARCEL GILT AMERICAN SILVER SOUP LADLE

Mark of Gorham, Providence, Rhode Island, c.1870

The matte parcel gilt bowl with engraved border along the interior leading up to a round handle which transforms to a convex flat and pointed terminus with bright-cut engraved floral decoration, double applied vines at join on reverse of bowl, *marked reverse of handle*

11.5in. long

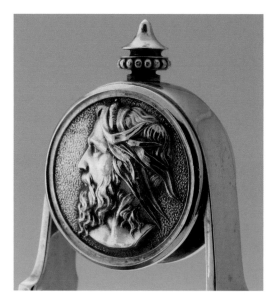

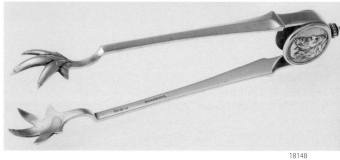

18148

AN UNUSUAL PAIR OF AMERICAN SILVER MEDALLION PATTERN TONGS

Mark of Gorham, Providence, Rhode Island, c.1865

With the original box, retaining original factory tags identifying these as 'Medl Sug Tongs', a two-sided medallion featuring a man and woman fitted in the middle of the tongs and secured by a screw and nut, claw feet, *marked inside edge*

5.1in. long

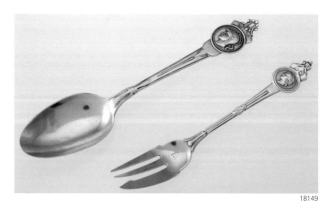

18149

TWO AMERICAN SILVER MEDALLION PATTERN ITEMS

Various makers, c.1870

The first a Gorham pickle fork with George Shreve retail marks, a script reverse monogram, the second a dessert spoon retailed by McMullen & Hamilton, *marked reverse of handles*

7in. the longest item

(Total: 2 Items)

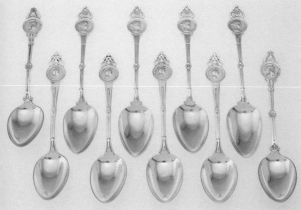

18150

A GROUP OF TEN AMERICAN SILVER MEDALLION PATTERN SPOONS

Various makers, San Francisco, California, c.1870

Four by Gorham, retailed by George Shreve, classic helmeted male figure, two by Shulz & Fischer, classic helmeted male figure, four by Koehler & Ritter, classic female bust, *marked reverse of handles*

5.9in. average length (Total: 10 Items)

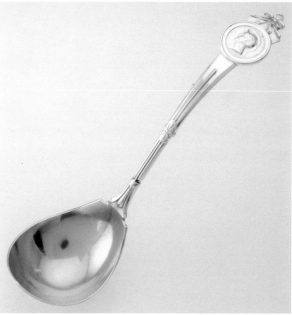

18152

A PARCEL GILT AMERICAN SILVER MEDALLION PATTERN GRAVY LADLE

Mark of Gorham, Providence, Rhode Island, c.1865

Oval gold wash bowl with classic helmeted Greco-Roman figure, *marked reverse of handle*

8in. long

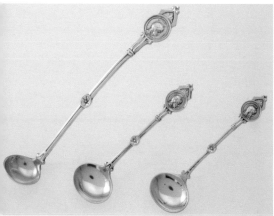

18151

THREE AMERICAN COIN SILVER MEDALLION ITEMS

Shulz & Fischer, San Francisco, California, c.1870

Two master salt spoons and one mustard ladle, one master salt and the mustard ladle retailed by 'Parrett & Sherwood', the third item with no retail marks, excellent overall condition, *marked reverse of handles*

5in. the longest (Total: 3 Items)

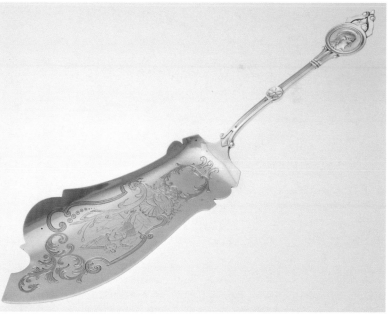

18153

AN AMERICAN SILVER MEDALLION PATTERN FISH SLICE

Shulz & Fischer, San Francisco, California, c.1870

A prize for any California maker medallion collector, this fish server features a completely engraved blade, a boy carrying a fishing net with a fish in his hands, a sailboat in the background, a classic helmeted male figure at the top of handle, marked only 'coin' *marked reverse of handle*

12.2in. long

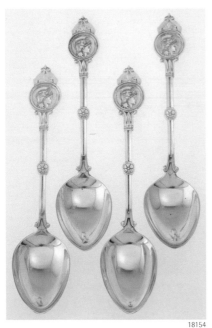

18154

FOUR AMERICAN COIN SILVER MEDALLION PATTERN SPOONS

Shulz & Fischer, San Francisco, California, c.1870

Each with a classic helmeted male bust, script 'H&C' monogram, *marked reverse of handles*

5.9in. long (Total: 4 Items)

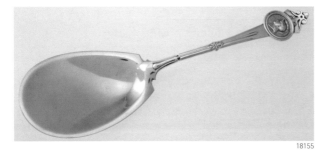

18155

AN AMERICAN SILVER MEDALLION PATTERN PUDDING SPOON

Mark of Gorham, Providence, Rhode Island, c.1865

Retailed by Starr & Marcus, the reverse of handle with a period ribbon script 'WHG' monogram, *marked reverse of handle*

9.5in. long

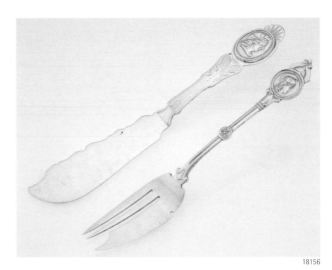

18156

TWO AMERICAN SILVER MEDALLION PATTERN ITEMS

Hhulz & Fischer, San Francisco, California, c.1870

The pickle fork by Shulz & Fisher, retailed by G.H. Hain Co., the knife marked Hense & Gottesleben, *marked reverse of handles*

7.2in. the knife (Total: 2 Items)

18157

AN AMERICAN SILVER MEDALLION PATTERN SERVING SPOON

Mark of Schulz & Fischer, San Francisco, California, c.1870

The oval fluted bowl with scalloped edges, the medallion a classic helmeted Greco-Roman figure, script monogram 'Edwina', *marked reverse of handle*

8.6in. long

18158

FOUR AMERICAN SILVER MEDALLION PATTERN DESSERT SPOONS

Mark of Gorham, Providence, Rhode Island, c.1870

Each with a matching classic bust of a woman, various period monograms, two retailed by J.W. Tucker of San Francisco, *marked reverse of handles*

6.9in. each (Total: 4 Items)

18159

AN AMERICAN SILVER MEDALLION PATTERN SERVING SPOON

Mark of Gorham, Providence, Rhode Island, c.1865

Triple lobed fluted bowl, classic helmeted Greco-Roman figure, period monogram 'HA', marked

8.9in. long

18160

A PAIR OF AMERICAN SILVER MEDALLION PATTERN TABLESPOONS

Mark of Gorham, Providence, Rhode Island, c.1870

Each with a classic helmeted male bust, retailed by Tiffany & Co., matching period script 'EER' monograms, *marked reverse of handles*

8.6in. long (Total: 2 Items)

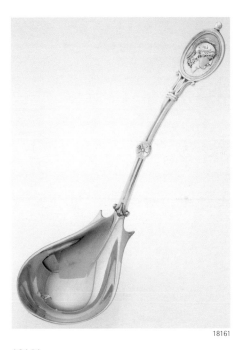

18161

A PARCEL GILT AMERICAN COIN SILVER MEDALLION PATTERN GRAVY LADLE

Maker unknown, c.1870

The shaped bowl leading to a heavy arched handle with a rosette mid-handle and a warrior's profile at the terminus, ball finial, script engraved 'Edith' reverse of handle, stamped by San Francisco retailer Braverman & Levy, *marked 'coin' and 'patent' reverse of handle*

8in. long

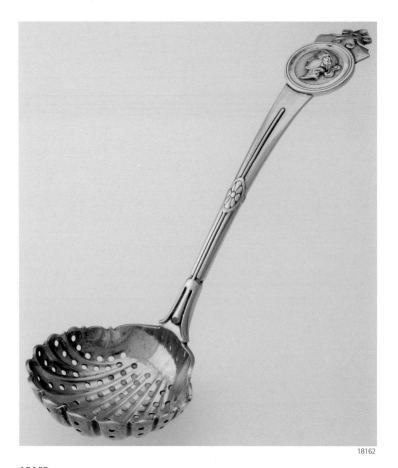

18162

A PARCEL GILT AMERICAN SILVER MEDALLION PATTERN SUGAR SIFTER

Mark of Gorham, Providence, Rhode Island, c.1865

The fluted gilt bowl with elaborate openwork, period script monogram 'Overton', *marked reverse of handle*
6.2in.

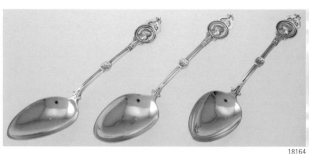

18164

A GROUP OF THREE AMERICAN SILVER MEDALLION PATTERN DESSERT SPOONS

Shulz & Fisher, San Francisco, California, c.1870

Various monograms, excellent condition, marked 'coin', *marked reverse of handles*
7in. long each (Total: 3 Items)

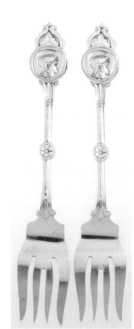

18163

TWO AMERICAN SILVER MEDALLION PATTERN FISH FORKS

Shulz & Fischer, San Francisco, California, c.1880

Each with Shreve & Co. retail marks, marked sterling, crisp pattern, matching period script 'SAS' monograms, *marked reverse of handles*

7.2in. long each (Total: 2 Items)

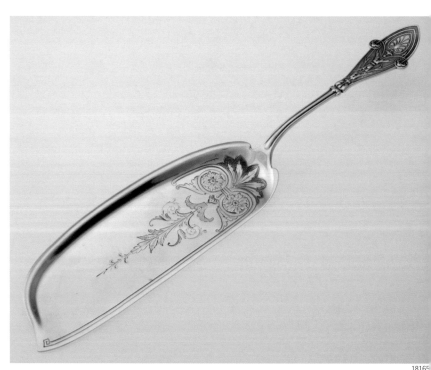

18165

AN AMERICAN SILVER ITALIAN PATTERN CRUMBER

Mark of Tiffany & Co., New York, c.1910

The blade with elaborate bright cut engraved that mimics the pattern, period script monogram reverse of handle, date marked 'm', *marked reverse of handle*
13.2in. long

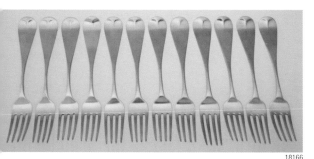
18166

18166

TWELVE AMERICAN COIN SILVER TIPT PATTERN FORKS

Mark of Bigelow Bros. & Kennard, Boston, Massachusetts, c.1845

Each with matching period script 'LW' monogram on the reverse of handles, very nice original patina and heavy weight construction, *marked reverse of handles*

7.4in. long each (Total: 12 Items)

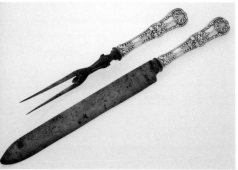
18167

18167

AN AMERICAN SILVER ENGLISH KING PATTERN CARVING SET

Tiffany & Co., New York, c.1910

With original Tiffany carbon steel blades, date marked 'm', *marked on edge of handles*

The longest 14.3in. (Total: 2 Items)

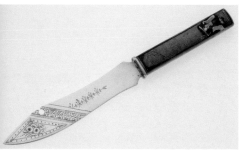
18168

18168

AN AMERICAN MIXED METAL JAPANESE STYLE KNIFE

Maker unknown, c.1880

Marked only sterling, the handle with brass retainer holding two bronze plates, each with a gold silver and bronze applied figure standing upon engraved ground, the blade matte finished with Japanese style bright cut engraving, *marked on blade*

7.9in. long

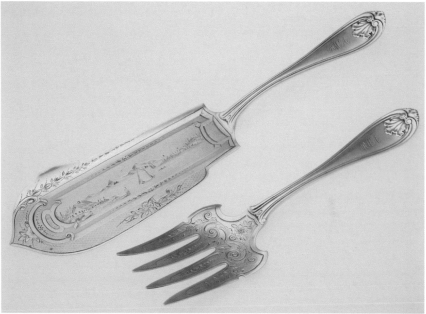
18169

18169

AN AMERICAN SILVER JOSEPHINE PATTERN FISH SET

Mark of Gorham, Providence, Rhode Island, c.1855

The knife blade with elaborate bright cut engraved lake scene including mountains, trees, sailboats, and houses; the serving fork with elaborate bright cut engraving around the tines, period script monogram, 'RMcA', *marked reverse of handles*

the longest 11.7in. (Total: 2 Items)

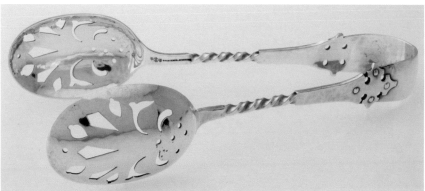
18170

18170

A PAIR OF AMERICAN SILVER 14TH CENTURY PATTERN ICE TONGS

Mark of Shreve, San Francisco, California, c.1910

A rare serving piece in a rare pattern, entirely hand hammered, mid-handle twist, bowls with fancy hand-cut open work, *marked inside handle*

6.6in. long

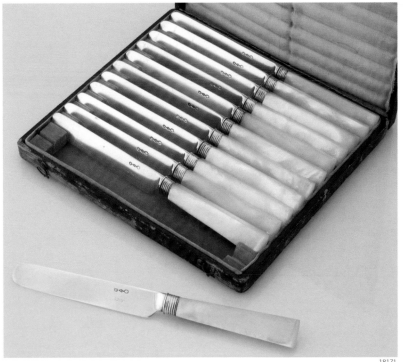

18171
A RARE BOXED SET OF SQUARE HANDLE MOP COIN SILVER KNIVES
Mark of Albert Coles, New York, c.1860

Cased in their original plush lined box, the square handles of carved mother of pearl, the ferrules and blades of pure coin silver, each blade marked with the Albert Coles trademark and a period script miniature 'SES' monogram, condition like new, MOP lustrous, *marked on blades*

7.9in. long each (Total: 12 Items)

18173
AN AMERICAN SOUTHERN COIN SILVER FISH SERVING FORK
Mark Gregg Hayden & Co., Charleston, South Carolina, c.1850

An unusual fish serving fork in an olive pattern variation, the solid silver tines completely engraved with flowers and leaves, a rubbed pseudo hallmark below that of Gregg Hayden & Co., *marked reverse of handle*

10.7in. long

18172
A PARCEL GILT AMERICAN SILVER STUFFING SPOON
Mark of George Sharp, Philadelphia, Pennsylvania, c.1860

The fluted oval shaped bowl with scalloped edges, bowl and handle with decorative engraving, fiddle thread pattern, retailed by Bailey & Co., *marked reverse of handle*

12.9in. long

18174
A GROUP OF SIX AMERICAN COIN SILVER SHEAF-OF-WHEAT SPOONS
Mark of Pelletreau, Bennett & Cooke, New York, c.1826

Each with a sheaf-of-wheat design at the top of handle, matching period 'MB' monograms, faint shell-back design, *marked reverse of handles*

5.9in. each
(Total: 6 Items)

18175
AN AMERICAN SILVER AESTHETIC MOVEMENT BERRY SPOON
Mark of Shiebler, New York, c.1885

The hand hammered finish with an acid etched abstract organic design climbing the handle which graduates in thickness, an irregular shaped bowl, Old English 'C' reverse of handle, retailed by Theodore Starr, *marked reverse of handle*

9in. long

18176
AN AMERICAN SILVER FIDDLE THREAD PATTERN SCOOP
Mark of Shreve Stanwood, Boston, c.1860

Fiddle Thread pattern, shallow bowl with elaborate shell, scroll, strawberries, leaves and vines, *marked reverse of handle*

8in. long, 3.4oz

18175

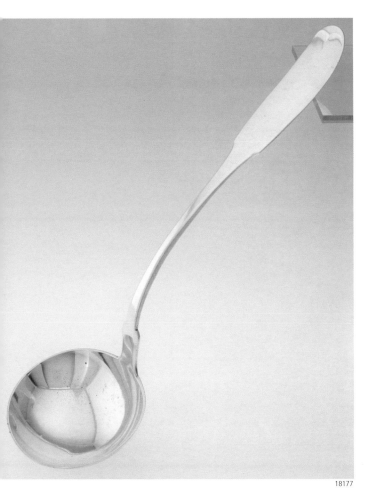

18177

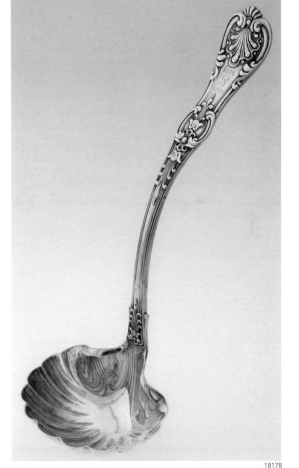

18178

18177
AN AMERICAN COIN SILVER ALABAMA SOUP LADLE
Mark of Knapp & Leslie, Mobile, Alabama, c.1850

An Antebellum soup ladle from Alabama, makers Knapp & Leslie of Mobile, hallmark very clear, excellent original condition, 'Tipt' pattern, reverse period script 'KJR' monogram, *marked reverse of handle*

14in. long

18178
AN AMERICAN SILVER ENGLISH KING PATTERN SOUP LADLE
Mark of Tiffany & Co., New York, c.1890

A very heavy soup ladle in the English King pattern, wonderful original patina, pattern showing no wear, marked with the early upper case 'M' date mark, with the scalloped edge bowl variant, *marked reverse of handle*

12.5in. long

18179

A PARCEL GILT AMERICAN SILVER
MIXED METAL SERVING SPOON

Mark of Whiting, Providence Rhode Island, c.1880

Hammered surface with applied silver and copper leaves, cherries and a cherry blossom, Old English monogram 'C' at terminus, *marked reverse of handle*

9.25in. long

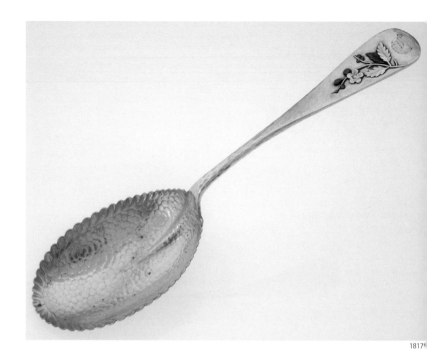

18179

18180

AN AMERICAN SILVER AESTHETIC
MOVEMENT FLAT SERVER

Maker unknown, c.1875

Most likely produced by The Whiting Manufacturing Company, the flat surface parcel gilt with a matte finish, the tubular handle with trifid joins that terminate in leaves, the top of handle also trifid with leaves and a berry, the blade with blooming lilies, marked sterling, 'A' and '10', *marked reverse of handle*

10.6in. long

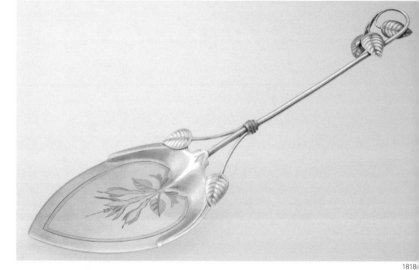

1818

18181

AN AMERICAN SILVER NEW ART PATTERN BERRY SPOON

Mark of Durgin, Concord, New Hampshire, c.1899

The shaped bowl with lilies and an Old English 'A' in the cartouche, *marked reverse of handle*

9in. long, 4.9oz

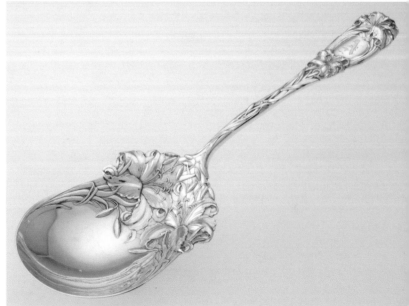

1818

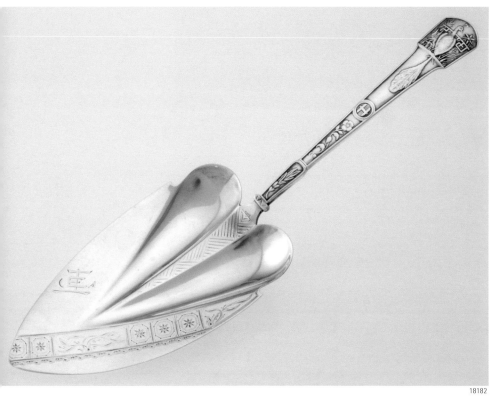

18182
AN AMERICAN SILVER JAPANESE PATTERN FLAT SERVER

Mark of Gorham, Providence, Rhode Island, c.1870

The heart shaped blade with japanese style engraving, the handle depicting a peacock in a marsh, reverse of handle with monogram 'ALA Oct. 21.1874.', *marked reverse of handle*

8.6in. long

18182

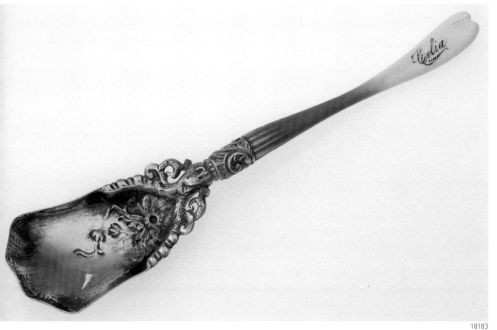

18183
AN AMERICAN SILVER IVORY PATTERN SERVING PIECE

Mark of Whiting, Providence, Rhode Island, c.1880

Possibly a sugar shell or preserve spoon, marked '2888' on the reverse of the bowl, this comes from a small group of Ivory pattern in superb original condition, shaped, engraved and tinted ivory handle like new and tightly fitted to bowl, gold wash on bowl shows no wear, scrimshaw signature 'Celia' on handle, *marked reverse of bowl*

6.1in.

18183

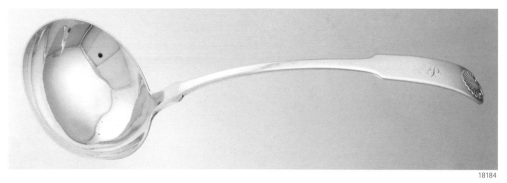

18184

A SOUTHERN COIN SILVER SHELL PATTERN MARQUAND LADLE

Mark of Frederick Marquand, Savannah, Georgia, c.1820

An oval bowl with shell back design, the handle with shell obverse, monogrammed with a period script 'P', 'F. Marquand' mark with pseudo hallmarks, 'G' date letter, *marked reverse of handle*

13.2in. long, 7.3oz

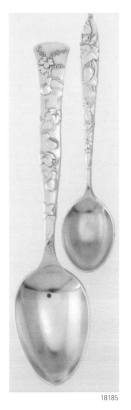

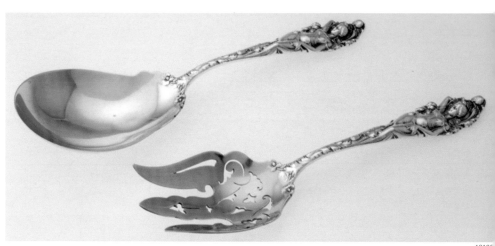

18186

AN AMERICAN SILVER LOVE DISARMED PATTERN SALAD SERVING SET

Mark of Reed & Barton, Taunton, Massachusetts, c.1905

Distinctly old, the bold strike, clarity and delicate open-work seen only on the originals, a period script 'AHB' monogram on the reverse of handles, the majority of the original gold wash still intact, *marked reverse of handles*

8.5in. long the spoon
(Total: 2 Items)

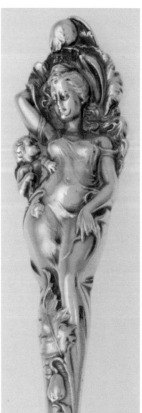

18185

A PAIR OF AMERICAN SILVER VINE PATTERN SPOONS

Mark of Tiffany & Co., New York, c.1890

A teaspoon in the gourd variation with a 'G' monogram and a coffee spoon in the squash variation, *marked reverse of handle and bowl*

6.1in. the teaspoon, 4.7in. the coffee spoon
(Total: 2 Items)

From the Collection of Dr. Dale Bennett

Lots 18187–18219

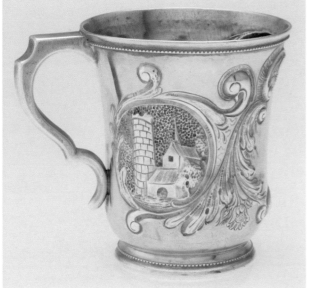

18187

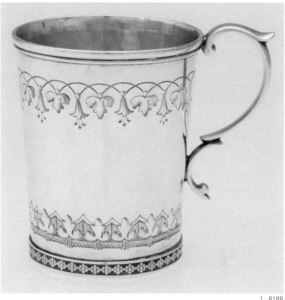

1...8188

18187

AN AMERICAN COIN SILVER ARCHITECTURAL REPOUSSE CUP

Mark of William Gale & Son, New York, c.1852

The body chased with repousse acanthus leaves and architectural scenes, a beaded edge round pedestal foot, date marked for 1852, *marked underside*

3.3in. high

18188

AN AMERICAN SILVER HONEYSUCKLE CUP

Mark of Tiffany & Co., New York, c.1860

Retailed by Tiffany & Co., this cup bears elaborate hallmarks including those of Grosjean & Woodward the manufacturers, marked 'English Sterling' and 550 Broadway, the body decorated with a repeating honeysuckle design, the base die rolled and applied, the monogram reads 'Bessie 1860', *marked undersides*

3.2in. high

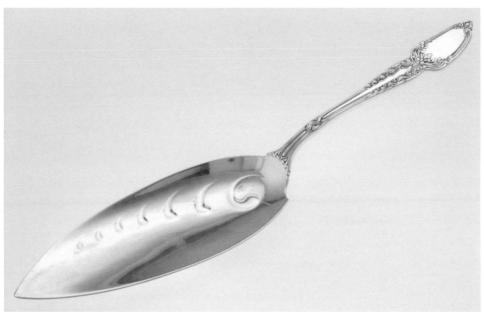

18189

18189

AN AMERICAN SILVER BROOMCORN PATTERN FISH SLICE

Mark of Tiffany & Co., New York, c.1900

The lines, leaves and berries in this pattern seem a precursor to the art nouveau movement of the early 20th century, the flat serving area with graduated raised swirls, *marked reverse of handle*

12.3in. long

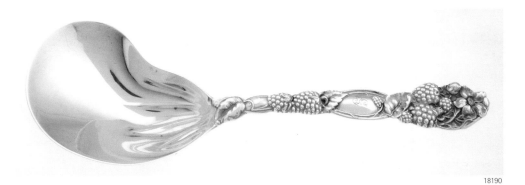

18190

18190

AN AMERICAN SILVER BLACKBERRY PATTERN BERRY SPOON

Mark of Tiffany & Co., New York, c.1905

The kidney shaped bowl with raised flowing lines, clusters of blackberries, vines, leaves and flowers combine to make this particular serving piece one of the most attractive ever produced by Tiffany, a period script 'G' monogram in the obverse cartouche, *marked reverse of handle*

9.5in. long

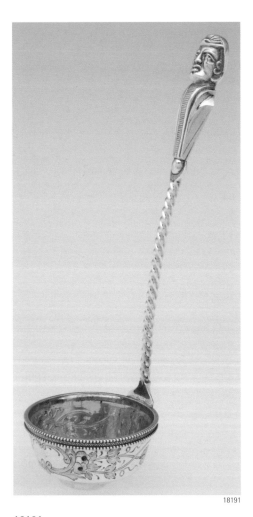

18191

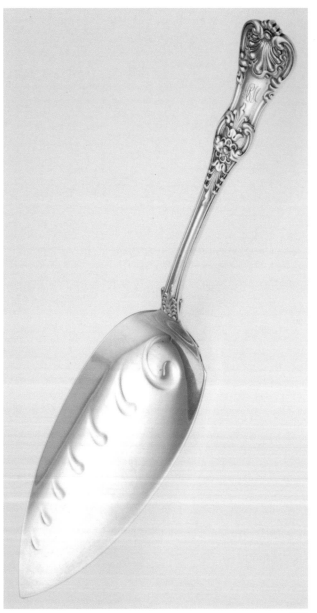

18192

18191

A RARE AMERICAN SILVER FIGURAL OLMEC LADLE

Attributed to Schooley & Ludwig, c.1870

A rare and possibly unique example of the ancient Olmec culture in American silver, similar to Egyptian revival figural pieces though the facial features on the bust distinctly ancient American, parcel gilt, twist handle, the bowl elaborately chased and engraved with a fancy applied beaded edge design, marked coin with an arrow hallmark, *marked reverse of bust*

7.5in. long

18192

AN AMERICAN SILVER ENGLISH KING PATTERN FISH SLICE

Mark of Tiffany & Co., New York, c.1890

The pointed blade with a raised graduated swirling pattern, traditional kings style pattern, period script 'MRM' obverse monogram, block 'M' date mark, *marked reverse of handle*

11.2in. long

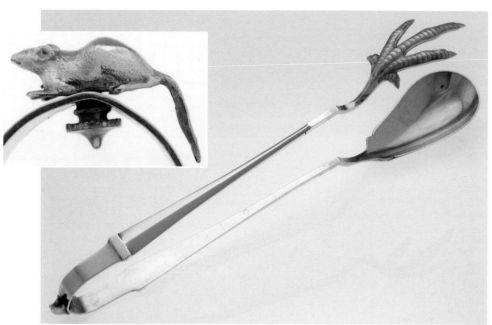

18193
AN AMERICAN PAIR OF FIGURAL CHICKEN TONGS
Maker unknown, c.1860

A rare form in American silver flatware, chicken tongs seldom appear for sale on the market, this pair with parcel gilt realistic claw and bowl, the geometric shaped handles terminate with an applied figural mouse, the mouse secured by screw and nut, *marked inside handles*
12in. long

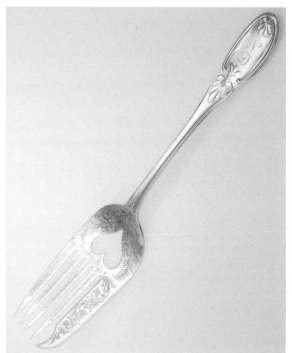

18194

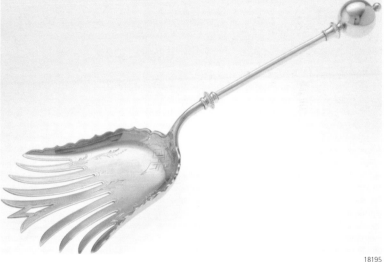

18195

18195
AN AMERICAN SILVER BALL PATTERN MACARONI FORK
Mark of George Sharp, Philadelphia, c.1865

This most unusual serving fork has eleven tines, with parcel gilt, pierced and decorated with bright cut engraving, marks included 'patent' '1863 G.S.' and sterling, *marked reverse of handle*
10.6in. long

18194
AN AMERICAN COIN SILVER ASPARAGUS FORK
Mark of Bailey & Co., Philadelphia, c.1855

A rare form of asparagus serving fork from the antebellum period, a classic Olive pattern variation with elaborately engraved tines and a most unusual cut-out heart-shaped design at the base of the tines, marks include Bailey & Co., T&J and Pattern, monogram removal and replacement 'ND' in script, obverse of handle, *marked reverse of handle*
12.5in. long

18196

AN AMERICAN SILVER MACARONI SERVER

Maker unknown, c.1885

Parcel gilt flaring tines and deep bowl, the handle
with acid-cut-back rococo design and cartouche,
monogrammed 'G', marked only 'sterling', *marked reverse
of handle*

11in. long

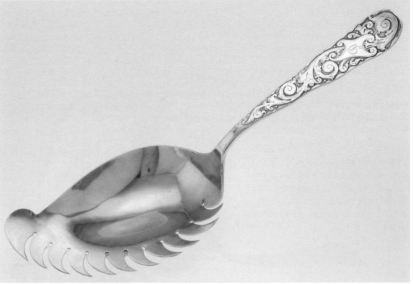

18196

18197

AN AMERICAN SILVER
FONTAINEBLEAU PATTERN
ASPARAGUS TONGS

Mark of Gorham, Providence, Rhode Island, c.1885

An exceedingly rare pair of asparagus
tongs with floral bright cut engraving
inside the elaborately hand-cut ends,
a bar runs between each side and
removable for cleaning, period script
'FCE' monogram at the terminus,
marked inside handle

10.1in. long

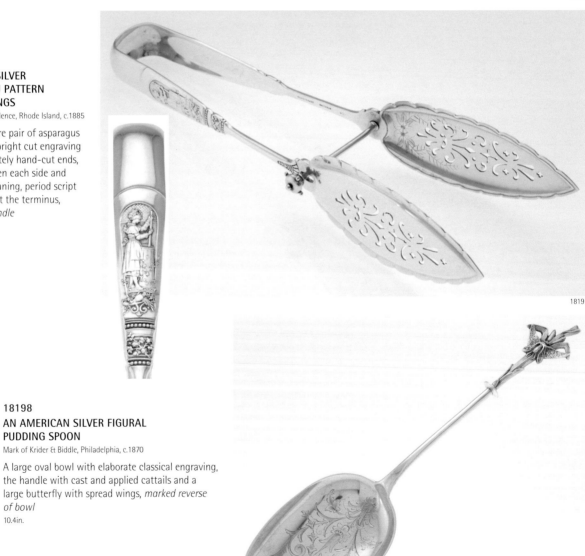

18197

18198

AN AMERICAN SILVER FIGURAL
PUDDING SPOON

Mark of Krider & Biddle, Philadelphia, c.1870

A large oval bowl with elaborate classical engraving,
the handle with cast and applied cattails and a
large butterfly with spread wings, *marked reverse
of bowl*

10.4in.

18198

18199

AN AMERICAN SILVER OLYMPIAN PATTERN ICE CREAM SLICE

Mark of Tiffany & Co., New York, c.1895

Parcel gilt, this variant of the pattern 'Venus born of the sea', the blade with raised swirls, the pattern crisp with a very original appearance, a period script 'AFB' monogram, 'T' date mark, *marked reverse of handle*

11.4in long

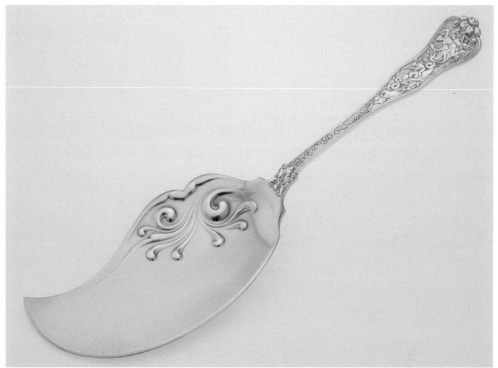

18199

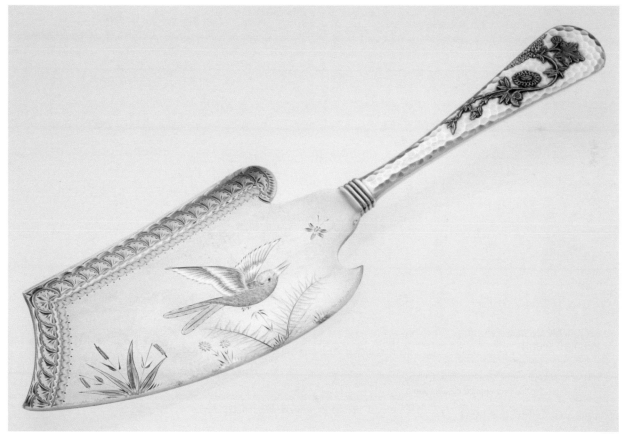

18200

18200

AN AMERICAN SILVER MIXED METAL JAPANESE STYLE ICE CREAM SLICE

Mark of Gorham, Providence, Rhode Island, c.1880

Parcel gilt, the handle with hammered surfaces and applied copper and silver floral decoration, reverse of handle matte finished, the blade also matte finished with Japanese style bright cut engraving, a bird in flight pursuing an insect above a foliate background, *marked reverse of handle*

10.1in. long

18201

A RARE EARLY AMERICAN SILVER MACARONI SERVER

Mark of Crosby Morse & Foss, Boston, c.1856

Geometric bright cut engraving, the blade reticulated with engraved ivy leaves and vines, American macaroni servers seldom date prior to the middle 1860's, this example with a patent date of July, 1, 1856, *marked reverse of handle and under blade*

10in. long

18201

18202

18202

AN AMERICAN SILVER MEDALLION SOUP LADLE

Mark of Gorham, Providence, Rhode Island, c.1865

Parcel gilt with the bust of a woman at the top of the handle, bearing Tiffany & Co. retail marks, reverse of handle, *marked reverse of handle*

13.8in. long

18203

18203

AN AMERICAN SILVER FLORENTINE PATTERN FISH SET

Mark of Tiffany & Co., New York, c.1900

The knife blade with raised swirling patterns, one of Tiffany's most attractive patterns, acanthus leaves and scrolls lead to a heart shaped cartouche surmounted by a pine cone, a period script three letter monogram, marked 'patent 1900', *marked reverse of handle*

11.2in. long, the knife

18204

AN UNUSUAL AMERICAN SILVER FLISH SLICE

Mark of Tiffany, New York, c.1860

The curved, notched blade with elaborate engraving and a curled back leading to a twist mid-handle and bright-cut engraved top, reverse stamped with 'H&M', *marked reverse of handle*

11.6in. long

18204

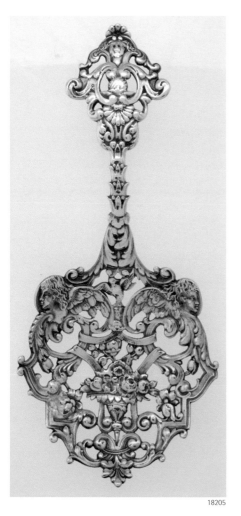

18205

18205

AN AMERICAN SILVER CAST BON BON SPOON

Mark of Gorham, Providence, Rhode Island, c.1880

Cast, hand chased and open-cut, the spoon marked '588' and features winged cherubs and floral, rococo design, *marked reverse of handle*

6.2in. long

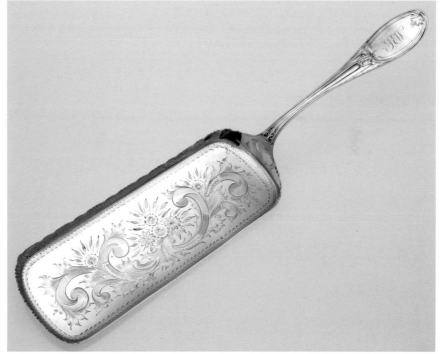

18206

18206

AN AMERICAN COIN SILVER CRUMBER

Mark of Tiffany & Co., New York, c.1850

The olive variation pattern with a large flat scoop, raised scalloped edge with floral engraved surfaces, a period script 'SEW' monogram, *marked reverse of handle*

12.5in. long

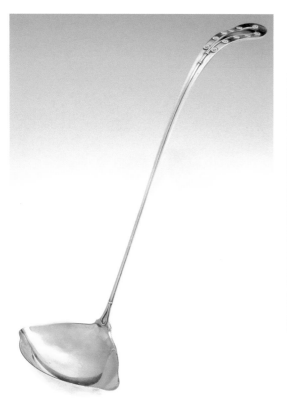

18207

AN AMERICAN SILVER DAISY PATTERN PUNCH LADLE

Mark of Tiffany & Co., New York, c.1910

The matte finished handle with applied, full length wire decoration surmounted by numerous applied daisies, parcel gilt, the bowl with a lip on both sides, *marked reverse of handle*

12.2in.

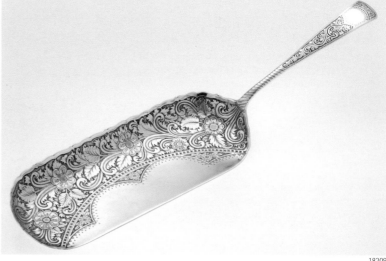

18209

AN AMERICAN SILVER TUDOR PATTERN CRUMBER

Mark of Gorham, Providence, Rhode Island, c.1880

Tudor, a very uncommon, artfully hand chased pattern, the blade and handle with paisley-like rococo work complemented by rosettes and bright cut engraving, *marked reverse of handle*

12.1in.

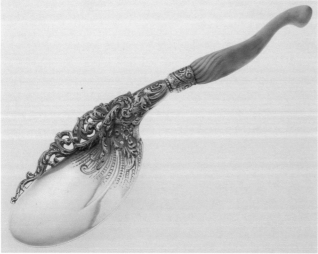

18208

AN AMERICAN SILVER IVORY PATTERN JELLY SERVER

Mark of Whiting, North Attleboro, Massachusetts, c.1890

The carved ivory handle pinned to an ornate, reticulated sterling scoop, hand chased decoration, a very uncommon American pattern, *marked reverse of handle*

9.1in. long

18210

AN AMERICAN SILVER ATLANTAS PATTERN FISH SLICE

Mark of Tiffany & Co., New York, c.1900

The pointed blade with raised decoration, art nouveau design featuring overlapping leaves and vines, 'patent 1899' marked reverse of handle

12.2in. long

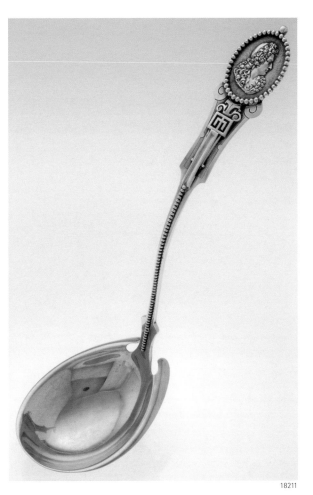

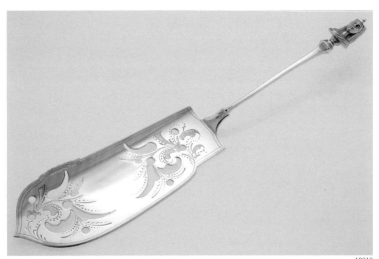

18212
AN AMERICAN SILVER EGYPTIAN REVIVAL FISH SLICE
Maker unknown, c.1870

The flat surface with elaborate bright-cut engraving and open-work, square handle terminates in an intricate cast bust of a pharaoh, marked sterling and 925, the fish slice one of the more uncommon serving pieces in American Egyptian revival flatware, *marked reverse of handle*
11.9in. long

18211
AN AMERICAN PARCEL GILT COIN SILVER SOUP LADLE
Mark of Wood & Hughes, New York, c.1860

Applied beaded decoration from the bowl to the upper part of the handle, cast and applied classical decoration and engraving surmounted by a beaded cartouche which surrounds the bust of Louis XIV, engraved 'Emma' reverse of medallion, retailed by E. Jaccard of St. Louis Missouri, *marked reverse of handle*
13.5in. long

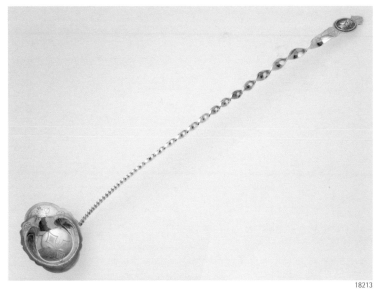

18213
AN AMERICAN SILVER MEDALLION PUNCH LADLE
Attributed to George Sharp, Philadelphia, Pennsylvania, c.1860

The twist handle terminates with the bust of a woman, accented by bright cut engraving, the bowl with gilt interior and elaborate engraving, a period 'LEC' monogram on the reverse of the medallion, marked sterling with two lion pseudo hallmarks, *marked under bowl*
17.9in. long

18214
AN AMERICAN SILVER CHRYSANTHEMUM PATTERN FISH SLICE
Mark of Shiebler, New York, c.1890

Matte surfaces and raised chrysanthemums upon a textured ground, period script 'MFJ' monogram reverse of handle, marked 'PAT' with the Shiebler trademark and sterling, *marked reverse of handle*
10.8in. long

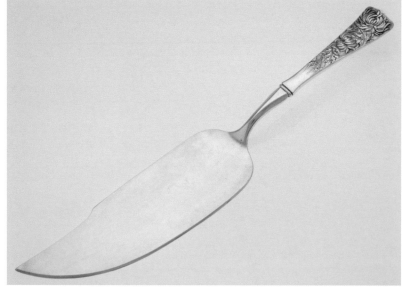
18214

18215
AN AMERICAN SILVER VINE PATTERN BERRY SPOON
Mark of Tiffany & Co., New York, c.1890

The handle with stippled surfaces and raised grape, vine and leaf decoration, parcel gilt, the bowl a realistically formed scallop shell, an early block 'M' date mark and a period vine style 'OLP' monogram, reverse of handle, *marked reverse of handle*
9.1in.

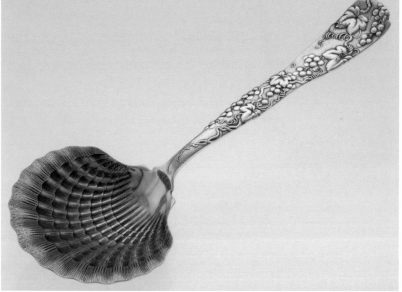
18215

18216
AN ENGRAVED AMERICAN SILVER FISH SLICE
Mark of Jones, Shreve & Brown, Boston, c.1854

Oval threaded pattern, back of handle monogrammed 'HD from CCA', the curved blade with elaborate floral rococo engraving, open-work and a large carp, *marked reverse of handle*
11.5in. long

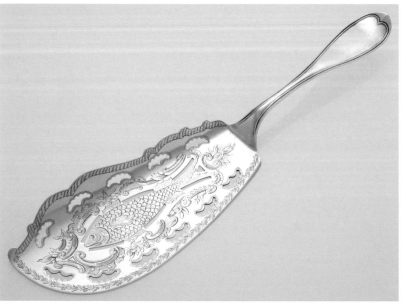
18216

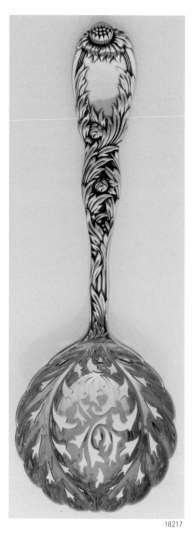

18217
AN AMERICAN SILVER CHRYSANTHEMUM PATTERN GILT SUGAR SIFTER

Mark of Tiffany & Co., New York, c.1890

The handle entirely covered with chrysanthemum decoration, the bowl with elaborate hand-cut open work, *marked reverse of handle*

6.9in. long

18217

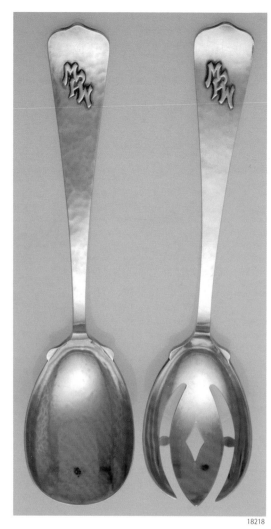

18218
AN AMERICAN SILVER HANDWROUGHT ARTS AND CRAFTS SALAD SET

Randahl Shop, Park Ridge, Illinois, c.1915

An older pair of servers with JOR trademark, hand wrought and '441' stamped on each piece, hammer marks throughout, evidence of original rose or copper colored gold wash in bowl and tines, applied 'MPW' monogram on obverse of handles, *marked reverse of handles*

the spoon 8.9in. long
(Total: 2 Items)

18218

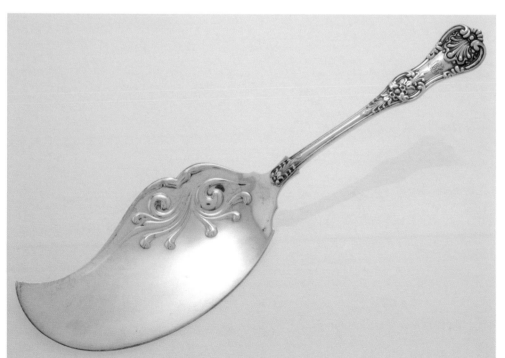

18219
AN AMERICAN SILVER ENGLISH KING PATTERN ICE CREAM SLICE

Mark of Tiffany & Co., New York, c.1890

The curved blade with raised swirling decoration, a period script monogram 'MBA' and an old block 'M' datemark, *marked reverse of handle*

11.2in. long

18219

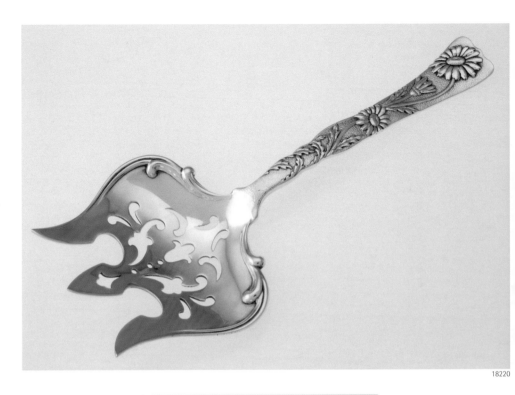

18220

AN AMERICAN SILVER VINE PATTERN CUCUMBER SERVER

Mark of Tiffany & Co., New York, c.1890

An uncommon serving piece in the desirable 'Vine' pattern by Tiffany, hand cut reticulated surfaces with raised daisies on a matte finished background, upper case 'M' date mark, *marked reverse of handle*

7in. long

18220

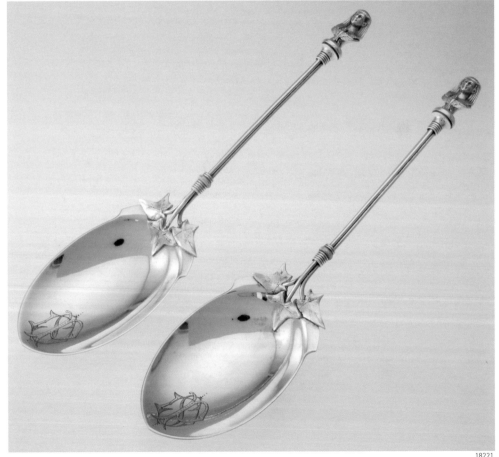

18221

18221

A PAIR OF AMERICAN SILVER EGYPTIAN REVIVAL SERVING SPOONS

Mark of Gorham, Providence, Rhode Island, c.1870

Parcel gilt, the pointed oval bowls with period 'DPS' monograms, ivy leaves connect to the bowl with trifid tubular construction, circular decorative bands and lightly gold washed pharaoh head finials, *marked reverse of handles*

8.9in. long each (Total: 2 Items)

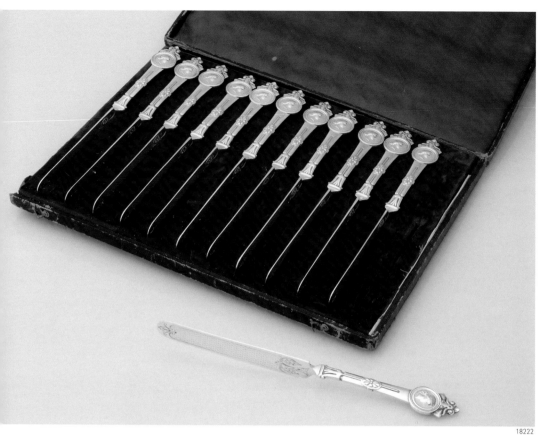

18222

18222

TWELVE AMERICAN SILVER RIGHT ANGLE MACHINED MEDALLION PATTERN KNIVES

Mark of Gorham, Providence, Rhode Island, c.1870

The original box fatigued, the pattern crisp, the machined blades fully lustrous as if new, each handle at a right angle, a period script 'HEW' monogram on the reverse of each handle, certainly one of the finest sets of Medallion pattern knives, *marked reverse of handles*

9.6in. long each (Total: 12 Items)

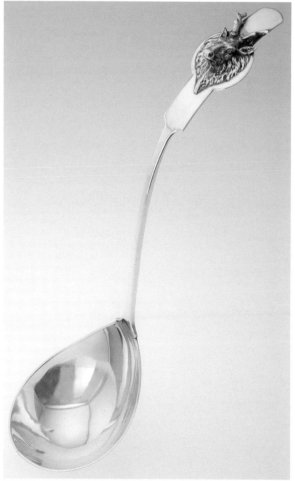

18223

AN AMERICAN COIN SILVER STAG HEAD PATTERN SOUP LADLE

Mark of Gorham, Providence, Rhode Island, c.1855

This rare ladle one of Gorham's earliest patented patterns with a cast and applied Stag head at the top of the handle, marked simply with Gorham's trademark and the retail mark of Starr & Marcus, this ladle pre-dates the sterling standard in America, the pattern was patented in 1855, one of the hardest to find Gorham patterns today, *marked reverse of handle*

14.7in. long

18223

18224

A MATCHING SET OF TWELVE AMERICAN SILVER JAPANESE PATTERN SPOONS

Mark of Gorham, Providence, Rhode Island, c.1880

This matching set of coffee spoons a 'conditional rarity' in that they have survived in as close to 'factory original' condition as any we have ever seen, the handles have gilt highlights and the spoons retain their original factory matte finish throughout, matching period script 'FAS' monogram on the reverse of each, *marked reverse of handles*

5in. long each (Total: 12 Items)

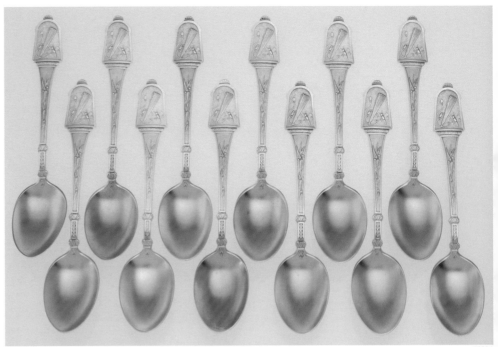

18224

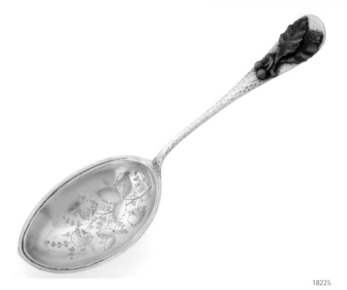

18225

18225

A PARCEL GILT AMERICAN SILVER MIXED METAL SERVING SPOON

Mark of Albert Coles, New York, c.1880

The rimmed bowl with bright-cut engraved strawberries leading to a hammered handle with a chased and applied bronze cluster of cherries, *marked reverse of handle*

8.9in. long

18226

18226

A RARE SET OF GORHAM SILVER EVANGELIST SPOONS

Mark of Gorham, Providence, Rhode Island, c.1895

An original matched set of four Evangelist spoons, each heavy cast spoon in excellent condition, all reverse cartouche with matching script 'AFS' monogram, finials representing Mark, Matthew, Luke and John, *marked reverse of bowl*

8.2in. long, average length, 18.5oz gross weight (Total: 4 Items)

18227

8227

A GROUP OF EIGHT AMERICAN SILVER LAP-OVER-EDGE ACID ETCHED FORKS
Mark of Tiffany & Co., New York, c.1880
Each with different acid-cut-back decoration including birds, fruit, flowers and berries, *marked reverse of handles*
in. average length

(Total: 8 Items)

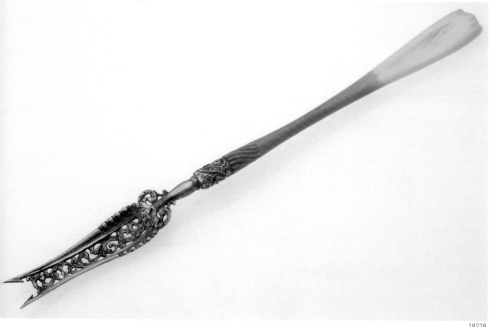

18228

8228

AN AMERICAN SILVER IVORY PATTERN SERVING FORK
Mark of Whiting, Providence, Rhode Island, c.1890
Multi-piece construction with a carved, engraved and tinted ivory handle, part of a group in outstanding original condition, probably an olive fork, this piece like the other ivory pattern objects from this collection considered a 'conditional rarity' *marked under tines*
in. long

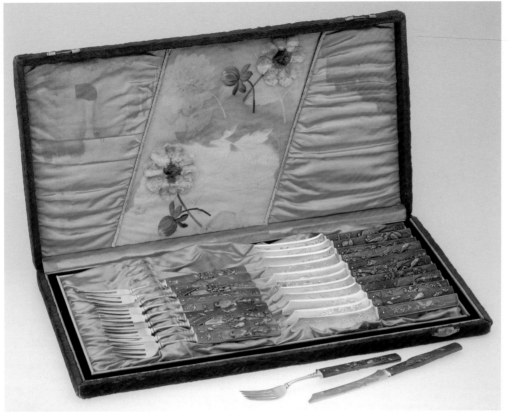

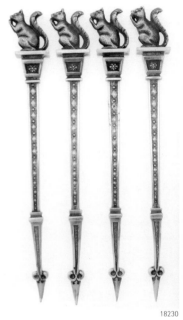

18230

A SET OF FOUR AMERICAN SILVER SQUIRREL NUT PICKS

Unmarked, possibly George Sharp, c.1860

The spade form picks surmounted by arched slightly flared handles with repeating geometric design running up the obverse and reverse ending in a squirrel sitting on a rosette adorned pedestal, stamped 'sterling patent'

each 5in. long (Total: 4 Items)

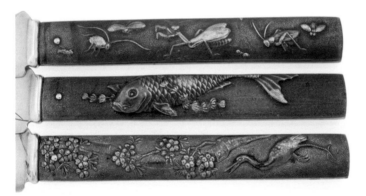

18229

AN AMERICAN MIXED METAL JAPANESE STYLE FRUIT SERVICE

Mark of Gorham, Providence, Rhode Island, c.1880

A twenty-two piece boxed set, missing two forks, according to Charles Carpenter, 'the Japanese prototypes for Gorham's Japanese fruit knives were the small *Kogatama* knives with removable push-on handles called '*kodzuka*', the handles in this set are silver and bronze with varying factory patinas with gold, silver and copper highlights throughout the set, each knife blade bright cut engraved by hand, the blades and reverse of tines marked 'sterling 5' with the Gorham trademark, in the original factory lined and decorated box, the embossed logo 'Gorham sterling silver, Union Square' still visible in the upper left hand corner, *marked on blades and reverse of tines*

the knives 7.7in.

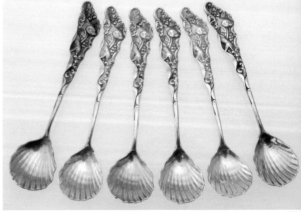

18231

AN ASSOCIATED GROUP OF SIX AMERICAN SILVER HIZEN PATTERN CHOCOLATE SPOONS

Mark of Gorham, Providence, Rhode Island, c.1880

The scallop shell form bowls with traces of gilding, the terminals formed of cascading water and a sinewy fish, four monogrammed 'McCR', one 'H', one 'E.P.', *marked reverse of handles*

4.25in. long (Total: 6 Items)

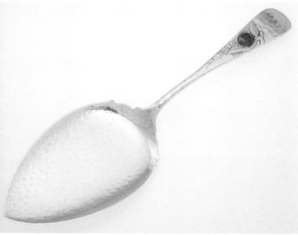

18232
AN AMERICAN SILVER MIXED METAL FLAT SERVER
Mark of Whiting, Providence, Rhode Island, c.1880

Hammered surface, applied and engraved silver branch with
a copper applied single cherry, foliate script monogram
reverse of terminus, *marked reverse of handle*
9in. long

18232

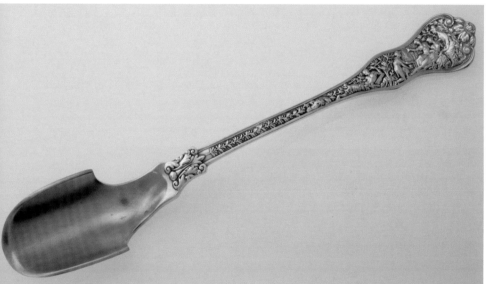

18233
A PARCEL GILT AMERICAN SILVER
OLYMPIAN PATTERN CHEESE SCOOP
Mark of Tiffany & Co., New York, c.1890

A large sized cheese scoop, with Paris, the
son of Priam, crisp near-mint condition, date
marked 'M', period script 'BWE' monogram,
marked reverse of handle
9.25in. long

18233

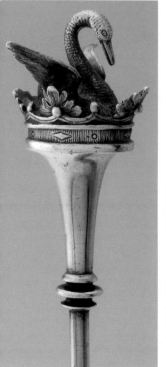

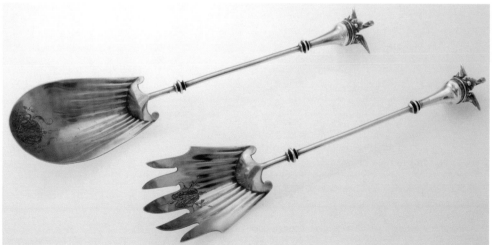

18234

18234
AN IMPORTANT PARCEL GILT AMERICAN SILVER
FIGURAL LONG HANDLED SALAD SET
Mark of Gorham, Providence, Rhode Island, c.1865

Fluted gilt engraved bowls, each with tubular handle and circular decorative mounts,
ovoid trumpet shaped support surmounted by a heraldic swan resting within an
elaborate cast crown, possibly unique, *marked edge of handle*
12in. long; 8.3oz (Total: 2 Items)

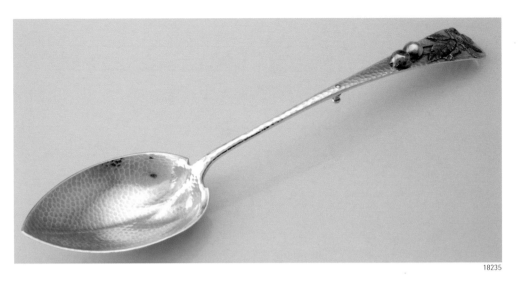

18235

AN AMERICAN SILVER JAPANESE STYLE STUFFING SPOON WITH BUTTON

Mark of Gorham, Providence, Rhode Island, c.1880

Parcel gilt, entirely hand hammered, applied gold and copper berries, leaves and branches, the bowl heart shaped, a button affixed to the back of the handle, a period 'C June 2. 1881' monogram reverse of handle, aside from a soup ladle, probably the largest serving piece in this pattern, *marked reverse of handle*

12.7in. long

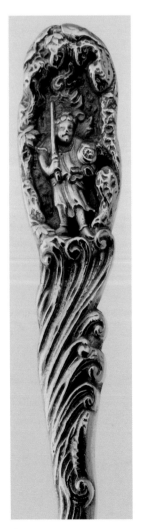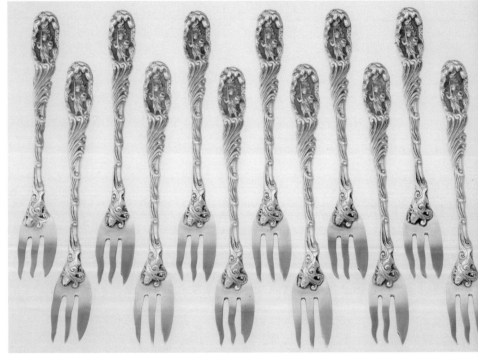

18236

A RARE SET OF TWELVE PARCEL GILT AMERICAN SILVER HIZEN PATTERN SEAFOOD FORKS

Gorham, Providence, Rhode Island, c.1880

Each of two piece construction, cast handles featuring stylized ocean waves and sea life including a large fish at join of handle and tines, a cast cartouche at the top of handle with a standing full figure Samurai carrying a swo no Gorham marks but simply 'Sterling C', fancy script 'FED' monograms on the reverse of each piece, *marked reve of tines*

5.9in. long

(Total: 12 Item

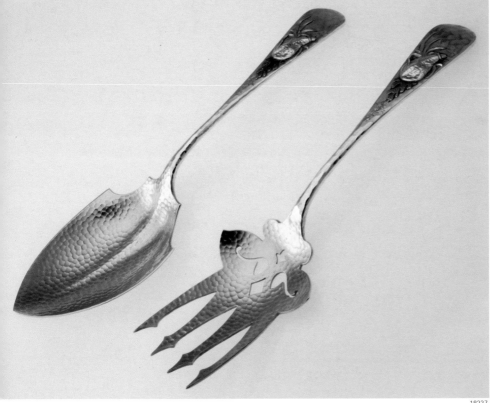

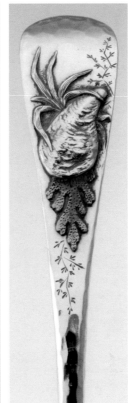

18237

18237
AN AMERICAN SILVER MIXED METAL JAPANESE STYLE SALAD SET
Mark of Whiting, Providence, Rhode Island, c.1880

This parcel gilt mixed metal salad serving set entirely hand hammered, the top of the handles with applied mussel shells, kelp and eel grass, bright cut foliate engraving surrounds, only slight wear on the heal of each piece, gold wash virtually intact, an outstanding example of the American Aesthetic movement in silver, *marked reverse of handles*
9.7in. the spoon (Total: 2 Items)

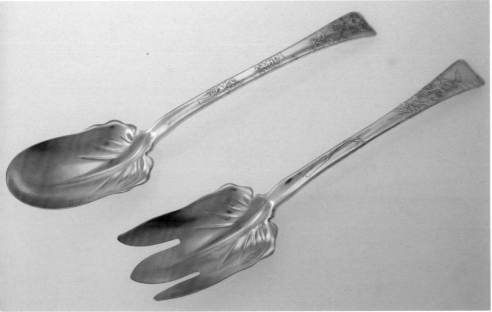

18238

18238
AN AMERICAN SILVER LAP-OVER-EDGE SALAD SERVING SET
Mark of Tiffany & Co., New York, c.1890

The pair with gold washed bowls, one with Japanese style acid-cut-back bamboo and a bird scratching its head with a claw, the other with foliate decoration and an owl resting on a branch, near mint condition with upper case 'M' date mark, *marked reverse of handles*
the spoon 10.4in. (Total: 2 Items)

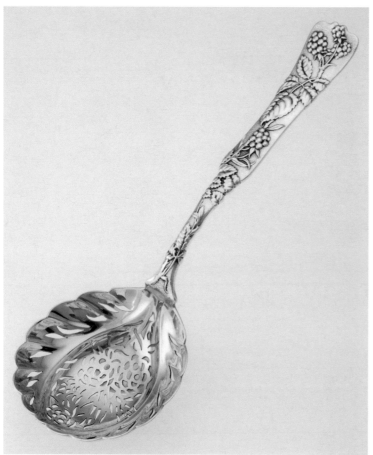

18239

AN AMERICAN SILVER VINE PATTERN SUGAR SIFTER

Mark of Tiffany & Co., New York, c.1890

In the Raspberry variation, parcel gilt, the bowl artfully cut by hand with a cluster of raspberries and leaves, the handle with raised berries upon a matte finish, *marked reverse of handle*

7.1in. long

18240

A PAIR OF AMERICAN MIXED METAL SUGAR TONGS

Mark of Whiting, Providence, Rhode Island, c.1885

The handle with hand hammer finish and applied copper and yellow metal cherries, *marked inside handles*

Approximately 5.5in. long

18241

A GEORGE II STYLE ENGLISH SILVER BOWL

Marked Charles Stuart Harris, London, 1904-5

The body with chased rococo decoration in the style of George II, *marked on body*

4.25in. high, 6.25in. wide, 7.87oz

18242

AN ENGLISH GEORGE III SILVER CASTER

A round base with rococo chasing and fluting, the body with similar decoration, a friction fit top with elaborate open work, *marked on body and top*

8in. high, 6.90oz

18243

AN AMERICAN SILVER DANISH MODERN STYLE BOWL

Maker unknown, c.1940

A circular form stand supporting an unadorned bowl with applied flower and beaded handles, *marked underside*

3.3in. high, 10in. diameter, 23.63 oz

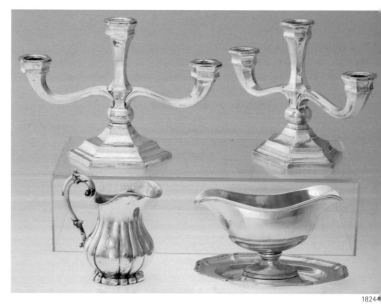

18244

A GROUP OF FOUR CONTINENTAL SILVER OBJECTS

Various marks, 20th century

A pair of art deco three-arm candelabra, a sauce boat on stand and a cream pitcher, all with differing marks, *marked undersides*

7.5in. high, 48.4oz gross weight

(Total: 4 Items)

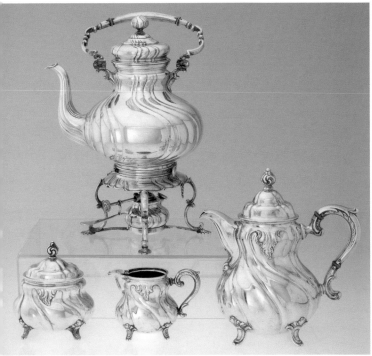

18245

A FOUR PIECE CONTINENTAL SILVER TEA SERVICE

Maker unknown, c.1920

The bodies decorated with curving lines and stylized acanthus leaves, the kettle with shell feet and tilting hinges, original burner, the other pieces with rocaille feet, the kettle, coffee pot and sugar bowl all with hinged lids, marked 830 fine, *marked undersides*

16in. high, the kettle on stand, 104oz gross weight (Total: 4 Items)

18246

A CONTINENTAL SILVER THREADED EDGE OVAL MEAT PLATTER

Germany, 20th century

Handwrought, in excellent condition with an applied threaded rim, 800 fine, *marked underside*

21.6in across, 14.6in. wide, 52.4oz

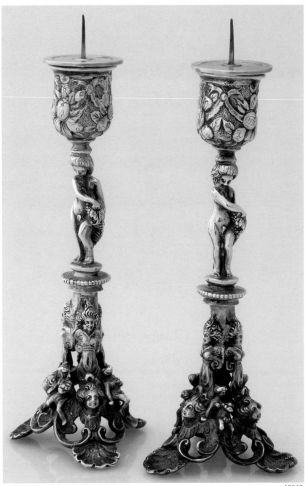

18247

A PAIR OF BRITISH IMPORT SILVER RENAISSANCE REVIVAL PRICKET STICKS

With British import marks for 1891

The pair cast and applied with numerous cherubs and angelic faces, the stem with putti supporting a cornucopia, retaining original prickets, Mark M.S in square with standard and date marks, *marked inside shell feet*

5.8in. each, 10.5oz gross weight (Total: 2 Items)

18248

A PAIR OF CONTINENTAL SILVER BOWLS

Maker unknown, Germany, c.1920

One with hammered lobed panels and flaring lip set upon three scroll feet, the other with beaded edge and six panels, spreading foot also with beaded edge, *marked underside and on edge of base*

11in. diameter, the largest, 9in. across, the other, 37.4oz (Total: 2 Items)

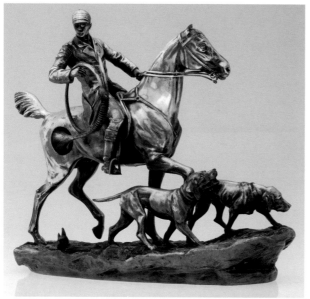

18249
CONTINENTAL SILVER PLATE EQUESTRIAN SCULPTURE HUNT SCENE
Probably German, early 20th century

Two hounds leading horse mounted with a uniformed trumpeter, realistically formed figures, ground and foliage, silver over base-metal, signed 'Berbst', *marked front of base*
9in. high, 11in. long

18250
A CONTINENTAL SILVER GADROON EDGE MEAT PLATTER
Germany, 20th century

The rectangular tray with an applied gadroon edge, signed 'Gutruf', excellent condition, 800 fine, *marked underside*
18.5in. across, 13in. wide, 47.5oz

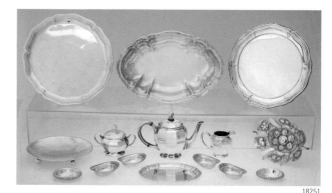

18251
A GROUP OF FIFTEEN PIECES CONTINENTAL SILVER
Various makers, 20th century

A three piece single serving tea service, six nut dishes, an entree dish and several handwrought trays, most marked 800 or 835 *marked undersides*
61.2oz gross weight (Total: 9 Items)

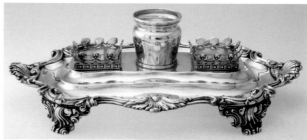

18252
A FUSED SILVER ON COPPER STANDISH
Sheffield, unmarked, c.1830

The shaped rectangular form on four rocaille feet, the plate with shell ends and scroll border, the raised center supporting two square inkstands flanking a urn form pen receptacle
16in. across

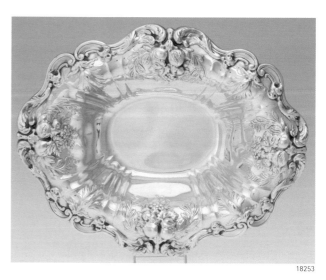

18253
AN AMERICAN SILVER FRANCIS I PATTERN FRUIT BOWL
Mark of Reed & Barton, Taunton, Massachusetts, c.1953

The oval form with undulating rococo-style border decorated with clusters of fruit, date marked, *marked underside*
12in. across

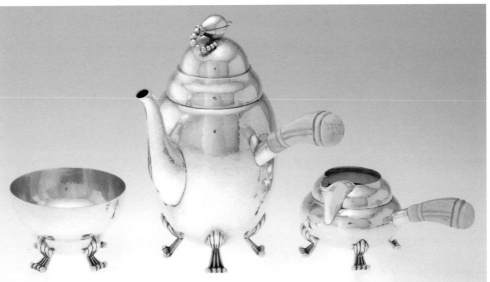
18254

8254
AN AMERICAN SILVER DANISH MODERN STYLE TEA SERVICE

Mark of Shreve & Co., San Francisco, California, c.1940

Entirely handwrought, the finish with hammer marks throughout, oval bodies set upon stylized lion paw feet, finial a blossom with graduated balls, carved ivory handles, in the manner of Georg Jensen Blossom pattern, pattern number on base '10910', *marked undersides*

8.3in. high the coffee pot, 32.2oz gross weight

(Total: 3 Items)

18255

18257

18255
A LARGE ENGLISH SILVER CIGAR HUMIDOR

Maker unknown, Birmingham, England, c.1928

With two hinged compartments and an omega shaped handle, each compartment with a different armorial, a sprinting horse and a lions head, testimonial engraved on the side, 'Presented to Bro. G.F. Ingham Clark on the occasion of his marriage, from the brethren of Provincial Grand Lodge of Argyll and the Isles, FebY 8th, 1928' *marked on one side*

12.2in. wide, 9.2in. across, 3.2in. high

18257
AN AMERICAN SILVER DELORES PATTERN CENTERPIECE

Mark of Shreve & Co., San Francisco, California, c.1925

Shreve & Co, well known for their quality arts and crafts silver of the early 20th century, the Delores pattern features a hammered undulating applied border, marked 'Shreve & Co. San Francisco, Sterling 7482', a monogram '1875 T 1925' on one side, *marked underside*

15in. diameter, 2.7in. high, 31.2oz

18256

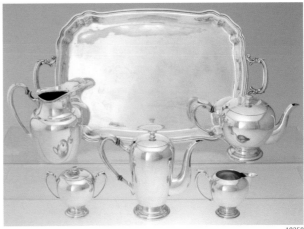
18258

18256
AN AMERICAN SILVER GEORGIAN REPRODUCTION STYLE FRUIT BOWL

Mark of Gorham, Providence, Rhode Island, 20th century

A very heavy pie-crust style bowl, marked 'reproduction Dublin 1720', a script 'FDR' monogram engraved in the center, *marked underside*

12.5in. diameter, 1.8in. high, 33.6oz +

18258
A SIX PIECE PERUVIAN SILVER TEA SERVICE

Mark of Camusso, 20th century

Consisting of a tray, coffee pot, tea pot, sugar, creamer and water pitcher, excellent condition with no monograms, each marked 'Camusso, Peruana, plata esterling industrial 925' *marked undersides*

24.5in. across, the tray, 8.5in. high, the coffee pot, 118.5oz gross weight

(Total: 6 Items)

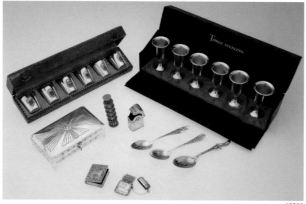

18259

A GROUP OF TEN SILVER AND SILVER PLATE ITEMS
Various makers

Including a boxed set of six Towle silver cordials, two silver stamp boxes, an 18K gold plated leaning tower of Pisa lipstick case, three silver golf-themed souvenir spoons, *each marked various places* (Total: 10 items)

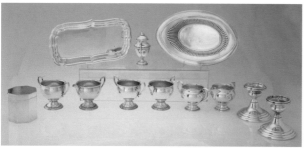

18260

TWELVE SILVER AND SILVER PLATE HOLLOWARE PIECES
Various makers

Comprising:

Two sterling creamer sugar sets by Rogers, weighted, one parcel gilt
A sterling creamer sugar set by Newport
A sterling oval tray marked Wilcox & Wagoner
A sterling shaped rectangular tray date marked 1949 Reed & Barton 'Windsor'
An English hallmarked and weighted urn-form cigar lamp
A silver plate octagonal hinged box marked 'Exeter'
A pair of electro-plated candlesticks by Gorham, weighted (Total: 12)

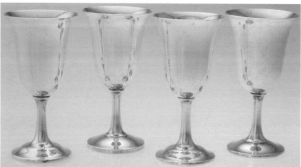

18261

FOUR AMERICAN SILVER WATER GOBLETS
Various makers, 20th century

Two marked *Wallace sterling 122,* one marked *Wallace sterling 14,* one marked *Preisner sterling 214*
each 6.75in. tall (Total: 4 Items)

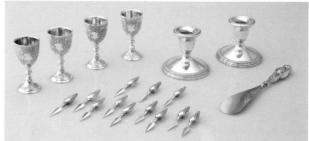

18262

A GROUP OF FOUR SILVER AND SILVER PLATE ITEMS
Various makers

Comprising a pair of silver weighted candlesticks, a silver floral decorated shoe horn, a set of twelve silver corn holders, and a box set of four silver plated cordials (Total: 4 items)

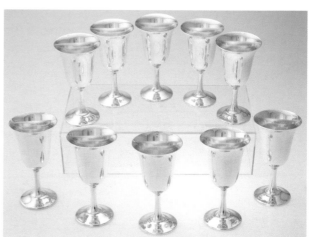

18263

TEN AMERICAN SILVER WATER GOBLETS
Mark of Wallace, Wallingford, Connecticut, 20th century

The everted bell-form cups on circular bases, each marked *sterling 14,* each marked undersides
6.75in. high (Total: 10 Items)

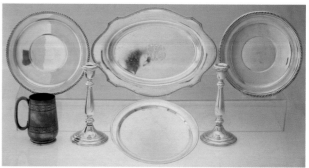

18264

A GROUP OF SEVEN SILVER AND SILVER PLATE ITEMS
Various makers

Comprising, a pair of weighted American silver candlesticks; a silver plated mug; three assorted silver circular trays; a shaped oval tray with script monogram, mark of *Gorham* (Total: 7 Items)

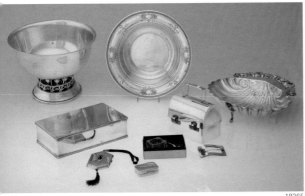

18265

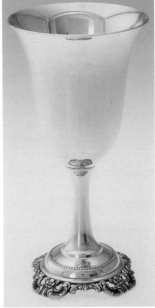

18268

18268

A PARCEL GILT AMERICAN SILVER GRANDE BAROQUE PATTERN WATER GOBLET

Mark of Wallace, Wallingford, Connecticut, c.1950

The cast and applied floral and rococo foot with tapering stem and everted bell form cup, *marked underside*

7in. high, 6.2oz

18265

NINE SILVER AND SILVER PLATE ITEMS

Various makers

The group including, a silver Cartier double-clasp lunch box block inscribed 'S.D.C. with deep affection'; a Sheffield silver plated and wood lined cigarette box; an English silver plated three-footed shell form bowl with armorial; an American silver circular footed presentation bowl inscribed 'To/ Lovely Elise of The House of McCloy/ Queen of The Mystic Society of The Memphi/ From The Sublime Ouro/ 1969', 9in. diameter (Total: 9 items)

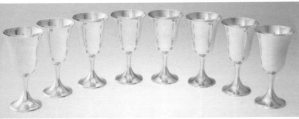

18266

18266

A GROUP OF EIGHT AMERICAN SILVER WATER GOBLETS

Mark of Gorham, Providence, Rhode Island, 20th century

Each goblet marked '272', one with slight bend to base, *marked undersides*

6.5in. high, approximately 49oz gross weight (Total: 8 Items)

18269

A PARCEL GILT AMERICAN SILVER GRANDE BAROQUE PATTERN WATER GOBLET

Mark of Wallace, Wallingford, Connecticut, c.1950

The cast and applied floral and rococo foot with tapering stem and everted bell form cup, *marked underside*

7in. high, 6.6oz

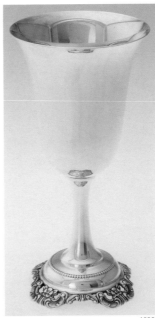

18269

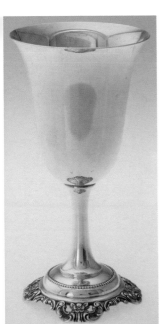

18267

18267

A PARCEL GILT AMERICAN SILVER GRANDE BAROQUE PATTERN WATER GOBLET

Mark of Wallace, Wallingford, Connecticut, c.1950

The cast and applied floral and rococo foot with tapering stem and everted bell form cup, *marked underside*

7in. high, 6oz 63

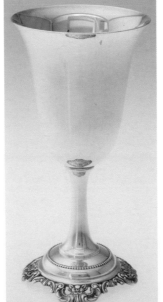

18270

18270

A PARCEL GILT AMERICAN SILVER GRANDE BAROQUE PATTERN WATER GOBLET

Mark of Wallace, Wallingford, Connecticut, c.1950

The cast and applied floral and rococo foot with tapering stem and everted bell form cup, *marked underside*

7in. high, 6.2oz

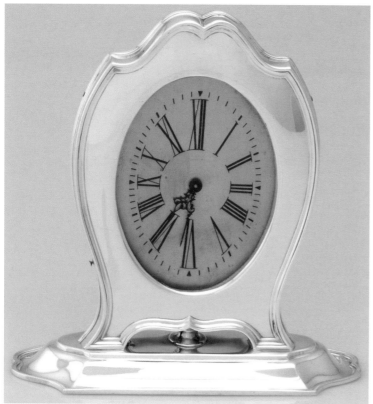

18271

AN AMERICAN SILVER HEPPLEWHITE PATTERN CLOCK

Mark of Reed & Barton, Taunton, Massachusetts, c.1920

Hepplewhite form, an oval dial with Roman numerals and minute markers, movement fitted to a wood insert, marked Waltham, *marked underside*

8.5in. high

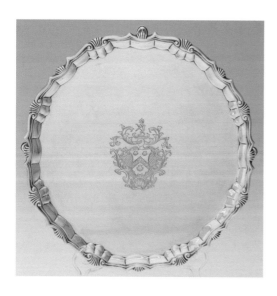

18272

AN AMERICAN SILVER FEDERAL STYLE SALVER

Mark of S. Kirk & Son Co., Baltimore, Maryland, c.1900

The footed circular salver with applied shell and scroll decoration engraved with an elaborate armorial, monogrammed under the base 'Mar. 20, 1919,' *marked underside*

10.9in. diameter, 24.3oz

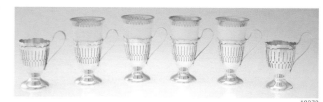

18273

A GROUP OF DEMITASSE CUPS IN THE DELORES PATTERN

Mark of Shreve & Co., San Francisco, California, c.1920

Each with reticulated sides, hammered and applied rims and spreading round feet, four with porcelain inserts, *marked undersides*

3.7in. high with insert (Total: 10 Items)

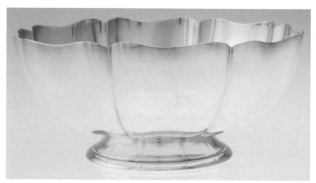

18274

AN AMERICAN SILVER COLONIAL REVIVAL BOWL

Mark of Gorham, Providence, Rhode Island, c.1928

The lobed body with undulating rim, round pedestal base, script 'SSG' monogram, pattern name under base 'Standish', *marked underside*

8in. diameter, 3.4in. high, 14.7oz

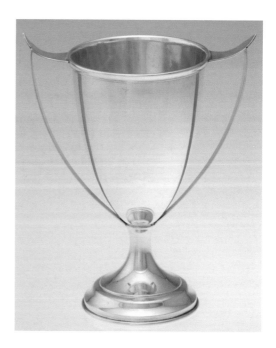

18275

AN AMERICAN SILVER TWO-HANDLED LOVING CUP

Maker unknown, c.1910

The body of tapering cylindrical form, round spreading foot, handles attached at lip and join, makers mark NS overlapping, *marked underside*

10in. high, 20.3oz

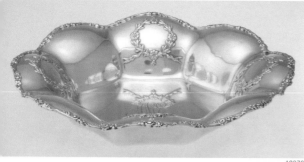

18276

AN AMERICAN SILVER FLORAL BOWL

Mark of Udall & Ballou, c.1900

The eight paneled bowl with applied floral rim and floral garlands, period script monogram in center 'AME', *marked underside*

9.2in. across, 9.3oz

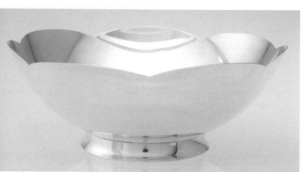

18277

AN AMERICAN SILVER FLORA FORM BOWL

Mark of Tiffany & Co., New York, c.1960

The bowl a large stylized flower, set upon a round pedestal base, *marked underside*

7.5in. across, 2.6in. high, 12.7oz

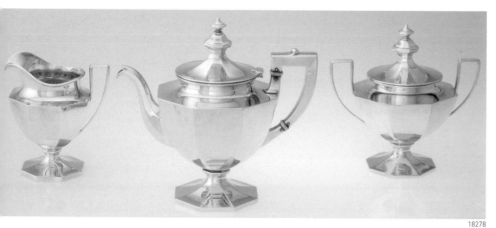

18278

A THREE PIECE AMERICAN SILVER OCTAGONAL TEA SERVICE

Mark of Gorham, Providence, Rhode Island, c.1910

Parcel gilt, octagonal shape, urn shaped finials and ivory insulators, a period Old English 'G' monogram, *marked undersides*

5in. high the tea pot, 41.5oz gross weight

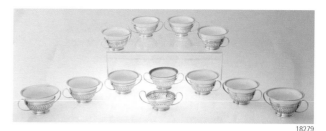

18279

A GROUP OF TWELVE AMERICAN SHERBERTS AND PORCELAIN INSERTS

Mark of Gorham, Providence, Rhode Island, c.1920

Ten with Lenox inserts, one with Limoges insert and one missing insert, *marked on edge of base*

2.1in. high

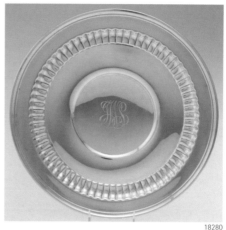

18280

AN AMERICAN SILVER FLUTED CAKE STAND

Mark of Gorham, Providence, Rhode Island, 20th century

A cast and applied stepped rim, fluted inside edge, set upon a round pedestal base, script central monogram 'FWS', *marked underside*

10in. across, 14oz

18281

AN AMERICAN SILVER VASE

Tuttle trademark, made for Shreve Crump & Low

Circular, on circular base, wide flaring rim, the body chased with floral and fluted decoration, *marked underside FRIII for Franklin Roosevelt, hand chased, 950, sterling*

7.75in. high, 8in. wide, 21.35oz.

18282

AN AMERICAN SILVER COVERED SUGAR BOWL

Mark of Gorham, Providence, Rhode Island, 1869

Circular form with two undecorated handles, the body chased with repeating designs centering an armorial on one side and a patterned monogram 'BIS' on the other, the lid similarly decorated with a shaped beaded finial, '10' stamped to lid and bottom of base, '700 B Sterling' stamped under base, *marked underside*

7in. wide, 13.37oz

18283

AN AMERICAN SILVER CHARGER

Mark of Tiffany & Co., New York, c.1950

Of circular form with threaded edge, date marked, *marked on reverse*

10in. diameter, 14.85oz

18284

AN AMERICAN SILVER AND ENAMELED
NAPOLEON PATTERN CHOCOLATE POT

Mark of Shiebler, New York, c.1895

Of tapering cylindrical form with hinged lid and finial, the body with a two-color enameled laurel wreath with bow and engraved script monogram 'LCK', the right angle ebony handle with chased end cap, gold wash interior, also script monogram under base '1895', *marked underside*

7.5in. high, 11.28oz

18285

AN AMERICAN SILVER
TROMPE L'ŒIL TEA SET

Mark of Tiffany & Co., New York, 20th century

Barrel shaped with threaded bands, the handle of ebony wood, acorn finial, *marked undersides*

9in. high, the teapot, 38.7oz gross weight (Total: 3 Items)

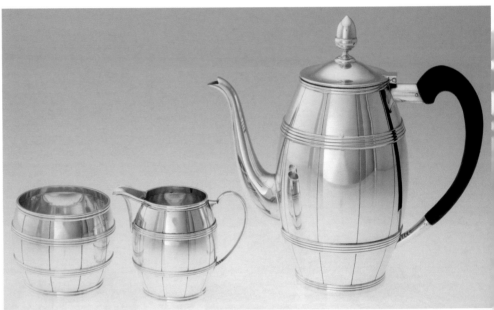

18285

18286

AN ENGLISH SILVER TWO-HANDLED
GADROON EDGE TEA SERVICE TRAY

Mark of A.E. Poston & Co. Ltd, London, England, 20th century

The large rectangle Georgian style tray with heavy applied gadroon, acanthus leaf and rococo rim, heavy cast handles, in superb condition, *marked underside*

26.5in handle to handle, 18in. wide, 126oz

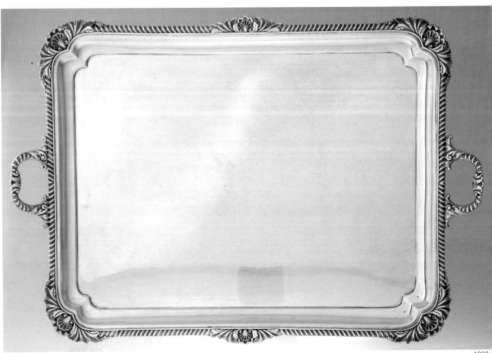

1828

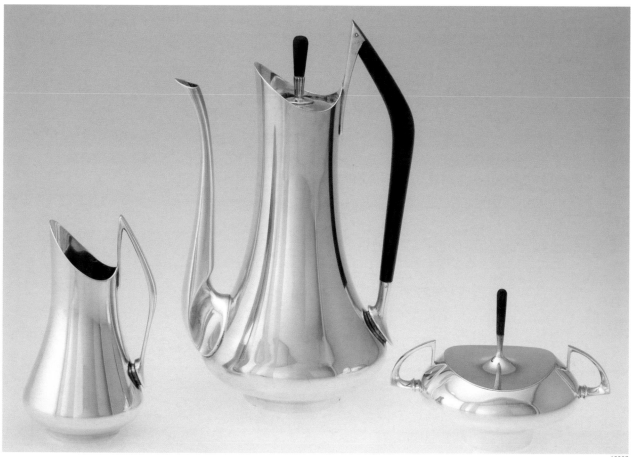

18287

**AN AMERICAN SILVER DONALD COLFLESH
DESIGN COFFEE SERVICE**

Mark of Gorham, Providence, Rhode Island, c.1960

The Donald Colflesh design Gorham coffee service the apotheosis of Modernist style, the use of obtuse and acute angles in this service epitomize the era of cutting edge space age design in the 1950's, ebony wood handles and finials, *marked undersides*

11.7in high, the coffee pot, 59oz gross weight (Total: 3 Items)

18288

A FRENCH ART DECO MIXED METAL VASE

Mark of Christofle, France, c.1925

The round pedestal base supporting a flaring cylindrical vase, the the interior entirely gilt, the exterior with geometric inlaid silver and brass shapes

18288

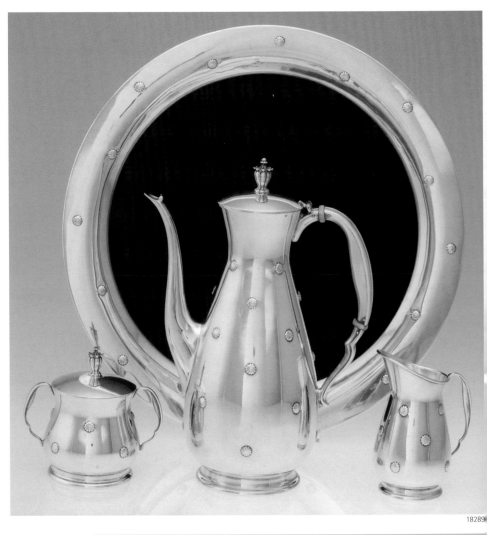

18289
AN AMERICAN SILVER FAR EAST PATTERN COFFEE SERVICE

Mark of Reed & Barton, Taunton, Massachusetts, c.1960

The bodies of each item with raised imperial chrysanthemum design, floral finials and ivory insulators, an Art Moderne tea service, a teapot, creamer, sugar and tray with black plastic base, *marked undersides*

11.2in. high, 36.9 oz gross weight, excluding tray

(Total: 4 Items)

18289

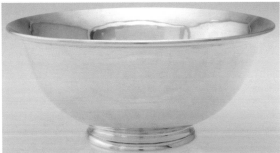

18290

18290
AN AMERICAN ARTS AND CRAFTS MOVEMENT BOWL

Mark of Arthur Stone, Chicago, Illinois, c.1915

An entirely handwrought bowl, round upward flaring shape, applied stepped rim, round pedestal base, with the artists 'G' signature, *marked underside*

8.1in. diameter, 3.5in. high, 18.4oz

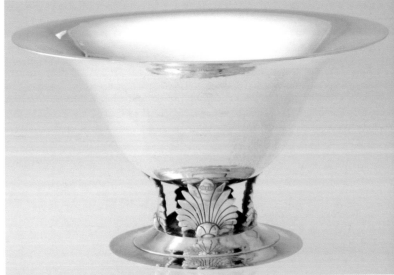

1829

18291
A SILVER ART DECO BOWL BY ERIK MAGNUSSEN

Mark of Erik Magnussen, Germany, c.1930

The round stepped foot leading to four stylized palmette, supporting a round round flaring bowl, produced in Germany prior to the 1920's, this piece an important precursor to the Art Deco movement, entirely handwrought, of large proportions and heavy weight, *marked underside*

6.7in. high, 12in. diameter, 43.5oz

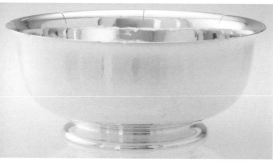

18292

AN AMERICAN SILVER ARTS AND CRAFTS BOWL

Mark of Porter Blanchard, Calabasas, California, c.1925

A round flaring bowl set upon a round pedestal foot, the rim with delicate lobes and interior lines, the entire surface with hand hammer marks, a three letter script monogram engraved on one side, *marked underside*

8.7in. diameter, 3.6in. high, 20.5oz

18292

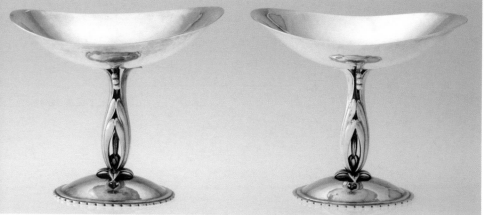

18293

A PAIR OF AMERICAN SILVER ARTS AND CRAFTS DANISH MODERN STYLE COMPOTES

Mark of Cellini Craft, Chicago, Illinois, c.1920

Each on an oval scallop edge domed foot with a stylized double-leaf form pedestal supporting a slightly flared delicately hand hammered oval bowl, *marked underside*

each approximately 5.75in. high, 6.8in. wide, 25.5oz gross weight (Total: 2 Items)

18293

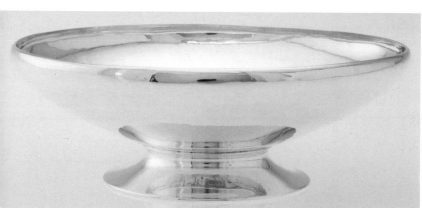

18294

AN AMERICAN SILVER ARTS AND CRAFTS BOWL

Mark of Topssen, location unknown, c.1907

A handwrought American silver bowl set upon a round pedestal base with evidence of hammer marks throughout, stamped 1907 on base, *marked underside*

5.9in. diameter, 2in. high, 8.1oz

18294

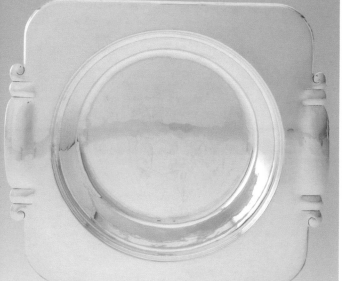

18295

AN AMERICAN SILVER PLATE ARTS AND CRAFTS BOWL

Mark of Dirk Van Erp, San Francisco, California, c.1940

An entirely handwrought and silver plated bowl by William Van Erp with the windmill mark of the shop his father founded, Dirk Van Erp was a premier art metal shop during the early 20th century, *marked underside*

15in. across, 13.2in. wide

18295

18296

AN AMERICAN SILVER ARTS
AND CRAFTS BOWL

Mark of Arthur Stone, Gardner, Massachusetts, c.1915

The round flaring body set upon a round
pedestal base, applied upper rim and threaded
foot decoration, marked 'C' for the actual maker
in the Stone factory, monogrammed in the 18th
century style of three letters with star, 'PMF,'
marked underside

7.2in. diameter, 3.1in. high, 14oz

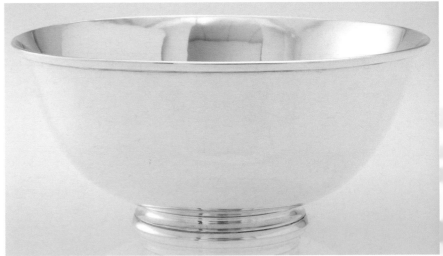

18296

18297

AN AMERICAN SILVER FOURTEENTH
CENTURY PATTERN BOWL

Mark of Shreve & co., San Francisco, California, c.1915

The six lobed bowl with hammered and riveted
strapwork, excellent original condition, an old
English 'B' monogram in the center, *marked
underside*

10.5in. across

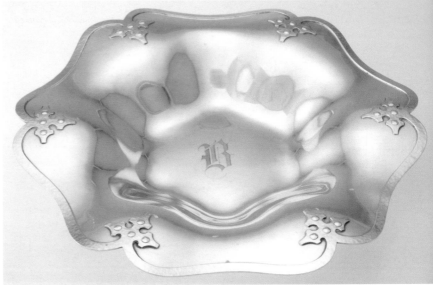

18297

18298

A PAIR OF AMERICAN SILVER GOLDEN GATE BRIDGE VASES

Mark of Shreve & Co., San Francisco, California, c.1939

Each with round spreading feet, trumpet shape with ruffled rim and
a cast and applied fourteen karat gold depiction of the Golden Gate
Bridge, these likely made for the official opening ceremony or for sale
at Shreve at the Golden Gate Exposition, *marked undersides*

7.7in. high, 16oz gross weight

See Heritage Galleries sale #600 lot 18042 for matching pitcher (Total: 2 Items)

18298

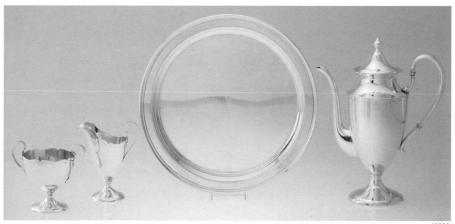

18299

18300

18299
AN AMERICAN SILVER ARTS AND CRAFTS DOLORES PATTERN COFFEE SET
Mark of Shreve & Co., San Francisco, California, c.1910

The baluster formed bodies mounted with hammered and applied decorative rims, period applied 'PC' monograms, engraved under base of coffee pot 'From Mr. & Mrs. Ferris, February 23rd, 1910', *marked undersides*

11in. high, 23.7oz gross weight

(Total: 4 Items)

18300
AN AMERICAN COPPER ARTS & CRAFTS BOWL
Mark of Falick Novick, Chicago, Illinois, c.1910

The graduating circular form with inward curved rim and hand hammered finish, Novick worked in the Kalo Shop until 1920, *marked underside*

6.25in. across

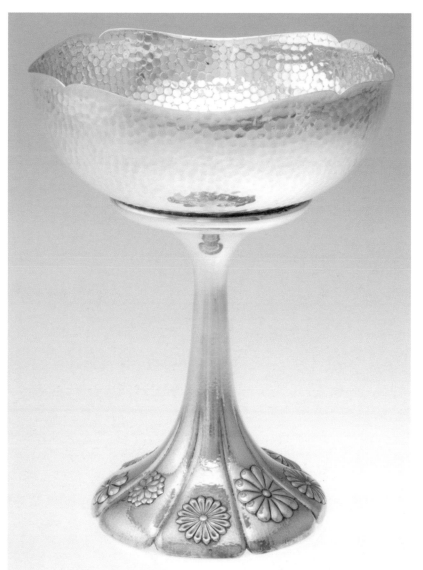

18301
AN AMERICAN SILVER ARTS AND CRAFTS BOWL ON PEDESTAL
Mark of Shreve & Co., San Francisco, California, c.1905

Entirely covered with hammer marks with flaring, undulated rim, lobed floral form base decorated with stylized blossoms set in an irregular pattern, pedestal base tapers and then flares into an exaggerated support for the bowl, *marked underside*

8.5in. diameter, 11in. high, 36.2oz

18301

Visit HeritageGalleries.com to view scalable images and bid online.

Session One, Auction #608 • Saturday, October 30, 2004 • 10:00 a.m.

79

18302

AN AMERICAN SILVER ATHENIC BOWL AND UNDERPLATE

Mark of Gorham, Providence, Rhode Island, c.1900

With deeply chased art nouveau floral designs, the bowl with a period script 'FMR' monogram, each piece marked Athenic, *marked undersides*

7.2in. across, the underplate, 14oz gross weight

(Total: 2 Items)

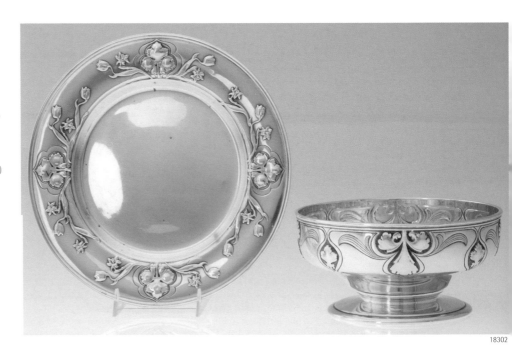

18302

18303

18303

AN AMERICAN SILVER OVERLAY SCOTCH BOTTLE

Mark of Mathews Co., Newark, New Jersey c.1915

Art nouveau style overlay in the form of wheat or barley, stalks twist upwards toward the silver overlay cork stopper, bottle neck engraved 'Scotch', cartouche of bottle engraved with an Old English style 'R', *marked on edge of base*

12.5in. high

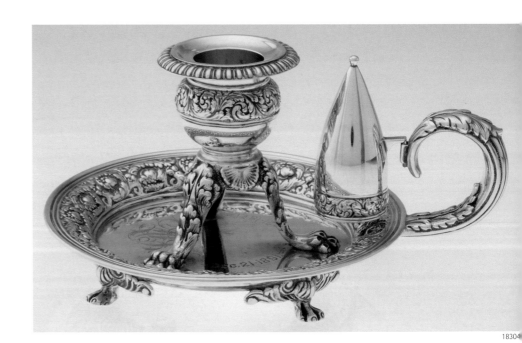

18304

18304

AN AMERICAN SILVER TIFFANY CHAMBERSTICK

Mark of Tiffany & Co., New York, c.1891

The round repousse base supported by four lion paw feet, the nozzle rests upon three acanthus leaf and lion paw feet, a removable gadrooned bobeche and snuffer, engraved on base 'MLS' 'Dec. 21 1871' 'Dec. 21 1891', *marked underside*

3.2in. high, 9.5oz

18305
AN AMERICAN SILVER VICTORIAN BOWL
Mark of Shiebler, New York, c.1890

The round body with an applied floral reticulated rim, a ribbon script monogram, "A.C.C.", *marked under base*
10.in. across, 2.5in. high, 18.7oz

18306
AN AMERICAN SILVER ENTREE DISH
Mark of Durgin, Concord, New Hampshire, c.1900

Ovoid shape with cast and applied floral rococo border, period script monogram, *marked underside*
13.5in. across; 16.2oz

18306

18307
A PAIR OF AMERICAN SILVER CANNS
Mark of S.Kirk & Son Co., Baltimore, Maryland, c.1900

Colonial American reproductions, of baluster form on round spreading foot, c-scroll handle with acanthus leaf thumb rest, elaborate foliate script monogram, extremely heavy and in superb condition, *marked undersides*
5.2in high, 31.5oz gross weight (Total: 2 Items)

18307

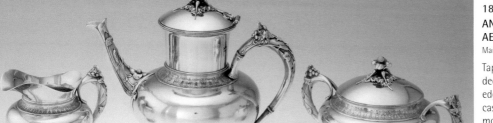

18308
AN AMERICAN SILVER AESTHETIC TEA SERVICE
Mark of Gorham, Providence, Rhode Island, c.1875

Tapering bulbous bodies with die rolled decorative bands surmounted by beaded edges, cast floral spout and handles, cast floral finials removable for cleaning, monogrammed 'Bell', *marked underside*
8in. high, the teapot, 55.4oz

18308

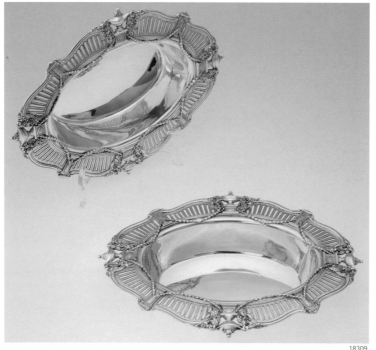

18309

18309
A PAIR OF AMERICAN SILVER ADAMS STYLE
RETICULATED ENTREE DISHES
Mark of Shreve & Co., San Francisco, California, c.1900

Early Shreve 'Bell' mark, cast and applied Adams style reticulated edges on
each dish, urns, roses, and garlands with an undulating gallery, excellent
condition, *marked undersides*
12.4in. across, 1.7in. high, 40.9oz gross weight (Total: 2 Items)

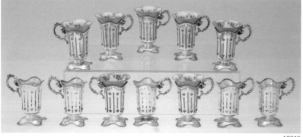

18310

18310
AN UNUSUAL MATCHED SET OF 12 AMERICAN
SILVER DEMITASSE CUPS
Mark of Mauser, New York, c.1890

Twelve matching, reticulated, beaded-edge cups, seven Limoges inserts with
floral accents, one insert with the Mauser trademark on the base, these
unusually slender and tall, *marked undersides*
4in. high (Total: 12 Items)

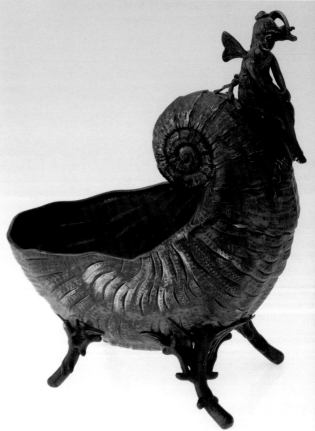

18311

18311
AN AMERICAN SILVER PLATE AESTHETIC BOWL
Mark of Middletown Plate Co., Middletown, Connecticut, c.1890

A large Nautilus shell with an exaggerated opening, set upon four stylized
coral feet, the shell surmounted by a cast and applied fairy resting upon
crescent moon, *marked underside*
11.2in. high, 10in. across

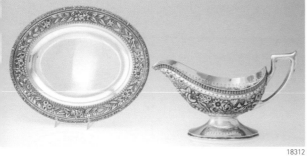

18312
AN AMERICAN SILVER PLATE SAUCE BOAT AND UNDERPLATE
Mark of Tiffany & Co., New York, c.1900

Floral repousse work throughout, chased, lobed decoration just below the papyrus die rolled edge, extensively hand-worked, marked 'silver-soldered' and 'Tiffany & Co. makers', *marked undersides*

10in. across, the underplate, 5.5in. high, the sauce boat (Total: 2 Items)

18312

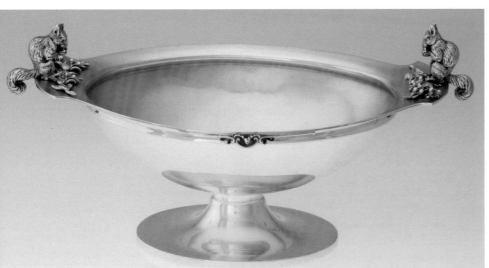

18313
AN AMERICAN SILVER FIGURAL NUT BOWL
Mark of Gorham, Providence, Rhode Island, c.1870

A parcel gilt oval bowl with flaring rims, set upon an oval pedestal foot, the interior matte finished with a cast and applied squirrel feasting on nuts at opposite ends, squirrels removable for cleaning, *marked underside*

12.5in. across, 6.2in. high, 17.5oz

18313

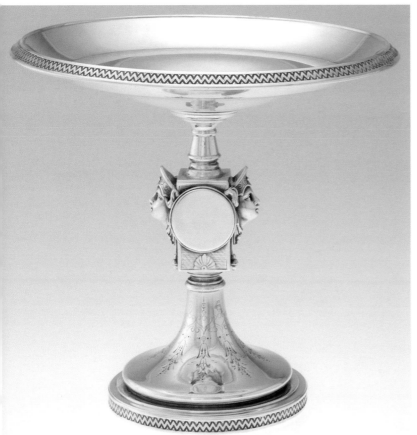

18314
AN AMERICAN SILVER NEOCLASSICAL TAZZA
Mark of Ball Black & Co., New York, c.1875

The round stepped foot with die rolled decorated rim, tapered stem with bright cut engraving, a pair of cast high relief, crowned female busts with flowing hair, removable bowl with matching die rolled decorated rim, *marked underside*

8.25in. high, 8.75in diameter 22.2oz

18314

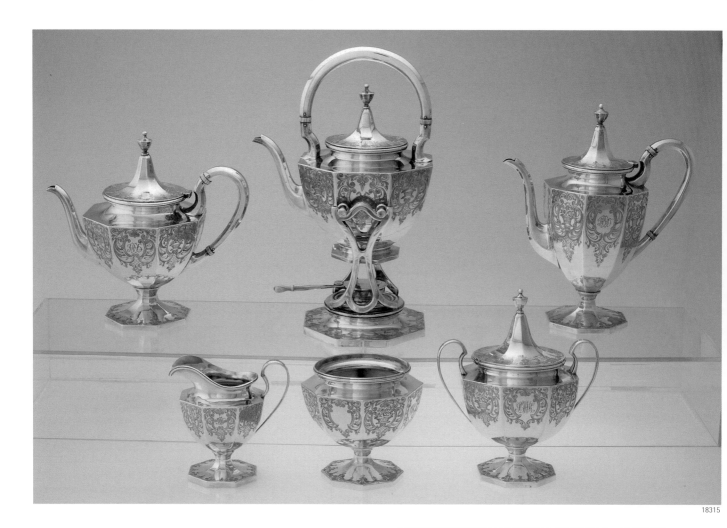

18315

18316

18315

AN AMERICAN SILVER SIX PIECE TEA SERVICE

Mark of Peter Krider, Philadelphia, c.1900

Of octagonal tapering form, elaborately engraved with rococo and 'basket of flowers' motif, including a hot water kettle with original burner, tea pot, coffee pot, creamer, sugar and waste bowl, each with period script 'JGWK monogram set in rococo cartouche, marked P.L. Krider & Co., *marked undersides*

13.5in. high, the hot water kettle, 10in. high the coffee pot, 140.5oz gross weight (Total: 6 Items)

18316

AN AMERICAN SILVER ART NOUVEAU BEER MUG

Mark of Whiting, Providence, Rhode Island, c.1895

Body of tapering cylindrical shape, the handle, organic form with chased swirls, a rolled undulating lip and a period engraving 'PEG September 1894', *marked under base*

5.7in. high, 15.1oz, 2 pint capacity

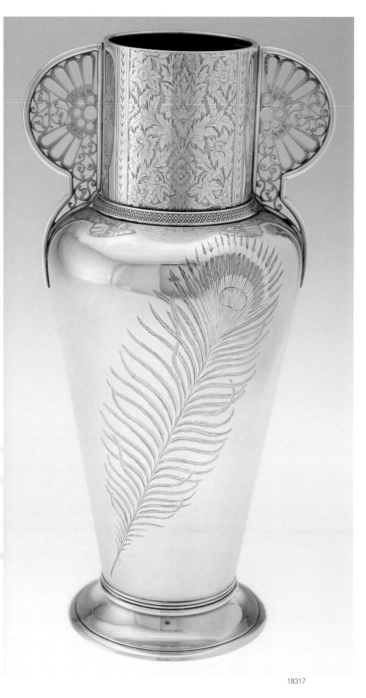

18317

18317
AN AMERICAN SILVER AESTHETIC MOVEMENT VASE
Mark of Gorham, Providence, Rhode Island, c.1875

The tapering body set upon a round spreading foot, hand-cut latticework applied to the sides of the neck, one side the neck with floral engraving, the body engraved with a large butterfly and peacock feather, *marked underside*
9in. high, 12.3oz

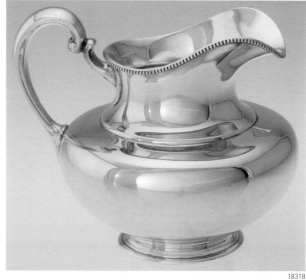

18318

18318
AN AMERICAN SILVER BEAD-EDGE PATTERN WATER PITCHER
Mark of Durgin, Concord, New Hampshire, c.1893

Of squat baluster form on circular foot with C-form scroll handle, script monogram, *marked underside*
6.75in. high, 12.79oz

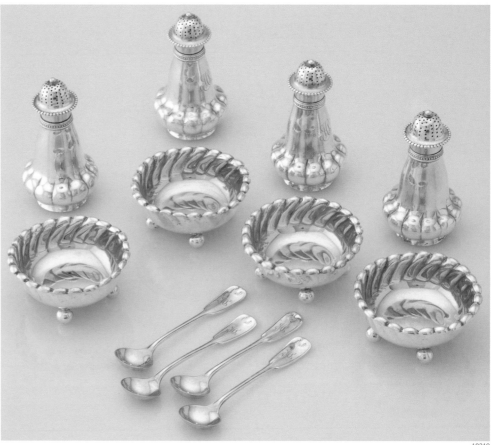

18319

**A MATCHING SET OF FOUR OPEN
SALTS, SPOONS AND PEPPER CASTERS**

Mark of Tiffany & Co., New York, c.1905

Each with a period script 'MS' monogram,
date marks of 'T' and 'C', salts and salt spoons
with gilt bowls, superb original condition,
the spoons in the Palm pattern, *marked
undersides*

3.4in. high, the casters, 13.9oz gross weight

(Total: 12 Items)

18319

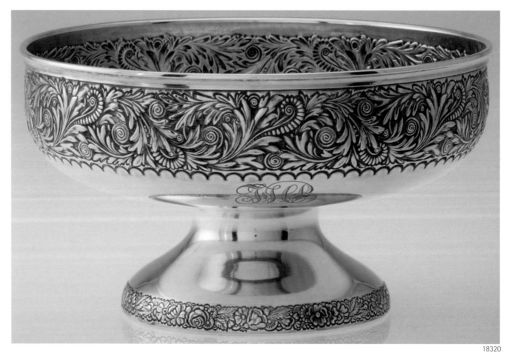

18320

18320

AN AMERICAN SILVER ST. CLOUD PATTERN PEDESTAL BOWL

Mark of Gorham, Providence, Rhode Island, c.1887

The domed circular foot with a band of hand chased flowers, tapering pedestal supporting a deep round bowl with
a band of St. Cloud pattern (introduced 1885 in flatware) spirals and leafy sprays, rolled edge rim, 1887 date mark,
script monogram 'FHB', *marked underside*

4.75in. high, 8.3in. diameter; 17.6oz

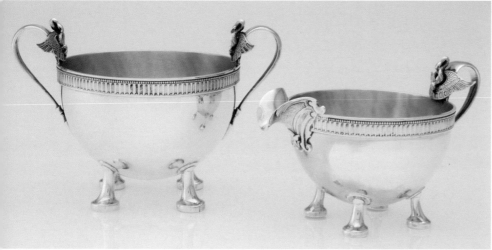

18321

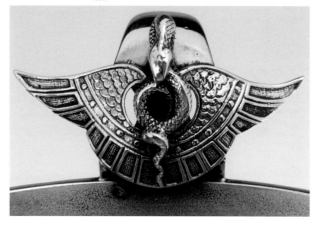

18321

A LARGE AMERICAN SILVER ISIS PATTERN CREAMER AND SUGAR

Mark of Gorham, Providence, Rhode Island, c.1872

The cast spout with ivy leaf decoration, each round body on four hollow feet, handles with cast spread wings and coiled snake, date mark 'E' for 1872, *marked undersides*

4in. high at handle of sugar bowl (Total: 2 Items)

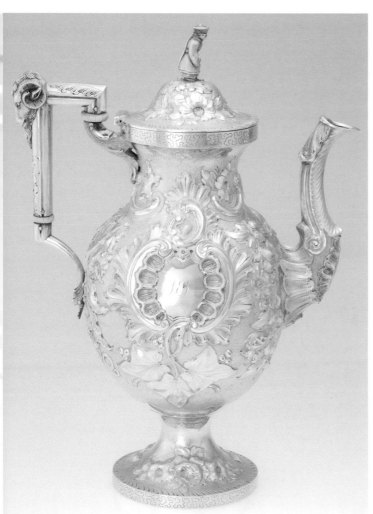

18322

AN AMERICAN COIN SILVER CHINOISERIE COFFEE POT

Mark of R&W Wilson, Philadelphia, Pennsylvania, c.1850

Of baluster form on a round pedestal base, chased, repousse design set upon a heavy matte finish, the cast spout with deeply raised ornament, handle with rams head and acanthus leaf mounts, the hinged lid with a Chinoiserie figure carrying a water pail, *marked underside*

13in high, 35.3oz

18322

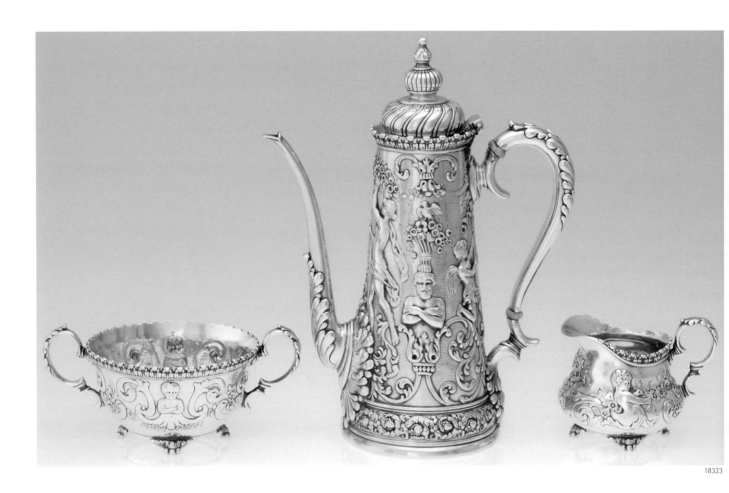

18323

A RENAISSANCE REVIVAL AMERICAN SILVER BLACK COFFEE SET

Mark of Tiffany & Co., New York, c.1880

The bodies entirely chased and repousse with nude women, deities, angels, birds, flower baskets and garlands, the spouts and handles with acanthus leaf thumb rests, creamer and sugar with lion paw feet, die rolled acanthus leaf rims on each, the spout also adorned with an acanthus leaf, a torch finial, creamer with gold washed interior, this service would compliment any Olympian pattern flatware set well, *marked undersides*

9.3in. high, the coffee pot, 32.3oz

Literature: An identical pot pictured on page 66 of *Collecting American 19th Century Silver* by Katherine Morris McClinton

(Total: 3 Items)

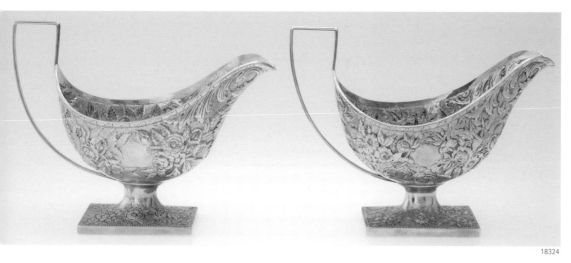

18324

18324

A PAIR OF AMERICAN SILVER REPOUSSE SAUCE BOATS

Mark of S.Kirk & Son, Baltimore, Maryland, c.1860

Each on rectangular spreading feet with square tapering handles, the bodies entirely repousse with blank open cartouche, original soft grey finish, 11 OZ mark, *marked undersides*

6in. top of handle, 16oz gross weight (Total: 2 Items)

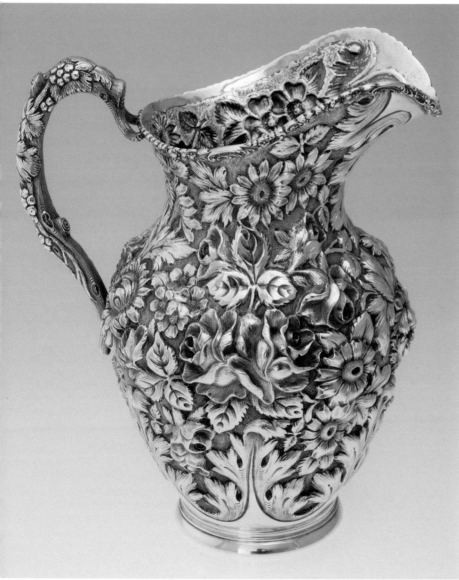

18325

18325

AN AMERICAN SILVER BALTIMORE ROSE PATTERN WATER PITCHER

Mark of Stieff, Baltimore, Maryland, 20th century

The body with high relief repousse decoration, an applied floral rim, cast grape, vine and leaf handle, upswept acanthus leaves from base to mid-body, *marked underside*

10in. high, 31.9oz

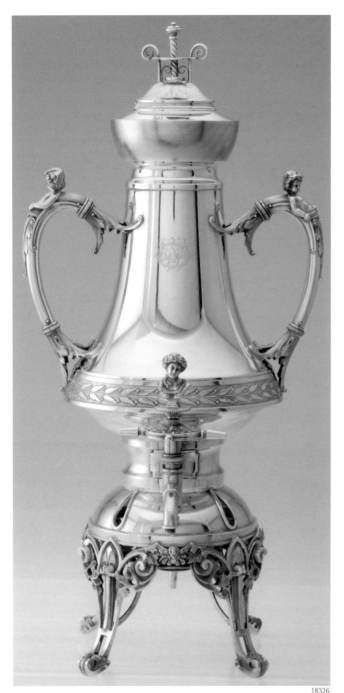

18326

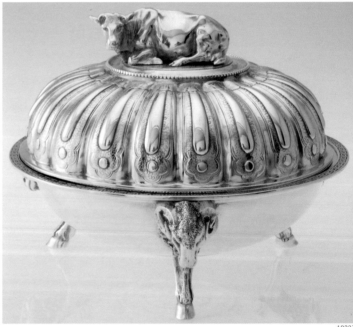

18327

18326

A MONUMENTAL AMERICAN SILVER NEOCLASSICAL HOT WATER URN

Mark of Wood & Hughes, New York, c.1870

Heavy cast rococo four footed base, the chased matte finished spicket surmounted by the neoclassical bust of a woman, the bell form body with die-rolled laurel wreath border at base, and a double dome top with twisted and knopped finial, two buttressed handles with acanthus leaf joins and classical form putti, with burner, period monogram on front and back of body, *marked on burner base and underside*

20.5in.; 82oz

18327

AN AMERICAN SILVER FIGURAL COVERED BUTTER DISH

Mark of Tiffany & Co., New York, c.1870

The cast and applied cow resting upon a patch of grass, the cover heavily fluted with stippled surfaces, an applied Greek key border on the plain base, three rams hoof and head feet, mark of Edward Moore and Tiffany & Co., excellent condition, heavy weight, original surfaces, *marked underside*

5in. high, 6.3in. diameter, 25.9oz

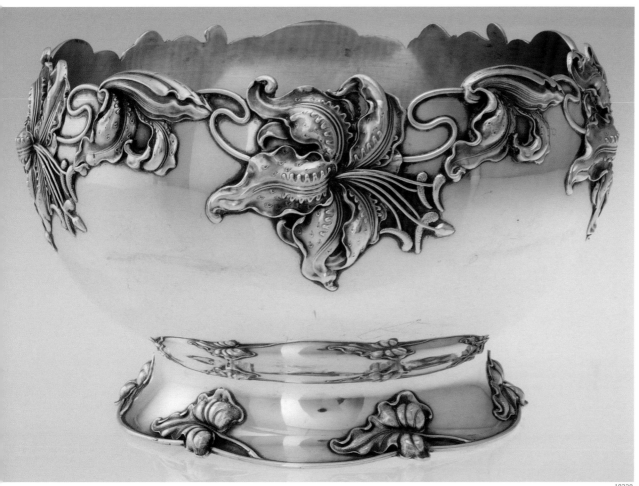

18328

AN AMERICAN SILVER ART NOUVEAU LILY BOWL

Mark of Shreve & Co., San Francisco, California, c.1900

A large round bowl with a spreading foot, undulating rims, the body decorated with cast and applied lilies in high relief, dark patina in all of the recessed areas, very original condition, with the high rim and large capacity, this would make an excellent soup tureen or salad bowl and would match well with Alvin Orange Blossom or Whiting Lily pattern

8.8in. across, 5.5in. high, 29oz

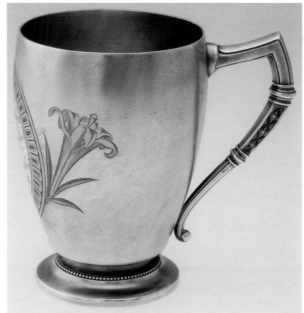

18329

AN AMERICAN AESTHETIC MOVEMENT PARCEL GILT CUP

Mark of Whiting, Providence, Rhode Island, c.1871

The matte finish body decorated with engraved gilt lilies and interior, a large central cartouche reading 'To grandfather and grandmother from James Barlow 1846 Oct. 13 1871', *marked under base*

4in. high, 5oz

Visit HeritageGalleries.com to view scalable images and bid online.

Session One, Auction #608 • Saturday, October 30, 2004 • 10:00 a.m.

91

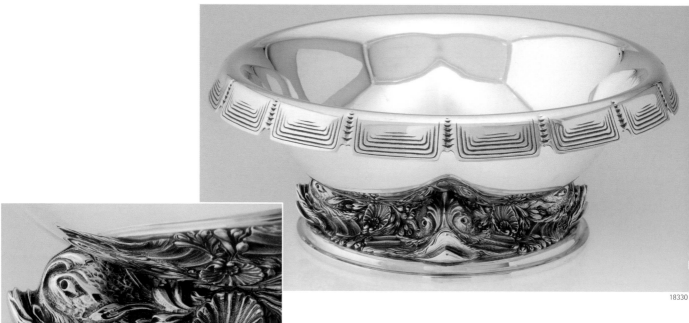

18330

AN AMERICAN SILVER ART NOUVEAU CENTERPIECE

Mark of Black Starr & Frost, New York, c.1900

The four panel bowl with stylized turtle shell lobes, the base with four large neo-classical dolphins, shells and sea life, a very heavy ornamental centerpiece with an art nouveau flair, *marked underside*

12.5in. diameter, 4.7in. high, 61oz

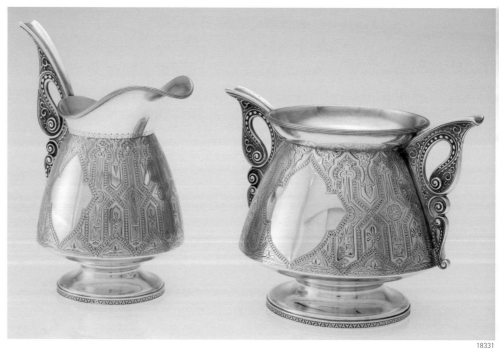

18331

18331

AN AMERICAN SILVER PERSIAN PATTERN CREAMER AND SUGAR

Mark of Tiffany & Co., New York, c.1885

Cast handles, heavily engraved in the Persian taste, original copper colored gold was on the interiors, die rolled edges on the round pedestal bases, period 'HJ' monograms, upper case block 'M' date mark, *marked undersides*

5in. high, the creamer, 13oz gross weight

(Total: 2 Items)

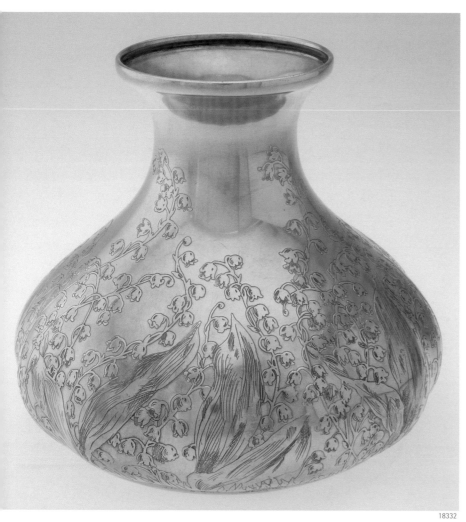

18332
AN AMERICAN STERLING LILY OF THE VALLEY VASE
Mark of Tiffany & Co., New York, c.1905

The lobed squat base tapers as it ascends to an everted thick rolled lip rim, entirely gilt, the body covered with acid-cut-back lilies of the valley, period three letter script monogram under base, art nouveau in form and decoration, *marked underside*
6.5in. high, 7.5in. across at base, 23oz

18332

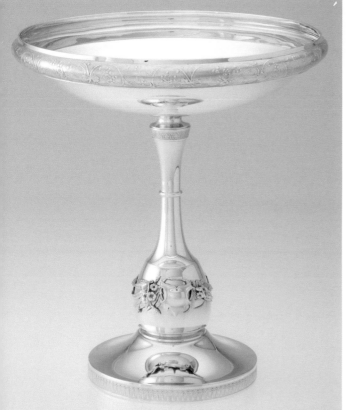

18333
A MONUMENTAL AMERICAN SILVER CENTERPIECE
Mark of Gorham, Providence, Rhode Island, c.1872

The foot with 'rosette and drop' die rolled edge surmounted by a bulbous, tapering cylindrical neck, the detachable bowl with a wide band of flower and berry decoration, cast and applied floral cartouches removable for cleaning, a period 'ML' monogram on the foot, *marked underside*
12.6in. high, 11.5in. wide, 40.8oz

18333

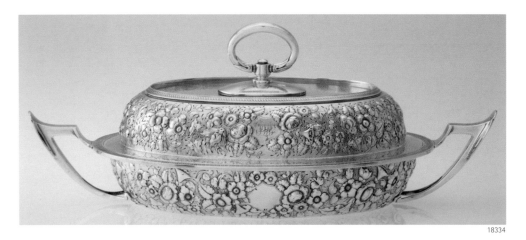

18334

18334
AN AMERICAN SILVER COVERED ENTREE DISH
Mark of Gorham, Providence, Rhode Island, c.1870

The oval body with removable cover and handle, the body repousse with roses and morning glories, plain surfaces have been completely stippled giving a moss-like appearance, Greek revival handles slope outwards giving an exaggerated sense of proportion, superb original condition and very heavy weight, retailed by Bailey & Co. of Philadelphia, 1869 date mark, *marked underside*

5.8in. high, 15in. across, 43.5oz gross weight

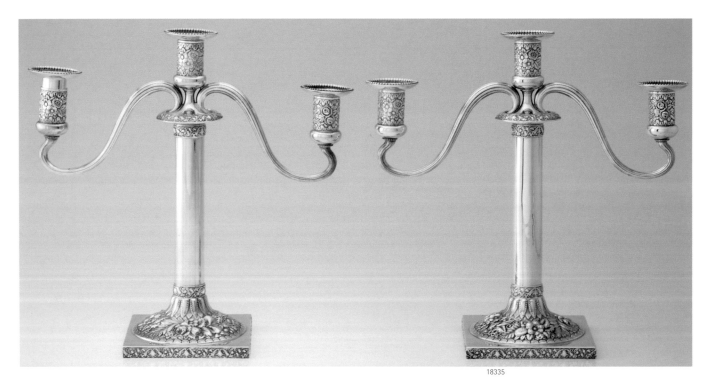

18335

18335
A PAIR OF AMERICAN SILVER FLORAL REPOUSSE THREE BRANCH CANDELABRA
Tiffany & Co., New York, c.1895

Each on square form base with die-rolled cornucopia border, floral repousse domed foot leading to a cylindrical stem, each beaded edge bobeche removable, the sticks convertable to single candlestick, date marked 'T', *marked undersides*

12in. high, 12.7in. across; 46.7oz gross weight

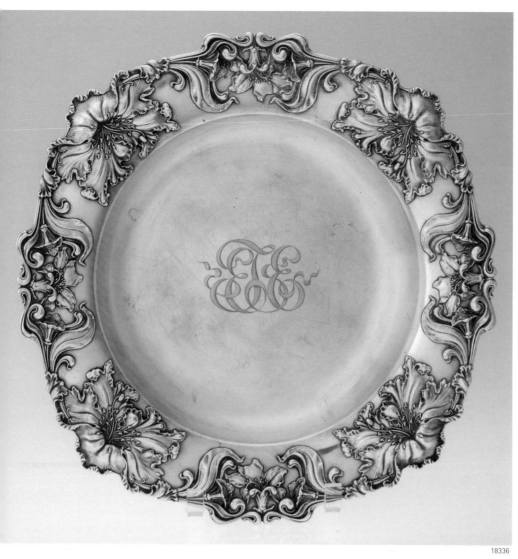

18336

**AN AMERICAN SILVER
MONUMENTAL ART NOUVEAU BOWL**

Mark of Shiebler, New York, c.1900

The edge decorated with a wide band
of art nouveau lilies, almost certainly an
accessory to the popular Flora pattern
by the same company, a period 'ribbon
script' monogram in the center 'EFE',
one of the largest and visually stunning
pieces of Shiebler holloware we have
ever seen, *marked underside*

14.5in. diameter, 32.8oz

18337

**AN AMERICAN SILVER
MIXED METAL BOWL
AND UNDERPLATE**

Mark of Tiffany & Co., New York, c.1877

Japanese style inlaid copper
and gold decoration includes a
stalk of wheat, two butterflies, a
dragonfly, an iris, and calla lily,
the hammered finish in a large
honeycomb pattern, each with
a rolled rim, elaborate hallmarks
including 'sterling silver and
other metals', 'patent applied
for' and '540' the hammering
and mounting design, the date
letter an upper case 'M' and the
pattern number corresponds
with the date 1877, *marked
undersides*

7.1in. across the underplate, 2.9in. high
the bowl, 14.2oz gross weight
(Total: 2 Items)

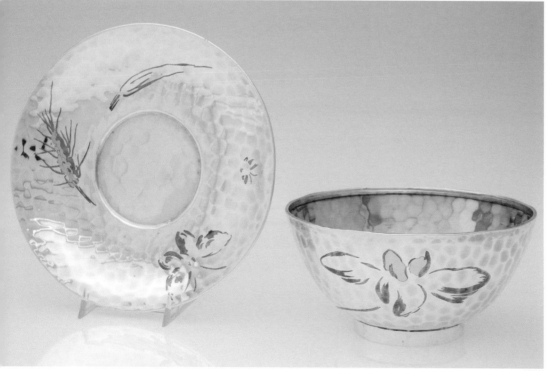

18338

AN AMERICAN SILVER AESTHETIC MOVEMENT PITCHER WITH GOBLETS

Mark of Whiting, Providence, Rhode Island, c.1875

The parcel gilt pitcher with round body with slender neck and flaring lip, round pedestal foot, the handle with water lilies at join, the body with a matte finish, a large Greek style cartouche surrounded by delicately engraved flowers, leaves and vines, a pair of matching goblets, all with the name 'Clay' engraved within the cartouche, retailed by F.D. Barnum Co., *marked undersides*

11in. high, the pitcher, 7in. high the goblets, 30.1oz gross weight
(Total: 3 Items)

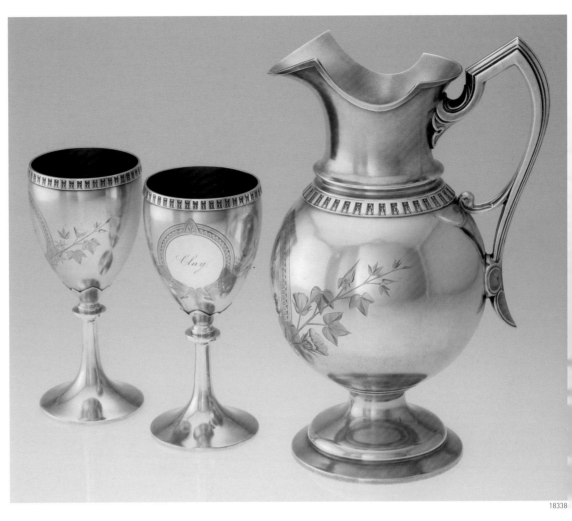

18338

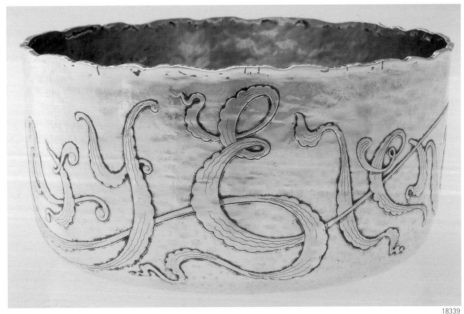

18339

18339

AN AMERICAN SILVER HANDWROUGHT AESTHETIC STYLE BOWL

Mark of Dominick & Haff, New York, c.1884

Retailed by Tiffany & Co., entirely hand hammered with acid etched dedication 'Mary Elena', ruffled edge and 1884 D&H datemark, *marked underside*

4.8in. diameter, 6.7oz

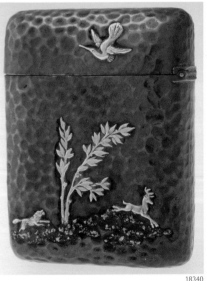

18340

18340

AN AMERICAN MIXED METAL JAPANESE STYLE CHEROOT CASE

Mark of Gorham, Providence, Rhode Island, c.1880

The hammered and red patina case with applied silver hummingbird, wolf, elk, butterfly, bird of prey, butterfly and foliate decoration, an uncommon cheroot case made for a left handed person, *marked inside cover*

3.2in. high, 2.5in. across

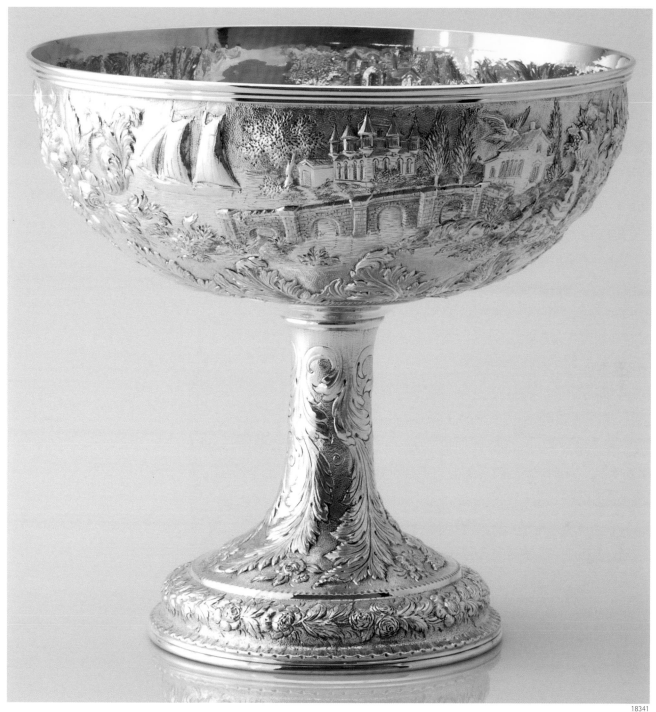

18341

A PARCEL GILT AMERICAN SILVER ARCHITECTURAL REPOUSSE PUNCH BOWL

Mark of S. Kirk & Son, Baltimore, Maryland, c.1885

The domed and threaded circular foot entirely hand chased and repousse with
acanthus leaves swirling up to a tapered stem supporting a large deep bowl chased
and repousse with acanthus leaves, roses, and pastoral architectural scenes, including
a country home with cows feeding from a trough, and a town scene with a stone
bridge and a sailboat with a bird flying between a cathedral and a house, and hounds
chasing a deer, 11.oz standard mark, *marked underside*

10.5in. high, 11.2in. diameter; 39oz

18342

18344

18344

A PAIR OF AMERICAN SILVER TROMPE L`OEIL CREAMER AND SUGAR

Mark of Gorham, Providence, Rhode Island, c.1869

Barrel shaped bodies with cast and applied butterflies atop threaded rings, excellent condition, *marked undersides*

3.9in. high, the creamer, 7.5oz gross weight

18342

AN AMERICAN SILVER AESTHETIC MOVEMENT TRAY

Mark of Gorham, Providence, Rhode Island, 1907

Circular, the hammered surface with applied branch form border, date marked, *marked underside*

10.75in. diameter, 16.3oz

18343

AN AMERICAN SILVER MIXED METAL BOUDOIR LAMP

Mark of William Rogers, Hartford, Connecticut, c.1885

A most unusual form from this manufacturer, in silver, copper and brass, the lamp has been electrified, large cast and applied dragonflies on the shade and base, hammer marks throughout, the lamp shade pierced at the top and swivels on its base, remnants of a cord coming from the base, marked on the top of the base near the stem, pull switch. socket and bulb intact, a very unusual, possibly experimental piece from one of the companies that would eventually form International Silversmiths, *marked above base*

9in. high, 11oz

18343

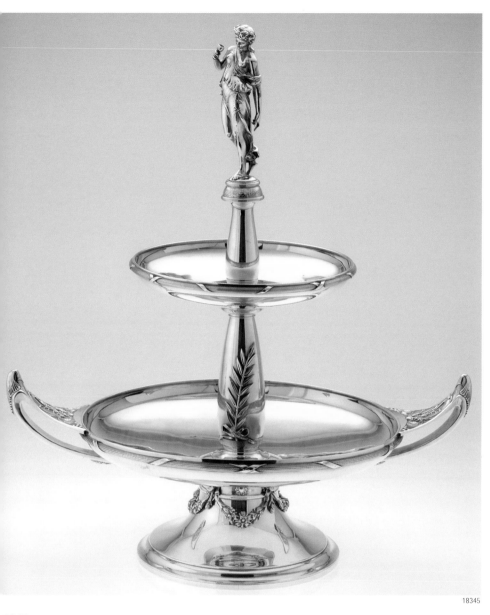

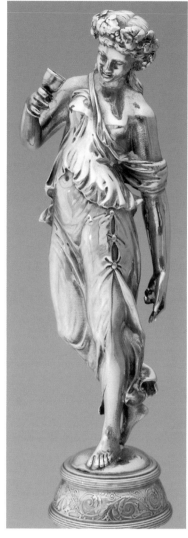

18345

8345

A NEOCLASSICAL FIGURAL AMERICAN SILVER FRUIT STAND

Mark of Gorham, Providence, Rhode Island, 1874

This parcel gilt multi-piece construction fruit stand with a round spreading foot and removable cast garlands, the lower bowl with cast and applied threaded band, heavy cast handles with papyrus decoration, the central column with two applied leafy branches tied with bows at their base, upper bowl with applied threaded band, the upper column with a large partially nude Bacchante holding a wine glass, adorning her head a crown of grapes, leaves and vines, disassembles to approximately eight main pieces for cleaning, this rare monumental centerpiece accompanied by a Gorham archival report prepared by Samuel Hough, *marked various places*

22in. high, 19in. across at the handles, 115oz according to factory records

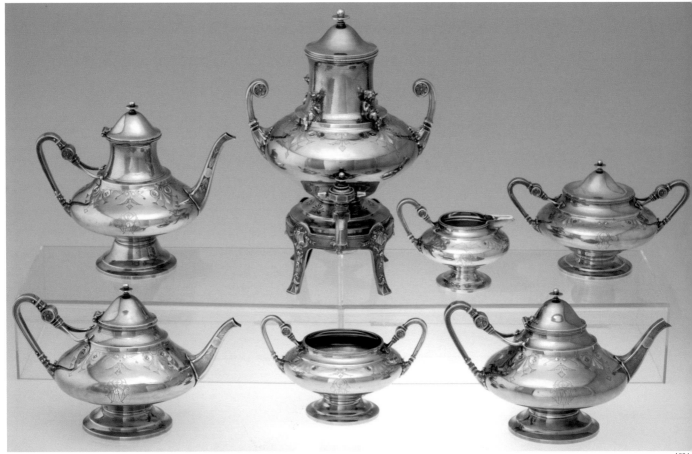

1834

18346

A SEVEN PIECE AMERICAN SILVER EGYPTIAN REVIVAL TEA SERVICE

Mark of Gorham, Providence, Rhode Island, c.1870

The service comprising a hot water kettle, coffee pot, tea pot, chocolate pot, creamer, sugar, waste bowl; of round tapering form, the hot water kettle retains its original burner set upon a reticulated base decorated with raised floral baskets surmounted by four putti, the bodies each chased with Egyptian-style ornament and eggshell decoration around the necks with beaded rims, the heavy handles decorated with rosettes and attached by acanthus mounts, *marked undersides*

14in. high the hot water kettle, 180oz gross weight (Total: 7 Items)

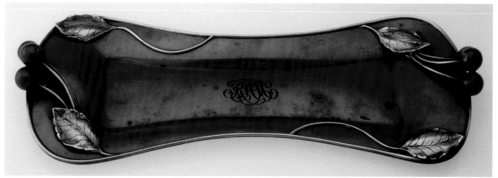

18347

A MIXED METAL JAPANESE STYLE VANITY TRAY

Mark of La Pierre, Newark, New Jersey, 1890

The shaped copper tray with candy apple red patina rimmed with silver, each end with applied silver leaves and three applied copper cherries on silver stems, script monogram in center, *marked underside*

11.2in. across

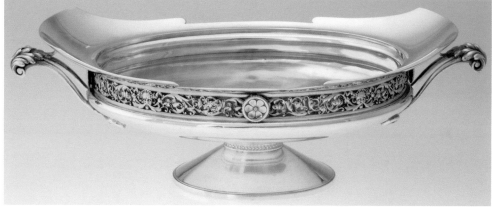

18348

AN AMERICAN SILVER NEOCLASSICAL CENTERPIECE

Mark of Gorham, Providence, Rhode Island, c.1870

An oval shaped two-handled bowl with exaggerated flaring rim supported by an oval pedestal foot, four rosette form nuts secure a parcel gilt reticulated band which encircles the upper perimeter just below the rim, *marked underside*

14in. wide, 30.6oz

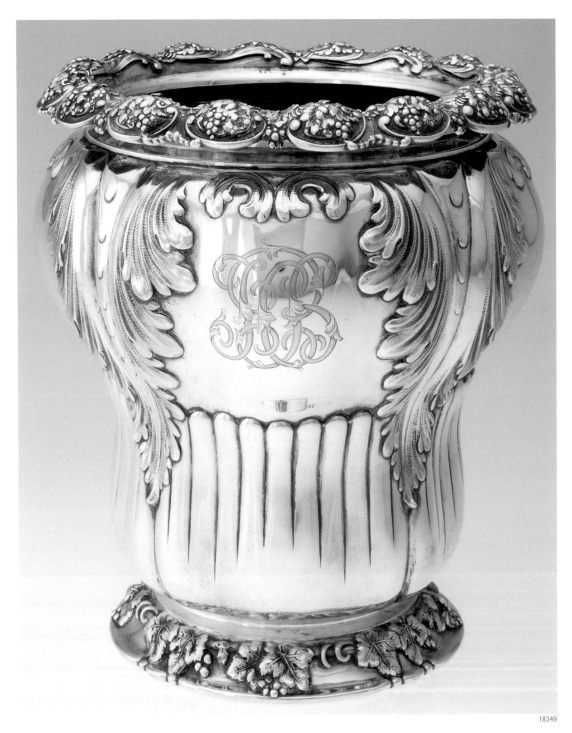

18349

AN IMPORTANT AMERICAN SILVER WINE COOLER

Mark of Tiffany & Co., New York, c.1888

The round pedestal foot decorated with cast and applied grapes, leaves and vines, body with vertical ribs, adorned with large acanthus leaves and a heavy grape motif rim, interior fitted with a sleeve, elaborate script monogram, engraved under base 'April 19th. 1888', this wine cooler featured in Charles and Mary Carpenter's 'Tiffany Silver' book, page 87 of the 1st edition, *marked underside*

9in. high, 60.3oz

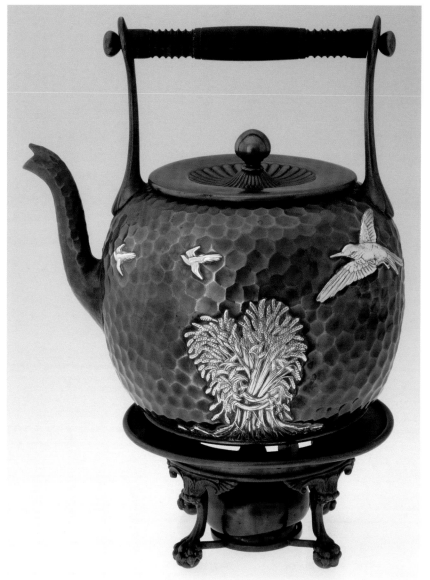

18350

AN AMERICAN MIXED METAL TEA POT ON STAND

Mark of Gorham, Providence, Rhode Island, c.1880

The body entirely hammered, decorated in the Japanese style with cast and applied hummingbird, various birds in flight, large sheaf of wheat, lizard, chinoiserie figure juggling balls and a large pine tree branch with an owl resting upon it, grifid joins connect the supports to a turned wood handled, removable fluted lid, burner and lion paw base, color soft brown and aged, *marked undersides*

10in. high

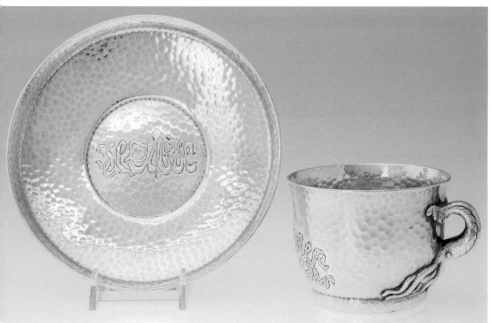

18351

AN AMERICAN SILVER AESTHETIC MOVEMENT CUP AND SAUCER

Mark of Tiffany & Co., New York, c.1890

Surfaces entirely hand hammered, Japanese style, chased and engraved stylized octopus tentacle 'H.E.M.Y.C.' monograms on both pieces, the handle of the cup a handwrought stylized octopus, upper case 'M' date mark, *marked undersides*

2.5in. high, 11oz gross weight (Total: 2 Items)

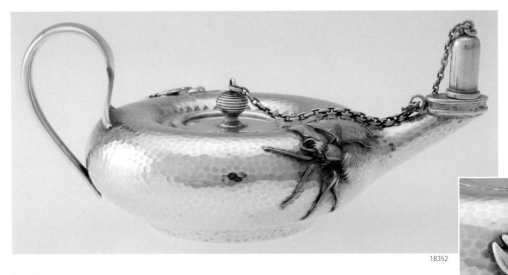

18352

18352

AN AMERICAN SILVER MIXED METAL TABLE LIGHTER

Mark of Gorham, Providence, Rhode Island, c.1885

The body entirely hand hammered, a large cast and applied silver crab, a large cast and applied copper and brass spider, with the original lid and cap, missing wick retainer, excellent condition, marked sterling & other metals, *marked underside*

5in. handle to spout

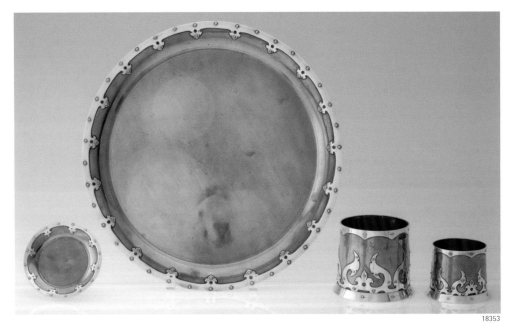

18353

18353

A FOUR PIECE AMERICAN SILVER-APPLIED COPPER MIXED METAL SMOKING SET

Mark of Theodore Starr, New York, c.1900

The group similarly decorated with applied silver strapwork attached to the edges of each copper body with copper rivets, stamped 'sterling silver & other metals,' *each marked undersides*

the tray 13.75in. diameter (Total: 4 Items)

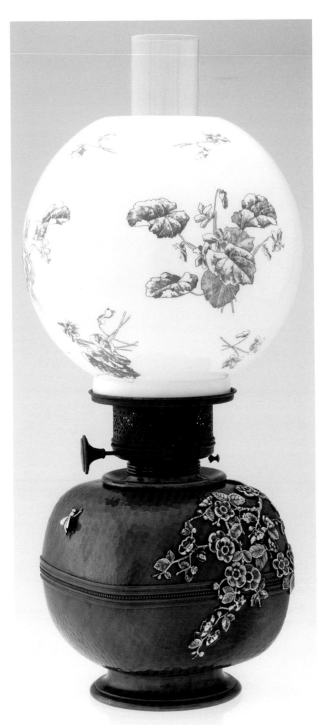

18354

18354

AN AMERICAN AESTHETIC JAPANESE STYLE KEROSENE LAMP

Mark of Gorham, Providence, Rhode Island, c.1880

A rare mixed metal, large size kerosene lamp by Gorham, the original
candy apple red finish over 90% intact, the body entirely hand hammered
with applied silver cherry blossoms, foliage, dung beetle and bee, never
been electrified, the original removable kerosene tank intact, the wick and
mechanism fully functional complete, *marked underside*

18.5in. high with shade, 10.25in. high from base to wick

18355

A PAIR OF AMERICAN SILVER MOUNTED MARBLE CANDLESTICKS

Mark of Towle, Newburyport, Massachusetts, c.1905

Each circular sterling base chased with art nouveau scroll work, decorated with a beaded edge and laurel band, supporting a tall white and grey variegated marble column with laurel wreaths, swags and two detailed Faun busts mounted mid-column, surmounted by a removable fluted and bead-edge bobeche, the candlesticks possibly commissioned or created for the 100th anniversary celebrating the birth of Nathaniel Hawthorne, the celebrated American author of *The Scarlet Letter, The House of The Seven Gables,* and *The Marble Faun,* Hawthorne was born in Massachusetts, the location of Towle Silversmiths, these candlesticks provide the only example of American silver mounted marble candlesticks we have seen or heard of, *marked undersides*

12.8in. high (Total: 2 Items)

18356

AN AMERICAN MIXED METAL TWO-HANDLE VASE

Mark of Gorham, Providence, Rhode Island, 1900

The silver circular tapered foot supporting a cylindrical copper body with rounded bottom and flared lip edged in silver, the silver branch form handles with spreading leaves and hand chased bark texture, date stamped, *marked underside*

5.25in. high, 8in. across

18356

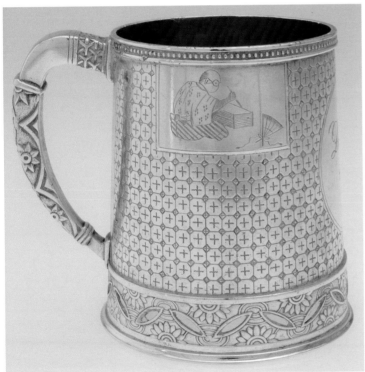

18357

18358

18358

AN AMERICAN MIXED METAL AND STONE AESTHETIC STYLE GAVEL

Unmarked, c.1915

The cylindrical hollow handle with applied mixed metal leaves and berries with inscription 'Centennial gavel/ presented by Camden M. Cobern to/ President Wm. H. Crawford DD-LLD/ the Creator of the "New Allegheny" to be used by him during Centennial Week/June 20-26, 1915', the stone gavel head with a hand hammered silver collar inscribed 'This Stone was obtained by the donor during April 1913 near the summit of Mt. Sinai (Jebel Musor)'

9.25in. long

18357

AN AMERICAN SILVER CHINOISERIE DECORATED CUP

Mark of Tiffany & Co., New York, c.1870

An early example of Tiffany & Co. silver, marked by Edward Moore, heavy die rolled base with open-work, the body and handle covered with rosettes and two paneled scenes, one of a crane with two shells, the other of a man seated, wearing glasses, writing calligraphy, *marked underside*

3.5in. high, 6.8oz

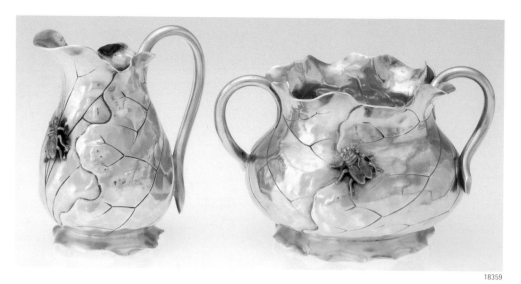

18359

AN AMERICAN SILVER MIXED METAL JAPANESE STYLE CREAMER & SUGAR

Mark of Shiebler, New York, c.1885

Parcel gilt, each of organic nature, the bodies formed as leaves with stylized stems for handles, both with cast and applied silver and copper insects, gold washed interiors, *marked undersides*

2.9in. high the creamer,

(Total: 2 Items)

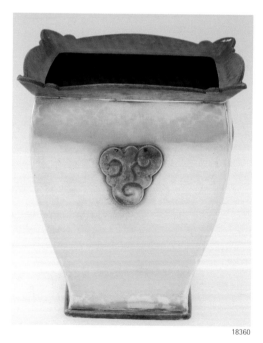

18360

A MIXED METAL JAPANESE STYLE VASE

Mark of Gorham, Providence, Rhode Island, c.1880

The copper edge square foot supporting a flaring square silver body surmounted by a shaped and radiating square copper rim, with applied copper stylized cloud forms to each silver panel, delicate hand hammered finish, stamped 'Sterling & other metals'; factory mark 'EXA', *marked underside*

4in. high, 3.5in. wide

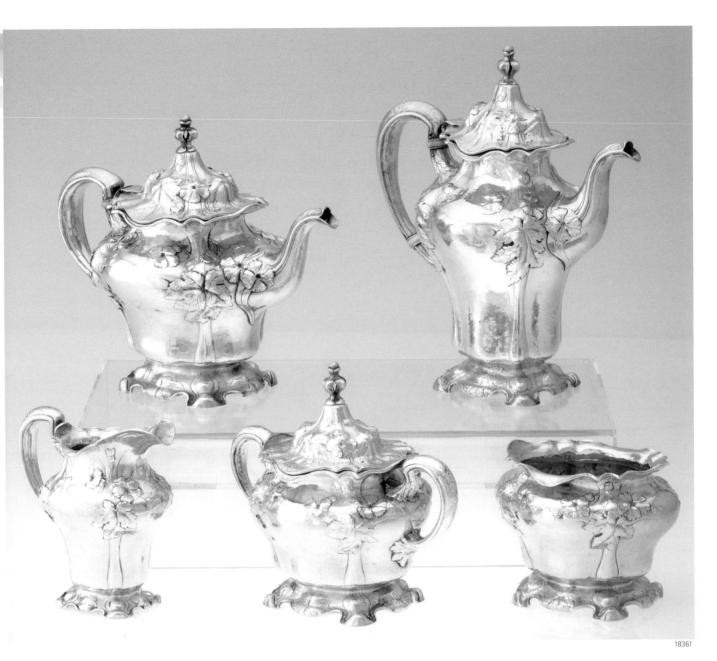

18361

18361
A FIVE PIECE AMERICAN SILVER MARTELÉ TEA SERVICE
Mark of Gorham, Providence, Rhode Island, c.1906

Comprising a coffee pot, tea pot, creamer, sugar and waste, art nouveau in form and decoration, Gorham Martelé a handwrought line of silver that was produced from the late 19th to early 20th century, factory records indicate that this service required 308 hours to raise by hand and 295 hours to chase, the finish retains an original aged soft patina and delicate hammer marks throughout, an Old English style 'H' monogram on the underside of each item, this service descended through the family of the original purchaser, a document with provenance information will accompany this lot, *marked undersides*

10.5in. the coffee pot, 124oz gross weight

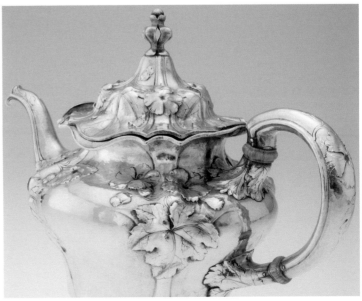

18362

A PARCEL GILT AMERICAN ART NOUVEAU STYLE MIXED METAL DESK ACCESSORY

Mark of Thomas G. Brown & Sons, New York, c.1900

The silver threaded base supporting a baluster form candy apple red patina copper body, a swirling silver art nouveau style band at rim with two opposing owl masks on wings, script monogram, deep gold wash interior, stamped 'sterling and other metals', *marked underside*

18363

AN AMERICAN SILVER JAPANESE STYLE CUP

Mark of Tiffany & Co., New York, c.1880

A parcel gilt mug, round multi-piece construction foot with geometric designs, body decorated with bamboo and blossoms, handle with stylized scales, interior with copper colored gold wash, engraved on front in period script lettering 'Mary', *marked underside*

4in. high, 6oz

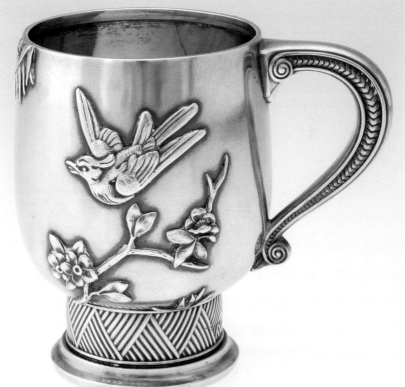

18364

AN AMERICAN SILVER JAPANESE STYLE CUP

Mark of Tiffany & Co., New York, c.1880

A parcel gilt mug, round multi-piece construction foot with geometric designs, body decorated with foliage and two birds in flight, handle with stylized scales, interior with copper colored gold wash, engraved on front in period script lettering 'Almira' *marked underside*

4in. high, 6.2oz

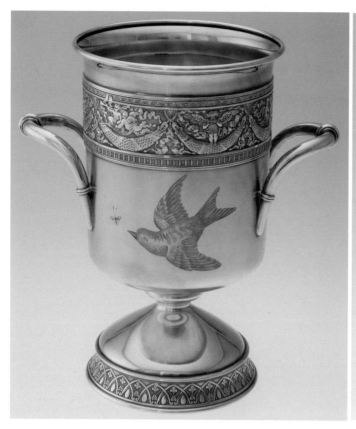
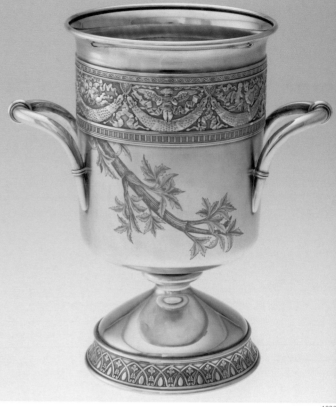

18365

A RARE PARCEL GILT AMERICAN SILVER AESTHETIC MOVEMENT CELERY VASE

Mark of Gorham, Providence, Rhode Island, c.1876

A copy of the report by Samuel Hough titled 'The Gorham Special Order Celery Vase N' accompanies this vase, according to Mr. Hough, this vase "represents a pretty rare category," though unable to track this specific vase, the report covers a vase with the factory designation 'Z', the Z vase identical with the exception that it has no engraving, the engraving on this vase features a bird chasing an insect and on the opposite side, a stalk of leafy celery, the interior of the vase gilt with a large die-rolled band of cherubs playing musical instruments just below the flaring rim, a facsimile of the original factory photograph of the 'Z' vase accompanies the vase and report with this lot, *marked underside*

7.7in. high, 4.7In. diameter, 20oz

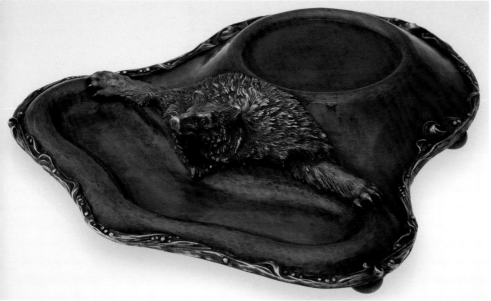

18366

AN AMERICAN MIXED METAL STANDISH

Mark of Shreve, San Francisco, California, c.1900

Of bell shaped form, the domed copper hammered body applied with silver
art nouveau border and a chased and applied silver bear skin with front paws
outstretched surrounding a pentray, on four ball feet, *marked underside*

3in. wide, 11.75in. across

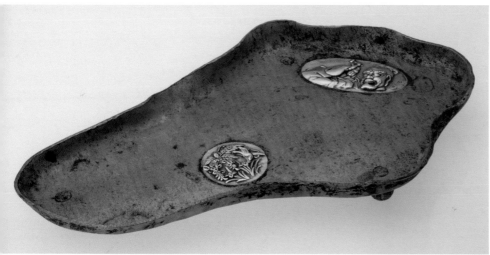

18367

A RARE AMERICAN IRON JAPANESE STYLE MIXED METAL TRAY

Mark of Gorham, Providence, Rhode Island, c.1880

The organic iron form with upturned edges on three iron ball feet, with two silver
cast and applied 'medals', one depicting birds and flowers, the other depicting an
Asian sculptor chiseling a kabuki mask, stamped with the Gorham anchor/Gorham
& Co./Sterling/ & Iron/ W6/ P, medals stamped on back '6351' and possibly '8356'
respectively, *marked underside*

3in. across

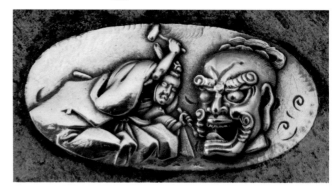

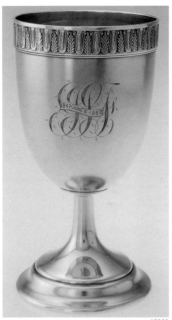

18368

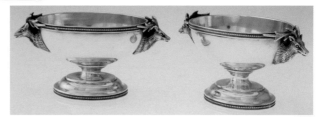

18370

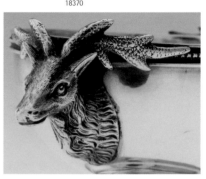

18370

A PAIR OF AMERICAN COIN SILVER SILVER STAG HEAD SALTS

Mark of John Westervelt, New York, c.1850

Each with beaded edge oval foot and rim, marked J.H.W., each with an applied stag head on ends, *marked undersides*

3.2in. across, 2.2in. high (Total: 2 Items)

18368

AN AMERICAN SILVER PRESENTATION GOBLET

Mark of Gorham, Providence, Rhode Island, c.1887

A round spreading base and tapering stem lead to a bullet shaped vessel with a heavy die rolled rim of wheat stalks, body with matte finish, interior gilt, engraved 'GGF' 1847 June 6 1887', also engraved under base 'from father & mother June 6 1887', *marked underside*

6.3in. high 6.8oz

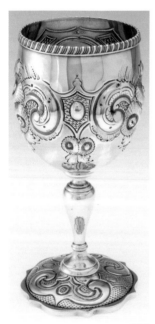

18369

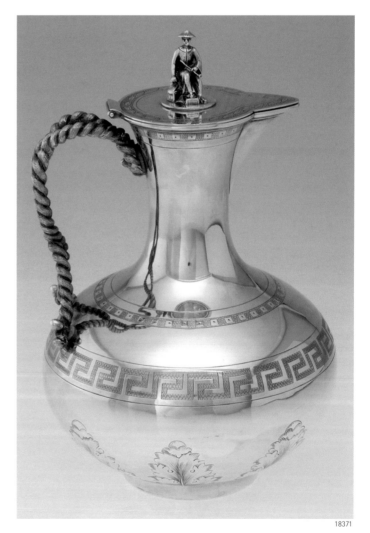

18371

18369

AN AMERICAN COIN SILVER CHALICE

Mark of Tiffany & Co., New York, c.1859

An ornately chased chalice with a dedication from a graduating class of 1859, inscription 'To Miss C.A. Perry from the graduates of 1859', manufactured by John Moore for Tiffany & Co., *marked underside*

8.7in. high, 10.3oz

18371

AN AMERICAN COIN SILVER CHINOISERIE HOT MILK JUG

Mark of Jones Shreve & Brown, c.1850

Parcel gilt with round body with tapering cylindrical neck, hinged lid and goose neck spout, the finial a seated chinoiserie figure, stylized rope handle attached with ivory insulators, engraved Greek key band at mid body with upswept acanthus leaf engravings rising from the base, mounted on a circular base, *marked underside*

10in. high, 26.9oz

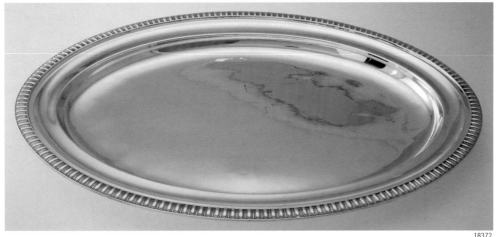

18372

AN AMERICAN SILVER OVAL GADROONED EDGE MEAT PLATTER
Mark of Gale & Willis, New York, c.1859

The oval platter with applied gadrooned edge, Gale & Willis date mark
for the year 1859, *marked underside*
20.2in. across, 14.5in. wide, 49.4oz

18373

AN AMERICAN SILVER GADROON EDGE SALVER
Mark of Gorham, Providence, Rhode Island, 20th century

The classic design featuring a gadroon border, an Old English style P
monogram at center, *marked underside*
14in. diameter, 23.6oz

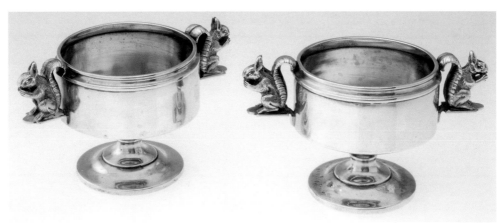

18374

A PAIR OF AMERICAN COIN SILVER FIGURAL OPEN SALTS
Maker unknown, c.1860

Cylindrical bodies set upon round spreading feet, threaded rim decoration,
each with two mounted opposing cast squirrels, *unmarked*
2.7in. high, 7.5oz gross weight (Total: 2 Items)

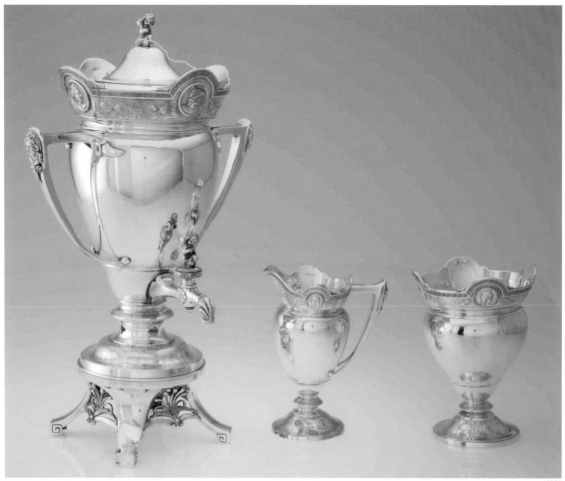

18375

AN AMERICAN COIN SILVER MEDALLION PATTERN TEA SERVICE

Mark of J.W. Tucker & Co., San Francisco, California, c.1870

Consisting of a hot water urn, creamer and sugar, the urn with detachable base, the spigot and hinged lid mounted by cast and applied angels, handles with applied busts of maidens, rims decorated with male and female classic busts, ivy leaves, vines, foliage and berries, matching decoration on the creamer and sugar, *marked undersides*

16.5in. high, 99.5oz gross weight (Total: 3 Items)

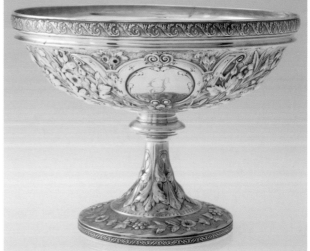

18376

AN AMERICAN SILVER FLORAL REPOUSSE PEDESTAL BOWL

Mark of Kennard & Jenks, Boston, Massachusetts c.1870

The circular base and tapering pedestal with repousse morning glories and foliage supporting a deep bowl decorated with repousse flowers against a matte background, script monogram in cartouche, *marked underside*

6.3in. high, 8.3in. diameter; 14.8oz

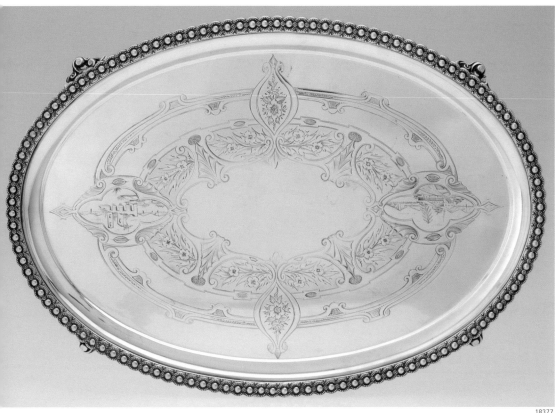

18377

18377
AN AMERICAN SOUTHERN COIN SILVER TRAY
Mark of E.A. Tyler, New Orleans, Louisiana, c.1850

An oval meat platter with a heavy cast and applied bulls-eye and rosette rim, the surface engraved with foliate Greek revival design, two cartouche, one with a mill near a lake, the other with ruins of a building on a lake, set on four heavy cast ornate feet, an unusually large piece of coin silver from New Orleans, *marked under rim on left side*

18in. across, 12.5in. across, 42oz

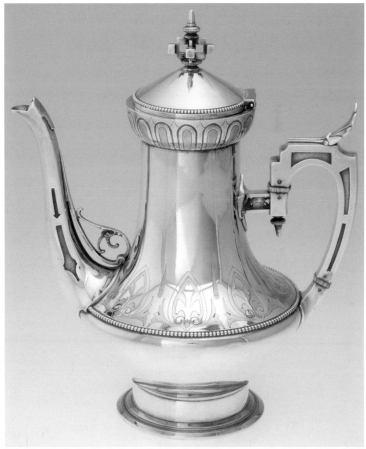

18378
AN AMERICAN COIN SILVER GREEK REVIVAL COFFEE POT
Mark of Wood & Hughes, New York, c.1870

Baluster form with round spreading base, engraved with stylized Greco-Roman designs, the handle with ivory insulators and papyrus form thumb rest, period monogram 'VS' with later script monogram 'LVS', unusual finial, *marked underside*

11.5in. high, 31.6oz

18378

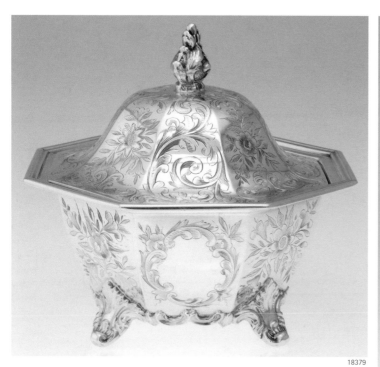

18379

AN AMERICAN COIN SILVER BUTTER TUB

Mark of Gale & Son, New York, c.1850

An octagonal covered butter tub with four applied rococo feet, the body entirely engraved with floral rococo work, the finial, a flame cast and applied, *marked underside twice*

6in. diameter, 5.5in. high, 14.7oz

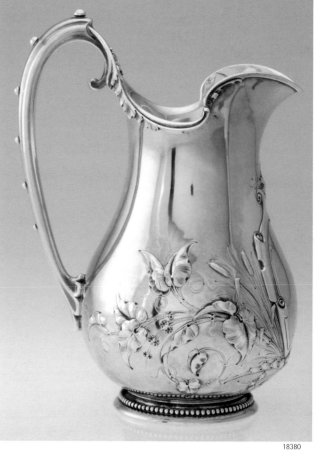

18380

AN AMERICAN COIN SILVER WATER PITCHER

Mark of Gorham, Providence, Rhode Island, c.1863

Of baluster form on a beaded circular foot, the hand chased and repousse body with cattails, floral spray, grapes and vines surrounding a strapwork bordered oval cartouche engraved 'Y.N.W./ From her Mother/ Oct. 1863', the handle with graduated ball decoration, *marked underside*

11.5in. high; 30.9oz

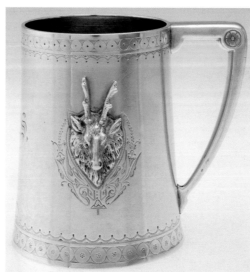

18381

AN AMERICAN COIN SILVER SAXON STAG PATTERN MUG

Mark of Gorham, Providence, Rhode Island, c.1865

Of tapering cylindrical form, with engraved borders and two applied saxon stag heads, Old English monogram 'W.L.S.', *marked underside*

3.75in. high, 6.17oz

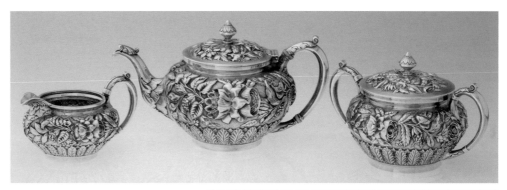

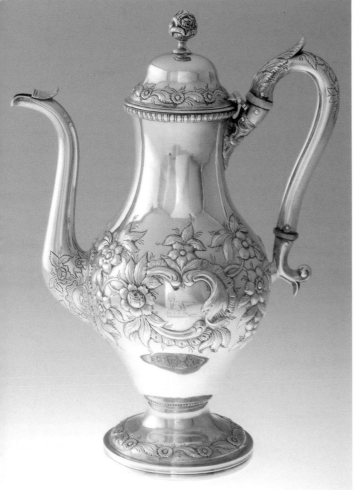

18383

AN AMERICAN REPOUSSE TEA SERVICE
AND HISTORICAL MANUSCRIPT

Mark of Junius H. Davis, Philadelphia, Pennsylvania, c.1888

An uncommon Philadelphia maker, Junius H. Davis would go on to become a partner in the firm Davis & Galt, bulbous bodies with acanthus leaves and repousse floral design throughout, a period script 'HBC' monogram on the base of each piece, the initials those of Hannah Blair Crossman whose life history in manuscript form accompany this lot, Hannah was born December 28, 1810, the document titled 'Hannah Blair Crossman Pioneer' 195 pages long and well written, due to her relationship with a military officer, it chronicles most wars and many political events of the 19th century, truly a unique opportunity for the history buff with an affinity for silver, *marked undersides*

5.5in. high the tea pot, 49.8oz gross weight

(Total: 3 Items)

18382

AN AMERICAN COIN SILVER REPOUSSE COFFEE POT

Mark of Andrew Warner, Baltimore, Maryland, c.1830

A round spreading base chased with flowers and leaves, the pear shaped body with repousse floral and rococo design, the hinged lid rests upon a cast and applied gadroon border, floral finial, *marked underside*

13.2in. high, 39.8oz

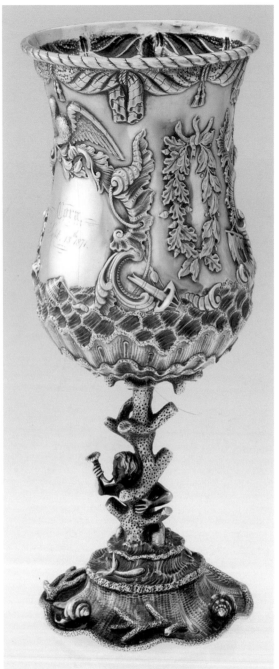

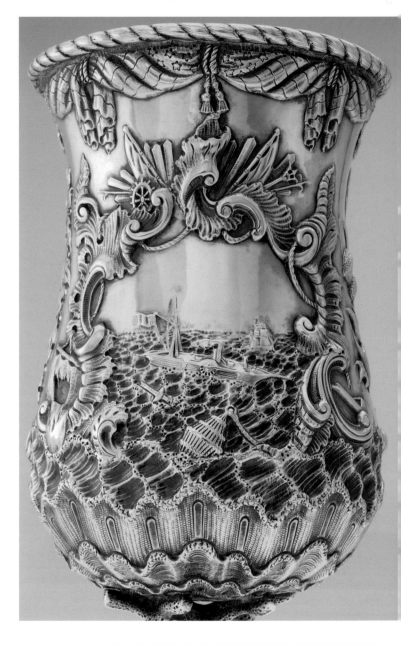

18384

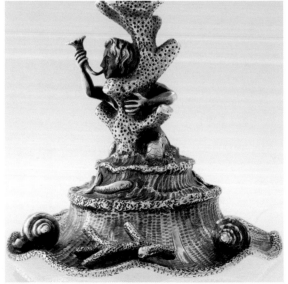

18384

AN AMERICAN COIN SILVER EARLY AESTHETIC MOVEMENT MARINE MOTIF PRESENTATION CUP

Mark of Ball Black & Co., New York, c.1870

The American-themed marine-motif cup with coral and shell base surmounted by a merman blowing a horn and grasping the coral form stem supporting a baluster form cup replete with repousse and chased decoration, the cup with an upsweeping shell form radiating from the bottom gives way to crashing waves flooding into two rocaille cartouches with an anchor, shattered mast, torn sail and broken prow flanking the sides; a radiating cluster of swords atop one cartouche featuring flotsam, a sinking side wheeler ship flying an American flag upside-down in distress, and a schooner appearing to come to its rescue; the other cartouche with an American eagle perched with outspread wings holding a twig of holly with the inscription "Cora/ Sept. 13th 1871"; outside the cartouche, a wreath of oak and holly on one side and a thistle spray on the other; the top bordered with a cast and applied rim formed as rope holding swags of American flags, *marked at join of cup and stem*

10.2in. high; 20oz

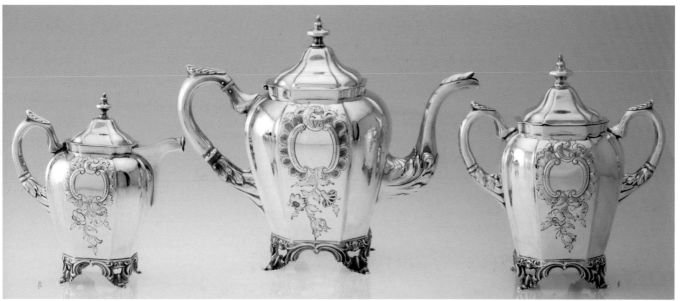

18385

18385

A THREE-PIECE AMERICAN COIN SILVER TEA SERVICE

Mark of F.W. Cooper, New York, c.1840

Each piece with cast and applied rocaille feet supporting a paneled bombe form body, chased with floral rococo decoration, the handles with acanthus leaf joins and thumb rests, the paneled double domed lids with knopped finials; matching creamer unmarked, *marked undersides, the teapot and sugar*

the teapot 10.5in. high, 66oz gross weight (Total: 3 Items)

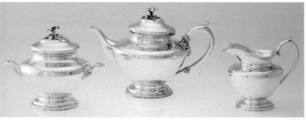

18386

18386

AN AMERICAN COIN SILVER TEA SERVICE

Mark of Bailey & Kitchen, Philadelphia, Pennsylvania, c.1840

Urn form with cast and applied foliate finials, teapot and sugar bowl handles with acanthus leaf mounts, faint period script 'E' monogrammed mid-body of each item, *marked undersides*

7.5in. high, 50.2oz (Total: 3 Items)

18387

AN AMERICAN SILVER PLATE

Mark of Tiffany & Co., New York, c.1870

Circular form with threaded rim, made by Moore, *marked on reverse*

6.25in. diameter, 2.79oz

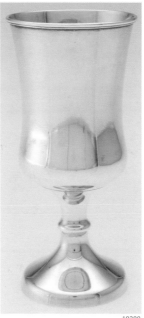

18388

18388

AN AMERICAN COIN SILVER CHALICE

Mark of Dennison & Jones, Boston, c.1850

Parcel gilt, the round spreading foot tapers upward, the body plain with an applied threaded rim, *marked underside*

8.3in. high, 12.5oz

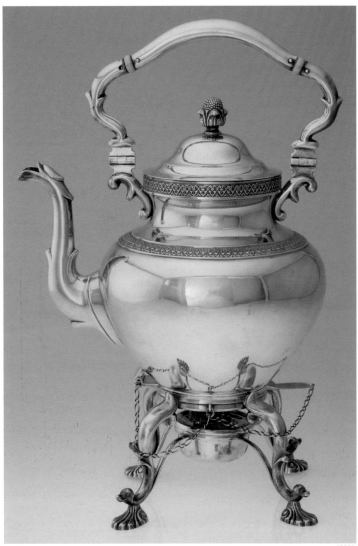

18389

18389

AN AMERICAN COIN SILVER TILTING HOT WATER KETTLE

Mark of Eoff & Conner, New York, c.1839

The base with shell feet and stylized goose head legs, retains the original burner, two pins chained to base secure the kettle, one can be removed to allow tilting, the tapering round body with a die rolled band near the base of the handle decorated with heart shapes, another band of identical design set below the hinged lid, handle also hinged, a period script 'MCJ' monogram mid-body, and a very small engraving on the hinge attached to the base 'from ESM 1858', the hallmarks chronicle the beginnings of this kettle on stand, first an 'E & C' for Eoff & Connor, the makers, second a Marquand & Co. for the firm started by Frederick Marquand of New York and Savannah Georgia and last the mark Ball Tompkins & Black, successors to' Marquand & Co., *marked underside*

15in. high, 51.6oz gross weight

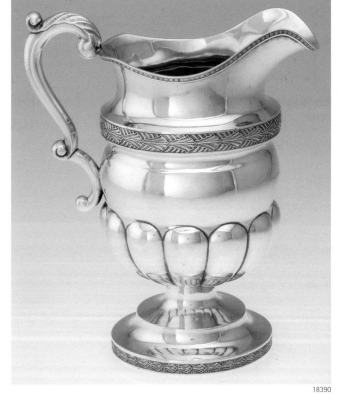

18390

18390

AN AMERICAN SILVER WATER PITCHER

Farnham & Ward, Norwich, Connecticut c.1815

The lobed body with round spreading foot, die rolled applied rims and mid-body decoration, the C scroll handle with Acanthus leaf thumb rest. Inscribed 'Benjamin Eddy Cotting' in period script lettering, *marked underside*

9.7in. high, 32.7oz

18391

18391

AN AMERICAN SILVER BEAKER OF KENTUCKY INTEREST

Mark of Asa Blandhard, Lexington, Kentucky, c.1820

With rolled threaded rim and base, some small dings, *marked underside*

3.2in. high, 3.4oz

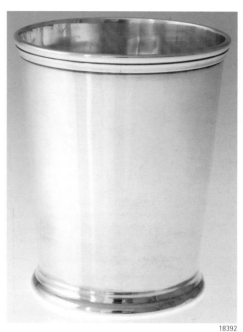

18392

18392

AN AMERICAN COIN SILVER MINT JULEP CUP

Mark of R. & W. Wilson, Philadelphia, Pennsylvania, c.1850

Tapering cylindrical form with an applied threaded rim and round spreading foot, *marked undersides*

3.7in. high, 4.4oz

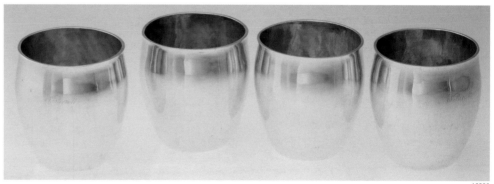

18393

18393

A GROUP OF FOUR FEDERAL COIN SILVER BEAKERS

Maker unknown, c.1810

Each in excellent condition, each with a matching period engraved name 'S. Parrot', hand raised with hammer marks throughout the interior, federal beakers uncommon, groups of two or more rare, each with natural soft grey patina, *unmarked* 3.5in. high each, 20.2oz gross weight

(Total: 4 Items)

Visit HeritageGalleries.com to view scalable images and bid online.

Session One, Auction #608 • Saturday, October 30, 2004 • 10:00 a.m. 123

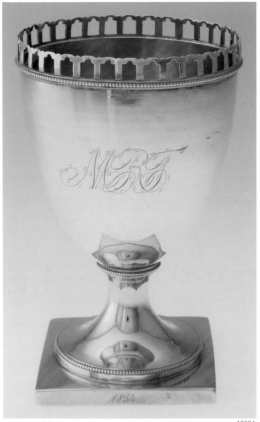

18394

18394

**AN AMERICAN FEDERAL PERIOD
COIN SILVER SUGAR BOWL**

Mark of Joshua Davis, Boston, Massachusetts, c.1795

The everted conical shape with applied gallery rim, beaded decoration and square base, the body engraved with period script 'MR', base engraved on edge 'July 19th 1794', the opposite side of the base engraved '1854', *marked four times under base*

6.3in. high, 9.6oz

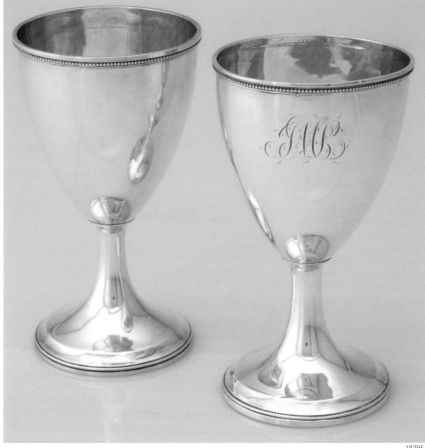

18395

18395

A PAIR OF AMERICAN COIN SILVER GOBLETS

Samuel Williamson, Philadelphia, Pennsylvania c.1795

The bodies of tapering cylindrical form, round spreading feet, base and rim with beaded edge decoration, matching period script 'JMS' monograms, marked 'S.W', gilt interiors, among other notable clients, Samuel Williamson produced silver broaches and rings for the Lewis & Clark expedition, *marked undersides*

6.7in. high, 17.3oz gross weight (Total: 2 Items)

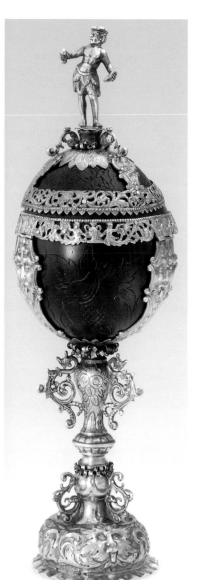

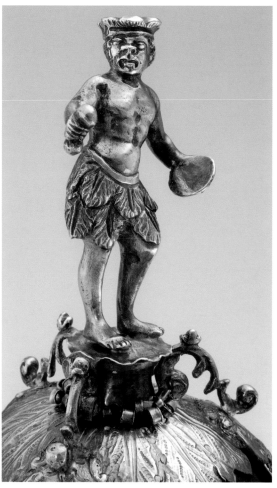

18396

18396
A CONTINENTAL SILVER MOUNTED COCONUT CUP
Probably 17th century

Gilt with carved coconut, ruffled edge and repousse 'North wind' faces decorate the base, stylized cast birds of prey applied to the stem, the frame of the coconut similarly decorated, the finial a man with native tropical dress and headwear, holding what appears to be a pestle and mortar, probably Tahitian, two hallmarks on edge of rim,
13in. high

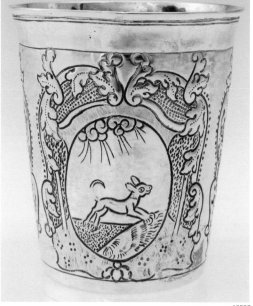

18397

18397
A RUSSIAN SILVER ENGRAVED BEAKER
Russian silver marks, c.1752

Of flaring cylindrical form, the hammered finish with three engraved cartouche depicting a dog, a castle, and a flower, *marked underside*
3.3in. high

18398
A GEORGE II PIERCED SILVER BASKET

Mark of Edward Aldridge, London, England, 1751

Elaborate openwork, cast and applied shell, scroll and foliate rim, hinged castings of mythical beasts suspend a handle with rococo cartouche, the body set upon four feet with applied female busts, armorial of a winged helmet surmounted by a raised arm holding a staff, some repairs to body and handle, *marked underside*

approximately 10.5in. high, 42.5oz

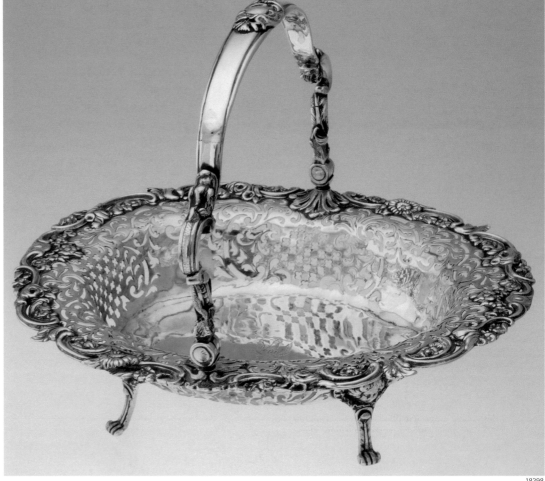

18398

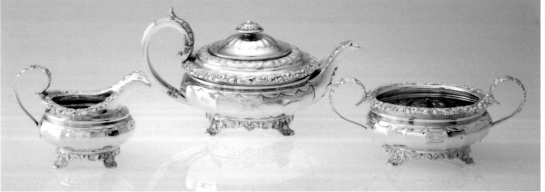

18399

18399
A LATE GEORGIAN THREE PIECE SILVER TEA SERVICE

Mark of Emes & Barnard, London, 1824

Manufactured by Rebecca Emes and Edward Barnard, this tea service distinguished from others of the era by the uncommon trait of being manufactured by a female silversmith, a trade like many in the 19th century not generally open to the gender, the set consists of three pieces, a tea pot, creamer and sugar, each piece with cast and applied floral rococo decoration and acanthus leaf handles, each with an interesting armorial of a severed hand clutching a fleur di lis beside an arm clutching a severed head with the latin motto 'par se signe a agincourt' 'by this sign agincourt', *marked on sides*

10.5in. from handle to spout, 45.4oz gross weight

(Total: 3 Items)

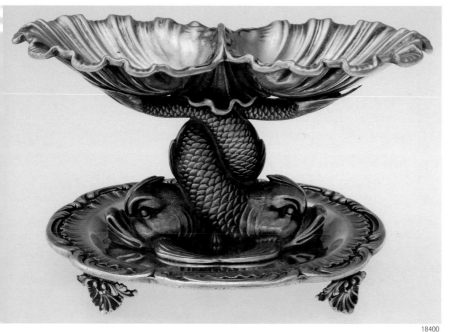

18400

A FRENCH SILVER FIGURAL NEOCLASSICAL SALT BASIN

Mark of Odiot, France, c.1870

Set upon four shell feet, the base a plateau of stylized waves, two intertwined neo-classical dolphins with a pair of everted scallop shells that serve as salt basins, the workmanship outstanding as would be expected with the most respected 19th century silversmithing firm in France, first standard quality marks, *marked in various places*

3.6in. high, 6.25in. across, 13oz

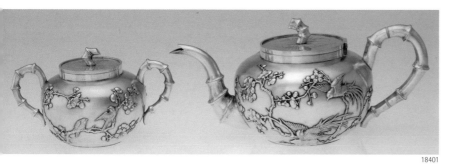

18401

A CHINESE EXPORT SILVER TEAPOT AND SUGAR BOWL

Maker unknown, 20th century

An exceptional pair of Chinese export silver items, the handles, finials and spout of stylized bamboo, bodies with cast and applied cherry blossoms and birds in flight, lids with engraved bamboo, hallmarks include a Chinese symbol '90 H.M', *marked undersides*

4.5in. high, the teapot, 26oz (Total: 2 Items)

18402

AN AMERICAN SILVER JAPANESE STYLE SHOE HORN

Mark of Whiting, Providence, Rhode Island, c.1890

The handle with a matte finished marsh scene including a crane, owl and foliage, the obverse of blade with a Japanese style 'ASW' monogram, the reverse with a Japanese style '1890' monogram, *marked reverse of handle*

6in. long

18403

A CHINESE EXPORT SILVER SHOE HORN

Maker unknown, c.1890

With matte finish foliate handle, makers mark appears to be a 'Wc', *marked reverse of handle*

8.7in. long

18404

A PAIR OF CHINESE EXPORT SILVER TEA CADDIES

Maker unknown, c.1920

Each of cylindrical form, with paneled floral decoration and a single figure in one panel each, *marked underside*

4in. high, 2.75in. diameter (Total: 2 Items)

18405

A CHINESE EXPORT COVERED SILVER BOWL

Unknown, c.1880

The parcel gilt finish over an elaborate design, unsigned

3in. across

18406

AN ITALIAN COVERED SILVER BOWL GIACINTO MELILLO

Mark of G. Melillo, Naples, Italy, c.1894

The two-handled handwrought bowl entirely chased and engraved with Roman decoration, the lid with a high relief medallion of Medusa, Melillo worked in the Castellani shop, known for their Etruscan style gold 'archaeological jewelry', silver by Melillo uncommon and this an exceptional quality piece, signature 'G. Melillo, Naples', *marked underside*

6.3in. across, 2.7in high, 19.6oz

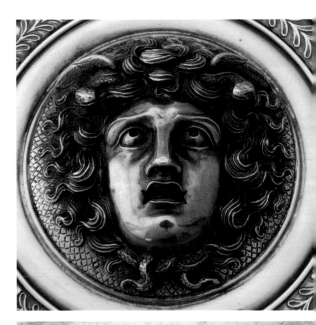

18407

AN ITALIAN COVERED SILVER BOWL GIACINTO MELILLO

Mark of G. Melillo, Naples, Italy, c.1894

The two-handled handwrought bowl entirely chased and engraved with Roman decoration, the lid with a high relief medallion of Medusa, Melillo worked in the Castellani shop, known for their Etruscan style gold 'archaeological jewelry', silver by Melillo uncommon and this an exceptional quality piece, signature 'G. Melillo, Naples', also signed 'copied from original, Naples museum 1894', *en suite with preceding lot, marked under lid*

6.3in. across, 2.7in. high, 19oz

8408

A FIGURAL CONTINENTAL SILVER TEA CADDY

Maker unknown, Austro-Hungarian, c.1880

The oval shaped body with hinged lid, honeysuckle engraving throughout, cast rocaille feet and bird-of-prey finial, interior gilt, *marked inside lid and inside bottom*

5.7in. high, 6.2in. wide, 10.9oz

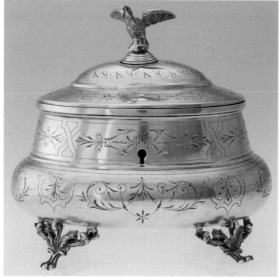

18408

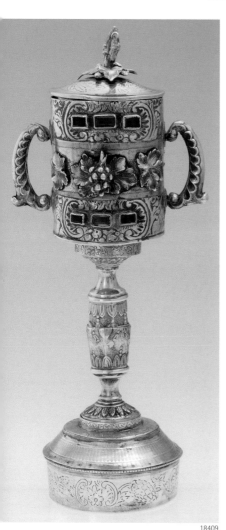

18409

18410

18410

A SPANISH COLONIAL SILVER BOWL

Unmarked, 19th century,

A two-handled round bowl, the thick handles decorated with bright cut and thread design, a very primitive and clearly handwrought piece of Spanish Colonial silver, *Unmarked*

6.5in. diameter, 4.5in. high, 14.4oz

8409

A SILVER JUDAICA TRAVELING WORSHIP SET

Various makers, various locations

Comprised of ten separate pieces that combine to form a standing lidded cup, the cup with inset gems, hallmarks from Europe and Baltic states as well as early 19th century American, this was probably assembled by several generations, a very unusual item,

8.2in. assembled (Total: 10 Items)

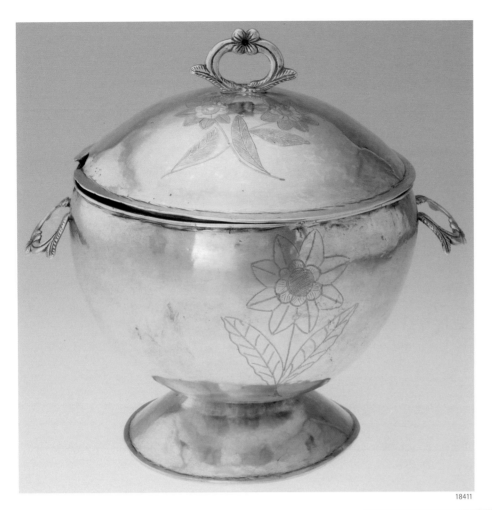

18411

A SPANISH COLONIAL COVERED SOUP TUREEN

Maker unknown, Mexico, 19th century

An uncommon article, primitive construction, the domed lid and bulbous body with matching floral engraving, the cast handles with stylized leaves and flowers, *unmarked*

10.5in. high, 8.2in. diameter, 46.3oz gross weight

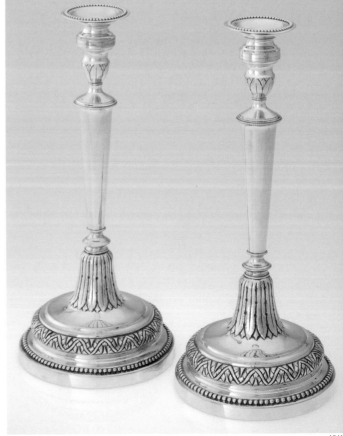

18412

A PAIR OF CONTINENTAL SILVER CANDLESTICKS, PROBABLY BELGIUM

Late eighteenth century

Each on a circular domed base with beaded edge below a band of laurel leaves, stems with a chased band of acanthus leaves and tapered cylindrical shape, similar decoration on terminals with threaded bands and beaded edge detachable nozzles, period script 'RP' monograms and 'MM' hallmark on the edge of each base

11.7in. high (Total: 2 Items)

18413

AN AMERICAN SILVER MOUNTED WALKING STICK

Mark of Unger Bros., Newark, New Jersey, c.1900

The sterling handle a helmeted diety in chain mail with wings spreading backward across the handle, large heart-shaped emblems mounted on the sides, *marked inside handle*

34.2in. long

18414

A GROUP OF FIVE FIGURAL AMERICAN COIN SILVER OPEN SALTS

Mark of Vanderslice, San Francisco, California, c.1870

Each a realistically formed broken egg with a rocky foliate base, all marked with the Vanderslice bear hallmark, *marked undersides*

2in. high

(Total: 5 Items)

18415

A GROUP OF FIVE AMERICAN SILVER NURSERY RHYME ITEMS

Various makers, c.1900

Comprising a heavy Gorham Zodiac plate, script period 'Lesley' monogram, a William Kerr nursery rhyme plate with acid-cut-back decoration, a Gorham acid etched plate with Dutch children and windmills, a Gorham acid-cut-back plate, images of birds and children dining, a William Kerr plate with acid-cut-back animals named below supporting cartouche, *marked undersides*

7.4in. the widest diameter, 21.2oz gross weight

(Total: 5)

Visit HeritageGalleries.com to view scalable images and bid online.

Session One, Auction #608 • Saturday, October 30, 2004 • 10:00 a.m.

131

18416

AN AMERICAN SILVER ART NOUVEAU WINE COASTER

Mark of Gorham, Providence, Rhode Island, c.1913

Engraved with ribbons and art nouveau style flowers, original lining intact, a period 'AVBB' monogram in a cartouche, *marked underside*

4.4in. across, 1.5in. high

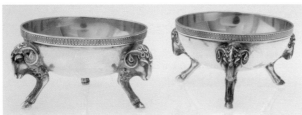

18417

A PAIR OF FIGURAL AMERICAN SILVER OPEN SALTS

Mark of Tiffany & Co., New York, c.1865

Parcel gilt round bodies with an applied tongue and groove style die-rolled rim, each with three rams head and hoof' feet, period 'EMFW' conjoined monogram, with an early John Moore trademark, *marked undersides*

1.6in. high, 2.7in. across (Total: 2 Items)

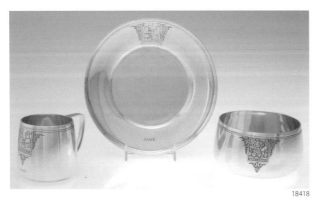

18418

A THREE PIECE AMERICAN SILVER CHILD'S BREAKFAST SET

Mark of Tiffany & Co., New York, c.1930

A bowl, underplate and cup in nursery rhyme themes, the cup 'Jack & Jill', the bowl 'Mary Mary', the underplate 'Bow Wow Wow', designs acid-cut-back, each engraved with the name 'Jane', *marked undersides*

2.5in. high, the cup, 17oz gross weight (Total: 3 Items)

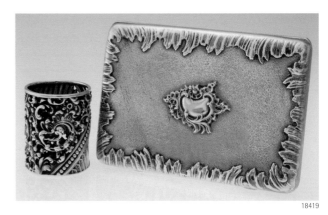

18419

TWO AMERICAN SILVER SMALL ITEMS

Mark of Shiebler, New York, c.1890

The first a toothpick holder with rococo openwork, the second a parcel gilt card or cigarette case with rococo decoration and the name of the state 'VIRGINIA' engraved, *marked inside lip and underside*

3.7in. across the card case (Total: 2 Items)

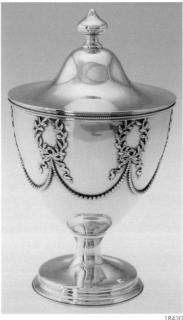

18420

AN AMERICAN SILVER NAPOLEON PATTERN COVERED SUGAR BOWL

Mark of Shiebler, New York, c.1890

The circular domed foot with beaded edge leading to a flaring conical body with cast and applied laurel wreaths joined by graduated beaded swags, the domed lid with knopped finial, *marked underside*

7in. high, 4.2in. diameter; 8.7oz

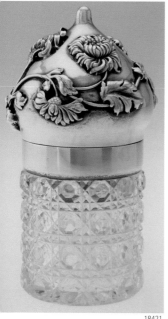

18421

18421

AN AMERICAN SILVER AND CUT-GLASS CHRYSANTHEMUM PATTERN DRESSER JAR

Mark of Shiebler, New York, c.1890

Cylindrical form, the cut-glass base surmounted by a domed hinged lid with applied trailing chrysanthemums in high relief, *marked on neck below hinge*

5in. high

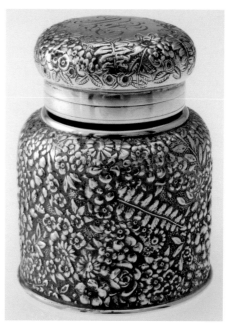

18423

18423

AN AMERICAN SILVER FLORAL INKWELL

Mark of Tiffany & Co., New York, c.1885

Of cylindrical form with die-rolled floral decoration throughout the body and hinged lid, script monogram on lid, original glass insert intact, date marked, *marked underside*

2.75in. high

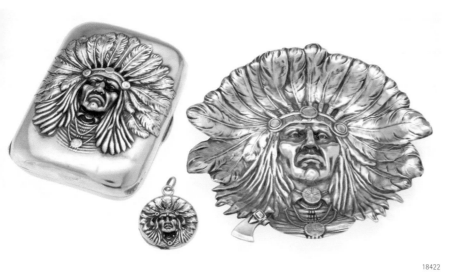

18422

18422

A GROUP OF THREE AMERICAN SILVER UNGER INDIAN PATTERN SMALLS

One unmarked, two mark of Unger Bros., Newark, New Jersey, c.1900

All three Unger Indian pattern, consisting of a circular Indian bust ashtray, a parcel gilt cigarette case with script monogram on reverse, and a circular locket marked 'sterling', *marked various places*

The ashtray 4.2in. diameter

(Total: 3 Items)

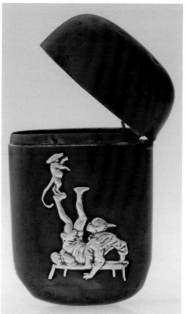

18424

18424

A SILVER ON COPPER JAPANESE-STYLE CHEROOT CASE

Mark of Gorham, Providence, Rhode Island, c.1880

The rectangular hinged case on one side with silver applied Chinese circus performer balancing a dancing cat, the other with an applied cow jumping over the moon and a boy, gold wash interior, *marked inside rim*

3.5in. high, 2.3in. wide

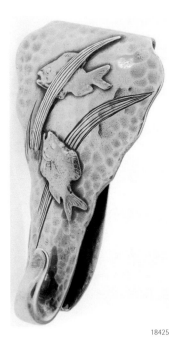

18425

AN AMERICAN JAPANESE STYLE MIXED METAL CHATELAINE CLIP

Mark of Tiffany & Co., New York, c.1880

Of organic triangular form, the hand hammered ground with two cast and applied gold fish swimming around silver cast and applied, and engraved aquatic fronds, date marked, *marked reverse*

2.25in. high

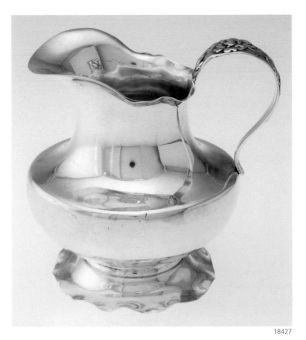

18427

AN AMERICAN SILVER FLORA PATTERN CREAMER

Mark of Shiebler, New York, c.1890

Undulating rim and round spreading base, the handle one of the variations of the floral pattern by Shiebler, a very fancy script 'JSA' period monogram, *marked underside*

4in. high, 4.79oz

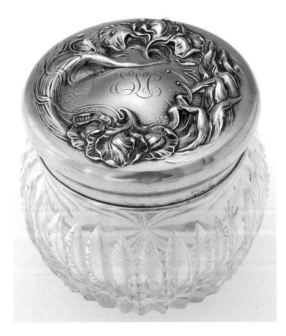

18426

AN AMERICAN SILVER ART NOUVEAU CUT GLASS DRESSER JAR

Mark of Unger Bros., Newark, New Jersey, c.1900

An American brilliant cut glass dresser jar with a silver lid, the lid decorated in relief, a woman with flowing hair reaching out toward a large iris, other foliage in the foreground, 'ELC' script monogram, *marked on the side of lid*

3in. high, 3.2in. across

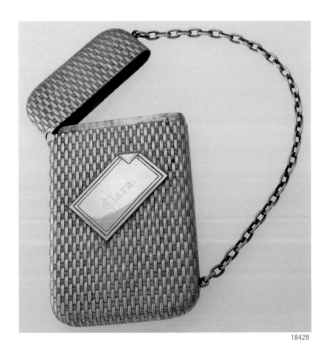

18428

AN AMERICAN SILVER TROMPE L'OIEL CARD CASE

Mark of Whiting, Providence, Rhode Island, c.1880

Of rectangular form, woven basket design with an applied trompe l'oiel folded napkin, with monogram 'Clara', *marked inside rim*

4.1in. high, 2.3in. wide

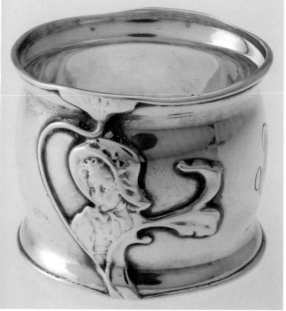

18429

AN AMERICAN SILVER KATE GREENAWAY FIGURAL NAPKIN RING

Mark of Gorham, Providence, Rhode Island, c.1900

In the English arts and crafts manner, two images of children with bonnets, confirmed Kate Greenaway characters, *marked inside ring*

1.8in. across

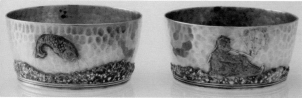

18430

A PAIR OF AMERICAN MIXED METAL JAPANESE STYLE OPEN SALTS

Mark of Gorham, Providence, Rhode Island, c.1880

Cylindrical hammered bodies, round threaded bases, applied pebble ground, applied silver and copper fish, applied chinoiserie character and bird in flight, see condition report, *marked underside*

2in. diameter (Total: 2 Items)

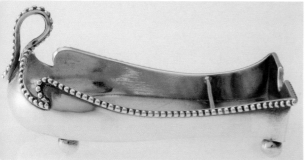

18431

AN AMERICAN SILVER BEADED EDGE PIPE STAND

Mark of Tiffany & Co., New York, c.1870

Set upon four ball feet, the body surrounded by a beaded edge, a turned beaded handle and a divot for the pipestem at the base, *marked under base*

3.5in. across

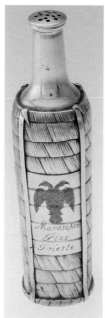

18432

AN AMERICAN SILVER TROMP L' OEIL COLOGNE BOTTLE

Mark of Durgin, Concord, New Hampshire, c.1880

In the shape of a cane and leaf wrapped rum bottle, pierced friction fit top, engraved in script 'Marasepino fino trieste', retailed by Shreve Crump & Low, *marked underside*

5.2in. high

18433

A PAIR OF AMERICAN COIN SILVER OPEN SALTS

Mark of Wood & Hughes, New York, c.1860

Parcel gilt, half round bodies with extensive machine work, period script 'EM' monogram in cartouche, set upon round pedestal bases, base and lip with die rolled repeating oval motif, *marked undersides*

2.8in. diameter, 2.2in. high (Total: 2 Items)

18434

AN AMERICAN SILVER CUP WITH BIRDS AND BUTTERFLIES

Mark of Wood & Hughes, New York, c.1870

Greek revival engraving, 'Mary Martin Mills' engraved front and center, diamond design die rolled rim, the base die rolled with birds, butterflies and foliage, *marked underside*

3.2in. high

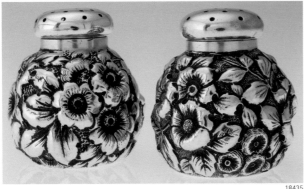

18435
**AN AMERICAN SILVER PAIR OF REPOUSSE
SALT AND PEPPER SHAKERS**
Mark of Shiebler, New York, c.1890

The squat shakers entirely covered with floral repousse work, *marked
undersides*
1.7in. high

18436
AN AMERICAN COIN SILVER MEDALLION PATTERN NAPKIN RING
Maker unknown, c.1865

One side with applied medallion of a classic female bust, *unmarked*
2.2in. across

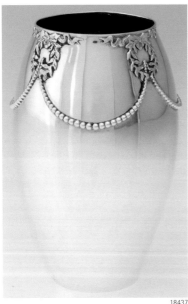

18437
AN AMERICAN SILVER NAPOLEON PATTERN FLOWER VASE
Mark of Shiebler, New York, c.1900

A tapering cylindrical body with applied graduate bead work and garlands, a
three letter period script 'LEK' monogram, *marked underside*
5.1in. high, 6.5oz

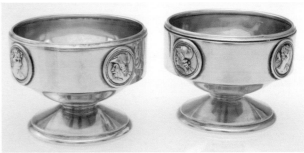

18438
A PAIR OF AMERICAN COIN SILVER MEDALLION OPEN SALTS
Mark of Gorham, Providence, Rhode Island, c.1860

Parcel gilt, each with four medallions, two male, two female, round bodies
set upon round pedestal feet, *marked undersides*
2.3in. diameter, 1.7in. high (Total: 2 Items)

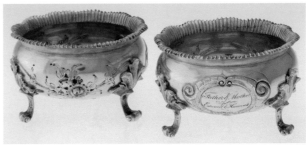

18439
A PAIR OF GILT AMERICAN COIN SILVER OPEN SALTS
Mark of Gorham, Providence, Rhode Island, c.1855

Each with three curled feet and acanthus leaf joins, the body lightly chased
with floral decoration, cartouche on each engraved 'Father and Mother
from Edward and Hannah', *marked undersides*
2.5in. diameter

18440
AN AMERICAN SILVER ART NOUVEAU MATCH SAFE
Mark of Unger Bros., Newark, New Jersey, c.1900

A nude woman reclining on a bed of ocean waves amongst floral rococo
decoration, some wear *marked inside lip*
2.5in. long

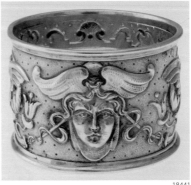

18441
A CONTINENTAL SILVER NAPKIN RING
Maker unknown, Austro-Hungarian, c.1890

Matte finished with a winged Mercury head with a griffon on each flank,
vines and flowers, monogrammed, *marked on side*
2.1in. wide

18442
A SILVER OVERLAY GOLF THEME WHISKEY DECANTER
Maker unknown, c.1920

Silver overlay in a barely design, a large central cartouche showing three golfers sipping from a flask of whiskey, caption 'One up and two to go', marked sterling, *marked on neck*
9in. high

18443
AN AMERICAN SILVER PIN CUSHION AND FRAME
Mark of Shiebler, New York, c.1890

The chair form pin cushion with reticulated back and burgundy velvet cushion, *marked underside*, 3.25in. high; the rectangular frame with hinged stand, *marked reverse of frame*, 4.75in. high

(Total: 2)

18444
FIVE SILVER MISCELLANEOUS PIECES
American and British hallmarks

The first, a cylindrical sterling powder box with architectural scene of St. Paul's Cathedral, London, signed by metalsmith J. Wiener of Brussels on the lid and underside, gilt interior, the ostrich feather puff with porcelain maiden handle, c.1897, *marked on rim, English hallmarks*; the second, a three-footed ball-form yarn holder with swirled fluting, *marked on rim, English hallmarks*; the third, an American silver toast rack by Reed & Barton; the fourth, a Cartier Paris enamelled, silver and 18K gold cigarette case, gilt interior, sapphire studded clasp, *marked interior edge*; the fifth, a silver oval frame on ball feet with engraved decoration, original green velvet back, *marked Wm. B. Kerr*

(Total: 5)

18445
TWO SILVER AND SILVER PLATED SOUVENIR PIECES
Various makers

The first, an enamelled and silver plated hinged souvenir box depicting a port scene inscribed 'Habana: Morro Castle', stamped *Alpaca* to inside rim, gilt interior; the second a sterling circular form mercury thermometer with the words 'The elements be kind to thee and make thy spirits all of comfort'

(Total: 2)

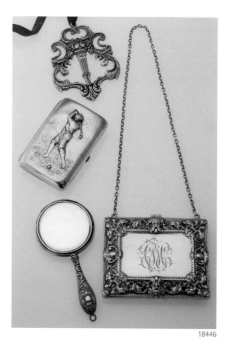

18446

FOUR SILVER AND SILVER PLATE MISCELLANEOUS SMALLS

Various makers

The first, a small silver vanity mirror depicting a woman playing golf in high relief, attributed to Unger Brothers; second, a silver plate ornament by Reed & Barton; third, a silver rectangular purse on a chain with original silk interior coin compartment, script monogram, marked Wm Kerr to interior edge; fourth, a parcel gilt silver cigarette case depicting a man playing golf in high relief, marked Unger Brothers

(Total: 4)

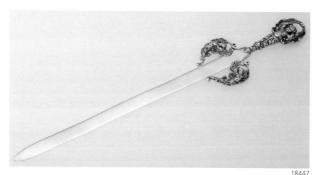

18447

AN AMERICAN SILVER RENAISSANCE REVIVAL LETTER OPENER

Mark of Shiebler, New York, c.1890

With three winged heraldic cherubs, one at each side of the top of the handle, one as the finial, pattern repeats on each side, *marked reverse of handle*

10.5in. long

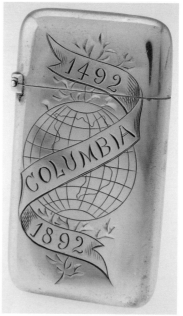

18448

AN AMERICAN SILVER COLUMBIA EXPOSITION MATCH SAFE

Mark of Whiting, Providence, Rhode Island, c.1892

Engraved on one side, a ribbon over a globe inscribed '1492/ Columbia/ 1892', *marked* inside edge

2.25in. high

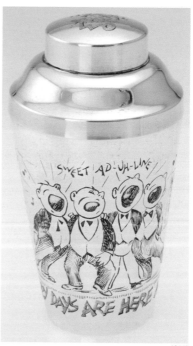

18449

AN AMERICAN SILVER COCKTAIL SHAKER

Mark of Blackington, North Attleboro, Massachusetts, c.1933

Of tapering cylindrical form, acid etched to depict a barbershop quartet singing 'Sweet Ad-uh-line' while a dog and a police officer smile at the scene, a radiant sun peeking out from behind a fence inscribed '21st Amendment', captioned 'tea for two' on lid, and 'Happy days are here again' at base, *marked underside*

4.25in. high

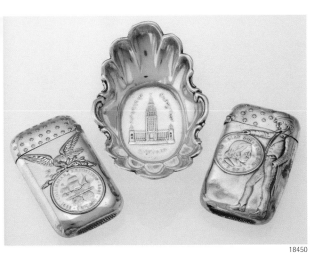

18450

**TWO AMERICAN SILVER MATCH SAFES,
CHICAGO'S COLUMBIAN EXPOSITION**

Unmarked, c.1892

Of similar design, the obverse depicting Uncle Sam holding up a Columbian
Souvenir Coin, the reverse depicting the American Eagle flying over the
reverse of the coin, stars on both sides of lid; *together with* a silver souvenir
nut dish depicting the American Exposition, Buffalo, 1901 by Knowles

3.75in. across (Total: 3)

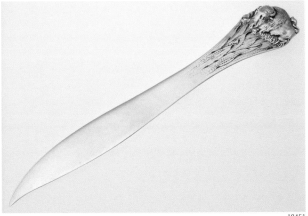

18451

AN AMERICAN SILVER WESTERN MOTIF LETTER OPENER

Mark of Shiebler, New York, c.1885

The handle with a buffalo in motion on the prairie, an unusual motif for
an American silver item of this era, retailed by Bigelow Kennard, *marked
reverse of handle*

8.2in. long

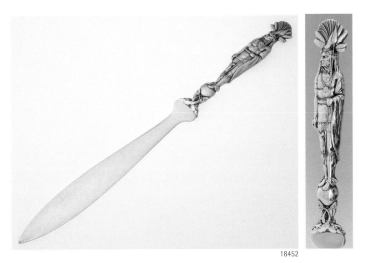

18452

A RARE AMERICAN SILVER NATIVE AMERICAN MOTIF LETTER OPENER

Mark of Shiebler, New York, c.1885

This unusual letter opener features a Native American warrior in full regalia
standing upon a globe supported by two neo-classical dolphins, fully detailed
front and back, in outstanding condition, *marked reverse of handle*

10in. long

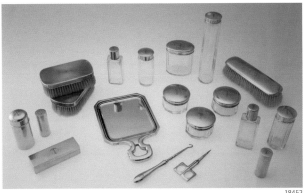

18453

AN AMERICAN SILVER GILT TRAVELLING VANITY SET

Various Makers, San Francisco, California, c.1930

The custom made blue leather fitted box with the original brown canvas cover,
box made by D. Balazs of San Francisco and retailed by Shreve & Co. of that
same city, the gilt vanity items by Gorham, Shreve and Simmons, consisting of
19 pieces excluding the case, all items with matching deco monogram, 'HTH', all
but two of the pieces sterling, two perfume bottles have identical monogrammed
tops but not silver (Total: 19 Items)

18454

A MODERN AMERICAN SILVER MINIATURE TROPHY URN

Maker unknown, c.1950

Urn on stand with two handles, decorative band on rim and body, *marked under
base*

1.1in. high

18455

A SILVER MINIATURE MUG

Unmarked, c.1900

Of cylindrical form with bands at base and rim, single shaped handle

1.6in. high

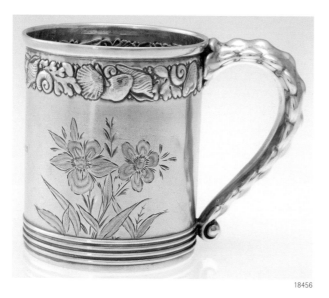

18456

AN AMERICAN SILVER AESTHETIC MOVEMENT CUP

Mark of Gorham, Providence, Rhode Island, c.1889

The base with threaded design, body engraved with foliage, upper rim with marine motif, shells and sea life, handle of organic form, a script period monogram, 'Allison', *marked underside*

3in. high

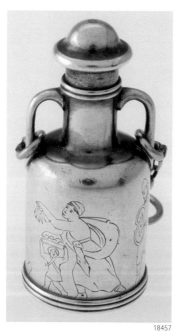

18457

AN AMERICAN SILVER GREEK REVIVAL SCENT BOTTLE

Mark of Tiffany & Co., New York, c.1875

Of amphora form hanging from a chain and chatelaine hoop, the body engraved with six different Greco-Roman figures, *marked underside*

3.7in. base to hoop

18458

AN ENGLISH SILVER MINIATURE CHOCOLATE POT

British hallmarks, Chester, England, c.1900

Of tapering cylindrical form with working hinged lid and right angle ebony handle, gold wash interior, *marked under base and interior of lid*

1.2in. high

18459

18459

AN AMERICAN SILVER ART NOUVEAU BELT BUCKLE

Mark of Kerr, Newark, New Jersey, c.1900

Each side of the buckle formed as neo-classical dolphins with an art nouveau flair, intact and devoid of repairs, *marked reverse*

4.8in. across

(Total: 2 Items)

18460

AN AMERICAN SILVER MINIATURE COVERED SUGAR BOWL

Mark of Black, Starr, Gorham, New York, 1940

A round miniature sugar bowl with a shaped lid and ball finial, *marked under base*

1.6in. diameter

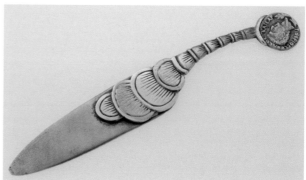

18461

18461

AN AMERICAN SILVER AESTHETIC MOVEMENT MEDALLION BOOK MARK

Mark of Gorham, Providence, Rhode Island, c.1880

Alternating bands of gold and silver decoration surmounted by a two-sided stylized Roman coin, similar to items in Shiebler's Homeric pattern, *marked reverse of handle*

4.25in. long

18462

A FIGURAL AMERICAN SILVER AESTHETIC MOVEMENT MINIATURE TABLE ACCESSORY

Maker unknown, c.1870

Probably by the Whiting Manufacturing Co., the stylized egg shell with cattails and leaves on each side, multi-piece construction, gilt interior, marked '925 sterling 150', for toothpicks or other items, *marked underside*

2.5in. high

18462

18463

AN ENGLISH SILVER MINIATURE TROPHY URN

c.1900

The urn with two handles and a single band along middle of body, engraved "1906. L.C.P.L.J.H.MILADY", *marked on outside near rim*

2in. high

18464

AN AMERICAN SILVER MINIATURE TROPHY URN

Mark of Reed & Barton, Taunton, Massachusetts, c.1900

Of baluster form on circular base, shaped handles, no monogram, *marked under base*

2.1in. high

18465

A SILVER MINIATURE TROPHY URN

Unmarked, c.1900

Of tapering ovoid form with circular base and two slender handles

2.1in. high

18466

18466

AN AMERICAN COIN SILVER GREEK REVIVAL SCENT BOTTLE

Attributed to Gorham, Providence, Rhode Island, c.1865

The amphora shaped vessel with curled handles, connected by a chain, generally hung from a chatelaine, parcel gilt with Greek revival engraving, matte finish, marked 'O3', no visible makers mark, *marked underside*

3in. not including chain

18467

AN AMERICAN SILVER MINIATURE CUP

Mark of Woodside, New York, c.1900

Baluster form body on circular stand, rococo figural handle, *marked under base*

1.9in. high

18468

AN ENGLISH SILVER MINIATURE CHOCOLATE POT

British hallmarks, Chester, England, c.1900

Of tapering cylindrical form with working hinged lid and right angle ebony handle, gold wash interior, *marked under base and interior of lid*

1.2in. high

18469

18469

AN AMERICAN SILVER AESTHETIC MOVEMENT BUCKLE

Mark of Shiebler, New York, c.1880

The hand hammered ground with applied owl, moth, bat, dragonfly, and spider, *marked reverse*

3in. high, 2.1in. wide

18470

A DANISH SILVER MINIATURE TRAY

Mark of Georg Jensen, c.1900

The tray with hammered finish, gadrooned edge and berry decoration, *marked on reverse*

2.3in. diameter

18471

A GERMAN SILVER CUP AND SAUCER SET

C-scrolls and flowers on a pebbled ground, the cup with gold wash interior and an open cartouche, *marked on both: '800', crown hallmark and 'GGH'*

the plate 5in. diameter, the cup 3in. high, 6.99oz (Total: 2)

18472

AN AMERICAN SIX PIECE BALTIMORE ROSE PATTERN VANITY SET

Mark of Stieff, Baltimore, c.1919

Two round brushes, one oval brush, one handled brush, one comb frame and one hand mirror, all with script monograms, some bristles missing, date marked for 1919, mirror in excellent condition, *marked on edges* (Total: 6)

Visit HeritageGalleries.com to view scalable images and bid online.

Session One, Auction #608 • Saturday, October 30, 2004 • 10:00 a.m. 141

18473

18473

AN AMERICAN SILVER ACID-CUT-BACK BRIDGE TROPHY

Mark of Tiffany & Co., New York, c.1895

A detailed engraving of two Victorian era couples playing cards at a table, a laurel wreath with hints of art nouveau decoration on the base, the interior gold washed, two handles and a round spreading base, 'T' date mark, *marked underside*

3.5in. high

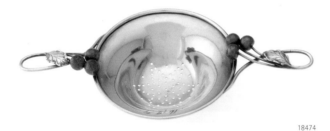

18474

18474

AN AMERICAN AESTHETIC MOVEMENT MIXED METAL TEA STRAINER

Mark of La Pierre, Newark, New Jersey, c.1880

The circular flaring lip tapering to a round bottom, hand drilled star-pattern holes, with two looped handles terminating in a cluster of three cherries each, script monogram interior rim, *marked underside*

6.75in. across

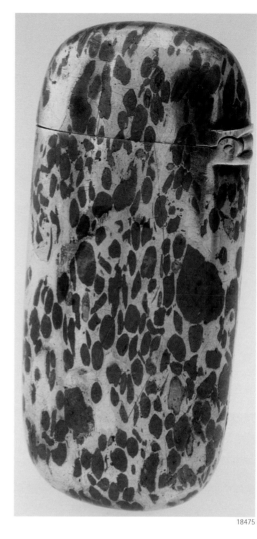

18475

AN AMERICAN AESTHETIC MOVEMENT MIXED METAL MATCH SAFE

Mark of Gorham, Providence, Rhode Island, 1879

The slender body in Cairo or 'Curio' style, date marked, stamped 'sterling and other metals', *marked on both interior rims*

2.75in. high, 1.2in. wide

18475

18476

AN ENGLISH SILVER MINIATURE TROPHY URN

c.1900

The urn with three shaped handles and a single band along middle of body and rim, *marked on outside near rim*

1.1in. high

18477

AN ENGLISH SILVER MINIATURE PITCHER

c.1930

Baluster form body on circular stand, shaped handle, *marked on outside near rim*

1.3in. high

18478

A PAIR OF AMERICAN BRASS VICTORIAN WALL SCONCES

Cast and engine turned extensions with stamped nozzles and wax pans, *together with* a single Victorian era cast and engine turned candlestick

the pair 8.5in. long (Total: 2)

18479

AN AMERICAN SILVER VICTORIAN ERA BABY RATTLE

Mark of Gorham, Providence, Rhode Island, c.1896

Twisted wire handle with two small attached bells and two large rattles, rattles with beaded edge and open work, *marked on edge*

3.8in. long

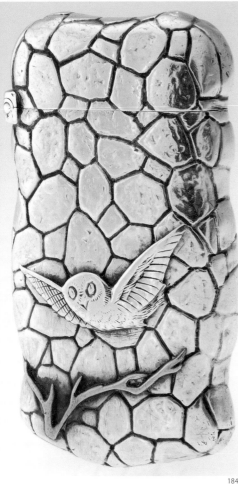

18480

18480
AN AMERICAN AESTHETIC MOVEMENT MIXED METAL MATCH SAFE
Mark of Whiting, Providence, Rhode Island, c.1880

The organic rectangular shaped body with pebble pattern ground, on one side a copper and silver applied crab, the other a silver applied owl in flight and a copper applied branch, gilt interior rim, *marked interior rim*
2.5in. high, 1.3in. wide

18481
AN AMERICAN SILVER EQUESTRIAN MOTIF MATCH SAFE
Mark of Gorham, Providence, Rhode Island, c.1890

One side depicting three racing horses neck in neck, the other with saddle, riding crop and helmet, period 'MFT' monogram, *marked inside rim*
2.5in. long

18481

18482
AN AMERICAN SILVER MEDALLION BROOCH
Maker unknown, c.1880

Of circular form with hammered finish, profile of Greco-Roman deity, *marked on reverse*
1.25in. diameter

18483
A MINIATURE CONTINENTAL PEARL-SET AND ENAMEL HAND MIRROR
Marked 900, 1910

Laurel wreath rim with bezel set seed pearls at terminal and base, multi-color enameled architectural depiction titled 'Paris Trocadero' foliate handle with ring for suspension, mirror with foxing, *marked on handle*
2.7in. long

18484
TWO AMERICAN COIN SILVER BUTTER DISH COVERS
Unmarked, c.1870

One hemisphere form cover with beaded finial, machining and four ovoid cartouches, two with lake scenes; one dome form cover with five-piece flower finial and hand engraved decoration, *together with* a partially complete coffee percolator, marked Black, Starr & Frost, New York, c.1890
the largest cover 4in. high, 5.75in. diameter (Total: 3)

18485
AN AMERICAN SILVER ADVERTISING LETTER OPENER
Mark of Shiebler, New York, c.1896

Fritzsche Brothers 25th anniversary, 1871 - 1896 *marked on blade*
9.5in. long, 2oz

18486
A MATCHED SET OF SIX CONTINENTAL SILVER LIQUEUR GLASSES

Inverted bell shape upon round pedestal foot, engraved with floral decoration, each with an open cartouche, gold wash interior, *marked on body of each, 84, 0.875, HN and duty mark*
2.5in. high, 4.14oz (Total: 6)

18487
AN AMERICAN SILVER MINIATURE CANDLESTICK
Mark of Dominick & Haff, New York, c.1890

Georgian style with round foot, gadrooned edge, a script monogram on foot, 'HMAN', *marked under base*
4in. high

18488
AN AMERICAN JAPANESE STYLE MIXED METAL MATCH SAFE

Mark of Gorham, Providence, Rhode Island, 1879

The slender rectangular body in the Cairo or 'Curio' style, one side with silver applied bird in rushes, the other with silver applied robed fisherman with pole and line, date marked and stamped 'sterling and other metals', *marked both sides of interior rim*

2.6in. high, 1.2in. wide

18488

18491

18491
AN AMERICAN COIN SILVER ARCHITECTURAL CARD CASE

Maker unknown, c.1865

Decorated with raised foliage, a large cartouche and a cathedral, hinged lid, *unmarked*

3.5in.long, 2.5in. across

18489
AN AMERICAN SILVER FIGURAL PAPER SPIKE

Mark of Kerr, Newark, New Jersey, c.1890

The body with four putti in relief, flanked by rococo decoration, original spike, original material under base, *mark on base*

6in. high

18490

18490
A PAIR OF MEXICAN SILVER WOOD MOUNTED SILVER DISHES

Mark of William Spratling, Taxco, Mexico, c.1950

Each mounted on a triangular piece of ebony wood, the interior of each bowl marked with the conjoined WS mark, William Spratling was a professor at Tulane university when he met William Faulkner, they were roommates in the French Quarter in the 1920's, Spratling went on to revive silversmithing in the town of Taxco Mexico which became a popular vacation spot for people in the motion picture industry during the 1940s, *marked inside bowls*

2.7in. diameter (Total: 2 Items)

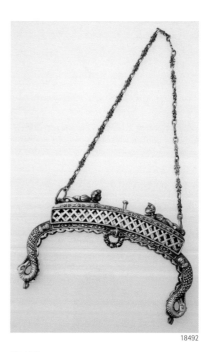

18492

18492
AN AMERICAN SILVER NEOCLASSICAL PURSE FRAME

Mark of Gorham, Providence, Rhode Island, c.1890

Chain with acanthus leaf links, frame surmounted by two human figures, lattice work and dragons on sides, *marked inside edge*

5.5in. across, 10.5in. long with chain extended, 5oz

18493

18493
AN AMERICAN SILVER AESTHETIC MOVEMENT COLOGNE BOTTLE
Mark of Gorham, Providence, Rhode Island, c.1885

Hand hammered surfaces, screw top with cork on interior, *marked on edge of top*
5in. long

18494
AN AMERICAN SILVER ART NOUVEAU BUCKLE
Mark of Unger Bros, Newark, New Jersey, c.1900

Oval form with art nouveau border and script monogram 'CES', *marked on reverse*
3in. wide, 1.31oz

18495
A PAIR OF AMERICAN SILVER SHERBERT BOWLS
Mark of Gorham, Providence, Rhode Island, c.1916

Both with reticulated rims, script monograms in bowl *marked under base*
5in. across, 7oz gross weight (Total: 2)

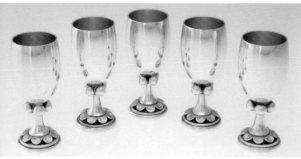

18496

18496
FIVE AMERICAN SILVER LA PAGLIA DESIGN CORDIALS
Mark of Alphonse La Paglia, Meriden, Connecticut, c.1955

The oval bodies set upon four balls, the stem with stylized floral ornament, marked 'La Paglia designed' in script
2.8in. high, 6.7oz (Total: 5 Items)

18497
TEN AMERICAN SILVER DECORATIVE NUT DISHES
Mark of Peter Krider, Philadelphia, Pennsylvania, c.1870

Each with matte finished bowls, engraved with period Greek revival decoration, *marked undersides*
2.2in. across (Total: 10 Items)

18498
A SILVER STRAWBERRY MOTIF VANITY BOX

Circular, the body with hinged lid decorated with deep repousse strawberries and vines, *marked 900, illegible makers mark*
1in. high, 4.5in. wide, 6.70oz

18499
A FRENCH SILVER CUP AND SAUCER SET

With chased paneled sweeping C-scroll form decoration and alternating floral motif marked underside of both with first standard mark and makers mark 'BB' with garland
the cup 2.5in. high, the plate 6.25in. diameter, 10.06oz (Total: 2)

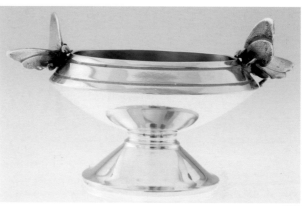

18500

18500
AN AMERICAN SILVER AESTHETIC MOVEMENT OPEN SALT
Mark of Gorham, Providence, Rhode Island, c.1865

Coin silver marks, applied butterflies on rim, *marked underside*
approx 2.2in. high

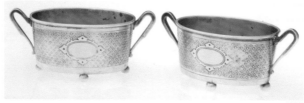

18501

18501
A PAIR OF AMERICAN SILVER OPEN SALTS
Mark of Ball Black & Co., New York, c.1860

Oval bodies, stippled surfaces with a cartouche on each side, one with a script 'N' monogram, cast and applied handles with four ball feet, *marked undersides*
1.6in. high, 4.3oz gross weight (Total: 2 Items)

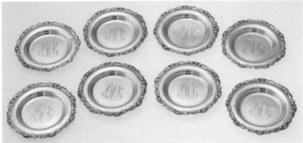

18502

18502
A SET OF EIGHT AMERICAN SILVER BUTTER PATS
Mark of Duhme, Cincinnati, Ohio, c.1900

Each with cast and applied rococo border and a period script 'FMS' monogram, *marked undersides*
3.2in. across (Total: 8 Items)

18503
AN AMERICAN SILVER-PLATED FIGURAL OIL LAMP
Mark of Derby Silver Co., Connecticut, c.1890

The round base with cast and applied dragon, hurricane shade and adjustable wick mechanism, some corrosion on base, *marked under base*
4.5in. high

18504
A LARGE GROUP OF LANTERNS
Various makers

The group consisting of fifty-three brass, copper and silver plate lanterns and lamp elements
the tallest 10in. high (Total: 53)

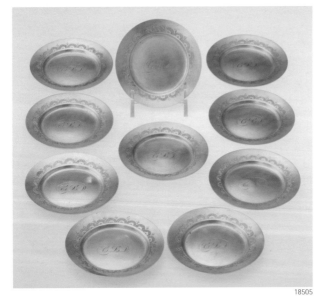

18505

18505
A GROUP OF TEN AMERICAN SILVER BUTTER PATS
Mark of Tiffany & Co., New York, c.1880

Each with a band of engraved semi-circles and floral accents, period 'CLD' monograms, block 'M' date mark, *marked undersides*
3in. diameter, 6.3oz gross weight (Total: 10 Items)

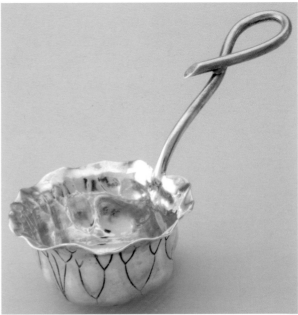

18506

18506
AN AMERICAN SILVER AESTHETIC MOVEMENT TEA STRAINER
Mark of Shiebler, New York, c.1885

Of deep leaf form, hand wrought, with veining detail to outside of strainer, vine looped handle, stamped 'O' on outside rim, *marked outside of rim*
4.5in. long, 1in. deep, 0.99oz

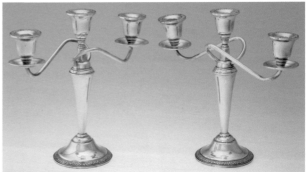

18507

18507
A PAIR OF AMERICAN SILVER PRELUDE PATTERN THREE-LIGHT CANDELABRA
Mark of International Silver, Meriden, Connecticut, 20th century

Each on circular base decorated in Prelude-pattern, the weighted candlesticks with attached bobeches, two arms supporting candle sockets decorated in Prelude-pattern radiating from a central candle socket, *marked undersides*
each 10.25in. high (Total: 2)

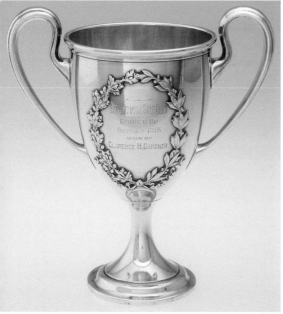

18508

AN AMERICAN SILVER GOLF TROPHY

Mark of Gorham, Providence, Rhode Island, c.1915

On circular base with two handles, with an applied wreath one side of holly and berries, the other of oak leaves and acorns, inscribed 'Hot Springs Golf Club/ Runner Up/ October 1915/ Won By/ Clarence H. Gardner,' *marked underside*

8.5in. high

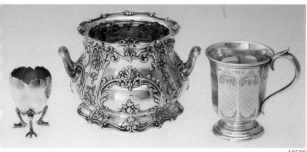

18509

THREE AMERICAN SILVER HOLLOWARE PIECES

Each marked Gorham, Providence, Rhode Island, various dates

The first a parcel-gilt and paneled bombe-form two-handled bowl with floral, foliate, and shell rococo-style decorations, script monogram and inscribed underside 'Jan'y 1903'; the second an engraved and machine-worked single-handle coin silver cup on circular base, c.1860; the third an egg cup on three chicken-form legs, c.1860; *each marked underside*

(Total: 3)

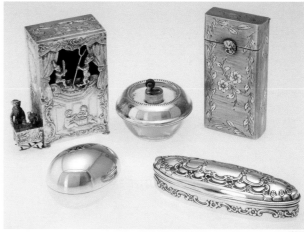

18510

FIVE SILVER MISCELLANEOUS SMALLS

Various makers

The first, a model of the Punch and Judy show, with an applied organ grinder and monkey to one side, the front with Punch facing a satyr on a stage, with scenes of putti engaged in various activities circling the box, continental hallmarks; the second a silver Cartier parcel-gilt egg form box with block initials 'S.D.C.,' marked to interior edge; the third a pressed glass and silver lighter marked Frank M. Whiting, Pat. Pending; the fourth a continental silver lady's cigarette case; the fifth a hinged vanity box by Tiffany & Co. dated marked 1890's (Total: 5 items)

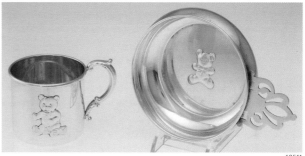

18511

A MATCHING AMERICAN SILVER CHILDS CUP AND PORRINGER

Mark of Lunt, Greenfield, Massachusetts, 20th century

Each with a raised 'Teddy Bear,' no monograms, excellent condition, *marked undersides*

5.6in. across, the porringer (Total: 2 Items)

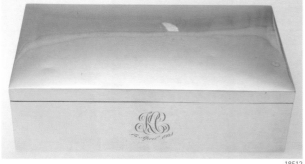

18512

AN AMERICAN SILVER HUMIDOR

Shreve Crump & Low, Boston, Massachusetts, c.1901

Rectangular with cedar wood lining, piano hinged lid, and script monogram with '16 April 1901,' *marked underside*

2.6in. high, 9in. wide; 31.06oz gross weight

18513

AN AMERICAN SILVER BREAD BASKET

Mark of Ferdinand Fuchs & Bros., New York, c.1900

The oval form basket with applied rococo scrolls, flowers and shells, the interior of bowl with radiating lobes surrounding an engraved armorial of a dancing leopard, reverse stamped Bailey Banks & Biddle, the Philadelphia retailer, *marked underside*

13.25in. long, 17.92oz

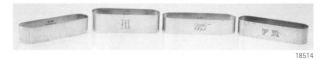

18514

FOUR AMERICAN SILVER HANDWROUGHT NAPKIN RINGS

Mark of Randahl Shop, Chicago, Illinois, c.1915

All four showing hammer marks through out, old JOR trademark, three with monograms, one without, *marked inside edge*

2.8in. wide each

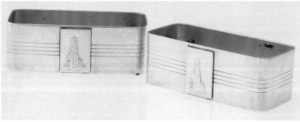

18515

A PAIR OF AMERICAN SILVER ART DECO NAPKIN RINGS

Mark of La Pierre, Newark, New Jersey, c.1930

The rectangular shaped rings decorated with straight lines and two applied medallions of skyscrapers, *marked inside*

2.5in. across

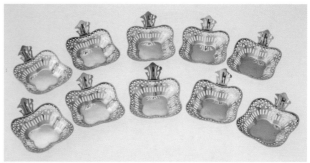

18516

A SET OF TEN AMERICAN SILVER NUT DISHES

Maker unknown, c.1920

Beaded edge rims with reticulated bodies, each set with a free standing cut monogram that functions as a clip for place cards, *marked undersides*

2.7in. across (Total: 10 Items)

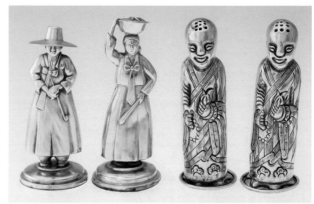

18517

TWO PAIR OF FIGURAL SILVER SALT AND PEPPER SHAKERS

Maker unknown, c.1950

The first pair a man and woman, one with a hat and one with a basket on her head, the second a pair of Buddha-like figures, *marked underside*

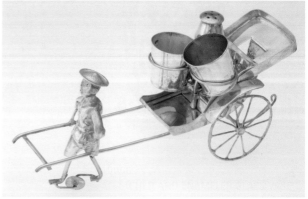

18518

A SILVER FIGURAL OPEN SALT AND PEPPER CADDY

Maker unknown, 20th century

The form of a rickshaw with two removable open salts and one pepper shaker, the item upon functioning wheels, *unmarked*

7.7in. long, 3.75in. high

18519
A PAIR OF LOOKING GLASSES
LeMaire Fi, Paris, c.1900

Brass and mother-of-pearl, engraved 'Margurite 1903', telescoping handle, *marked on bridge*
4in. across

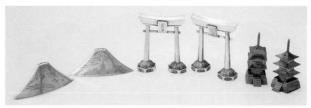
18522

18522
THREE PAIR OF FIGURAL SILVER SALT AND PEPPER SHAKERS
Maker unknown, 20th century

Each marked 'sterling 950', a gilt pair of pagodas, a pair in the form of Mount Fuji, a pair in the form of temple gates, *marked undersides*
3in. high, the largest

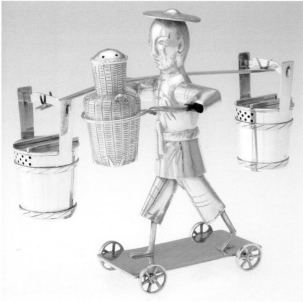
18520

18520
A FIGURAL SILVER SALT AND PEPPER CADDY
Maker unknown, 20th century

A man set upon a rolling cart carrying a pepper shaker in one hand and two salt shakers in the other, each piece marked 'sterling 950' *marked undersides*
5in. across, 4.7in. high

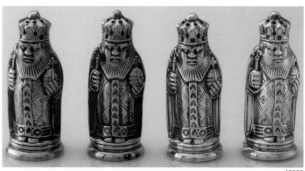
18523

18523
A GROUP OF FOUR SILVER GILT AND ENAMELED KING FIGURINES
Maker unknown, 20th century

One pair gilt and enameled, one pair silver, *marked undersides*
2.5in. high

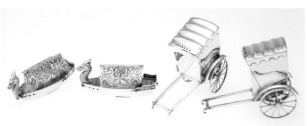
18521

18521
TWO PAIR FIGURAL SILVER SALT AND PEPPER SHAKERS
Maker unknown, 20th century

The first pair rickshaws, marked 950 sterling, the second pair covered hull boats with dragons mounted on the bow, also marked sterling 950, *marked undersides*
2.5in. across, each pair

END OF SESSION ONE

SESSION TWO — ART GLASS AND FINE ART

Public-Internet Auction #608

Saturday, October 30, 2004, 6:00 p.m., Lots 19001-19321

Dallas, Texas

A 19.5% Buyer's Premium Will Be Added To All Lots

Visit HeritageGalleries.com to view scalable images and bid online.

19001
AN OVERLAID AND ETCHED GLASS VASE
LeVerre France, c.1920

The canary yellow ground overlaid and etched in cobalt blue and orange with an art deco design depicting trees and fruit with stylized border, engraved signature, *LeVerre*
8in. high

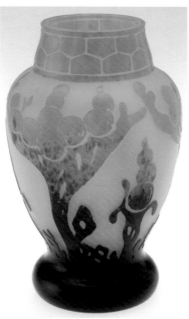

19001

19003
AN OVERLAID AND ETCHED GLASS VASE
Richard, c.1920

The solid yellow ground overlaid and etched with olive green foliage bearing a flower blossom, with cameo signature *Richard* and original label
6.5in. high

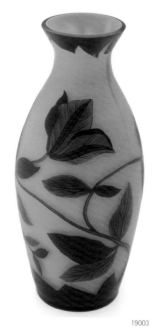

19003

19002
A CLASSICAL ROMAN MOTIF MOLDED GLASS VASE
Georges de Feure, c.1910

The footed vase molded in amethyst glass featuring a frieze of six classical Roman female musicians, antique embellishment such as chips and scratches added during factory process, manufactured by Daum Nancy for de Feure, molded signature to underside
5.5in. high
A similar lot illustrated: Guiseppe Cappa, *Le Genie Verrier De L'Europe*, p.255

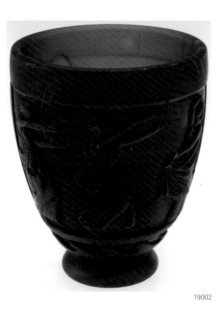

19002

19004
AN OVERLAID AND ETCHED GLASS VASE
Richard, c.1915

The canary yellow ground overlaid in purple and orange and etched to depict grapes and three butterflies in flight, with cameo signature *Richard*
10in. high

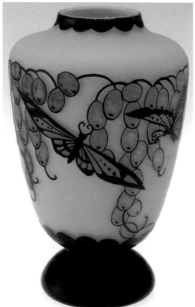

19004

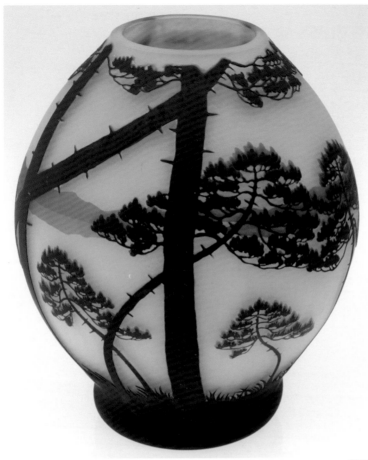

19005

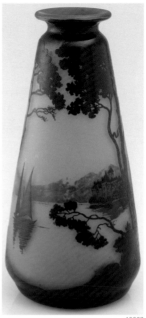

19007
AN OVERLAID AND ETCHED GLASS VASE
DeLatte, c.1900

The frosted blue ground overlaid in indigo and etched to depict a mountain-lined and wooded lake scene with sailboats and a chateau in the middleground, engraved *A. DeLatte Nancy*

19005
AN OVERLAID AND ETCHED GLASS VASE
Muller Frères, c.1900

The four-colored frosted ground overlaid with blue, green and black, etched to depict a wooded lake scene with mountains, with cameo signature *Muller Frëres Luneville*
12.75in. high

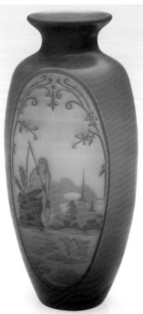

19006
AN OVERLAID AND ETCHED GLASS VASE
Muller Frères, c.1900

The frosted ground with an etched oval panel depicting a lady feeding birds beside a windy water front, the reverse with an etched oval panel depicting a lady fishing, a pond lily in the foreground, cameo signature *Muller Fres Lunéville*
12.5in. high

19006

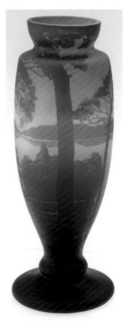

19008

19008
AN OVERLAID AND ETCHED GLASS PEDESTAL VASE
Muller Frères, c.1900

The frosted ground internally decorated with pink and white shading, acid etched and triple overlaid to depict a wooded lake front with mountains in the background, with cameo signature *Muller*
12in. high

19009

AN ART DECO PATE DE VERRE VASE

G. Argy Rousseau, c.1920

Internally decorated with a straight line design of orange brown and white, incised signature *G. Argy Rousseau*

8.5in. high

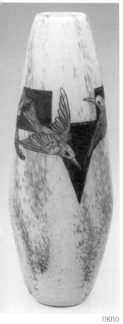

19010

AN ETCHED AND ENAMELED GLASS VASE

Legras, c.1920

The white ground speckled with brown, etched to depict birds in flight against an art deco pattern, engraved signature *Legras*

20in. high

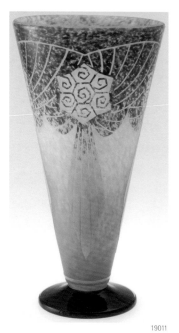

19011

AN OVERLAID AND ETCHED GLASS VASE

LeVerre Fransais, c.1920

The art deco style vase with black amethyst spreading foot, the internally mottled body flaring from peach to white to yellow to purple, cameo signature *Charder*

12in. high

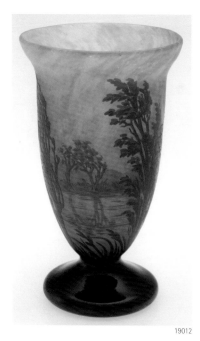

19012

AN OVERLAID AND ETCHED GLASS VASE

Daum Nancy, c.1910

The frosted mottled ground with pink, cream, and orange internal decorations acid etched to depict a burgundy wooded lake scene, with cameo signature *Daum Nancy/France* and the *Cross of Lorraine*

7.25in. high

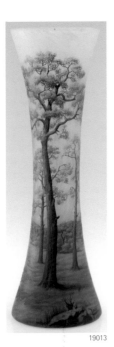

19013

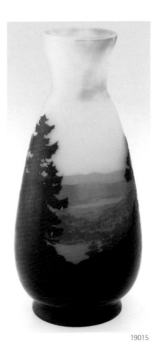

19015

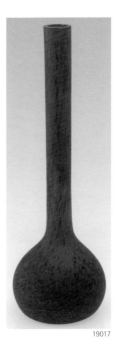

19017

19013
AN ETCHED AND ENAMELED GLASS VASE
Daum Nancy, c.1900

The white and blue mottled ground etched and intricately enameled to depict a mountain scene with trees and a lake in the foreground, best of color, enameled *Daum Nancy* with the *Cross of Lorraine* and artist signed *L.W.*
13.75in. high

19015
AN OVERLAID AND ETCHED GLASS VASE
Emile Gallé, c.1900

The frosted white and blue ground overlaid and etched in purple and blue overlaid and etched to depict a tree lined mountainous lake scene
10in. high

19017
A BULBOUS GLASS STICK VASE
DeLatte, c.1930

Mottled with red and dark orange colorations, stamped signature *DeLatte*
18.5in. high

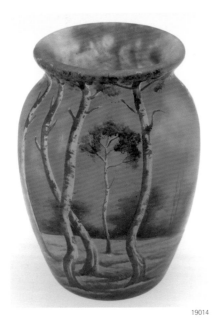

19014

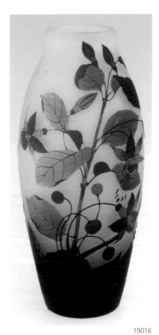

19016

19018

19014
AN ETCHED AND ENAMELED GLASS VASE
Muller Fréres, c.1900

The frosted blue, caramel and cream internally decorated ground overlaid with an etched enamel scene depicting a woody autumn field, signed in enamel *Muller Fres Luneville*
4.75in. high

19016
AN OVERLAID AND ETCHED GLASS VASE
Arsall, c.1900

The white frosted ground etched with a purple floral and berry design, with cameo signature *Arsall*
11.75in. high

19018
AN AMERICAN CONTEMPORARY GLASS VASE
Unknown, c.1960

The opaque ground with a swirling red and purple design in a cypriot technique, iridescent glaze, unsigned
11.5in. high

19019

19021

19023

19019
A BLUE AURENE BULBOUS VASE
Steuben, c.1900

The iridescent coloration reflects metallic purple, blue, green, and yellow hues, engraved signature *Steuben Aurene 7100*
12in. high

19021
A SORBET GLASS
Steuben, c.1920

The oriental poppy form with a striated pink and white coloration, *unsigned*
6in. high

19023
A BLOWN GLASS VASE
Schneider, c.1920

The tangerine, yellow and purple mottled internal decoration blend together in a smooth clear finish, engraved signature *Schneider/France*
7in. high

19020

19022

19024

19020
A MOSAIC THREADED GLASS VASE
Fenton, c.1920

The dark metallic baluster form decorated with yellow, red, orange and blue splattered dots covered with glass threading, *unsigned*
9.5in. high

19022
AN INTAGLIO CUT AND COLORED GLASS VASE
Moser, c.1890

Of baluster form, the green to clear glass with gold intaglio cut floral design and a scalloped rim, *unsigned*
14.7in. high

19024
A FLARED ITALIAN GLASS VASE
Murano, c.1940

The rainbow tinted glass varying from blue to orange to red with fluted rim, marked with the original label *Made in/Murano/Italy*
14in. high

19025
A FRENCH GLASS FIGURINE
Daum Nancy, c.1900

The glass a green transition to purple, carved figure of two bears, etched signature *Daum France*
4in. high

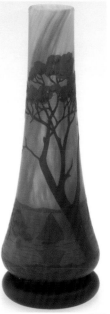

19027

19027
AN OVERLAID AND ETCHED GLASS VASE
Daum Nancy, c.1900

The orange, red and yellow streaked ground overlaid and etched to depict a wooded lake scene featuring sailboats, with cameo signature *Daum Nancy* and the *Cross of Lorraine*
8.5in. high

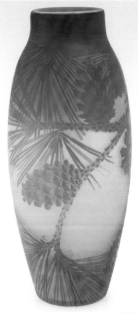

19026

19026
AN OVERLAID AND ETCHED GLASS VASE
Emile Gallé, c.1900

Of conical form and short collar, the milky ground overlaid and etched in caramel and amber depicting long needled pine tree branches laden with pine cones, signed *Gallé* after a star

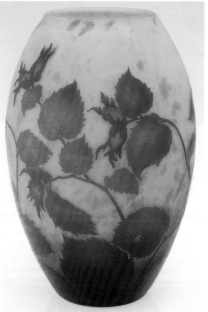

19028

19028
AN OVERLAID AND ETCHED GLASS VASE
Daum Nancy, c.1920

The yellow ground internally decorated with orange and green spots etched and double overlaid with amber leafed branches and floral patterns, with cameo signature *Daum Nancy/France* and the *Cross of Lorraine*
13in. high

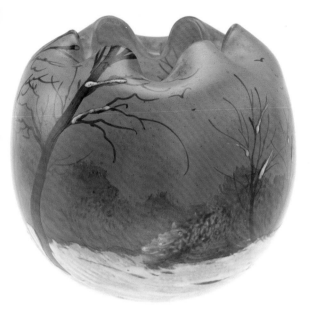

19029

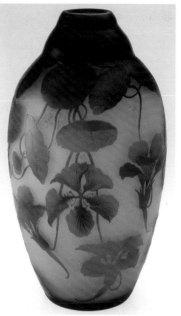

19031

19029
AN ENAMELED GLASS VASE
egras, c.1900

The rose bowl shaped vase has an amber ground with enameled decoration
n browns, orange and white depicting a winter scene, enamel signature
Legras
in. high

19031
AN OVERLAID AND ETCHED GLASS VASE
D'Argental, c.1900

The etched and overlaid vase depicting a floral design in brown and orange
on an ochre ground, double domed rim, best of color, signed *D'Argental*
with the *Cross of Lorraine*
12in. high

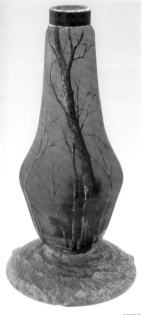

19030

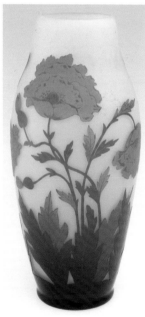

19032

19030
AN OVERLAID AND ETCHED GLASS LAMP BASE
Daum Nancy, c.1900

The gray base textured with white enamel to depict a snowy landscape,
rising to an orange frosted ground etched and enameled with a winter
forest scene, enameled *Daum Nancy* with the *Cross of Lorraine*
13in. high

19032
AN OVERLAID AND ETCHED GLASS VASE
Art, c.1920

The rose frosted ground triple overlaid and acid etched to depict two
butterflies on red and pink floral plants, with cameo signature *Art*
13.5in. high

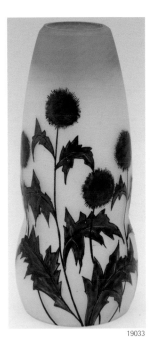

19033

AN ENAMELED DOUBLE GOURD VASE

Legras, c.1930

The frosted ground with enameled green and blue floral design and orange highlights near the rim, *unsigned*

12in. high

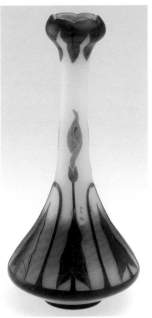

19035

AN OVERLAID AND ETCHED GLASS VASE

DeVez, c.1900

The textured cream and caramel ground overlaid and etched with dark ochre cut to orange, cameo signature *DeVez*

11in. high

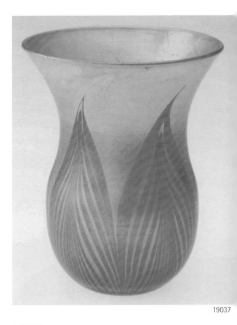

19037

AN AMERICAN IRIDESCENT VASE

Tiffany, c.1900

The iridescent finish features leaf design in green, etched signature *L.C.Tiffany*

4in. high

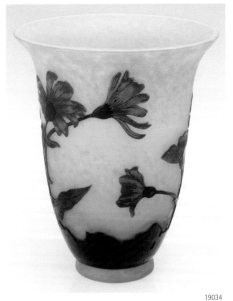

19034

AN OVERLAID AND ETCHED GLASS VASE

Andre DeLatte, c.1910

The yellow, orange and pink internally speckled ground overlaid and etched with dark blue branched flowers, cameo signature *ADeLatte Nancy-*

9in. high

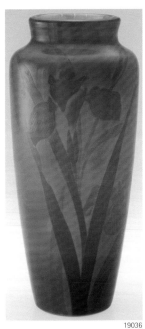

19036

AN OVERLAID, ETCHED AND WHEEL-POLISHED GLASS VASE

D. Christian Meisenthal, c.1900

The avocado to lime green ground etched and overlaid to depict irises, engraved signature *Christian Meisenthal*

11in. high

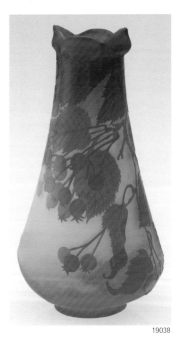

19038

AN OVERLAID AND ETCHED GLASS VASE

Emile Gallé, c.1900

With a sculpted rim, the white, red and yellow internal decorations triple overlaid and acid etched with fire polished cherries and leaves, cameo signature *Gallé*

10.75in. high

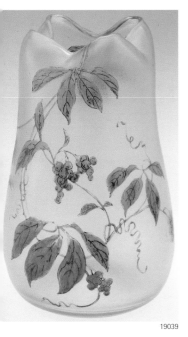

19039

AN ETCHED AND ENAMELED GLASS VASE

Daum Nancy, c.1900

The bulbous vase with a pinched top, silver and black enameling depicts vines and grapes, engraved Daum Nancy with the *Cross of Lorraine*

10in. high

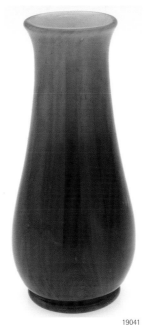

19041

AN AMERICAN REACTIVE PAPERWEIGHT GLASS VASE

Tiffany, c.1900

The laminated paperweight design with blue and amber swirls, engraved signature *L.C.Tiffany Favrile V259*

7in. high

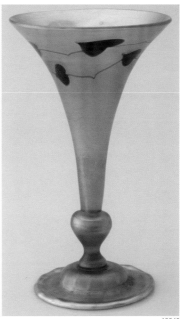

19043

AN AMERICAN IRIDESCENT HEART AND VINE MOTIF VASE

Tiffany, c.1900

The footed trumpet shape accentuated by brilliant gold highlights fully decorated in deep green hearts and vine motif, engraved signature *M. Louis C. Tiffany 'Furnitures Inc. Favrile'*

10in. high

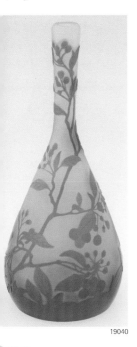

19040

AN OVERLAID AND ETCHED GLASS VASE

Emile Gallé, c.1900

The white frosted ground with fire polished orange cameo overlay etched to depict berries and leaves, with cameo signature *Gallé*

8in. high

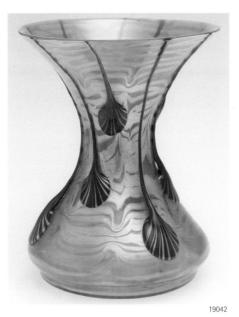

19042

AN IRIDESCENT APPLIED TEARDROP GLASS VASE

Loetz, c.1900

Decorated with a dripping teardrop applique in cobalt blue, the iridescent design covers the orange glass, engraved signature *Loetz/Austria*

7in. high

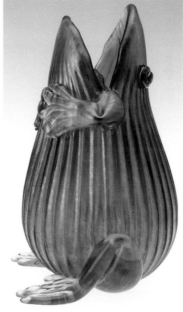

19044

AN IRIDESCENT FIGURAL GLASS FROG

Loetz, c.1900

The frog, green colored with iridescent highlights, applique arms and legs with applied eyes, ribbed body

7in. high

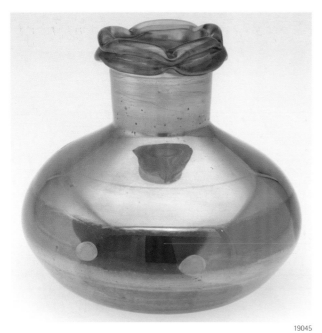

19045

19047

19045
AN AMERICAN PAPERWEIGHT GLASS VASE
Tiffany, c.1900

The iridescent glass decorated with an internal paperweight design of reds and greens with an unusual applique double lipped rim, engraved numbers on bottom *5536*

7in. high, 8in. across

19047
A JAPANESE STYLE GILT AND ENAMEL GLASS VASE
Auguste Jean, France, c.1885

The amethyst body with applied blue feet and decorative appliques, enameled and patterned Japanese style panels and foliage, signed *A. Jean*

11.7in. high

19046

19048

19046
AN AMERICAN SILVER MOUNTED AND ENAMELED GLASS DECANTER
Mark of Hawkes, c.1920

An enameled glass decanter with a mallard duck flying above a body of water with cattails, the friction fit sterling top perforated with a lid, *marked on silver mounts*

12in. high

19048
A CARVED AND GILT DECORATED 'VASA PARLANT' GLASS VASE
B & S, c.1909

The cobalt blue vase wheel carved with vines and highlighted with gilt on vines and rim, (this 'vasa parlant' speaks of a memorial to the women of the LaMilhusina in homeland defense of France dated 1909), gold gilt signature on bottom with the *Cross of Lorraine*

6in. high

19049

19049
AN INTAGLIO CUT GLASS THREE-HANDLED LOVING CUP
Moser, c.1890

The olive green ground with highly intricate intaglio cut gilt floral swags, *unsigned*
7in. high

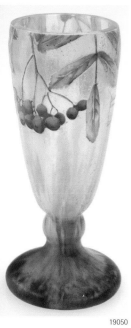

19050

19050
AN OVERLAID AND ETCHED GLASS CABINET VASE
Daum Nancy, c.1900

The red enameled cherries and leaves with yellow and brown cameo at the footed base, with cameo signature *Daum Nancy* and the *Cross of Lorraine*
4.75in. high

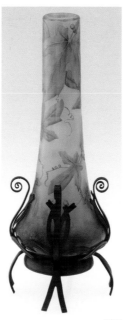

19051

19051
AN OVERLAID AND ETCHED VASE ON BRONZE STAND
Daum Nancy, c.1900

The overlaid and etched vase with internal color of mottled yellow, the overlay with green vines and red berries, the vase sits in a bronze pedestal, cameo signature *Daum Nancy* with the *Cross of Lorraine*
10in. high

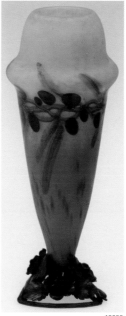

19052

19052
AN ENAMELED GLASS VASE WITH IRON FLORAL STAND
Schneider, c.1900

The base molded with rose buds supports a glass vase with orange to cream frosted glass ground, hand painted enamel olive branch, incised signature *Schneider*
12.3in. high

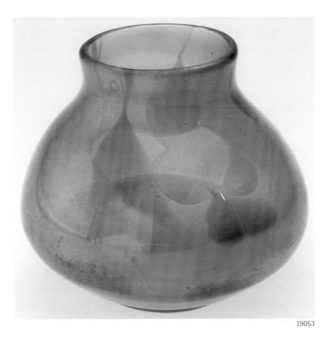

19053

19055

19053

AN AMERICAN PAPERWEIGHT GLASS VASE

Tiffany, c.1900

The umber ground decorated with cream flowers and olive green leaves, engraved signature *L.C.Tiffany Favrile*

6.25in. high, 7in. across

19055

AN OVERLAID AND ETCHED PANELED GLASS VASE

Emile Gallé, c.1904

The hexagon shape with frosted ground overlaid and etched to depict flowering purple hydrangea blossoms and leafage, with cameo signature *Gallé* after a star

8.75in high

19054

19056

19054

AN OVERLAID AND ETCHED GLASS VASE

Emile Gallé, c.1900

The frosted ground triple overlaid with lavender, pink, and sage, and etched to depict hydrangea, with cameo signature *Gallé*

19056

AN OVERLAID AND ETCHED GLASS VASE

Thomas Webb and Sons, c.1880

The azure ground overlaid in ivory and etched in a floral motif, stamped signature *Thomas Webb & Sons*

5in. high

19057

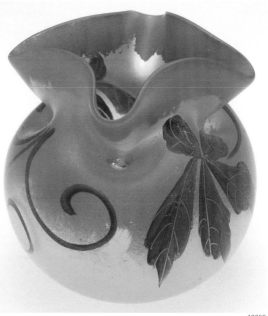

19059

19057
AN AMERICAN IRIDESCENT FLOWER FORM GLASS VASE
Tiffany, c.1900

The gold iridescent flower form fluted vase, best of color with blue and magenta highlights, signed *1066 - 1369K L.C. Tiffany - Favrile*
10.5in. high

19059
AN ENAMEL PAINTED GLASS VASE
Legras, c.1920

Pinched rim, the burnt orange top blends transitions into a frosted white and enameled with amber leaves, signed in enamel *Leg*
4.5in. high

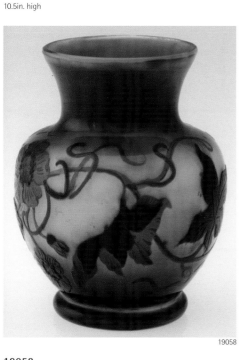

19058

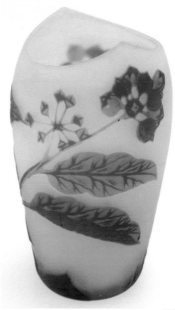

19060

19058
AN OVERLAID AND ETCHED GLASS VASE
Daum Nancy, c.1900

The frosted ground overlaid in deep purple and etched in a floral motif, fire polished, engraved *Daum Nancy* with the *Cross of Lorraine*
4in. high

19060
AN OVERLAID AND ETCHED CABINET GLASS VASE
Richard, c.1910

The frosted white and yellow ground double overlaid in forest green and olive, etched to depict flower buds and leaves, with cameo signature *Richard*
4.5in. high

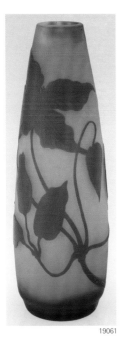

19061

AN OVERLAID AND ETCHED GLASS VASE

Emile Gallé, c.1904

The soft caramel and white frosted ground overlaid in amethyst and etched to depict a trailing floral design, with cameo signature *Gallé* after a star

10.25in. high

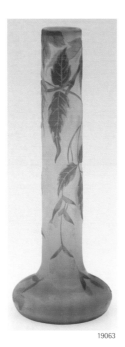

19063

AN OVERLAID AND ETCHED GLASS VASE

Emile Gallé, c.1900

The caramel to rose frosted ground overlaid with light green, cream and yellow leafy branches, cameo signature *Gallé*

13.5in. high

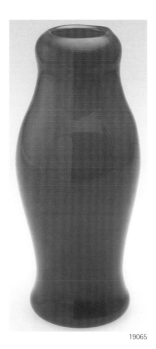

19065

AN AMERICAN FAVRILE GLASS VASE

Tiffany, c.1900

The double gourd shape cased in Chinese red, engraved signature *L.C.T.*

11in. high

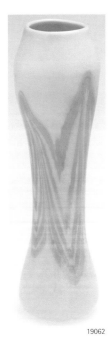

19062

AN AMERICAN FAVRILE GLASS VASE

Tiffany, c.1900

The tall slender form with ivory ground and pink internal coloration, elongated gold favrile decoration swirling around the body, engraved signature *L.C.T.*

12.7in. high

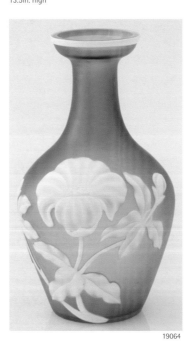

19064

AN OVERLAID AND ETCHED GLASS VASE

Thomas Webb and Sons, c.1890

The green frosted ground overlaid in ivory and etched to depict a floral design, *unsigned*

4in. high

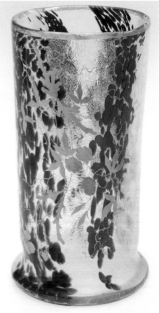

19066

AN ETCHED AND ENAMELED GLASS VASE

Ernest Baptiste Leveille, c.1900

The burgundy, white and burnt orange internally decorated ground overlaid with a gold gilt and enameled floral design, intricately etched on the inside, engraved signature *E.Leveille Paris*

9.5in. high

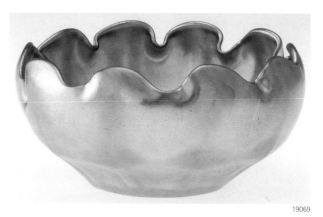

19069

AN AMERICAN IRIDESCENT GLASS BOWL
Tiffany, c.1900

With ruffled rim, iridescent gold with ink blue coloration, etched *L.C.T*
3.5in. diameter

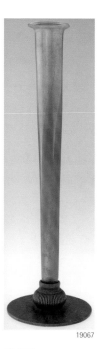

19067

19067

AN AMERICAN ART NOUVEAU BRONZE AND GLASS BUD VASE
Tiffany, c.1900

The bronze base supports a flaring bud vase with green frond decoration over gold iridescence, both glass and bronze signed, the glass engraved *L.C.T.,* the bronze stamped *Tiffany Studios New York 710*
11in. high

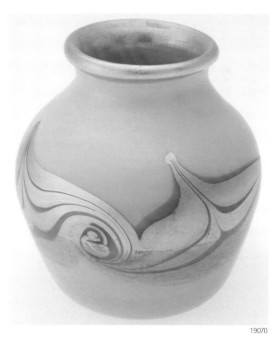

19070

19070

AN AMERICAN FAVRILE GLASS CABINET VASE
Tiffany, c.1900

The yellow ground with swirling green and metallic design in the center and soft gold rim, engraved signature *L.C. Tiffany Favrile*
3.5in. high

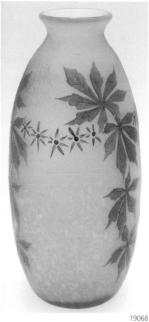

19068

19068

AN ETCHED AND ENAMELED GLASS VASE
Legras, c.1920

The pink ground acid etched and enameled with art deco style leaves and flowers in burgundy, internal white clethra dot decorations, enameled *Legras*
12in. high

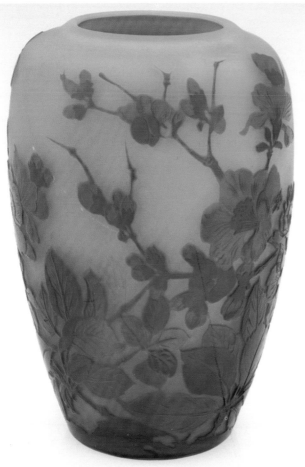

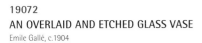

19071
AN OVERLAID AND ETCHED GLASS VASE
Emile Gallé, c.1915

The flattened form, fire polished frosted white ground with a yellow interior etched to depict orange and amber flowering cherry blossom branches, with cameo signature *Gallé*
7.5in. high

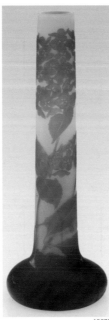

19072
AN OVERLAID AND ETCHED GLASS VASE
Emile Gallé, c.1904

The frosted peach shading to lavender ground overlaid in violet and carmel brown and etched to depict blossoming hydrangea and foliage, with cameo signature *Gallé* after a star
17.5in. high

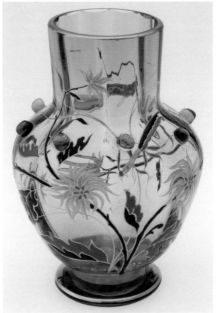

19073
AN ETCHED AND ENAMELED GLASS VASE
Emile Gallé, c.1900

The multi-colored enameling depicting a floral design and a praying mantis, and decorated with eight light blue applied glass beads, signed in enamel *E. Gallé Nancy*
5.7in. high

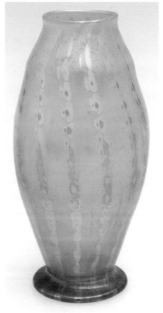

19074
AN AMERICAN IRIDESCENT GLASS VASE
Tiffany, c.1900

The opalescent glass with copper highlights and striated decoration from rim to base, engraved signature with numbers *LCT 92752*
6in. high

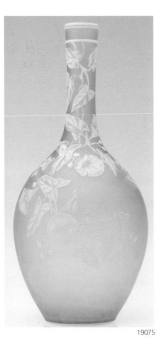

19075

AN OVERLAID AND ETCHED GLASS VASE

Thomas Webb & Sons, c.1880

The yellow ground etched with ivory colored leaves and flowers, stamped with signature *Thomas Webb & Sons/Cameo*

11in. high

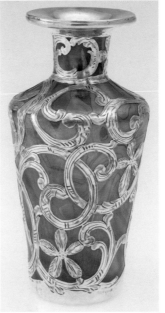

19077

A SILVER OVERLAID PAPERWEIGHT GLASS VASE

Loetz, c.1900

The iridescent ground overlaid with a silver design in an art nouveau motif, engraved signature *Loetz/Austria*

6in. high

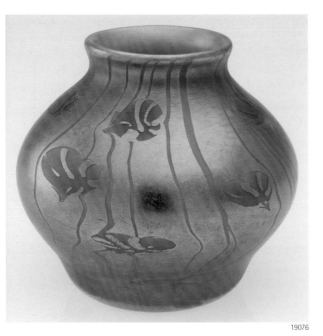

19076

AN AMERICAN ETCHED IRIDESCENT GLASS VASE

Tiffany, c.1900

The green ground overlaid and etched with an iridescent gold depicting leaves and vines that covers the entire bulbous form, engraved signature *L.C.T Favrile*

5.5in. high

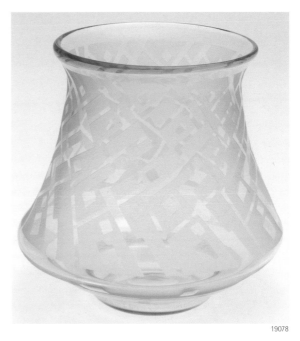

19078

AN ART DECO ETCHED GLASS VASE

Daum Nancy, c.1930

The peach tinted glass ground acid etched with an art deco pattern, engraved signature *Daum Nancy FRANCE*

8.25in. high

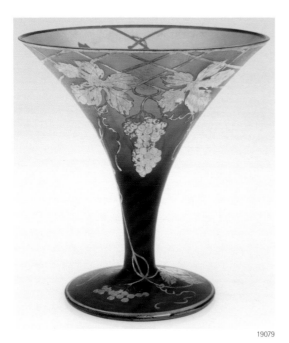

19079

A SILVER ENAMELED GLASS VASE

Loetz, c.1900

The art nouveau style enameled silver design consisting of berries and ivy leaves over a dark green tinted glass, *unsigned*

8.7in. high

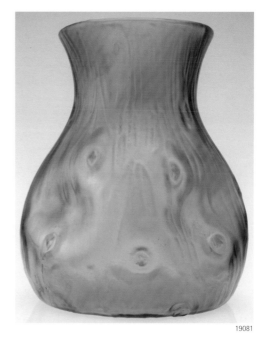

19081

A GREEN RUSTICANA GLASS VASE

Loetz, c.1900

The green glass with subtle iridescence, art nouveau form and five pinched sides, *unsigned*

7.3in. high

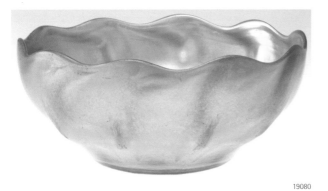

19080

AN AMERICAN IRIDESCENT GLASS BOWL

Tiffany, c.1900

An iridescent glass bowl with ruffled rim, magenta highlights, etched *L.C. Tiffany*

7.5in diameter

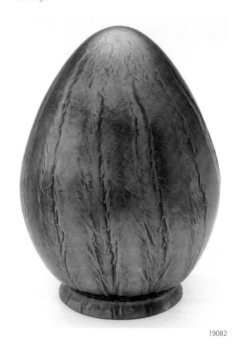

19082

AN IRIDESCENT BULLET FORM GLASS LAMP SHADE

Loetz, c.1900

The blue, green and purple iridescent glass in an egg shape with short collar, *unsigned*

7.5in. high

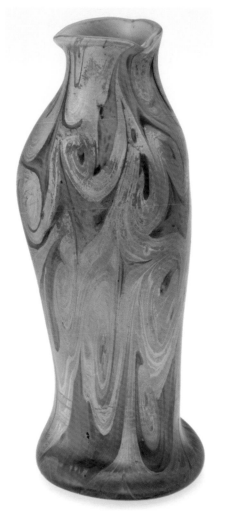

19083
A CYPRIOTE
GLASS VASE
Tiffany, c.1900

The three-sided rim
and form with green
iridescent glass covered
with heavy swirls of
multi-colored metallic
designs, engraved
signature *L.C.T.*
9in. high

19083

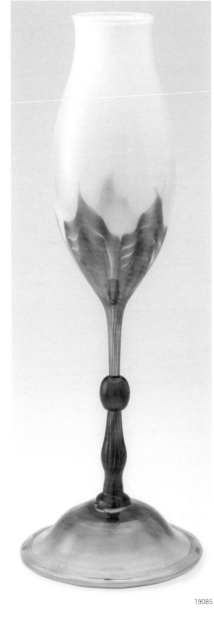

19085
AN AMERICAN
FLOWER FORM
GLASS VASE
Tiffany, c.1900

The flower form shape
begins with a gold
iridescent base rising to
a green stem finishing
with a green pulled
feather decoration in the
body, top turns to white
opalescent
15in. high

19085

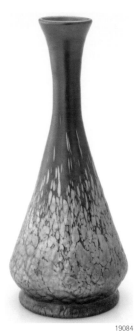

19084
AN IRIDESCENT GLASS VASE
Loetz, c.1900

Cobalt blue with heavy oil spot iridescent
decoration, best of color, engraved
signature *Loetz Austria Pontil*
10in. high

19084

19086
A GLASS FOOTED VASE
Loetz, c.1900

With an iridescent applique
on the stem that rises to
a sea shell motif cased
internally in white with
green outside, *unsigned*
7.5in. high

19086

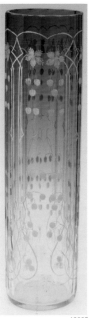

19087

19087
AN INTAGLIO CUT GLASS VASE
Moser, c.1890

The clear to green crystal glass with gold intaglio cut floral design, *unsigned*
14.7in. high

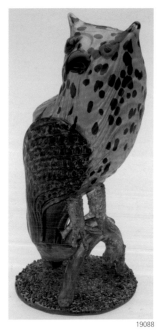

19088

19088
AN OWL SHAPED GLASS VASE
Loetz, c.1905

The iridescent glass sculpted owl perched on a branch, with a vase hole on the back, shows purple and green oil spots, *unsigned*
10.25in. high

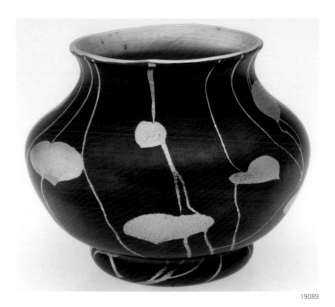

19089

19089
AN AMERICAN FAVRILE HEART AND VINE GLASS VASE
Tiffany, c.1900

The footed dark green iridescent bulbous form decorated with a metallic hearts and vines motif, engraved signature *L.C.Tiffany Favrile 2485B*
4in. high, 5.5in. across

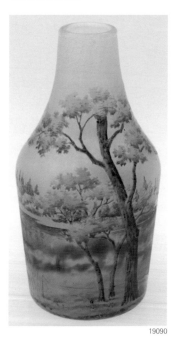

19090

19090
AN ETCHED AND ENAMELED GLASS SCENIC VASE
Daum Nancy, c.1900

The internally decorated blue, green and white ground overlaid to depict a placid lake scene with enameled trees, signed in enamel *Daum Nancy* with the *Cross of Lorraine*
5in. high

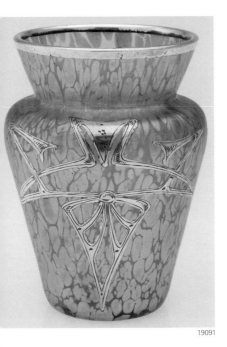

19091

A SILVER OVERLAID CRETA PAPILLON GLASS VASE

Loetz, c.1900

The green ground with blue oil spot decoration under a silver art deco design, *unsigned*

4.5in. high

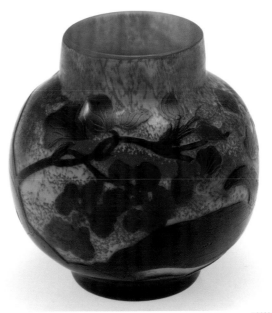

19093

AN OVERLAID AND ETCHED GLASS VASE

Emile Gallé, c.1900

The yellow and amber internal decorations and etched with brown leaves and flowers, with cameo signature *Gallé*

3.5in. high

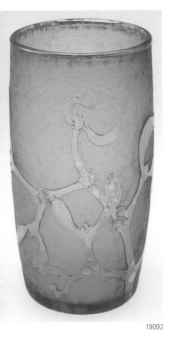

19092

AN ETCHED AND ENAMELED TUMBLER

Daum c.1900

The green glass tumbler etched in gold vine motif with white enameled berries, rim also gold, signed in gold *Daum, Nancy*

5in. high

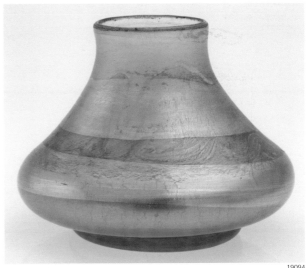

19094

AN AMERICAN IRIDESCENT GLASS CABINET VASE

Tiffany, c.1900

The iridescent glass with swirling blue, gold and magenta designs, engraved signature with numbers *LCT 8465*

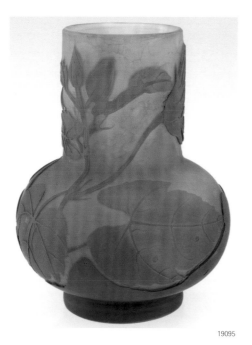

19095

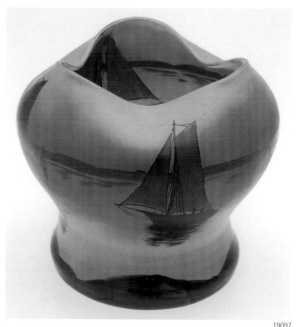

19097

19097
AN ENAMELED SCENIC GLASS VASE
Legras, c.1920

The tangerine and burnt yellow glass enameled to depict a coastal scene at dusk with sailboats, signed in enamel *Legras*
6.5in. high

19095
AN OVERLAID AND ETCHED GLASS VASE
Emile Gallé, c.1900

The frosted glass overlaid with green, etched to depict a floral motif, cameo signature *Gallé*
3.5in. high

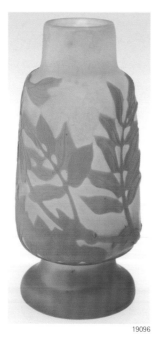

19096

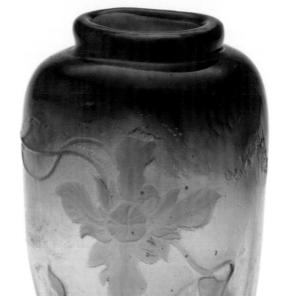

19098

19098
A THICK AMETHYST WHEEL CARVED VASE
Emile Gallé, c.1890

Wheel carved and engraved showing a clematis flower with leaves, engraved signature *cristallier Gallé Nancy Depose*

19096
AN OVERLAID AND ETCHED GLASS VASE
Emile Gallé, c.1900

The frosted glass vase overlaid in orange and carved in floral and leaf motif, cameo signature *Gallé*
3.75in.

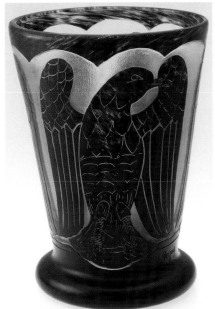

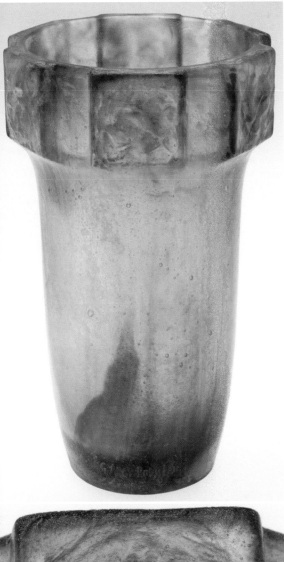

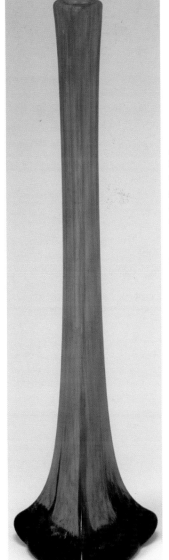

19100

AN OVERLAID AND ETCHED GLASS VASE

Degue, c.1920

The etched and overlaid art deco vase with purple cut to clear frosted etched depicting three eagles, engraved signature *Degue*

12in. high

19100

19101

A MONUMENTAL GLASS VASE

Daum Nancy, c.1900

With a long triangular neck spreading to the bulbous triangular base, streaked with splashes of forest green and burnt umber, signed in intaglio *Daum Nancy* with the *Cross of Lorraine*

29in. high

19099

19099

AN ART DECO PATE DE VERRE VASE

G. Argy Rousseau, c1920

The art deco style glass vase internally decorated with swirls of yellow, gold and brown, flaring border with six raised panels depicting a different face of a wild cat (lion, tiger, leopard, etc) on each, incised signature *G. Argy Rousseau*

8.5in. high

19101

19102

AN OVERLAID AND ETCHED GLASS VASE

Val Saint Lambert, c.1900

The frosted ground acid etched and fire polished with yellow, amber, purple and white colorations showing a spider hanging from web on a thorned blackberry bush, rare racoo firing at base, with cameo signature *V S L*

10in. high

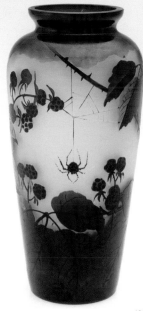

19102

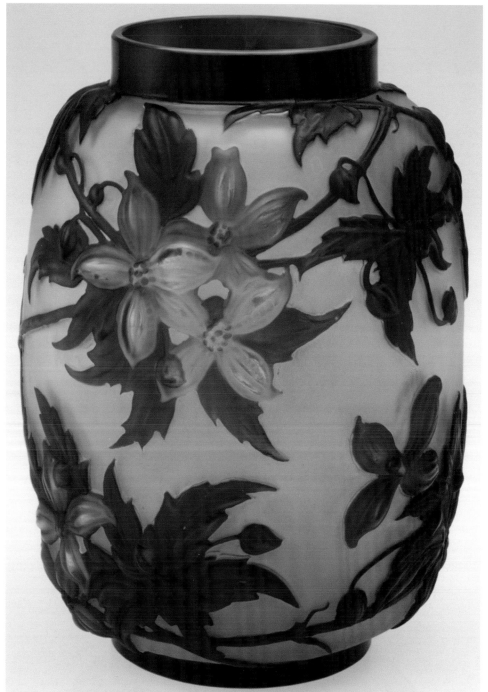

19103

A MOLD-BLOWN, OVERLAID AND ETCHED GLASS 'CLEMATIS' VASE

Emile Gallé, c.1910

The frosted gold opalescent ground mold-blown and etched to depict blossoming purple clematis on trailing branches, with cameo signature *Gallé*

10in. high

19103

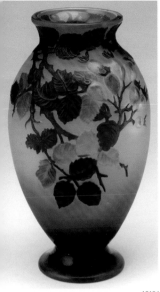

19104

19104
A WILD-ROSE MOLD-BLOWN, OVERLAID AND ETCHED GLASS VASE
Emile Gallé, c.1910

The frosted yellow shading to periwinkle ground, overlaid in sky blue and deep chestnut, mold-blown and etched with rose hips on leafing branches, with cameo signature *Gallé* after a star
9.75in. high

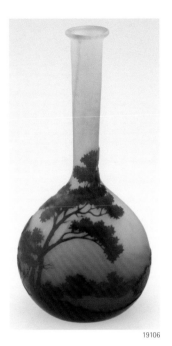

19106

19106
AN OVERLAID AND ETCHED GLASS VASE
Emile Gallé, c.1900

The light pink frosted background etched with olive green trees beside a placid lake, with cameo signature *E. Gallé*
7.3in. high

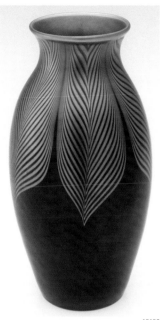

19108

19108
AN AMERICAN FAVRILE GLASS VASE
Tiffany, c.1900

The forest green glass decorated from the top down with five iridescent pulled feathers, engraved signature *L.C.T Favrile*
10in. high

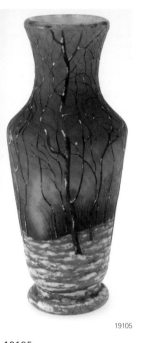

19105

19105
AN ETCHED AND ENAMELED GLASS VASE
Daum Nancy, c.1900

The orange and yellow internal decorations with a frosty overlay etched to depict a winter forest scene with leaf barren trees, signed in enamel *Daum/ Nancy*
5.7in. high

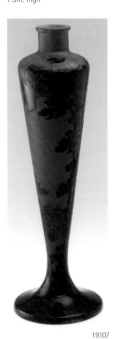

19107

19107
AN OVERLAID AND ETCHED GLASS LAMP BASE
Emile Gallé, c.1900

The pedestaled, fire polished purple trees reduced with martele technique to a burnt orange ground, signed in cameo relief *Gallé*
18in. high

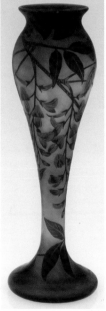

19109

19109
AN OVERLAID AND ETCHED GLASS VASE
Richard, c.1900

The frosted ground blended with purple, green and amber hues and acid etched with cameo branches bearing leaves and fuchsia, with cameo signature *Richard*
14in. high

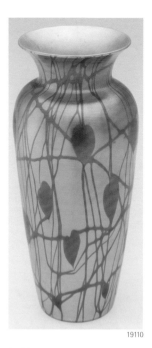

19110

AN IRIDESCENT HEART AND VINE MOTIF GLASS VASE

Durand, c.1900

The golden iridescent glass decorated with green hearts and vines, flaring rim and cylindrical tapered form, *unsigned*

11.5in. high

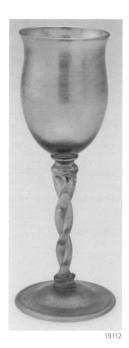

19112

AN AMERICAN IRIDESCENT WINE GLASS

Tiffany, c.1900

The gold iridescent glass with twisted free form stem, best of color, engraved *L C Tiffany*

6in. high

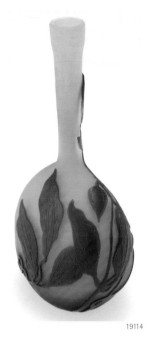

19114

AN OVERLAID AND ETCHED GLASS VASE

Emile Gallé, c.1900

The yellow frosted ground etched with chocolate brown colored flowers on the vine, with cameo signature *Gallé*

6.5in. high

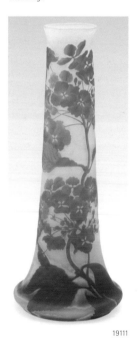

19111

AN OVERLAID AND ETCHED GLASS VASE

Emile Gallé, c.1904

With an everted rim, the gray, pink and pale green ground overlaid in white, lilac and purple, and acid etched with flowering branches, with cameo signature *Gallé* after a star

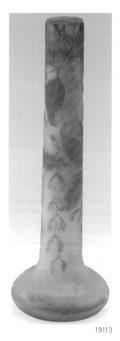

19113

AN OVERLAID AND ETCHED GLASS VASE

Emile Gallé, c.1900

The frosted glass vase overlaid with green to depict vines cascading down the side of the vase with a frosted white to orange ground, signed in cameo relief *Gallé* with star

18in. high

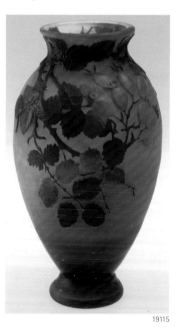

19115

A 'WILD-ROSE' MOLD-BLOWN, OVERLAID AND ETCHED GLASS VASE

Emile Gallé, c.1910

The frosted raspberry shading to violet ground, overlaid in deep caramel, mold-blown and etched with rose hips on leafing branches, with cameo signature *Gallé*

9.75in. high

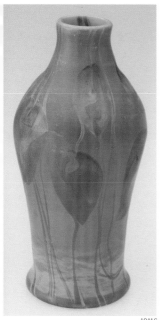

19116

19116

AN AMERICAN FAVRILE HEART AND VINE GLASS VASE

Tiffany, c.1900

The iridescent art nouveau design with swirling colors varying from magenta to green, engraved signature *L.C. Tiffany Favrile*

12in. high

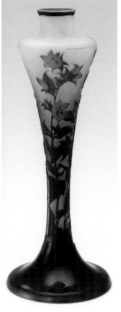

19117

19117

AN OVERLAID AND ETCHED GLASS LAMP BASE

Emile Gallé, c.1900

The frosted soft peach ground etched with light blue and purple floral design, with cameo signature *Gallé*

16in. high

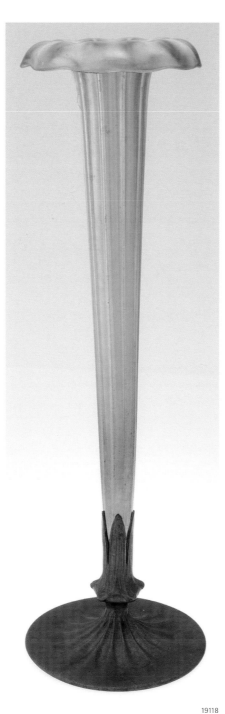

19118

19118

AN AMERICAN FLOWER FORM GLASS AND BRONZE VASE

Tiffany, c.1900

The gold iridescent flower formed vase held in a bronze art nouveau base, signed *LCT* on glass, *Louis C. Tiffany Furnaces Inc 158* on bronze

17in. high

19119

19119

AN OVERLAID AND ETCHED GLASS VASE

d'Argental, c.1900

The frosted light yellow ground etched with amber floral design and overlaid with burnt orange colorations, with cameo signature *d'Argental*

17in. high

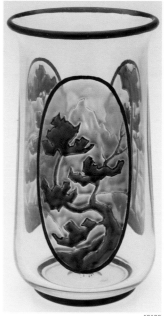

19120

19120

A FRENCH ENAMELED GLASS VASE

Marcel Goupy, c.1915

The clear crystal vessel with stylized art deco design in blue and black enamels, enameled signature, *M. Goupy*

10in. high

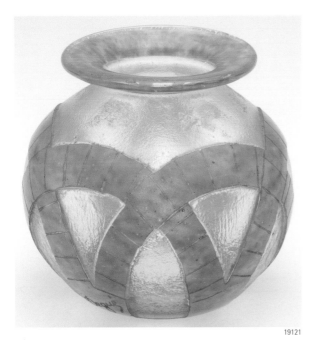

19121

AN OVERLAID AND ETCHED GLASS VASE

Degué, 1920

The frosted green ground acid etched with an art deco motif, engraved signature *Degué*

5in. high

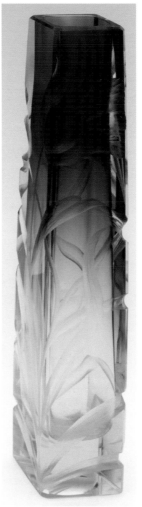

19123

19123

AN INTAGLIO CUT GLASS VASE

Moser, c.1880

The tapered glass form transitions from clear to amethyst, fully carved to depict blooming tulips, *unsigned*

15.8in. high

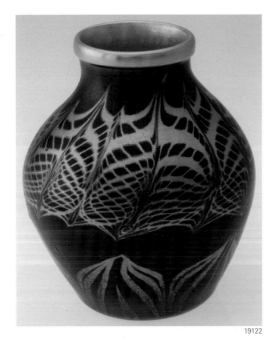

19122

19122

AN AMERICAN FAVRILE GLASS VASE

Tiffany, c.1900

The green iridescent form decorated with a pulled feather design around the base and an intricate metallic double feather pattern on body with an unusual lipped rim, engraved signature *L.C.Tiffany*

5.75in. high

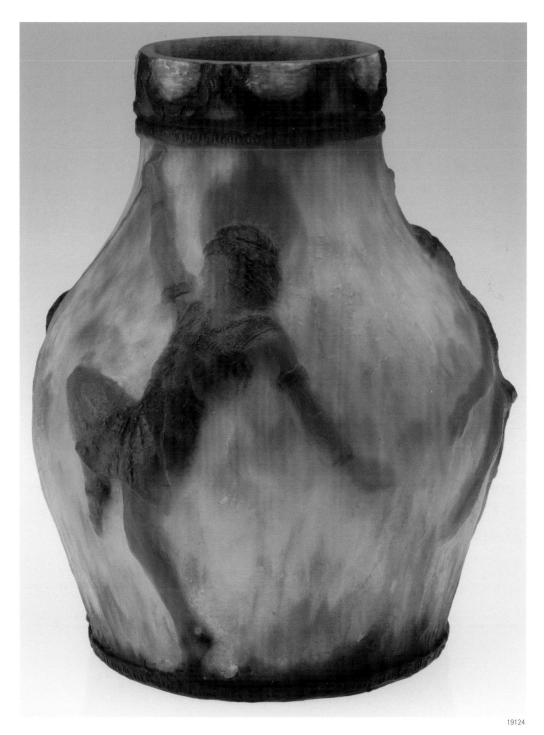

19124

19124
AN ART DECO PATE DE VERRE LAMPSHADE
G. Argy Rousseau, c.1920

The yellow, beige and orange ground with dark purple borders, the body depicting a frieze of three classical Roman dancers
in rich red and purple colors, signature incised at base, *G. Argy Rousseau*
10.5in. high

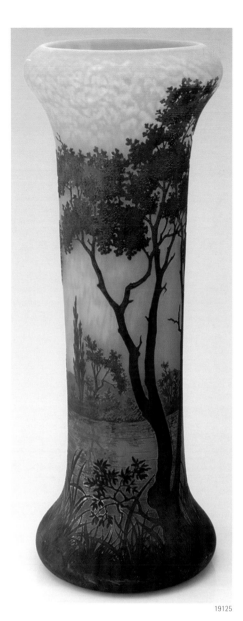

19125

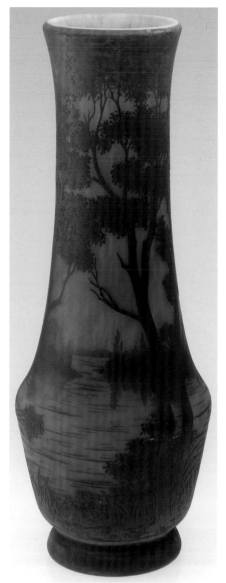

19126

19125

A TRIPLE OVERLAID AND ETCHED GLASS VASE

Daum Nancy, c.1900

The frosted mottled ochre ground transitions to a red base, overlaid and etched to depict a forest lake scene internally decorated red, with cameo signature *Daum* with the *Cross of Lorraine*

23.5in. high

19126

AN OVERLAID AND ETCHED GLASS VASE

Daum Nancy, c.1900

The frosted red and orange mottled ground, internally cased in yellow, overlaid in moss green and etched to depict a tree-lined lake scene with shrubbery, cameo signature *Daum, Nancy* with the *Cross of Lorraine*

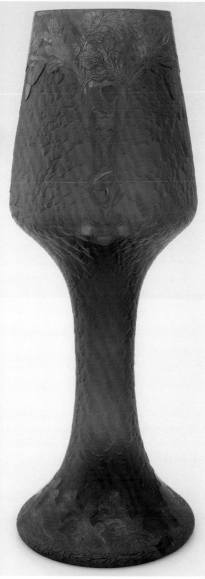

19127
A MONUMENTAL ETCHED AND GILT GLASS VASE
Mont Joye, c.1920

The large chalice form vase etched and gilt with intricate acorns and oak leaves in gold, white, and silver enameling, cut in relief to a vibrant green textured ground, gilt insignia *Mont Joye*
16.5in. high

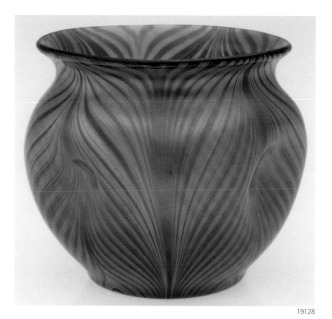

19128
AN AUSTRIAN GLASS VASE
Loetz, c.1900

The olive green glass decorated with an iridescent pulled feather design with a four-sided pinched form, engraved signature *Loetz Austria*
4.75in. high, 5.5in. across

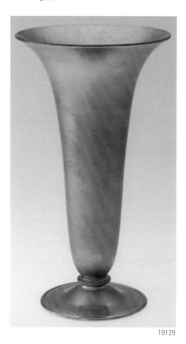

19129
AN AURENE AMERICAN GLASS VASE
Steuben, c.1900

The trumpet shape fully decorated in gold iridescent finish with green highlights, signature *Steuben Aurene* etched in base
10in. high

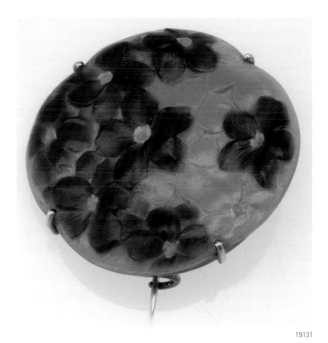

19131
A PATE DE VERRE GLASS PIN
G. Argy Rousseau, c.1900

Molded in a circular shape with deep purple and lavender flowers with yellow centers, *unsigned*

1.7in. diameter

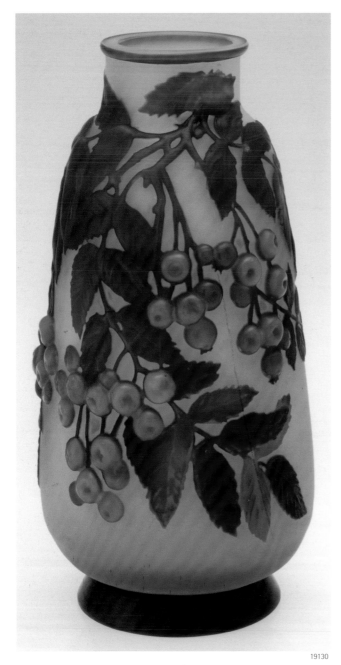

19130
A MOLD-BLOWN OVERLAID AND ETCHED GLASS VASE
Emile Gallé, c.1900

The frosted yellow ground overlaid in high relief with amber and brown molded cherries, with cameo signature *Gallé*

19132
AN ART NOUVEAU FRENCH PATE DE VERRE PENDANT
G. Argy Rousseau, c.1920

Hung from a knotted silk cord, the pendant of clear, yellow, olive and white glass, the subject a butterfly set upon a molded textured ground, signed *G.A.R.*

2.2in. across

19133

A PATE DE VERRE MOUSE PAPERWEIGHT

A. Walter, c.1900

Molded to depict a white mouse eating a brown walnut on a green rock, engraved signature *A. Walter Nancy*

3in. high, 3in. across

19135

AN ETCHED AND ENAMELED CABINET GLASS VASE

Daum Nancy, c.1900

The frosted glass etched and enameled to depict a wintry scene

2in. high

19134

AN AMERICAN IRIDESCENT CABINET GLASS VASE

Tiffany, c.1900

The shaped gold iridescent form with magenta and blue highlights, unsigned

2in. high

19136

A BURMESE CABINET VASE

Mount Washington, c.1890

The yellow to pink coloration with an enamel floral design, unsigned

3in. high

19137

AN AMERICAN IRIDESCENT GLASS MINIATURE VASE

Tiffany, c.1900

The gold iridescent glass with magenta highlights and a double baluster shape with two pulled applique handles, engraved signature with numbers *LCT*

3in. high

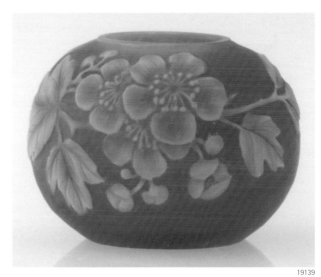

19139

AN OVERLAID AND ETCHED MINIATURE VASE

Thomas Webb and Sons, c.1890

The frosted rose ground overlaid in ivory and carved in a white floral design

1.5in. high

19140

A PATE DE VERRE CRICKET PAPERWEIGHT

A. Walter, c.1900

With a yellowish cricket on peach autumn leaves and berries, engraved signature *A.Walter Nancy*

1.5in. high 2.5in. across

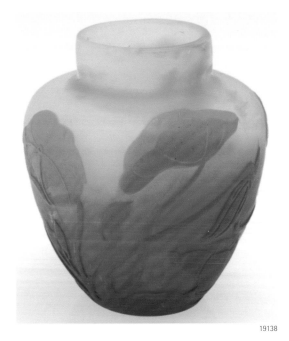

19138

AN OVERLAID AND ETCHED GLASS CABINET VASE

Emile Gallé, c.1900

The frosted tangerine and cream ground etched with burnt orange lily pads inspired by Japanese designs, with cameo signature *Gallé*

2.75in. high

19141

A PATE DE VERRE MOUSE PAPERWEIGHT

Decorchemont, c.1904

The heavy pate de verre paperweight shows a mouse on wheat over green grass, stamped signature seal *Decorchemont* and engraved with artist's initials *AP*

2.75in. high, 4in. across

19142
A PATE DE VERRE ASHTRAY
G. Argy Rousseau, c1920

The art deco style crystal ashtray with golden yellow in sunflower design, incised signature *G. Argy Rousseau*
3.5in. diameter

19142

19143
A FRENCH MOLD-BLOWN AMETHYST SAUTERELLES VASE
René Lalique, Paris, c.1925

The baluster form vase with grasshoppers in various positions upon a stylized meadow, flaring faceted collar, deep purple, amethyst color, script, etched signature, *R. Lalique Paris*
11in. high

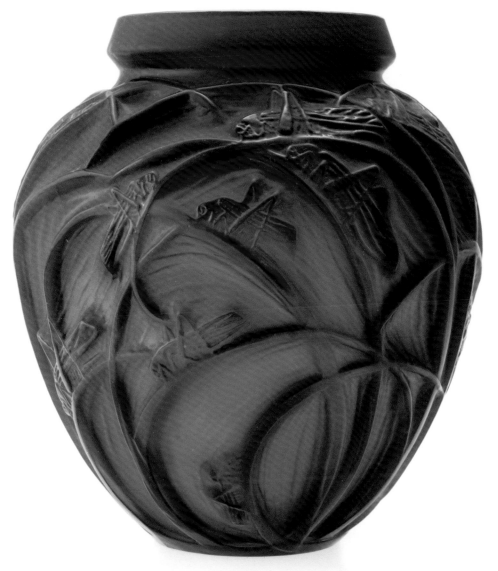

19143

19144

AN AMERICAN ART GLASS VASE

Kimball, c.1930

The baluster shaped fully decorated in clethra style in black, rust and white coloration

7.5in. high

19145

AN OVERLAID AND ETCHED GLASS VASE

Mont Joye, c.1910

The frosted mauve textured ground with intricate gold and silver gilding around the rim tapers down to the base, gilded signature *Mont Joye*

7.25in. high

19146

AN ETCHED AND ENAMELED GLASS COVERED PITCHER WITH TRAY

Daum Nancy, c.1900

The pink and apricot frosted ground with gold gilt highlights and floral design on pitcher and stopper, signed in enamel *Daum/Nancy* with the *Cross of Lorraine*

7.5in. high and 8in. diameter (Total: 2 Items)

19147

AN ETCHED AND ENAMELED GLASS VASE

Mont Joye, c.1910

The emerald green tinted ground with deep purple and lilac petaled pansies and gold gilt decorations, gilded signature *Mont Joye*

6in. high

19148

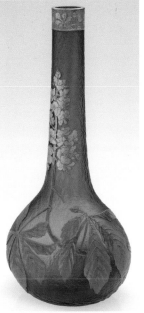

19150

19148

AN AUSTRIAN IRIDESCENT GLASS FIGURAL PIG VASE

Loetz, c.1900

The iridescent gold coloration highlighted with blue and pink, applique ears, lower lip, feet, and tail, *unsigned*

10in. across

19150

AN OVERLAID AND ETCHED GLASS VASE

Mont Joye, c.1900

The textured amethyst ground acid etched with large green cameo leaves and gold gilt flowers on neck and rim, gilded signature *Mont Joye L C*

15.75in. high

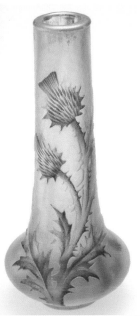

19149

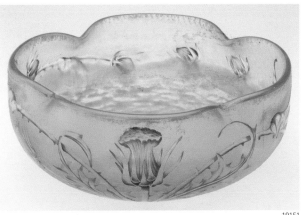

19151

19149

AN OVERLAID AND ETCHED GLASS CABINET VASE

Daum Nancy, c.1900

The white frosted ground internally decorated with yellow, orange, and pink streaks, acid etched and overlaid with amber incised thorned thistles with gold gilt around the rim, gilded signature *Daum Nancy* with the *Cross of Lorraine*

5in. high

19151

A FROSTED AND ENAMELED GLASS BOWL

Daum Nancy, c.1900

Frosted pink and yellow ground with enameled floral design, best of color, gilt rim, signed *Daum Nancy* with the *Cross of Lorraine*

6in. across

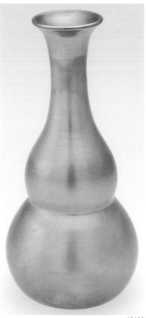

19152

AN AMERICAN IRIDESCENT GLASS VASE

Quezal, c.1900

The double gourd shaped gold iridescent with magenta highlights, best of color, engraved on pontil *Quezal*

8.75in. high

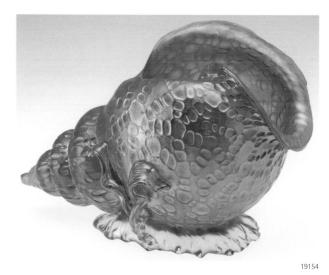

19154

19154

AN IRIDESCENT GOLD CHINÉ GLASS SEASHELL

Loetz, c.1898

The pedestaled gold iridescent shell has applique seaweed rising from base around shell on both sides, exceptional color with strong magenta highlights, signed *Loetz, Austria*

8.5in. high

19153

19153

A PATE DE VERRE STYLIZED SAND DOLLAR

Unsigned, c.1900

The molded sand dollar attributed to Marcel Goupy, unsigned

3in. across

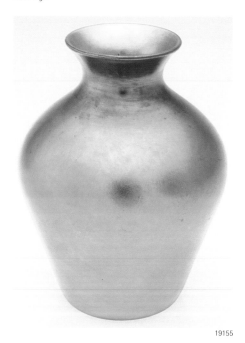

19155

19155

AN AMERICAN BLUE IRIDESCENT GLASS VASE

Quezal, c.1900

The bulbous shaped blue iridescent vessel flares at the top, best of color, signed on pontil *Quezal*

7in. high

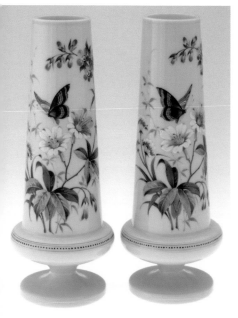

19156

19156
A PAIR OF ENAMELED BLUE OPALINE GLASS VASES
Webb, c.1880

The pedestaled turquoise colored vases with multi-colored floral designs each with a butterfly in flight, beaded enamel border, *unsigned*
11.5in. high

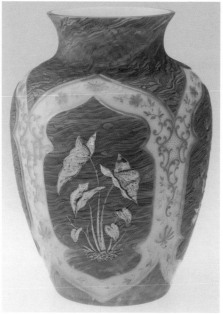

19158

19158
AN ENGLISH CHINOISERIE ETCHED AND ENAMELED GLASS VASE
Webb, c.1880

The ivory ground decorated with gold gilt floral motif with four iridescent insets illustrated with flowers and greenery, rim and base with iridescent design
8.5in. high

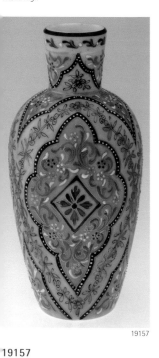

19157

19157
AN ENGLISH ENAMELED GLASS VASE
Webb, c.1880

The vase enameled in blue and pink with floral and vine design, *unsigned*
9.5in high

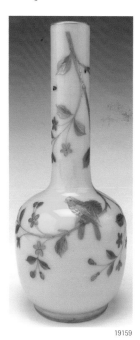

19159

19159
AN ENGLISH CHINOISERIE GLASS VASE
Webb, c.1890

The bulbous shape to elongated neck a bright yellow internally cased in pink, fully decorated in gold enamel depicting leaves and birds, unsigned
13in. high

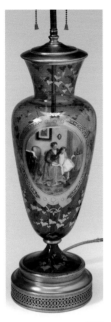

19160

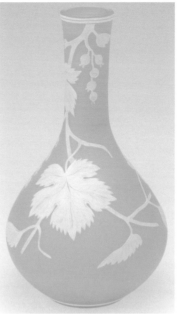

19162

19160
AN ENAMELED CAMEO GLASS LAMP
Moser, c.1900

The cranberry glass with gilt decoration and a center cameo depicting a Victorian woman and a young girl in a domestic scene, *unsigned*
18in. high

19162
AN OVERLAID AND ETCHED GLASS VASE
Thomas Webb and Sons, c.1880

The frosted yellow ground etched with ivory leafy tree branches, berries and a butterfly, *unsigned*
10in. high

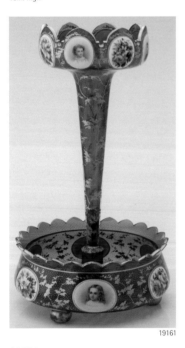

19161

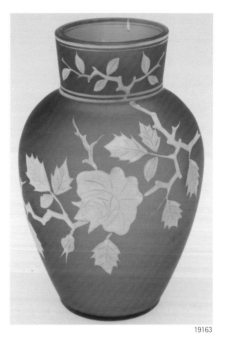

19163

19161
A CAMEO ENAMELED GLASS FOOTED EPERGNE
Moser, c.1880

The cranberry glass covered in alternating enameled cameos of flowers and Victorian children, gilt enameled foliage throughout, *unsigned*
15in. high

19163
AN OVERLAID AND ETCHED GLASS VASE
Thomas Webb and Sons, c.1880

The frosted raspberry ground with ivory cameo flowers on a leafed branch, *unsigned*
6in. high

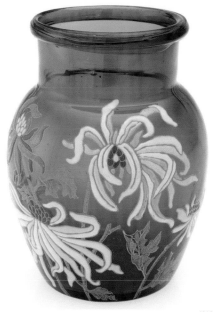

19164

AN ETCHED AND ENAMELED GLASS VASE

Emile Gallé, c.1890

The green glass with enamel and gold gilt designs depicting chrysanthemums, engraved signature *E. Gallé Nancy*

6.25in. high

19166

A GREEN IRIDESCENT RUSTICANA GLASS VASE

Loetz, c.1900

The free form art nouveau shape features brilliant iridescence with magenta highlights, *unsigned*

9.5in. high

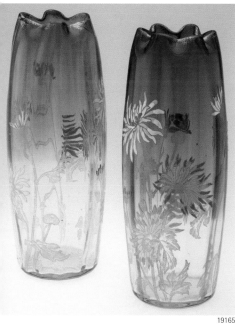

19165

A PAIR OF ETCHED AND ENAMELED GLASS VASES

Unsigned, c.1890

Each of elongated cylindrical form, clear base sweeping to ruby red, decorated with enameled chrysanthemums, pinched rim with gilt highlights

12in. high

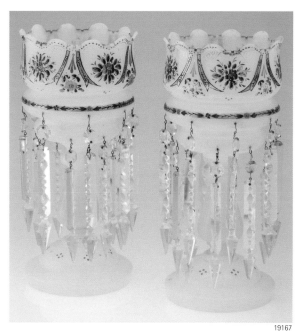

19167

A PAIR OF WHITE OPALENE VICTORIAN LUSTERS

c.1880

On circular footed bases with slender pedestals, cut crystals extend from the bowls, scallop edged and decorated with a floral design and highlighted with gilt borders, *unsigned*

each 14in. high

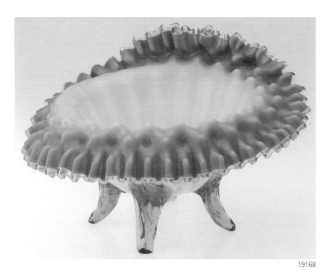

19168

AN ENGLISH RUFFLED EDGE GLASS COMPOTE
Stevens and Williams, c.1880

The applique feet support this rare multi-colored cased compote, shaded from white to pink then to vibrant rose color

11.5in diameter

19169

AN ITALIAN SEASHELL FORM GLASS CONSOLE
Murano

Blue ground highlighted in a white casing with gold inclusions throughout

18in. long

19170

A PAIR OF PINK OPALINE VICTORIAN LUSTERS

With gold gilt and enamel floral and geometric decorations, cut drop crystals

14in. high (Total: 2)

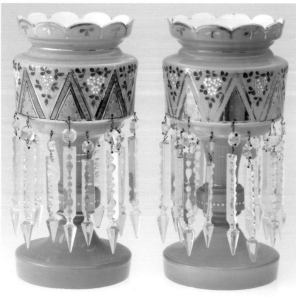

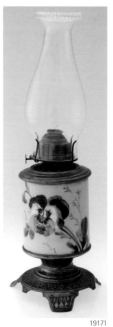

19171

AN ENAMELED AMERICAN KEROSENE LAMP
Mechanism marked Plume & Atwood, Fireside, c.1880

Bronze with an enameled glass body, hand painted enameled pansies, nice original patina, functional, wick mechanism marked Patent 1872

17.6in. top of shade

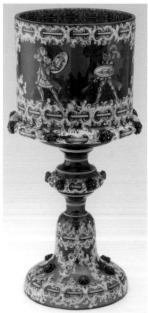

19172

AN ENAMELED GLASS VASE
Lobmeyer, c.1880

The green glass with hand painted knights surrounded by an intricate white lacy design, applied glass rosettes, unsigned

13in. high

19175

A MOTHER OF PEARL SATIN GLASS VASE

Stevens and Williams, c.1880

The bulbous six-sided form cased in white with internal sky blue bubble decorations, *unsigned*

8.25in. high

19173

AN ITALIAN ENAMELED GLASS VASE

Unsigned, c.1880

The pedestaled and handled translucent blue vessel fully decorated with elaborate enameled decorations depicting foxes, birds, and an antelope

8in. high

19174

AN AMERICAN FAVRILE FOOTED GLASS BOWL

Tiffany, c.1900

The gold iridescent bowl supported by three applique feet with a lime green decoration at rim, signed with engraved signature *L.C. Tiffany-Favrile* near pontil

7in. diameter

19176

AN OVERLAID AND ETCHED GLASS VASE

Daum Nancy, c.1900

The soft peach tinted ground overlaid with mauve branches and autumn leaves with two green glass ladybugs, engraved signature *Daum Nancy* with the *Cross of Lorraine*

18in. high

Visit HeritageGalleries.com to view scalable images and bid online.
Session Two, Auction #608 • Saturday, October 30, 2004 • 6:00 p.m.
193

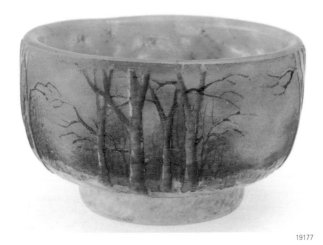

19177

AN ETCHED AND ENAMELED GLASS OPEN SALT

Daum Nancy, c.1900

The footed vessel depicts a winter scene with orange and yellow mottled ground, signed in enamel with *Cross of Lorraine*

1.5in. high

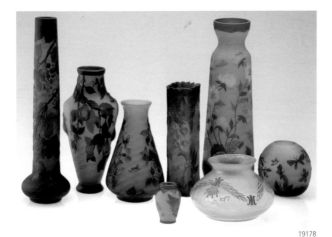

19178

A GROUP OF EIGHT OVERLAID AND ETCHED GLASS VASES

Seven in the style of Emile Gallé, one in the style of Legras. Three with overlaid and etched flowers, two with berries, one with cherries, another mold blown with pears, each bearing various signatures

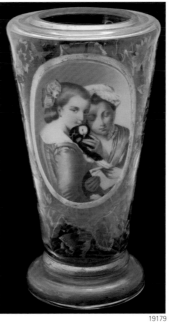

19179

19179

A EUROPEAN ENAMELED GLASS VASE

Attributed to Moser, c.1900

Featuring delicate floral designs of morning glorys and daisies, a cameo inset with a picture of two women and a bird accents the front of the vase

10in. high

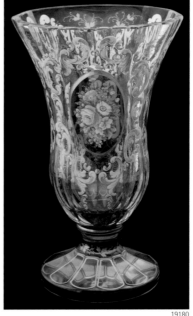

19180

19180

A VICTORIAN ENAMELED GLASS VASE

Attributed to Moser, c.1900

The pedestal and base with internal amber color, flaring from the pedestal with three raised enameled floral scenes on amber glass, the glass with elaborate design in cream and gilt

9in. high

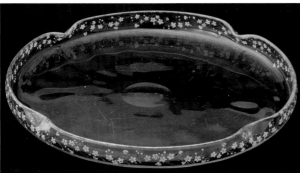

19181 •
AN ETCHED AND ENAMELED GLASS TRAY
Emile Gallé, c.1900

The tray with delicate hand painted blue and white flower design along the edge, signed *Emile Gallé* in enamel on pontil
9in. across

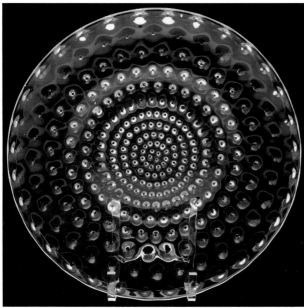

19182 •
AN ENAMELED GLASS PLATE
René Lalique, 'Cactus', c.1900

The clear crystal underside covered with black enamel dots over each point, stamped in block letters *R. Lalique*
13in. across

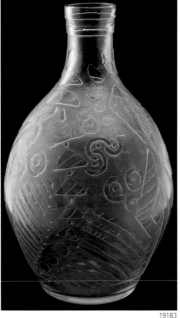

19183 •
AN OVERLAID AND ETCHED GLASS VASE
Val Saint Lambert, c.1925

The transparent ground etched with art deco forms, engraved with the artist's initials in the design *VSL*
7.75in. high

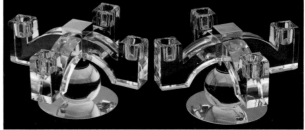

19184 •
A PAIR OF ART DECO CANDELABRA
Glass and Metal, c.1920

The four pronged candle extensions held in place by a chrome base, *unsigned*
5in. high

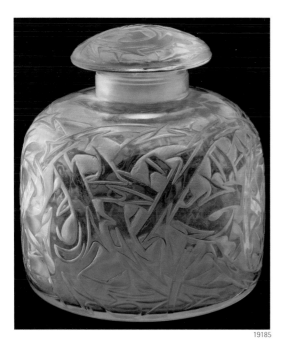

19185

A MOLD-BLOWN DRESSER JAR

René Lalique, 'Pervencles', c.1929

The frosted to clear glass molded with art deco design, raised signature in mold in block letters *R. Lalique*

4.5in. high

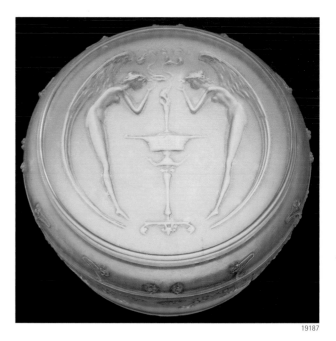

19187

A MOLD-BLOWN GLASS POWDER BOX

René Lalique, 'D'Orsay', c.1920

The frosted crystal molded with two nude angel figures and floral designs, stamped signature in block letter *R. Lalique*

3in. diameter

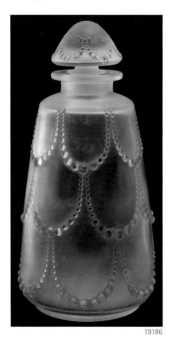

19186

A MOLD-BLOWN PERFUME BOTTLE

René Lalique, 'Perles', c.1920

The bottle and stopper decorated with art deco beaded swags, signed *R. Lalique France*

6.5in. high

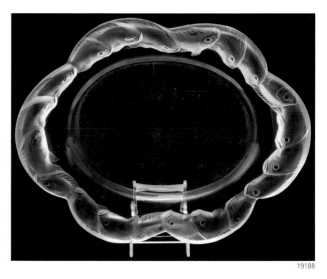

19188

AN OVAL MOLDED GLASS TRAY

René Lalique, c.1920

The tray has a opalescent molded fish border, strong mold in color, signed in script *Lalique, France*

10.75in. across

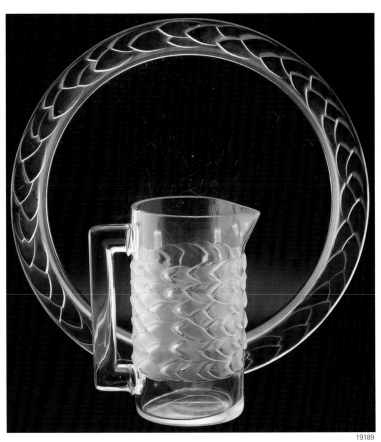

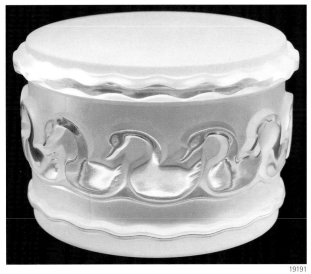

19191

A GLASS POWDER BOX

René Lalique, c.late 1900s

The clear glass molded with swans and irregular rim on lid, engraved
script signature *Lalique France*

3.7in. diameter

19189

A GLASS PITCHER AND TRAY

René Lalique, 'Bahia', c.1931

The frosted crystal molded with art deco design, engraved signature *R.
Lalique/France*

9.4in. high (Total: 2 Items)

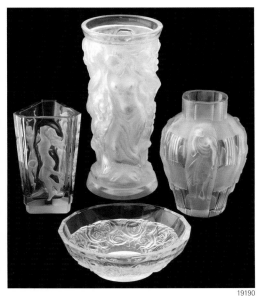

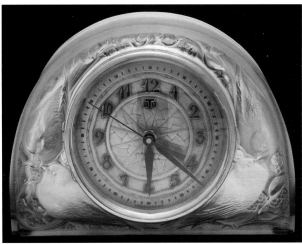

19192

A FRENCH GLASS CLOCK

René Lalique, 'Moineaux', c.1924

The clear molded birds surround the timepiece with original face in art
deco style, engraved in block letters on the side

6.5in. high

19190

FOUR CONTEMPORARY LALIQUE VASES

René Lalique, c.1980

Three of the pieces clear, one blue

 (Total: 4 pieces)

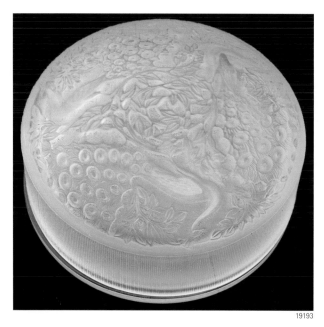

19193

A TINTED GLASS COVERED POWDER BOX

René Lalique, 'Trois Paons' c.1912

Trois Paons molded in light blue tinted crystal with a swirling art nouveau design, engraved signature *R. Lalique France*

3.5in. diameter

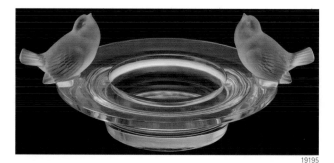

19195

A FIGURAL FRENCH GLASS CONSOLE

René Lalique

The clear glass console with a two inch flat rim and two frosted glass birds perched on either side

12in. diameter

19194

A GLASS EGG-SHAPED COVERED BOX

René Lalique, 'Poussins', c.1929

The frosted and molded baby chickens individually surrounded by a molded egg, raised block letter signature *R. Lalique*

4in. across

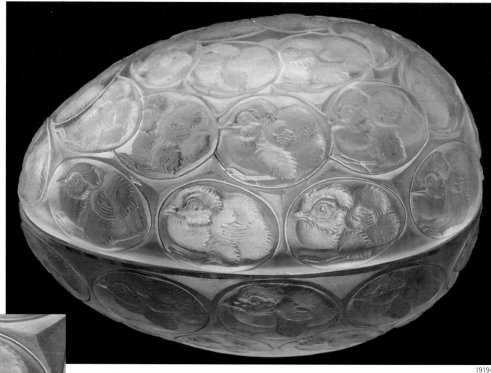

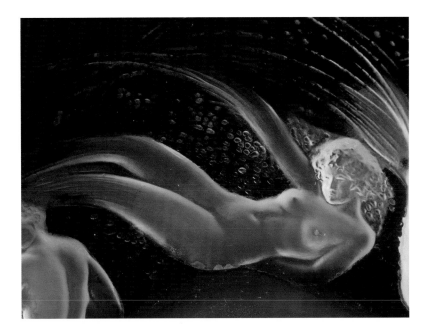

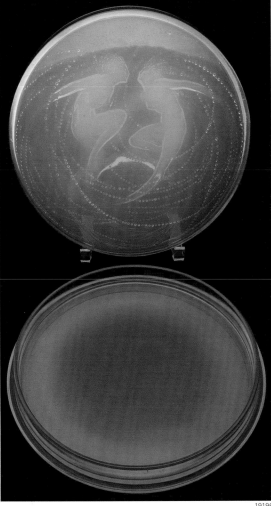

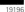

19196

19196
A COVERED OPALESCENT MOLDED GLASS BON BON DISH
René Lalique, 'Sirens', c.1921

The richly opalescent blue to tangerine color complements the raised figures, a dream-like scene of dance, graduated air bubbles and stylized ripples combine to create this Lalique masterwork
10in. diameter

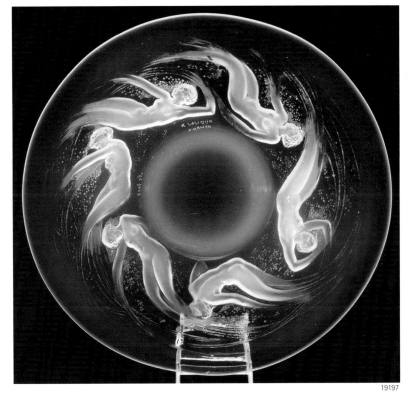

19197

19197
A MOLDED GLASS 'ONDINES' COUP
René Lalique, c.1921

The opalescent glass molded with six nudes in flowing art nouveau style, stamped signature
R. Lalique/France
11in. diameter

19198

A MOLD BLOWN GLASS DECANTER WITH FIGURAL STOPPER

René Lalique, 'Douze Figurines', c.1920

The frosted glass decanter features an affectionate couple in six different poses, the stopper a woman on bended knee

11in. high

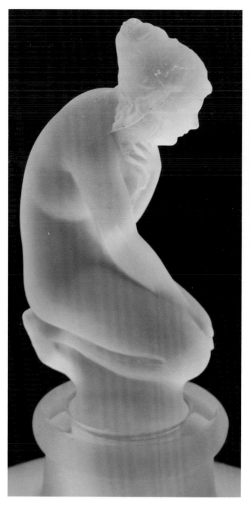

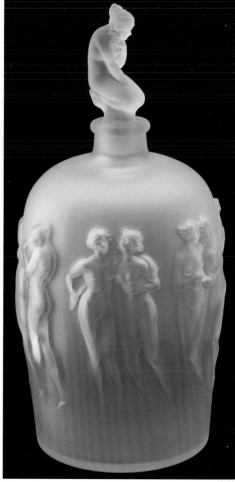

19198

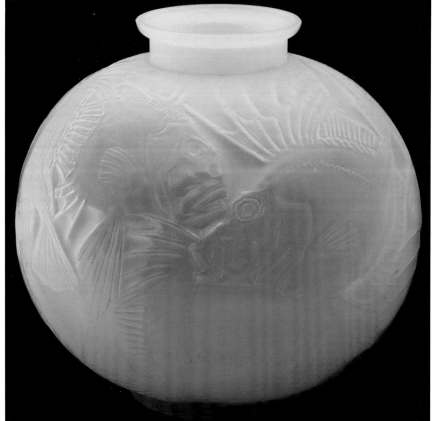

19199

A MOLD-BLOWN GLASS OPALESCENT VASE

René Lalique, 'Poissons' c.1921

The opalescent color molded with a design of fish, in low relief signature etched on bottom, *R. Lalique France*

9in.high

19199

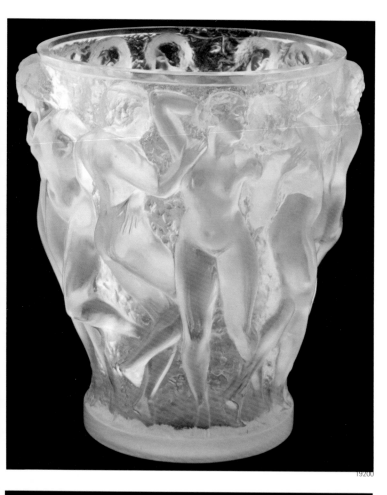

19200

AN OPALESCENT MOLD-BLOWN GLASS VASE

René Lalique, c.1921

The pedestaled frosted body with ten dancing nudes in art nouveau style, good mold and color

9.5in. high

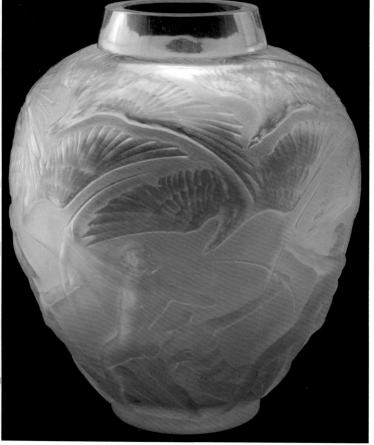

19201

A FROSTED MOLD-BLOWN GLASS VASE

René Lalique, 'Archers' c.1920

The large frosted glass vase features eight nude archers shooting at large swooping birds

11in. high

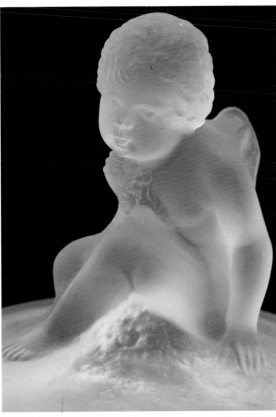

19202
A MOLD-BLOWN COVERED GLASS POWDER BOX

René Lalique, 'Armour' c.1919

Covered circular glass powder box features a sitting cherub with molded vines around sides of box

5.5in. high

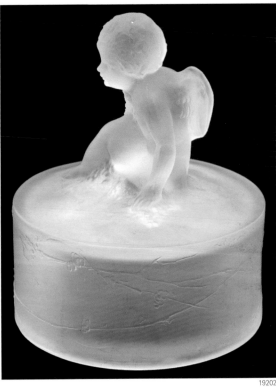

19202

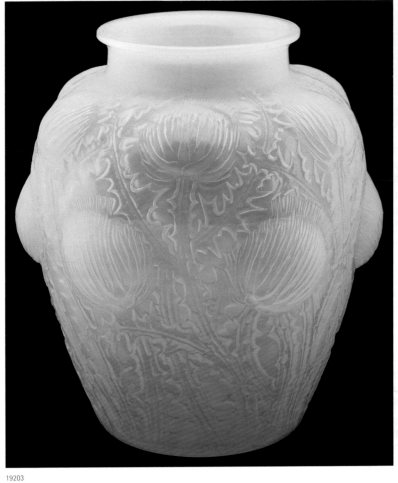

19203

19203
AN OPALESCENT MOLD-BLOWN GLASS VASE

René Lalique, 'Domremy', c.1926

The opalescent vase features a floral design with dandelions in heavy foliage, signature etched in bottom *R. Lalique*

8.5in high

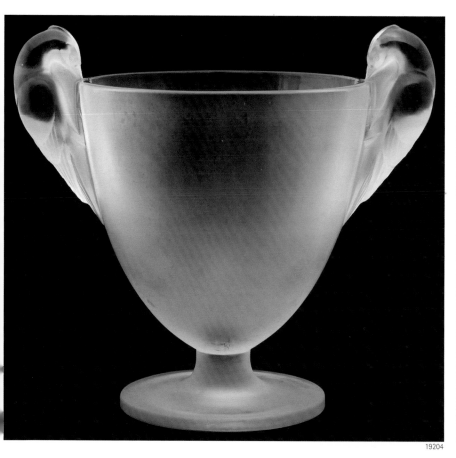

19204

19204
A MOLD-BLOWN GLASS COUPE
René Lalique, 'Ornis', c.1926

The frosted glass with two birds fashioned into handles,
signature *R. Lalique France*
6.5in. high

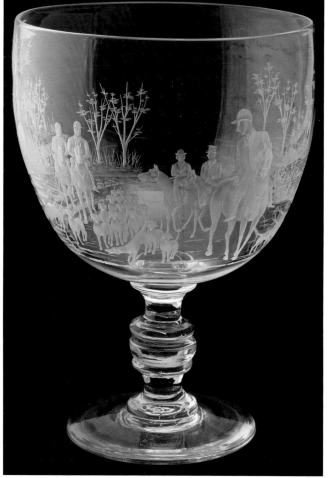

19205

19205
AN ENGRAVED GLASS GOBLET
Bavarian, c.1890

The oversized drinking vessel intricately engraved with a
fox hunt scene
10in. high

19206

**A MOLD-BLOWN GLASS
OPALESCENT VASE**

René Lalique, 'Moassic', c.1926

The opalescent glass vase with a design of interlacing
leaves, signature etched on bottom *Lalique France*

4in. high

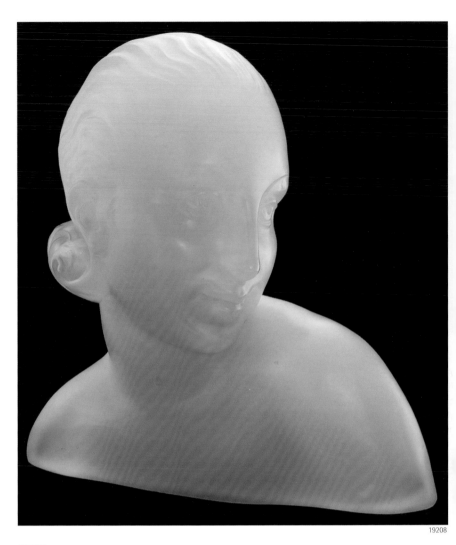

19208

AN OPALESCENT GLASS BUST ON WOOD STAND

Sabino, c.1920

The large opalescent glass bust of a woman, art deco in style, enamel signature

13.5in. high

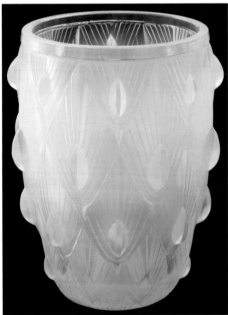

19207

**A MOLD-BLOWN GLASS
OPALESCENT VASE**

Sabino, c.1920

The opalescent glass molded with art deco designs,
raised signature *Sabino/France*

8in. high

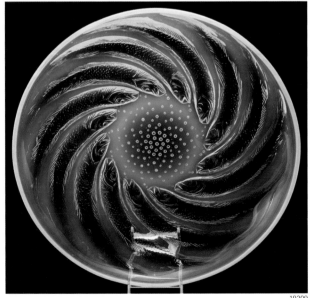

19209

**A MOLD-BLOWN
GLASS PLATE**

René Lalique 'Calypso' c.1920

The clear to opalescent plate
decorated in a fish design

11.5in diameter

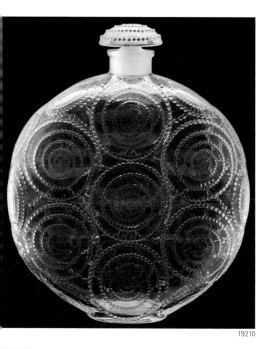

19210
AN ART DECO GLASS PERFUME BOTTLE
René Lalique, 'Relief', c.1924

The clear glass molded with a swirling art deco design, raised signature
R. Lalique
10in. high

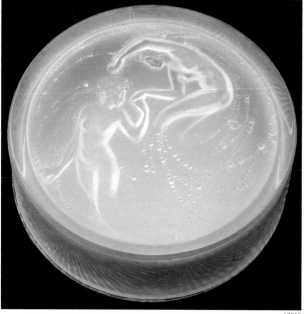

19212
A GLASS POWDER BOX WITH BLUE PAPER BOTTOM
René Lalique, 'D'Orsay', c.1920

The frosted opalescent glass with art nouveau figurines, stamp label on
paper bottom *Poudre Merveilleuse/Au Parfum D'Orsay/Naturelle/D'Orsay
Parfumeur/Paris*
3.3in. diameter

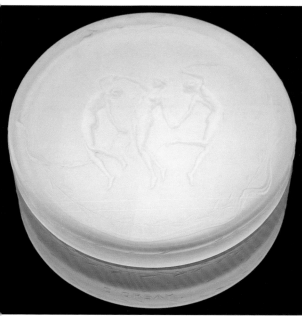

19211
A COVERED GLASS POWDER BOX
René Lalique, 'D'Orsay', c.1912

The frosted glass molded with three dancing nudes, raised signature in mold
R. Lalique
3.7in. diameter

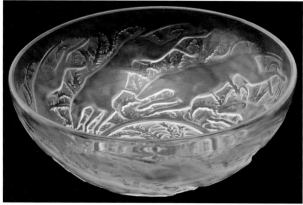

19213
A MOLD-BLOWN GLASS BOWL
René Lalique, 'Leurier' c.1928

The clear to opalescent bowl depicts six dogs in chase, signature
R. Lalique France etched in center of bowl
9.25in diameter

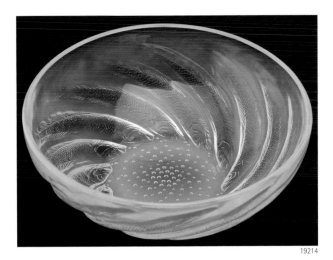

19214

19214
A MOLD-BLOWN OPALESCENT GLASS BOWL
René Lalique, 'Poissons' c.1926

The opalescent bowl with design of swirling fish and bubbles, signature *R. Lalique France* etched on bottom
9.25in. diameter

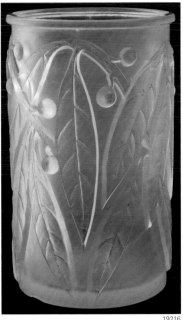

19216

19216
AN OPALESCENT MOLDED GLASS VASE
René Lalique, 'Laurier', c.1922

The cylindrical shape molded into leaves and berries
7in. high

19215

19215
A MOLD-BLOWN GLASS LIDDED POWDER BOX
René Lalique, 'D'Orsay', c.1912

The frosted glass molded with three dancing figures, raised signature in mold in block letters *R. Lalique France*
3.7in diameter

19217

19217
A BLOWN GLASS FOOTED PITCHER
René Lalique, 20th century

The clear crystal molded with an art deco design on the base, engraved script signature *Lalique/France*
7.5in. high

19218

A MOLD-BLOWN GLASS BOWL

René Lalique, 'Rose', c.1939

The frosted glass molded with art deco designs depicting garlands of roses, engraved script signature *Lalique/France*

9.7in. diameter

19219

A MOLD BLOWN GLASS 'MARIGNANE' VASE

René Lalique, c.1936

The frosted glass vase with winged applications molded in an art deco design, engraved stamp *R. Lalique/France*

9.5in. high

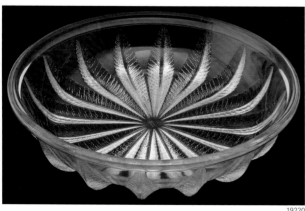

19220

A MOLD-BLOWN GLASS CENTER BOWL

René Lalique 'Chataignier', c.1933

The clear glass molded with art deco designs of fern leaves, engraved script signature *Lalique/France*

13.7in. diameter

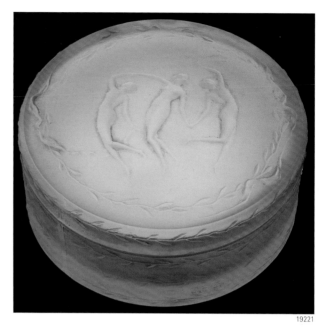

19221

A MOLD-BLOWN GLASS LIDDED POWDER BOX

René Lalique, "D'Orsay', c.1912

The frosted glass molded with three dancing figures and covered in light brown wash, raised signature in mold in block letters *R. Lalique France*

3.7in. diameter

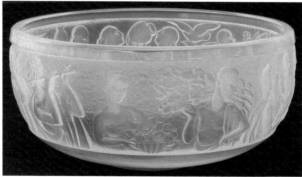

19222

A MOLD-BLOWN OPALESCENT GLASS CENTER BOWL

Sabino, c.1920

The entire circumference decorated with mythological figures, raised signature in mold *Sabino/France*

4.5in. high, 9.5in. across

Visit HeritageGalleries.com to view scalable images and bid online.

Session Two, Auction #608 • Saturday, October 30, 2004 • 6:00 p.m. 207

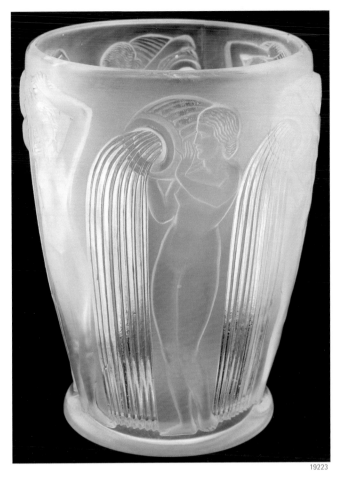

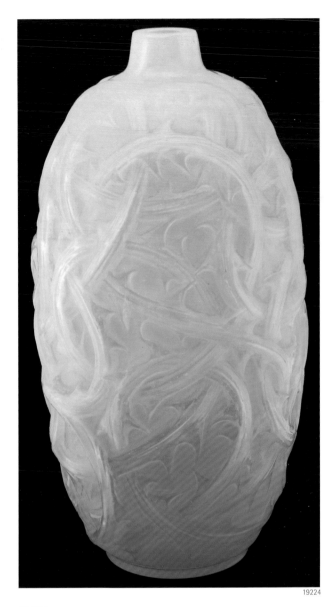

19223

A MOLD-BLOWN OPALESCENT GLASS VASE

René Lalique, 'Danaïdes' c.1926

The clear to opalescent colors complement the six figures pouring water, signed *R. Lalique* raised signature

7in. high

19224

A MOLD-BLOWN GLASS VASE

René Lalique 'Ronces,' c.1921

The green color washed vessel decorated with an intricate design of thorned vines

9in. high

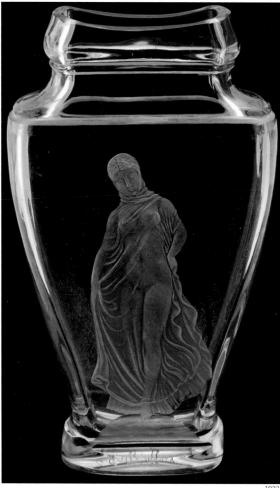

19225

A GLASS INTAGLIO CUT VASE

Emile Gallé, c.1900

The intaglio cut image of a woman seen through a flattened clear vessel, engraved signature *E.Gallé Nancy Depose*

9in. high

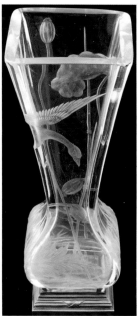

19226

A FRENCH BRONZE MOUNTED GLASS INTAGLIO CUT VASE

Paris, France c.1885

The square flaring body with deeply engraved intaglio cut design, foliage and a finely detailed swan in flight, etched signature of Escalier de Cristal, 'The Crystal Staircase', the bronze base stepped and crosshatched design *Escalier de Cristal*

9.5in. high

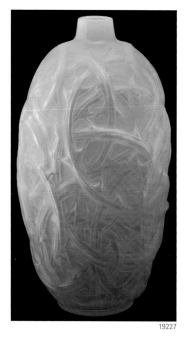

19227

A MOLD-BLOWN GLASS VASE

Lalique 'Ronces', c.1921

The gold color washed vessel decorated with an intricate design of thorned vines

9in. high

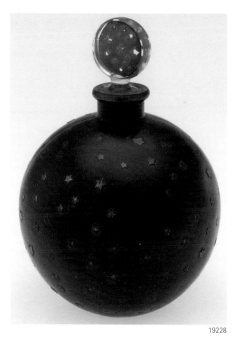

19228

A MOLD-BLOWN COLORED GLASS PERFUME BOTTLE

René Lalique, 'Dans La Nuit', c.1924

The deep blue enameled glass decorated with molded stars on both body and stopper, raised signature *R. Lalique*

5.5in. high

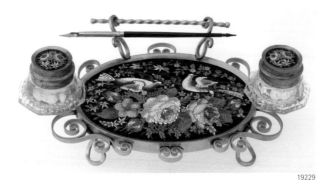

19229

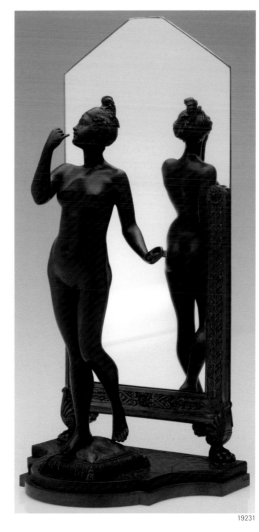

19231

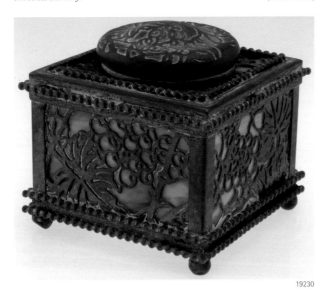

19230

19229
AN ITALIAN ORMOLU AND MICRO-MOSAIC STANDISH
Unmarked, c.1890

Delicately handwrought and gilt, two glass inkwells, each with floral mosaic tops, suspended by fitted decorative rings, the surface of the stand with elaborate mosaic of two birds amidist groups of various flowers, accompanied by a period dip pen with nib

9in. across 2.8in. high (Total: 4 Items)

19230
A FILIGREE BRONZE AND GLASS INKWELL
Tiffany studios, c.1900

The brown and green patinated filigree inkwell with green and white slag glass

3in. high

19231
A BRONZE AND GLASS FIGURAL, MECHANICAL MIRROR
Pinedo, Paris, c.1900

The brown patinated base supports a nude female standing on a pillow in art nouveau style with mirror supported by lion's feet and intricate floral design to the frame, the figure is mounted on a fixed bearing which enables rotation

18in. high

19232

19232
A PAIR OF PORTRAIT MINIATURES ON IVORY
French, c.1900

Marie Antoinette with ostrich feather hat, powdered wig and period clothing mounted in a wood frame, the other, an unidentified sitter in a gilt metal frame in late eighteenth century dress

(Total: 2 Items)

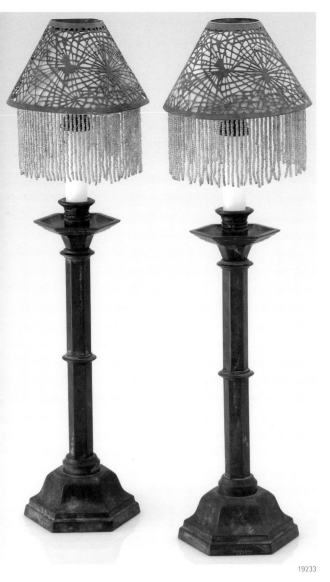

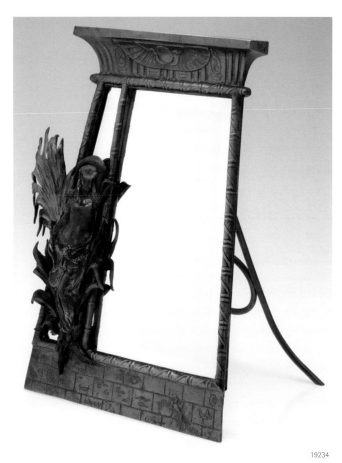

19234

19234
AN EGYPTIAN REVIVAL BRONZE FIGURAL BEVELED MIRROR
c.1890

The free standing dore bronze beveled mirror, green patina, Egyptian motif, hieroglyphics, Egyptian woman standing in reeds
16.5in. high

19233

19233
A PAIR OF BRONZE SHADED CANDLE STICKS
Tiffany studios, c.1900

The bronze candle sticks with filigree shades in a spider web design, beaded fringe, self adjusting risers, signed *Tiffany Studios*

20in. high (Total: 2 Items)

19235

19235
A MOTHER OF PEARL INLAY, PAPIER MACHE AND BRONZE BASKET
Unsigned, c.1880

The black papier mache base is intricately decorated with inlaid mother of pearl, gold gilt enameling, with Madonna in center, dore bronze handle has an intricate grape and leaf design with variegated loops
10in. diameter

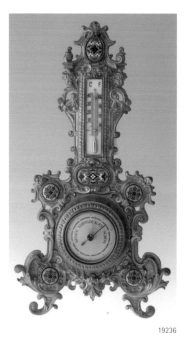

19236

AN AUSTRIAN BAROQUE STYLE ORMOLU BAROMETER

c.1900

The Austrian dore bronze barometer with thermometer has enamel insets, floral, rococo design

16in. long

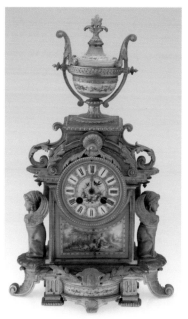

19238

A BRONZE, ENAMELED AND PORCELAIN CLOCK

Sevres, c.1880

The dore bronze clock features mythological female figures on sides of clock, enameled porcelain insets feature a man, woman and child, the clock face with bronze and porcelain insets

18in. high

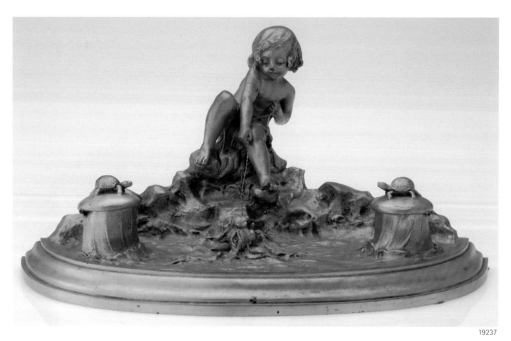

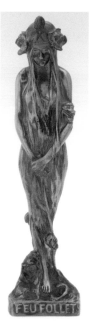

19237

A FRENCH FIGURAL DORE BRONZE STANDISH

Louchet, c.1880

Depicting a small child sitting on rocks fishing, with two turtle figurines on top of the ink well covers, original porcelain inserts, incised signature, *Louchet*

6.5in. high

19239

A "FEU FOLLET" ART NOUVEAU FIGURAL BRONZE

Gesetzt, c.1900

Molded to depict a maiden with flowers in her hair and sculpted waves crashing at her feet, incised signature *Gesetzt Geschutz*

8.5in. high

19241

19241
AN AMERICAN DORÉ BRONZE PEACOCK FEATHER DISH
Tiffany Studios, New York, c.1910

The gold colored surfaces mottled, the outer edge with a raised art nouveau peacock feather design, *marked underside*
6.6in. diameter

19242

19240

19240
AN ART NOUVEAU AMERICAN DORÉ BRONZE CANDLESTICK
Tiffany Studios, New York, c.1900

Two piece construction, textured gold over bronze finish, round base with slender stem, trifid arms clutch a small pot with removable bobeche, *marked underside*
17in. high

19242
AN AMERICAN DORÉ BRONZE TAZZA
Tiffany Studios, New York, c.1910

A sunburst base and tapering cylindrical stem support a round bowl with decorated rim, base detaches from bowl, *marked underside*
4in. high, 6in. diameter

19244

A FRENCH BRONZE PLAQUE

Solomon, c.1848

The brown patinated bronze with depiction of a revolutionary era woman, signature in mold, *Adam Solomon*, foundry mark at bottom

15in. diameter

19244

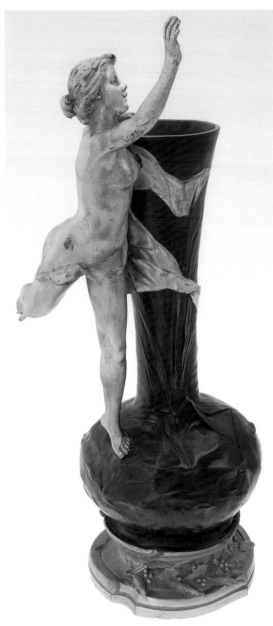

19243

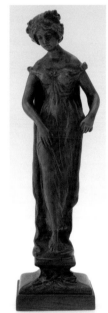

19245

A FIGURAL BRONZE STATUETTE

Ruff, c.1900

The bronze statue molded to depict a maiden with flowers in her hair, incised signature *Ruff*

6.5in. high

19245

19246

19243

AN ART NOUVEAU FIGURAL BRONZE

Antoine Bofill, Spain c.1900

Bearing the retail mark of Tiffany & Co., the dore bronze platform with holly leaf design supports a dark green patinated bulbous to flaring vase with intricate chasing to depict cattails and foliage, affixed to vase is a nude in art nouveau fashion, in a brilliant gold doré finish, artist signed *Bofill*

14in. high

19246

AN ARTS AND CRAFTS SILVER AND BRONZE CIGAR HUMIDOR

Mark of Heintz Art Metal Shop, Buffalo, New York, c.1912

With mottled green patina and an applied silver border, the original screen and green paper inserts still intact, virtually no wear, a superb near mint condition specimen, *marked underside*

10.2in. across, 2.5in. high

19247

A GROUP OF CANDLESTICKS

Various makers

The group consisting of one brass candlestick by Gorham, one bronze candlestick by Gorham, one English brass candlestick, and one silver plate candlestick, *together with* an American gilt latticework lamp base done in the rococo style

the tallest 11in. (Total: 5)

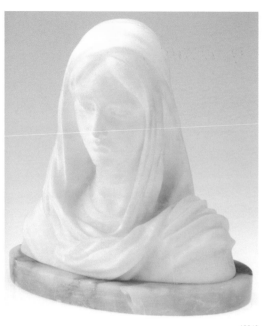

19248

19248
A CARVED ALABASTER BUST ON MARBLE BASE
Cousse, c.1900

Deeply cut Alabaster with fine detail to depict the Virgin Mary with Italian carrera marble base, engraved signature *Cousse*
10.5in. high

19250

19250
A SPANISH FIGURAL BRONZE
Spain, c.1930

Two young men in conversation, probably 'newsies', one with a cigarette, arm over the should of the other, signed *Julio*
23in. high

19249

19249
A FRENCH FIGURAL BRONZE SCULPTURE
Rousseau, c.1880

Sculpted to depict a village fisherman with a net and a bundle of fish on his shoulder, engraved signature *Rousseau*
22in. high

19251

19251
A FRENCH EMPIRE WALL CLOCK
c.1890

The black laminated wall clock decorated with decorated borders, doré bronze and porcelain inserts
18in. x 18in.

19252

19253

19252
A CHARLES RENNIE MACKINTOSH ARGYLE STREET DUTCH KITCHEN WINDSOR CHAIR

Traces of original green color in places, molded seat, tapering top rail, back with fifteen slats, painted blue

45.2in. high

19253
A CHARLES RENNIE MACKINTOSH OAK AND RUSH LADDER BACK ARMCHAIR

Believed to have been designed for Douglas Castle, the home of his fiance, Margaret Macdonald, a photocopy of photograph showing Mackintosh seated in the chair is included with this lot, the rush fatigued, the back with five graduated slats

29.7in. high

19254

AN AMERICAN SIDE CHAIR

Stickley, c.1900

The oak and cane seating is classic arts and craft style, stamped maker's mark

36in. high

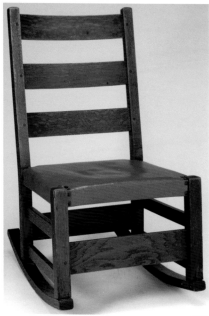

19255

AN AMERICAN ROCKING CHAIR

Stickley, c.1900

The oak and leather seating has its original tacking, stamped maker's mark

31.5in. high

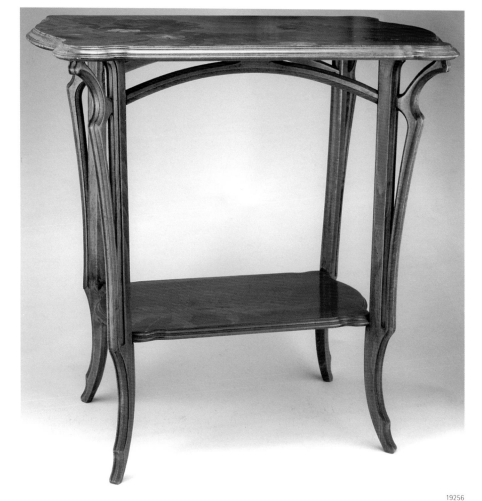

19256

A FRENCH ART NOUVEAU INLAID MARQUETRY TABLE

Emile Gallé, c.1890

The double tiered form with inlaid woods depicting leaf and flower design with butterfly in flight, signed *Gallé* within marquetry design

30in. across, 30in. high

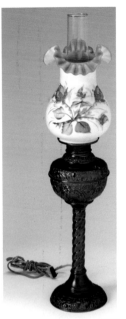

19257

19257

A BRASS OIL LAMP

Stevens and Williams, c.1890

The elaborate brass base with a satin glass shade highly decorated with a floral design and rose colored highlights, attributed to Stevens and Williams, *unmarked*

30in. high

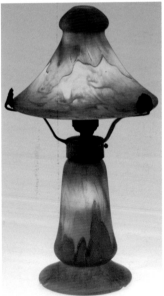

19258

19258

A GLASS AND WROUGHT IRON TABLE LAMP

Schneider, c.1920

The art deco style mottled glass with internal yellow, red and mauve colors, original metal fixture, signed gold gilt on base

14in. high

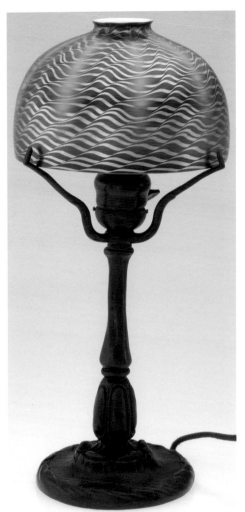

19259

19259

A BRONZE LAMP WITH FAVRILE GLASS SHADE

Tiffany, c.1900

The shade damascene ribbed on green and blue iridescent glass cased in white on a bronze patinated base, signature on base and shade rim *TIFFANY STUDIOS NEW YORK 608 and L.C.T*

13.5in. high, 7in. across

19260

AN ARTS AND CRAFTS BRONZE AND CERAMIC LAMP

Muncie, c.1900

The bronze art deco style base supporting a pedestal flaring to paneled green matte finish, six dancing figures around base with dancing figural finial, *unsigned*

28in. high

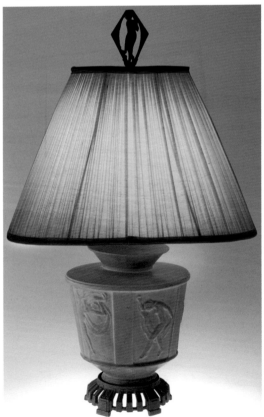

19260

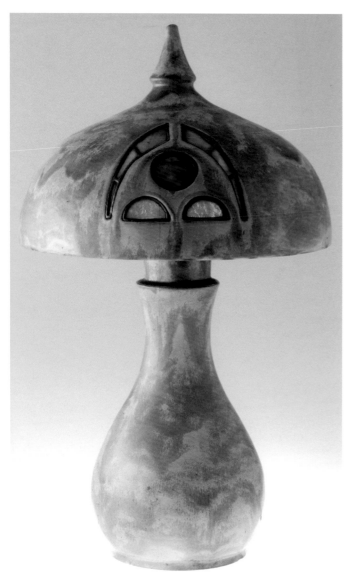

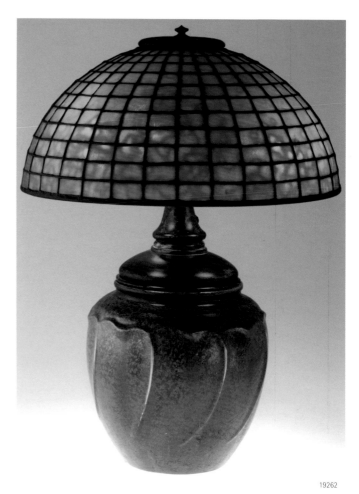

19262

19261

19262

AN ARTS AND CRAFTS POTTERY LAMP WITH LEADED GLASS SHADE

Tiffany, c.1900

The shade with heavy mottling supported by a brown patinated fount with a Hampshire pottery base, signed *Tiffany* on tag in leading, also signed *Hampshire* on base

18.5in. high, 14.5in. diameter shade

19261

19261

AN AMERICAN ARTS AND CRAFTS FULPER VASEKRAFT LAMP

Flemington, New Jersey, c.1915

Mottled matte green glaze, mushroom shaped, original hardware except cord and plug, inset colored slag glass, marked with rectangle 'Fulper' and circular 'vasekraft' mark, 'Patents pending in the United States and Canada and France and Germany', *marked inside base*

19in. high

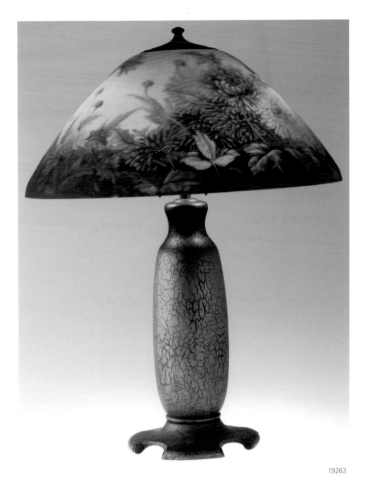

19263

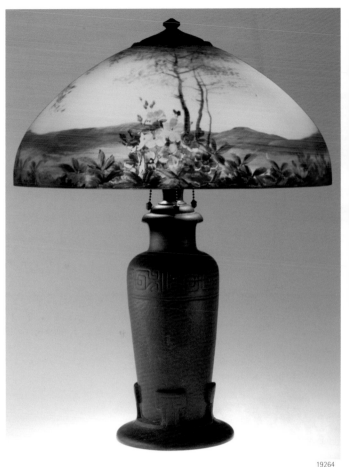

19264

19263

A BRONZE AND REVERSE PAINTED GLASS TABLE LAMP

Moe Bridges, c.1900

The gold matte bronze patina with reversed painted lamp shade decorated with leaves and pink chrysanthemums, impressed signature *Moe Bridges*

24in. high

19264

AN AMERICAN BRONZE AND REVERSE PAINTED GLASS TABLE LAMP

Handel, c.1900

The brown patinated bronze base with Egyptian style design supports a chipped ice shade depicting a yellow sky with mountain desert scene, red floral design and trees in foreground, both base and shade signed *Handel*

18in. diameter shade

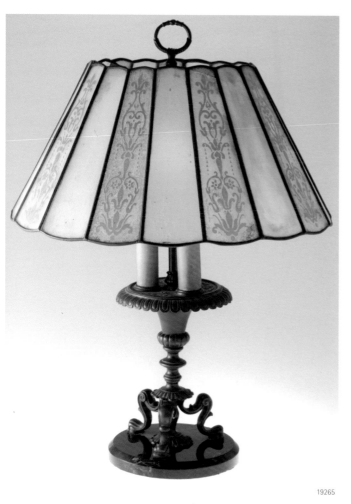

19265

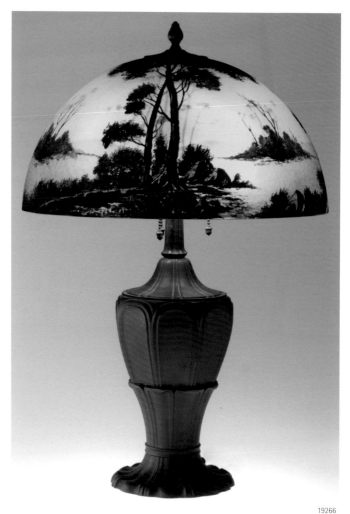

19266

19265
AN AMERICAN BRONZE AND REVERSE PAINTED GLASS TABLE LAMP
Handel, c.1900

The classical bronze base supports a multi-paneled chipped ice shade with an Edwardian design supported by a marble base, signed *Handel* tag on felt
26in. high

19266
A BRONZE AND REVERSE PAINTED GLASS TABLE LAMP
Pittsburg, c.1900

The chipped ice and reverse painted forest scene is done in vibrant red and green colorations and is supported by an unsigned bronze base, unsigned
25in. high and 18in. across shade

19267
A GROUP OF FOUR EUROPEAN TINTED ETCHINGS
c.1930

Each framed, signed and identified by location

(Total: 4)

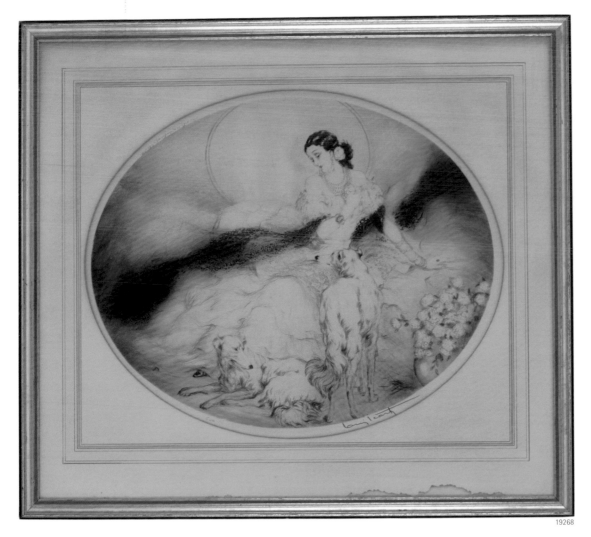

19268

19268
LOUIS ICART

Dame Aux Camelias c.1927

Etching and dry point printed in colors
20in. x 17in. (sight size)
Signed in pencil: Louis Icart with artist stamp
Original margins and mats

19269
KURT HILSCHER (German, b.1904)
Architectural Prints, group of ten (undated)
Various sight sizes
Signed

Ten small prints capture the scenic beauty of Old World architecture. Three of the prints are etchings, six are hand colored etchings, and the final one is a color lithograph. Each has a small image area, ranging from approximately 4in. x 7in. to 7.5in. x 5in. All are signed by their artist, in pencil, at the lower right corner.

(Total: 10 Items)

19269

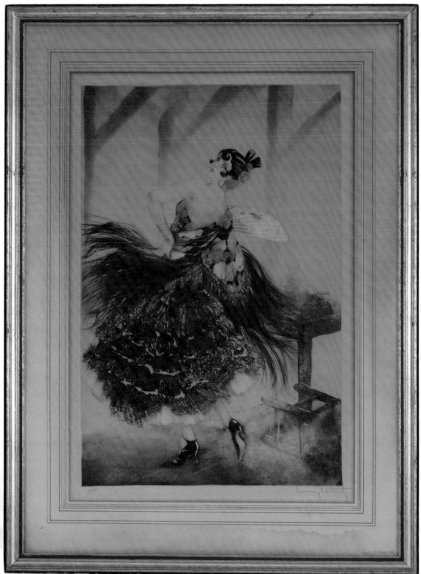

19270
LOUIS ICART

Spanish Dancer c.1927

Etching in dry point printing and colors
22in. x 17in. (sight size)
Signed in pencil: Louis Icart with artist blind stamp
The original frame and mat, some discoloration from light, good color overall

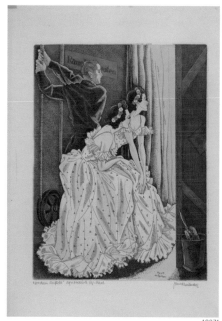

19271

19271
KURT HILSCHER (German b.1904)
Hand colored etchings, group of eleven
Ink and watercolor on paper
9.5in. x 7.25in. (sight size)
Signed lower right: Kurt Hilscher

Eleven prints showcasing the world of dance with Hilscher's uniue perspective. "Die Balleteuse" or the Balllerina; "Grazioser Auklanf" or Graceful Finale; "Vardem Austntt" or Before Taking the Stage; "Rumba" or Rumba; "Die Kerze" or The Candle; "Revue" or Revue; "Can-Can- Maedel" or Can-Can Girl; "Ballettgarderobe" or Ballet Dressing Room; "Prima Ballerina"; "Wierner Porzellan" or Vienna Porcelain; also one with an indecipherable title.

(Total: 11 Items)

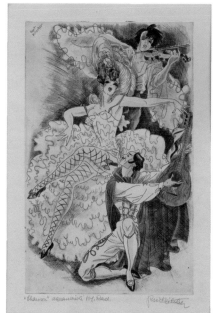

19272

19272
KURT HILSCHER
(German, b.1904)
Hand colored etchings, group of eleven
Ink and watercolor on paper
9.25in. x 6.25in. (sight size)
Signed lower right: Kurt Hilscher

Eleven Art Deco hand colored prints by German artist Kurt Hilscher celebrate the world of dance. Hilscher was born in Dresden, Germany in 1904 and lived in Berlin. He studied at the Academies of Art in Dresden and Munich and at the Academie des Beaux Arts in Paris.

(Total: 11 Items)

Visit HeritageGalleries.com to view scalable images and bid online.
Session Two, Auction #608 • Saturday, October 30, 2004 • 6:00 p.m.
223

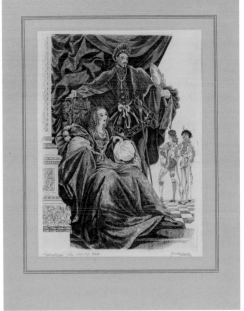

19273

KURT HILSCHER (German, b.1904)

Hand colored etchings, group of ten
Ink and watercolor on paper
9.5in. x 7.25in. (sight size)
Signed lower right: Kurt Hilscher

Ten satirical etchings chart fashion trends through the years. "Die Schaeferstunde" or the Romantic Interlude; "Der Poet" or The Poet; "Das Gestaendnis" or the Confession; "Opernball" or The Opera Ball; "Der Kritiker" or The Critics; "Spaziergang" or The Stroll; "Ausgang" or Going Out; "Grandessa"; "Paris de Boulogne"; and "Die Amarone." Hilscher is perhaps best known for his book illustrations, but art collectors often seek out his slightly decadent prints.

(Total: 10 Items)

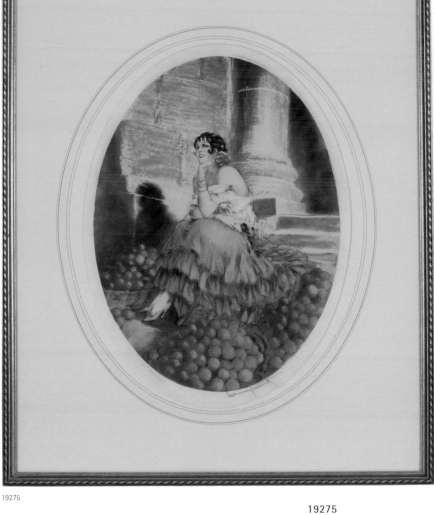

19275

19275
LOUIS ICART

Orange Cellar, c.1929

Etching and drypoint printed in colors
19in. x 13in. (sight size)
Signed in pencil: Louis Icart and artists blind stamp

19274
LOUIS ICART

Eve, c.1920

Etching and drypoint printed in colors
18in. x 22in. (sight size)
Signed in pencil: Louis Icart and artists blind stamp

19274

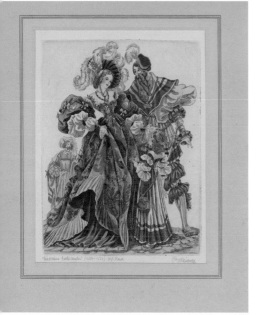

19276

KURT HILSCHER (German b.1904)

Hand colored etchings, group of five
Ink and watercolor on paper
9.5in. x 7.25in. (sight size)
Signed lower right: Kurt Hilscher

Five colored prints of Hilscher's unique take on romance,
"Die Kleine Gratulantin" or The Little Well-Wisher; "Rivalen"
or The Rivals; "Umwerbung" or Wooing; "Am Hof Heinrich
VIII" or At the Court of Henry the Eighth; also one with an
indecipherable title.

(Total: 5 Items)

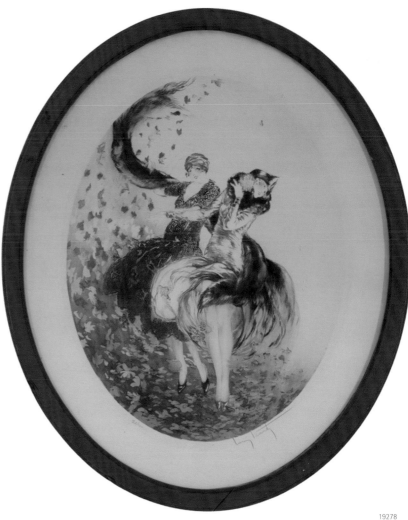

19278

LOUIS ICART

Autumn Leaves, c.1929

Etching and drypoint printed in colors
20in. x 15in. (sight size)
Signed in pencil: Louis Icart and artists blind stamp

19277

KURT HILSCHER (German b.1904)

Hand colored etchings, group of twelve
Ink and watercolor on paper
8.75in. x 7.5in. (sight size)
Signed lower right: Kurt Hilscher

Twelve prints lampoon the courting dance,
"Indiskret" or Indiscreet; "Buerger der
Revolution" or Citizens of the Revolution;
"Schlosspromenade"; "Der Musketier" or
The Musketeer; "Der Kunstfreund" or the
Patron of the Arts; "Das Geheimnis" or the
Secret; "Promenadenklatsch" or a Chat on
the Promenade; "In de Loge" in the Box
at the Opera; "Derby"; "Chambre Separee"
or Private Room at a resturant; and
"Plauderei" or Chatting; also, one with an
indecipherable title.

(Total: 12 Items)

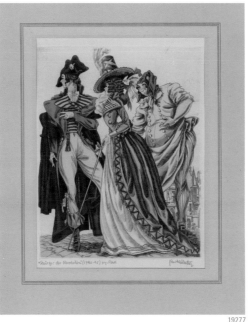

19277

Visit HeritageGalleries.com to view scalable images and bid online.
Session Two, Auction #608 • Saturday, October 30, 2004 • 6:00 p.m.
225

19279
LOUIS ICART

Hydrangea, c.1929

Etching and drypoint printed in colors
18in. x 22in. (sight size)
Signed in pencil: Louis Icart and artists blind stamp

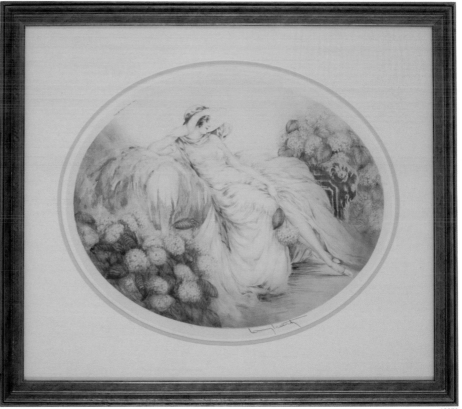

19279

19280

19280
KURT HILSCHER (German, b.1904)
Large Architectural Colored Etchings, group of ten (undated)
Various sight sizes
Signed

Ten colored intaglio etchings present detailed panoramic vistas of notable
German architecture and engineering sites. Castles, canals, bridge,
cathedrals and cities make for picturesque views. Each has an image area of
approximately 6.5in. x 10in. Each has been signed by its artist, in pencil, at
the lower right corner.

(Total: 10)

19281

19281
KURT HILSCHER (German, b.1904)
Hand Colored Architectural Etchings, group of five (undated)
Various sight sizes
Signed

Scenic views of European buildings and structures have been etched
and then hand colored. Castles, cathedrals, fountains, and bridges are all
rendered in accurate perspective and by keen observation. The image area
of the etchings range in size from 11in. x 7.5in. to 7.5in. x 6in. Each has
been signed, in pencil, at the lower right by its artist. A wonderful group of
studies.

(Total: 5 Items)

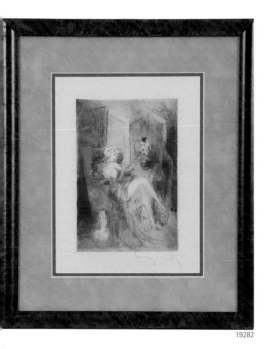

19282

LOUIS ICART (French 1888-1950)

Enchanté, c. 1946
Dry Point Etching
Image area 7in.x 9.25in.

The erotic Victorian scene depicts a seated lady with a gentleman kissing her hand, signed in pencil

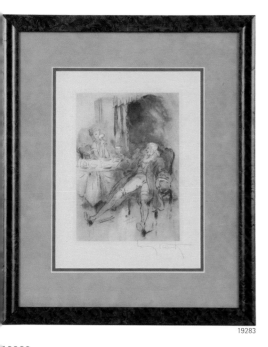

19283

LOUIS ICART (French 1888-1950)

A Glass of Wine, 1946
Etching, limited edition 525
12.75in. x 9.25in. sight
Signed lower right in pencil: Louis Icart
Letter of authenticity from Art Bank Ltd 2003 accompanies

19284

KURT HILSCHER (German, b.1904)

Hand colored botanical etchings, group of six (undated)
Aproximately 12.5in. x 9.5in. (sight size) and 8in. x 6.25in. (sight size)
Signed

Five beautifuly etched vintage botanical prints have been watercolored by hand. The sixth print, with an image of tulips, is a colored etching, printed with four colors of printmaking ink. Each print has been signed, in pencil, at the lower right by the artist.

(Total: 6 Items)

Visit HeritageGalleries.com to view scalable images and bid online.
Session Two, Auction #608 • Saturday, October 30, 2004 • 6:00 p.m.
227

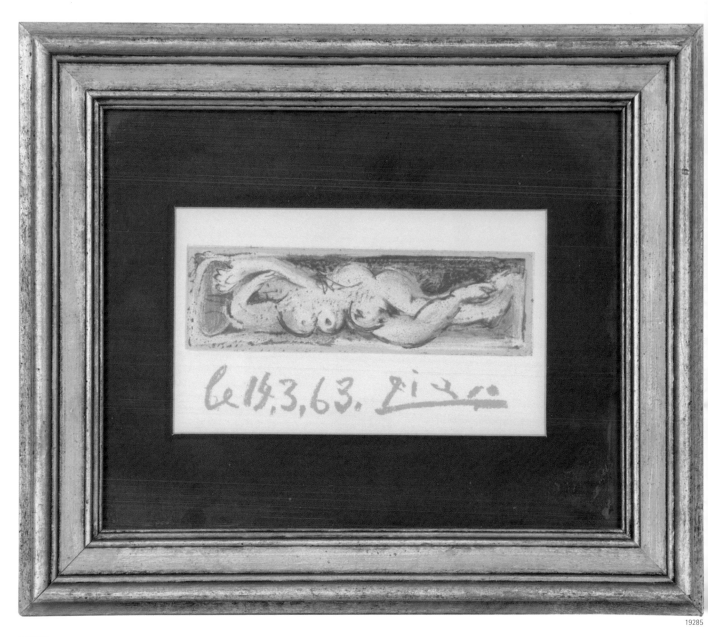

19285
PABLO PICASSO (Spanish 1881–1973)

Femme Nue Couchée, 1963

Color lithograph
4in. x 6.75in.
Inscribed on bottom: 14.3.63 Picasso

9286
UAN GRIS (Spanish 1887-1927)

aking Tea

Watercolor and ink on paper
in. x 5.25in. (sight size)
igned lower left in ink: Gris
ketch of a man on verso

osé Victoriano Gonzalez Pérez, known
o the world as Juan Gris, was born in
Madrid, Spain. His father was a prominent
ewspaper publisher and Gris was the 13th
f 14 children. As a boy, he excelled in
rawing and eventually attended art school,
owever he found academic training too
igorous and eventually quit. He traveled
o Paris and was admitted to the Bateau
avoir together with other artists, including
ablo Picasso. By 1910 Gris had devoted
imself entirely to painting and his work
vas greatly influenced by that of Cézanne
nd the cubist style of Picasso and Georges
raque. In 1912 he spent the summer in
Céret, France, working along side Picasso
nd executed his first collage works. During
World War I, Gris worked in Paris and had
is first one-man show in 1919. After 1925,
e worked primarily in gouache, watercolor
nd produced illustrations for books. His
aintings are housed in important public
collections, including the Musea del Prado,
Madrid; Philadelphia Museum of Art and the
Musée d'Orsay, among many others.

19286

19287
GUILIO ROSATI (Italian 1858-1917)

Orientalist Scene: The Fight

Watercolor on paper
21.5in. x 14.5in.
Signed lower right: Guilio Rosati

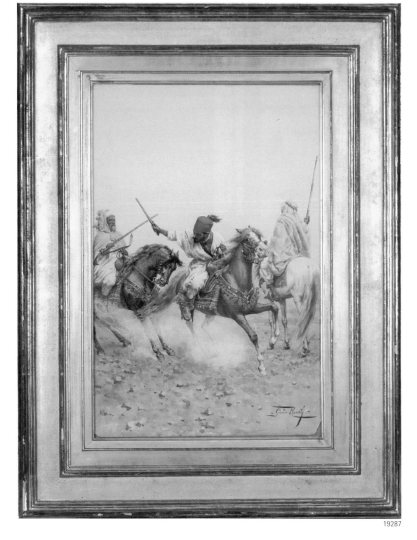

19287

19288

GEORGES CROEGAERT (Belgian 1848-1923)

Cardinal Paintings

Oil on panel
14in. x 10in.
Signed lower right: Georges Croegaert Paris
Provenance: W. Freeman & Son, London; MacConnal-Mason & Son, London; private collection, Dallas, Texas, 1984 to present

Georges Croegaert was born in Anvers in 1848. He spent most of his life in Paris where he was a portrait and genre painter celebrated for his meticulously rendered interiors of Cardinals engaged in leisurely activities, including reading, painting, taking tea, or writing. Croegaert exhibited at the Salon des Artists Francais, and his work is housed in the Museum of Sydney, Australia.

(Total: 2 Items)

19289

19289
ROELANDT JACOBSZ SAVERY (Dutch 1576-1639)

Landscape with Lions

Oil on panel
17.5in. x 24.75in.
Signed bottom center: Roelandt/ Savery
Provenance: private collection; Leger and Son, London, 1955; private collection, Middlesex, England
Exhibited: Museum voor Schone Kunsten, Ghent, Roelandt Savery 1576-1639, April- June, 1954, no. 87.

Roelandt Savery painted two similar versions of this subject, and both are signed. One is in the collection of Graf von Schonborn, Pommersfelden; the other in the Kulturgeschichtes Museum, Osnabruck. Savery was a versatile artist and superb draftsman who painted landscapes, genre scenes, still lifes and flower pieces. Savery was born in Kortijk and as a boy moved to Haarlem, in the southern Netherlands. By 1591 he was studying with his brother Jacob and the artist Hans Bol in Amsterdam.

Savery traveled widely and worked as a court painter for Henry IV of France. Beginning around 1603, he worked for ten years as court painter for Rudolph II of Prague. He traveled through Bohemia making sketches and drawings he used as the basis for his paintings. His work also incorporated exotic animals that he studied closely in Rudolf's menagerie, and he must have seen the now extinct dodo bird as is often appears in some of his paintings. Savery later worked in the court of Emperor Matthias of Vienna before settling in Utrecht in 1619.

While his work recalls the paintings by Jan Brueghel the Elder, Savery's style is more archaic. His landscapes are known for their abundance of flora and fauna, painted in meticulous detail. His landscape paintings with jagged rock formations and waterfalls influenced Dutch landscape painters such as Allart van Everdingen, Herman Saflteven the Younger and Jacob van Ruisdael. Savery's paintings are housed in important public collections, including the Louvre, Paris; National Gallery of Art, London; Norton Simon Museum, California; National Gallery of Prague, J. Paul Getty Museum, Los Angeles; and The Metropolitan Museum of Art, New York.

19290

19290
CHRISTIAN LUYCKS (Belgian 1623 – after 1670)

A Garland of Flowers

Oil on canvas
22.5in. x 20.25in.

The painting is accompanied by a letter from Dr. Samuel Segal of Still Life Studies, Amsterdam, dated December 2, 2003; painting number 30062; and an extensive condition report from Dr. Nicholas Eastaugh of UCL Painting Analysis, London accompanies this work

Provenance: private collection, Great Britain; [Bonham's July 8, 1998, lot 54 as Circle of Daniel Seghers]; private collection, Middlesex, England

This painting was formerly attributed to Daniel Seghers (Flemish 1590-1661), but after extensive research by still life specialist, Dr. Samuel Segal of Still Life Studies, Amsterdam, the painting is now attributed to Christian Luycks.

19291
CHARLES DESHAYES
(French 1831-1895)

River Landscape

Oil on canvas
17 x 16.5in.
Signed lower right: Ch. Deshayes
Paris makers stamp on verso
Framed

19291

19292

19292
AMERICAN SCHOOL (19th Century)

View of West Point Military Academy

Oil on canvas
29.5in. x 37.5in.
Provenance: the estate of Jacqueline B. Onassis; [Sothebys.com, July 13, 2001, lot 7F4G]; private collection

19293
GUSTAVE EUGENE CASTAN
(Swiss 1823–1892)

Figure in the Swiss Alps

Oil on canvas
25in. x 33in.
Signed lower right: G Castan
Provenance: private collection, France

19293

19294
CONTINENTAL SCHOOL

Harbor Scene

Oil on canvasboard
12.75in. x 17in.
Signed lower right: Sally Phillipsen

19294

19295
CONTINENTAL SCHOOL

Sailboats at Sea, 1920

Oil on canvas
14.75in. x 19.125in.
Signed and dated lower left: E.
Osterbye 1920

19295

19296

19296
FRANCOIS VANDEVERDONCK (Belgian 1848–1875)

Sheep in a Landscape, 1871 (pair)

Oil on panel
7in. x 9.375in.
Signed and dated bottom center: Vandeverdonck 1871
Inscribed on verso
These paintings are housed in antique fluted cove frames. (Total: 2 Items)

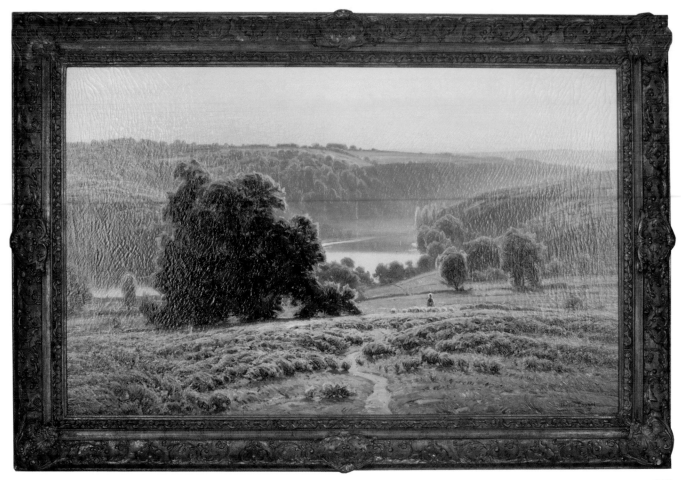

19297

WILLIAM DIDIER-POUGET (French 1864–1959)

Lavender Fields

Oil on canvas
22.5in. x 36.5in.
Signed and dated lower right: Didier-Pouget
Framed in reproduction frame

William Didier-Pouget began his formal art training at the École des Beaux-Arts in his native town Toulouse, France. He later studied at the Academy of Paris under French landscape painter Baudit and made his debut at the Paris Salon in 1866. Didier-Pouget focused on the countryside of southern France and infused his landscapes with light and color. During his career, his favorite subjects were beautiful fields of heather in the fog, forests filled with trees, plateaus in the Creuse Valley, and the Dordogne River. Didier-Pouget exhibited at various venues and upon winning the gold medal at the Universal Exposition 1913, he was selected as a member of the Jury as well as a permanent senior member of the Société des Artistes Francais. His paintings are housed in the Petit Palace, Paris; the Museum of Fine Arts, Boston; and public collections in Toulouse, and Lyon, France.

19298
FREDERICK BALLARD WILLIAMS
(American 1871-1956)

Landscape of Montclair, New Jersey 1937

Oil on board
12.5in. x 15.5in.
Signed lower left
Inscribed on verso label: "Landscape" Montclair NJ Oct 5, 1937

A painter of romantic and decorative canvases, Frederick Ballard Williams began his career by painting landscapes with women, usually depicted in 18th century gowns in the spirit of French Rococo painting of Antoine Watteau.

Williams was born in Brooklyn, New York, and began his training with night art classes in New York City at Cooper Union. He also studied at the New York Institute of Artists and Artisans and with John Ward Stimson, a romantic painter. Williams later attended the National Academy of Design where he first exhibited in 1901. He then traveled to England and France where he was inspired by the Barbizon aesthetic of placing figures at work in a landscape.

Williams lived most of his life in Glen Ridge, New Jersey where he found many of the subjects for his paintings. However, in the 1930s, he began omitting the idyllic figures, and painting pure landscapes. He also painted in the mountains of western North Carolina and also went to San Francisco for extended periods in 1896 and 1901. In 1910, he was part of the famous Santa Fe Railway and American Lithographic Company sponsored trip to bring well-known painters to the Grand Canyon. The group included Edward Potthast, Elliott Daingerfield, Thomas Moran, and De Witt Parshall. The artists were given lodging at El Tovar Hotel and studios at the South Rim of the Canyon in exchange for paintings for the railroad and for exhibition throughout the East.

19298

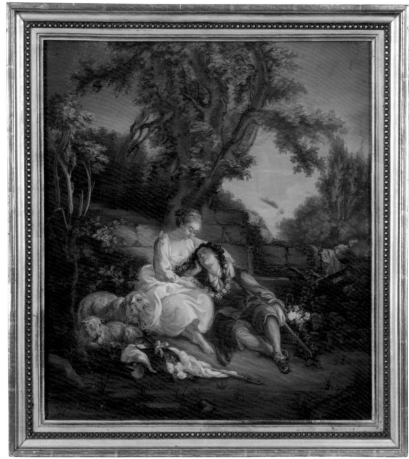

19299

19299
CONTINENTAL SCHOOL

Pastoral Scene, 1866

Pastel on paper
21in. x 19in.
Signed and dated lower right: A. Staiger
Provenance: private collection, France

Visit HeritageGalleries.com to view scalable images and bid online.

Session Two, Auction #608 • Saturday, October 30, 2004 • 6:00 p.m.

237

19300
CONTINENTAL SCHOOL

Pastoral Scene, 1867

Pastel on paper
21in. x 19in.
Signed and dated lower right: A. Staiger
Provenance: private collection, France

19300

19301
FRENCH SCHOOL
(19th-20th Century)

Parisian Street Scene

Oil on canvas
15in. x 19in.
Signed lower left: H. Bremat
This painting housed in an antique frame

19301

19302
EDOUARD JOHN E. RAVEL
(Swiss 1847-1920)

Painting en Plein Air, 1887

Engraving
21in. x 17in.
Incised lower right: Edouard Ravel 87
Provenance: private collection, France

19302

19303

19303
HENRY RYLAND, R.I. (British 1856-1924)

At the Fountain

Watercolor on paper
15in. x 21.5in.
Signed lower right: Henry Ryland
Inscribed on frame: At the Fountain/ Henry Ryland, RI
Provenance: private collection, Middlesex, England

Henry Ryland was born in Bedfordshire, England
and was a pupil of Benjamin Constant and
Boulanger in Paris. He exhibited often at the
Royal Academy in London starting from 1890.
Ryland specialized in watercolors of classically
dressed young women on marble terraces
painted in the spirit of Alma Tadema. Ryland
was also a notable illustrator and designer.

Ryland's classical paintings established him as
one of Britain's foremost neoclassical artists.
His meticulous brushwork and high finish
is comparable to J.W. Godward in subject
and style. Some of Ryland's paintings were
reproduced as prints and widely distributed

19304

19304
GEORGE LAWRENCE BULLEID (British 1858–1933)

A Columbarium, 1898

Watercolor on paper

12in. x 18.75in. sight

Signed and dated lower right: Lawrence Bulleid/ MDCCCXCVIII ARWS

Royal Scottish Society of Painters in Watercolours label on verso inscribed: A Columbarium/ G. Lawrence Bulleid/ 57 Combe Park/ BathJames Connell & Sons est 1862/ Fine Art Dealers & Publishers/ Glasgow label on verso

This painting retains its original frame with verso label inscribed: J.R. Harnall & Son/ Carvers, Gilders, & Picture Framers/ London

Provenance: James Connell & Sons Fine Art, Glasgow; [Phillips, London, November 5, 2001, lot 99]; private collection, Middlesex, England

Exhibited: The Royal Scottish Society of Painters in Watercolours

George Lawrence Bulleid was born in Glastonbury, England, the son of a solicitor. He began his career following in his father's profession but later attended the West London School of Art and subsequently studied at Heatherley's. By 1889 Bulleid was elected an associate of the Royal Watercolour Society, and often signed his works with the initials ARWS after his name. He was an active member of the society and exhibited over a 100 works there. Bulleid moved to Bath in 1890, and he spent the rest of his life there painting Greco-Roman scenes and floral pictures. Bulleid's celebrated paintings were of classical themes consisting of two or three figures — images imbued with graceful tranquility and painted in the spirit of Alma-Tadema. Bulleid was close friends with Godward and Ryland.

19305

19305
LINDA KOGEL (German 1861-1940)

Woman with A Bowl of Tulips, 1896

Pastel and pencil on board
24in. x 31in.
Signed and dated lower left: L Kogel/ 96
Framed in an antique frame under glass
Provenance: the collection of Karl Thieme, Munich (possibly from the artist); [Christie's Zurich, April 9, 1986, lot 213]; private collection, Middlesex, England

Linda Kogel was a painter and designer working in Munich in the late 1890s and early 1900s. She was a member of the Munich Secession Association, Vereinigte Werkstatten fur Kunst im Handwerk, a group of painters and designers that included Peter Beherns, Bernard Pankok, Otto Eckmann, Richard Riemerschmid, and Bruno Paul. The present painting originally comes from the house of Karl Thieme, a banker in Munich and an important patron of the Vereinigte Werkstatten whose house was furnished and decorated exclusively by this group of painters, architects, and designers.

19306
FRENCH SCHOOL

The Flower Seller, c.1900

Oil on canvas
21in. x 10.5in.
Signed lower right: P. Duval
Provenance: private collection,
Middlesex, England

19306

19307
ADOLPHE JOSEPH THOMAS MONTICELLI (French 1824–1886)

Conversion of St. Paul

Oil on panel
7.5in. x 15.25in.
Signed lower left: M
Provenance: Josef Herman; [Bonham's Knightsbridge, The Josef Herman Collection, November, 2000 lot 26]; private collection, Middlesex, England

Adolphe Joseph Thomas Monticelli was born in Marseille, France and studied painting at the École Municipale de Dessin from 1842 to 1846. At that time, the school was directed by Émile Loubon who encouraged his students to paint directly from nature. Monticelli moved to Paris in 1846 and entered the École des Beaux-Arts under Delaroche. He spent his free time in the Louvre copying works by old master painters.

In the subsequent years Monticelli spent his time divided between Marseilles and Paris. He traveled throughout Provence with Guigou, and together they painted the surrounding landscapes and villages. In 1856 he met Diaz de la Peña, who encouraged him to use bolder colors and a heavier texture. Under the influence of Diaz, he also began adding small figures in his landscapes. That same year Monticelli returned to Marseilles, where he would remain for seven years. He again made landscape studies while earning money with his portraits.

Monticelli returned to Paris in 1863 and specialized in painting fashionable society in lush landscapes, recalling the works of Watteau. He also encountered some impressionist painters, and he painted along with Cézanne in the areas around Aix and Marseilles. In his late landscapes Monticelli experimented with paint texture, using thick impasto on a bare canvas to create a dynamic surface. These experiments were to leave a strong impression on Van Gogh, who saw his work at the Galerie Delarebeyrette in Paris in 1886, the year of Monticelli's death.

Monticelli is regarded as a forefather of Abstract Expressionism due to his liberal use of dazzling colors applied with a thick impasto. His paintings are housed in public collections, including Lille, Marseilles, Boston, Chicago, New York City, St. Louis, and Washington, D.C.

19307

19308

19308
CONTINENTAL SCHOOL (19th Century)

Barn Interior with Chickens

Oil on canvas
33.5in. x 29in.
Signed lower right: J. Martin
This painting housed in an antique frame
Provenance: private collection, France

19309
CONTINENTAL SCHOOL (19th Century)

Domestic Interior

Oil on canvas
33.5in. x 29in.
Signed lower right: J. Martin
This painting housed in an antique frame
Provenance: private collection, France

19309

19310

WILLIAM ETTY, R.A. (British 1787-1849)

Britomart Redeems Faire Amoret, c. 1833

Oil on canvas
35.5in. x 25.5in.

Provenance: Forbes, Old Battersea House; [Sotheby's Forbes Magazine Collection, June 9, 1994 lot 178]; Maas Gallery; private collection, Middlesex, England

Exhibited: Manchester, Royal Institution, Modern Artists, 1833

William Etty appears to have made two versions of the present subject derived from Edmund Spencer's The Faerie Queene. The other version, which is a similar composition and an almost exact size to the present work, was formerly in the Lady Lever Art Gallery, Port Sunlight until the 1950s and was acquired by the Tate Gallery, London in 1958 (see Dennis Farr, William Etty, 1958 cat. no 44, pl. 46.) One of the two versions was exhibited at the Royal Academy, London in 1833, no. 7.

The present work depicts a scene from Book III, Canto XII, verses XXX- XXXIV of The Faire Queene. The heroine Britomart, intended as a type of Queen Elizabeth, represents the virtues of valour and chastity. She enters a chamber in which an evil sorcerer holds Amoret captive: "that same woefull Lady, both whose hands/ Where bounden fast, that did her ill become,/ And her small waste girt rownd with yron bands/ Upon brazen pillour, by the which she stands. The 'vile Enchanteur sate,/ Figuring strange characters of his art:/ With living blood', a spell with which he sought to cause Amoret to fall in love with him. Soone as that virgin knight he saw in place/ His wicked bookes in hast he overthrew and fiercely running to that Lady trew,/ A murderous knife out of his pocket drew. Britomart and the sorcerer fought, but at the moment when her tormentor was about to be killed, the Lady which by him stood bound,/ Dernly into her called to abstaine/ From doing him to dy. For else her paine/ Should be remedilesse; sith none but hee/ Which wrought it could the same recure againe./ Therewith she stayd her hand, loth stayd to bee/ For life she him envyde, and long'd revenge to see."

Etty's paintings can be found in important public collections, including the J. Paul Getty Museum, Manchester City Art Gallery, National Museum Liverpool, and the Tate Gallery, London.

19311

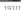

French School (19th Century)

Courtier and Lady, 1851

Oil on canvas
25.5in. x 20.25in.
Signed and dated lower left: Barnard/ 1851
This painting retains its original frame

19312

HOWARD CHANDLER CHRISTY (American 1873-1952)

Portrait of Frankie Witherspoon

Oil on canvas
31.25in. x 24.5in.
Signed lower right: Howard Chandler Christy
Provenance: from the artist to Mr. Ambrose Witherspoon, Lawrenceburg,
Kentucky; gifted to his wife Frankie Lillard Witherspoon

Frankie Lillard's family owned Bond Lillard Distillery,
Lawrenceburg, Kentucky, which later became National
Distillery, whose descendants now own Brown Williamson
Tobacco & Distilleries, Louisville, Kentucky. Mr. Ambrose
Witherspoon, was a physician who started Anderson National
Bank in Lawrenceburg.

Mr. and Mrs. Ambrose Witherspoon visited New York often
where they met and befriended Howard Chandler Christy at
the Café des Artistes. The present painting was a Christmas gift
from Mr. Witherspoon to his wife Frankie.

Noted portrait painter of Hollywood stars, presidents, and
high-society, Howard Chandler Christy was originally from
Ohio. Christy arrived in New York in 1890 and attended the
Art Students League where he studied under William Merritt
Chase. He first worked as an illustrator and was commissioned
to illustrate Frank Crowninshield's book in Camphor.

Christy enlisted to help cover the Spanish-American War.
He accompanied the Rough Riders into battle to make
illustrations for articles published in Scribner's, Harpers,
Century, and Leslie's Weekly. In the process, Christy befriended
Col. Theodore Roosevelt and gained a broader interest in
patriotic subjects. By the time he returned home in 1898, he
was a celebrity. His fame and reputation was secured with The
Soldier's Dream published in Scribner's where he portrayed a
beautiful girl known as "The Christy Girl," an idea image for an
all American woman.

From that point forward, Christy painted beautiful women for
McClure's and other popular magazines. In 1908, he returned
to Ohio and in spite of being far away from the mainstream,
he still had numerous commissions. In 1915, Christy returned
to New York and opened a studio apartment at the Hotel des
Artistes and continued illustrating. As war once again appeared
imminent, Christy rallied his talents to assist the war effort
by painting posters for government war bonds, the Red Cross,
Navy, Marines, and in support of civilian volunteer efforts. His
famous poster of a young woman dressed in a sailors uniform
with the caption, "If I were a man, I would join the Navy,"
is from this period. During the 1920s, Christy turned from
illustration to portrait painting. He painted Benito Mussolini,
Crown Prince Umberto of Italy, Captain Eddie Rickenbacker, U.S.
Presidents Franklin Roosevelt, Coolidge, Hoover, Polk, Van Buren
and Garfield; humorist Will Rogers, aviator Amelia Earhart,
General Douglas MacArthur, and William Randolph Hearst.

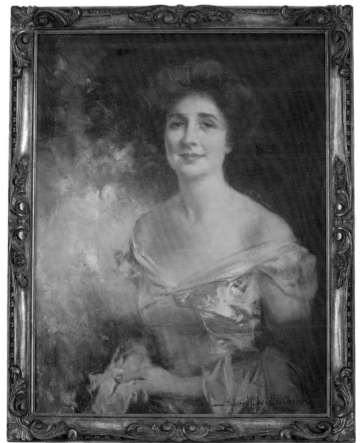

19312

19313
GERARD BERRY (American b. 1864)

Portrait of J.H. Catherwood, Sr., 1905

Oil on canvas
39.5in. x 31.25in.
Signed and dated lower left: Gerard Barry 1905

J.H. Catherwood, Sr. was owner of J.H. Catherwood & Co., a tea import company in Philadelphia, Pennsylvania

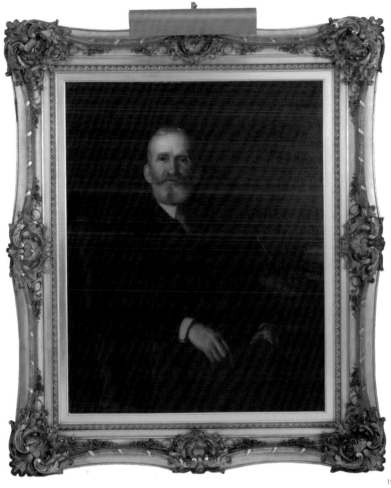

19313

19314
MARIE LAURENCIN (French 1885-1956)

Ladies with a Dog

Colored pencil on paper
13.1in. x 9.6in. (sight size)
Signed bottom center: Marie Laurencin

19314

15

CARLTON MEAD
(American 1902-1986)

Landscape, 1956

canvas
x 38in.
ed and dated lower left: c 1956 Ben Carlton

Carlton Mead was born in Bay
, Texas, however his family moved
during his childhood to Lamesa
Amarillo. He attended the Art
itute of Chicago under Jerome
en and Charles Schroeder. Mead
an his career as a designer for
Sunset Advertising System in San
onio, and subsequently opened
own commercial art studio in San
onio where he illustrated magazines,
spapers, and books. During the
0s, Mead taught at the Amarillo
ege and also gave private lessons
of his studio. Mead moved to Dallas
941 where he again opened a
mercial art studio and continued to
trate.

d helped organize the Dallas Corral
Westerners International, a group
ted to the study of the American
. Mead also a member of the
rnational Society of Artists and the
s Folklore Society. Mead moved
alifornia in 1981 where he taught
ting and drawing in his studio in
a Ynez valley.

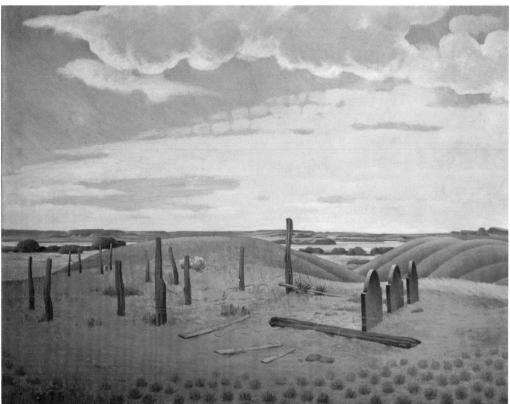

19315

16

GUSTUS DUNBIER (American 1888-1977)

sion, San Antonio, Texas

canvas
. x 15.5in.

ustus Dunbier was one of Nebraska's most
essful and influential artists and teachers. He
born near Shelby, Nebraska and spent most
is life in Omaha where he was an established
ter of landscapes and portraits. Dunbier began
art training at the Art Institute of Chicago and
at the Dusseldorf Academy in Germany. He
later influenced by Impressionism with its light
r palette and loose brushwork. Upon his return
merica, Dunbier worked for a short period with
w Nebraska artists Robert Henri and Robert
ncer.

le Dunbier made his living primarily as a
rait painter, his favorite subject was the
scape. His friend Walter Ufer persuaded
bier to visit Taos, New Mexico in the summer of
6. Eventually, Dunbier became friends with all
ne Taos artists especially Ufer and Ernest Couse.
bier returned to the southwest seasonally for
rest of his life.

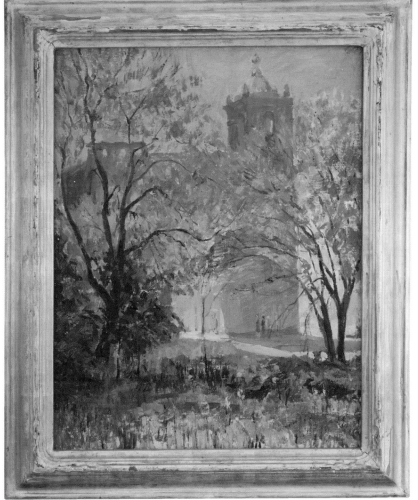

19316

19317

DIEGO RIVERA (Mexican 1886-1957)

Glass Blower

Ink on paper
15in. x 10.25in.
Signed lower left: Diego Rivera
Provenance: from the artist to Mr. Robert Foster; the estate of Mr. Robert Foster; Mr. Robert Foster was an art student in Guadalajara in 1946 and was given the drawing as a gift from the artist.

Considered to be Mexico's greatest painters of the 20th century, Diego Rivera's artwork of the working class had profound impact on the international art world. Among his many contributions, Rivera is credited with the reintroduction of fresco painting into modern art and architecture. His radical political views and tumultuous romance with surrealist painter Frieda Kahlo were a source of public intrigue, which still remains to this day. During his visits to America between 1930 and 1940, Rivera brought his unique artistic vision to public spaces and galleries, which inspired generations of American artists.

Rivera was born in Guanajuato, Mexico in 1886. He began to study painting at an early age and in 1907 moved to Europe. Spending most of the next 14 years in Paris, Rivera encountered the works of such great French masters as Cézanne, Gauguin, Renoir, and Matisse, as well as the Renaissance frescos of Italy. Rivera returned to Mexico where he began painting frescos for universities and public buildings. A life-long Marxist, Rivera's large, public frescos brought art to the common man — circumventing the elite walls of galleries and museums. Throughout the 1920s his fame grew with a number of large murals depicting scenes from Mexican history, technology, and progress.

In 1930, Rivera made the first of a series of trips to the United States that would alter the course of American painting. In November of that year, Rivera began work on the first of two major American commissions for the American Stock Exchange Luncheon Club and for the California School of Fine Arts. With these commissions, and all of the American murals to follow, Rivera explored and depicted the struggles of the working class. In 1932, at the height of the Great Depression, Rivera went to Detroit to paint a mural for the Detroit Institute of Arts commissioned by Henry Ford. In 1933 the Rockefellers commissioned Rivera to paint a mural for the lobby of the RCA building in Rockefeller Center.

Throughout his career, Rivera remained an important figure in the development of a national art in Mexico. Perhaps one his greatest legacies, however, was his impact on America's conception of public art. In depicting scenes of American life on public buildings, Rivera provided the inspiration for Franklin D. Roosevelt's WPA program. Of the hundreds of American artists who were employed through the WPA, many continued to address political concerns and struggles of the common laborer that had first been publicly presented by Rivera.

19318

DIEGO RIVERA (Mexican 1886-1957)

Glass Blower

Ink on paper
10.25in. x 15in.
Signed lower right: Diego Rivera
Provenance: from the artist to Mr. Robert Foster; the estate of Mr. Robert Foster; Mr. Robert Foster was an art student in Guadalajara in 1946 and was given the drawing as a gift from the artist.

319

GEORGES ROUAULT (French 1871-1958)

Misereux, 1911

watercolor and india ink on paper mounted on board
in diameter
signed and dated bottom center: G. Rouault 1911
Rowland Browse & Delbanco, London label on verso inscribed: La Famille/ Georges Rouault/ from the collection of Lord Bernstein

This painting will be included in the forthcoming catalogue raisonné on the artist

Provenance: The collection of Lord Bernstein; Rowland Browse & Delbanco, London; [Bonham's, London November 22, 2000 lot 47]; private collection, Middlesex, England

Georges Rouault was born the son of a cabinetmaker and his earliest education came from his grandfather, a man who possessed a strong knowledge of and appreciation for art. During grammar school, Rouault displayed skill in drawing and his art teacher encouraged his talents. As a young man, he apprenticed to a stained glass artisan and there he learned to restore medieval stained glass windows. This experience later influenced his painting style and his choice of subject matter — religion.

Rouault began evening classes at the Ecole National des Arts and later studied at the Ecole des Beaux-Arts. He befriended artist Gustave Moreau, who took young Rouault under his wing and encouraged him. Around 1900 Rouault radically changed his painting style and began working out new techniques and concepts. He exhibited at the Salon d'Automne in 1903 along with Matisse and other artists. Rouault was inspired by the theme of sin and salvation, and focused on religious subjects, prostitutes, judges, and tribunals. In 1916 Rouault illustrated a number of books and for some time focused entirely on printmaking. From this period came numerous etchings and aquatints entitled Miserere. He resumed painting in 1927. Rouault also made ceramics and created designs for theater sets, tapestries, and stained glass windows. His artwork is housed in important museums, including The Hermitage, St. Petersburg; National Gallery of Canada, Ottawa; Cleveland Museum of Art, Ohio; MF DeYoung Fine Arts Museum of San Francisco, California; and the Musée d'Art Moderne, Lille, France.

19320
REUVEN RUBIN (Israeli 1893-1974)

The Olive Tree

Oil on canvas
21.25in. x 29in.
Signed lower right: Rika/ Rubin
Texas Frame Corporation label on verso
Provenance: From the artist's home in Israel to present owner

Although Reuven Rubin was born in Rumania and studied art in Paris, his art is distinctly Israeli. He studied briefly at the Bezalel School of Art in Jerusalem, and he made his exhibition debut in Jerusalem in 1922. In 1924, he had his first solo show and in 1932, he had another one-man show as part of the opening of the Tel Aviv Art Museum. He designed scenery for Habimah, the National Theater of Israel. Rubin created a Jewish style of art. Influenced heavily by the work of Henri Rousseau, Rubin fused the French style with Jewish nuances. Among Rubin's most memorable works are his paintings of the Yishuv, particularly landscape scenes that depict the Israeli worker. Biblical themes also occur frequently in his paintings. His work was extremely popular in Israel and he was the first Israeli artist to achieve international acclaim. Rubin served as Israel's first ambassador to Rumania from 1948-1950. His autobiography, *My Life — My Art*, was published in 1969, and in 1973 he received the Israel Prize for his artistic achievements. Rubin signed his first name in Hebrew and his surname in Roman letters.

19321
REUVEN RUBIN (Israeli 1893–1974)

Jerusalem

Oil on canvas
21.25in. x 29in.
Signed lower right: Rika/ Rubin
Texas Frame Corporation label on verso
Provenance: From the artist's home in Israel to present owner

END OF SESSION TWO

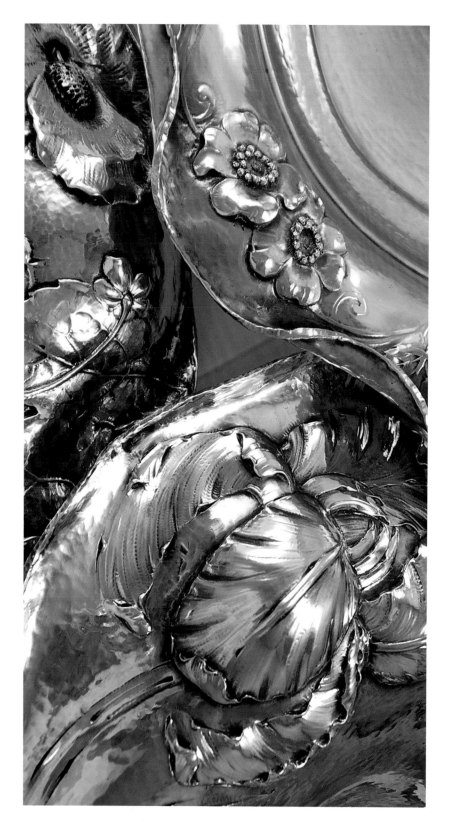

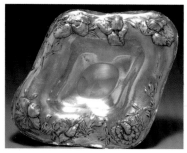
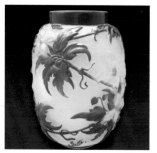

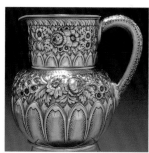

SESSION THREE — POTTERY AND CERAMICS

Public-Internet Auction #608
Sunday, October 31, 2004, 1:00 p.m., Lots 20001-20338
Dallas, Texas

A 19.5% Buyer's Premium Will Be Added To All Lots

Visit HeritageGalleries.com to view scalable images and bid online.

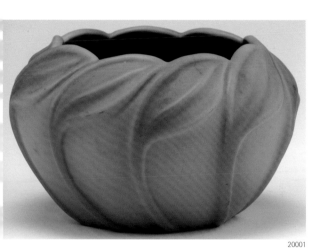

20001

20001

AN AMERICAN POTTERY BOWL

Van Briggle, c.1920

Blue swirling leaves over a wintergreen matte glaze complemented
with an irregular top, incised signature *Van Briggle*

5in. high

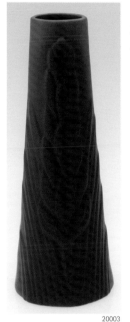

20003

20003

AN AMERICAN POTTERY VASE

Van Briggle, c.1920

The burgundy matte ground molded
to depict wheat in tall grass with
deep blue overspray, incised signature
Van Briggle

14.3in. high

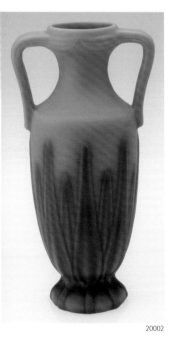

20002

20002

**AN AMERICAN POTTERY
FOOTED VASE**

Van Briggle, c.1920

The wintergreen matte glaze with
dark blue overspray covering a
molded pattern rising from the base,
incised signature *Van Briggle*

13.7in. high

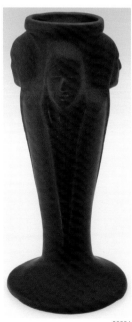

20004

20004

AN AMERICAN POTTERY VASE

Van Briggle, c.1920

The burgundy matte ground with
three molded Native American faces
with subtle blue overspray, incised
signature *Van Briggle*

11.5in. high

20005

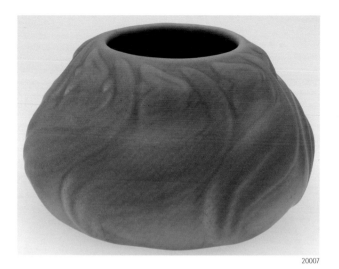

20007

20007
AN AMERICAN POTTERY SQUATTER VASE
Van Briggle, c.1915

The bulbous shape with periwinkle over wintergreen matte glaze and molded with tulip design, incised signature *Van Briggle*
4.5in. high

20005
AN AMERICAN POTTERY HANDLED VASE
Van Briggle, c.1920

The wintergreen ground with blue overspray, molded with iris floral design, looped handles at base, incised signature *Van Briggle*
14in. high

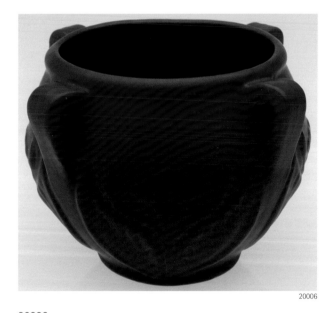

20006

20008

20006
AN AMERICAN POTTERY FOUR-HANDLED PLANTER
Van Briggle, c.1920

With blue over a deep rose matte glaze, molded floral design, incised signature *Van Briggle*
6.3in. high

20008
AN AMERICAN POTTERY EWER
Van Briggle, c.1930

The deep rose colored elongated ewer with bulbous base and extended handle, with incised signature *Van Briggle*
11in. high

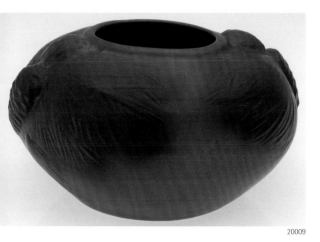

20009

AN AMERICAN POTTERY BOWL

Van Briggle, c.1915

The burgundy to deep blue matte glaze molded pine cone design, incised signature *Van Briggle*

5.5in. high

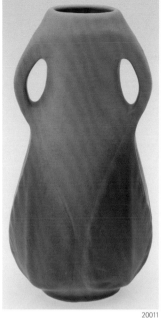

20011

AN AMERICAN POTTERY VASE

Van Briggle, c.1915

Elongated pear form, the ground transitions from blue to green with molded ivy leaves, strong color, incised signature *Van Briggle*

8.5in. high

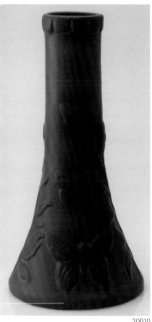

20010

AN AMERICAN POTTERY VASE

Van Briggle, c.1915

Of tapering cylindrical form, the deep maroon color molded with dark blue design of flowers and butterflies, best of mold and color, incised signature *Van Briggle*

13in. high

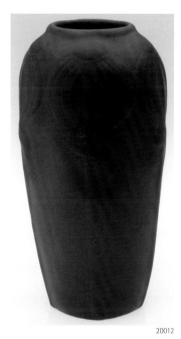

20012

A PARIAN ROSE AMERICAN POTTERY VASE

Van Briggle, c.1915

The rich burgundy to blue coloration molded with a floral design, incised signature *Van Briggle*

12in. high

Visit HeritageGalleries.com to view scalable images and bid online.

Session Three, Auction #608 • Saturday, October 31, 2004 • 1:00 p.m.

255

20013

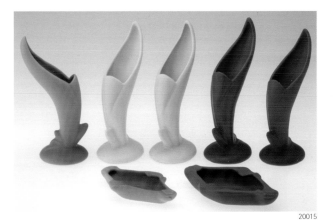

20015
A GROUP OF SEVEN ASSORTED AMERICAN POTTERY PIECES
Van Briggle, 1920

With matte glaze grounds varying in color from piece to piece incised signature *Van Briggle*

the tallest 9in. high; shortest 1in. high (Total: 7 Items)

20013
AN AMERICAN POTTERY VASE
Van Briggle, c.1920

Red with blue overspray, floral design with tulips, best of mold and color, incised signature *Van Briggle*

17in. high

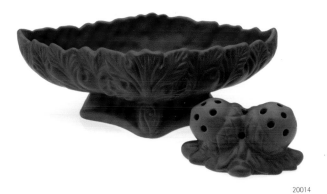

20014

20016

20016
AN AMERICAN POTTERY SQUATTER VASE
Van Briggle, c.1920

Dark blue matte over red glaze, molded tulip design, incised signature *Van Briggle*

4in. high

20014
AN AMERICAN POTTERY CENTERPIECE WITH ACORN FROG
Van Briggle, c.1900

The footed elongated bowl begins in burgundy turning to blue floral design with double acorn frog, incised signature *Van Briggle*

14in. wide

20017

20017

AN AMERICAN POTTERY VASE

Van Briggle, c.1920

The double gourd shaped vase begins in a brown ground and transitions to a green overspray, molded tulip and leaf design, incised signature *Van Briggle*

6in. high

20019

20019

A PEACOCK FORM AMERICAN POTTERY STATUE

Van Briggle, c.1917

The peacock on a sloping pedestal with a burgundy matte glaze, incised signature *Van Briggle*

5in. high

20018

20020

20018

AN AMERICAN POTTERY BULBOUS HANDLED VASE

Van Briggle, c.1915

The brown ground shades to green over ivy leaves, incised signature *Van Briggle*

8.5in. high

20020

AN AMERICAN POTTERY BULBOUS VASE

Van Briggle, c.1915

The green ground fades into a periwinkle blue, molded leaf design, incised signature *Van Briggle*

8.5in. high

20021

AN AMERICAN POTTERY SMALL VASE

Van Briggle, c.1915

The burgundy matte ground with deep blue overspray, molded ivy leaf
design, incised signature *Van Briggle*

5.5in. high

20023

AN AMERICAN POTTERY BULBOUS VASE

Van Briggle, c.1915

The burgundy ground fades into blue with molded ivy leaves, strong mold
and color, incised signature *Van Briggle*

8.5in. high

20022

AN AMERICAN POTTERY VASE

Van Briggle, c.1920

The burgundy matte ground with deep blue overspray, molded with a
swirling design, incised signature *Van Briggle*

7.5in. high

20024

AN AMERICAN POTTERY VASE

Van Briggle, c.1920

Wintergreen ground fades to deep blue matte glaze, incised signature *Van
Briggle*

5in. high

20025

20025

AN AMERICAN POTTERY POPPY VASE

Van Briggle, c.1915

The green ground transitions to blue molded with poppies, incised signature *Van Briggle*

3.5in. high

20027

20027

AN AMERICAN POTTERY VASE

Van Briggle, c.1930

The wintergreen and periwinkle matte ground molded with floral design, incised signature *Van Briggle*

5in. high

20026

20028

20028

AN AMERICAN POTTERY PLANTER

Van Briggle, c.1920

The wintergreen matte ground molded with a blue leaf design, incised signature *Van Briggle*

5in. high

20026

AN AMERICAN POTTERY VASE

Van Briggle, c.1920

The brown matte ground with an olive green overspray molded with a floral design, incised signature *Van Briggle*

4in. high

20029

AN AMERICAN POTTERY FOOTED CENTERPIECE

Van Briggle, c.1920

The foot supporting a foliate design flaring diamond form bowl, green with blue overspray, double acorn shaped frog, signed *Van Briggle*

14in. long

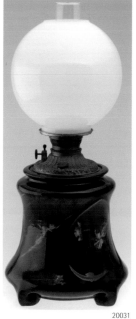

20031

AN AMERICAN POTTERY LAMP

Weller, c.1890

A floral design with high glazed brown twisted fluting, glass and brass fixtures on top and kerosene gas lit, incised signature *Weller*

23in. high

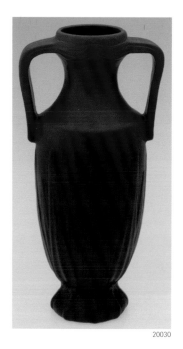

20030

AN AMERICAN POTTERY VASE

Van Briggle, c.1920

The burgundy matte ground with dark blue overspray and molded with a subtle geometric design, incised signature *Van Briggle*

13.5in. high

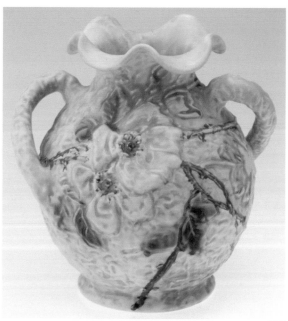

20032

A SILVERTONE AMERICAN POTTERY VASE

Weller, c.1915

Footed with looping handles and an undulating rim, light grey ground with shades of purple, green leaves and red poppy flowers, stamped underside *Weller Pottery* and artist initials

8.5in. high

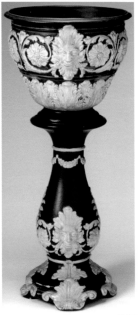

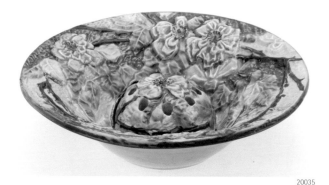

20033
AN AMERICAN POTTERY JARDINIERE AND PEDESTAL
Weller, c.1915

The cobalt blue matte ground molded with white floral decorations and masks, *unmarked*

32.3in. high
(Total: 2 items)

20035
A SILVERTONE AMERICAN POTTERY CENTER BOWL WITH FROG
Weller, c.1900

The pastel textured ground molded with pink wild roses on thorny green leafed branches, stamped with signature *Weller Pottery* and artist's initials *W.W.*

12in. diameter
(Total: 2 items)

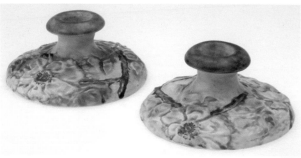

20036
A PAIR OF SILVERTONE AMERICAN POTTERY CANDLESTICKS
Weller, c.1900

Floral pastel colors with wild rose design fully decorates wide base, stamped with signature *Weller Pottery* and original paper label

3in. high

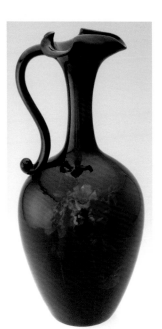

20034
AN UNUSUAL AMERICAN POTTERY EWER
Weller, c.1900

The standard glaze with richly colored floral designs and large looping handle rises to an irregular top, mint condition, signed *Weller, Louwelsa*

21in. high

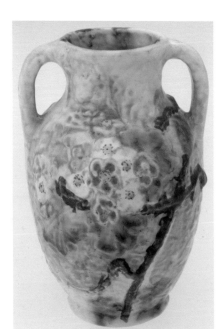

20037
A SILVERTONE AMERICAN POTTERY VASE
Weller, c.1900

Of baluster form, icy periwinkle blue matte textured ground with pastel flowers, stamped with signature *Weller Pottery* and artist's initials *B.F.*

8in. high

Visit HeritageGalleries.com to view scalable images and bid online.

Session Three, Auction #608 • Saturday, October 31, 2004 • 1:00 p.m.

261

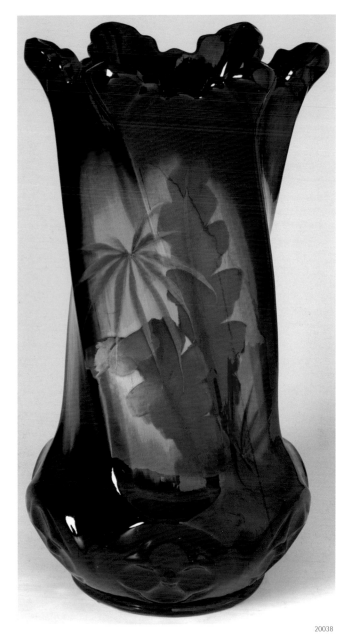

20038

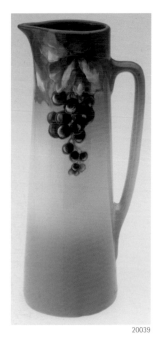

20039

20039
A HIGH GLAZED AMERICAN POTTERY TANKARD
Weller, c.1900

The light blue base flows to a cream ground transforming into a dark gray top with art nouveau style purple grapes hanging from vine, stamped signature *Weller/ETNA*

13.75in. high

20038
A MONUMENTAL UMBRELLA STAND
Weller, c.1900

Twisted paneled form, the standard glazed floral motif with vibrant brown, yellow and green colorations, good example of Louwelsa pottery, *unsigned*

23.5in. high

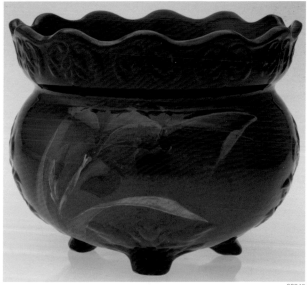

20040

20040
AN AMERICAN POTTERY FOOTED JARDINIERE
Weller, c.1900

The standard brown glazed ground with hand painted enamel floral decorations and irregular rim, *unmarked*

9in. high

20041

20041
TWO AMERICAN POTTERY FLARING VASES
Weller, c.1920

The smaller vase with dark blue base fading into a burgundy matte glaze
with molded leaf design; the larger vase with ivory ground and molded with
blue and wintergreen flowers, incised signature on both *Weller*

7.7in high and 10.5in. high, respectively (Total: 2 items)

20043

20043
A SILVERTONE AMERICAN POTTERY VASE
Weller, c.1900

The bulbous to flaring lip form molded with a calla lily motif and colored
with a pastel drip glaze, stamped signature *Weller/Pottery*

11.3in. high

20042

20044

20044
A BALDWIN AMERICAN POTTERY BOWL
Weller, c.1900

The deep blue matte ground molded with red apples on green leafed tree
branches, incised signature *Weller*

4in. high

20042
AN AMERICAN POTTERY JARDINIERE
Weller, c.1900

The standard glazed ground fades from a forest green into a dark brown
at the rim and hand painted with enamel yellow floral design, incised with
Weller mark *W*

11in. high

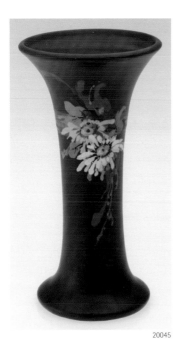

20045

A FLORAL MOTIF AMERICAN POTTERY VASE

Weller, c.1900

Trumpet form with spreading foot, the ground a blue matte glaze hand painted with yellow and white daisies, flaring rim, incised signature *Weller*

10.7in. high

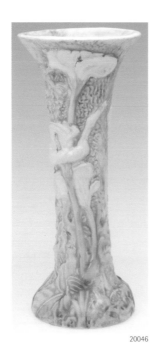

20046

A SILVERTONE AMERICAN POTTERY FLARING VASE

Weller, c.1915

The pastel blue textured ground molded with white flowers on soft green stems, stamped Weller mark *Weller Ware*

15.3in. high

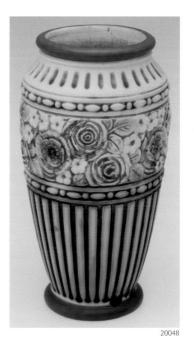

20048

AN AMERICAN POTTERY VASE

Weller, c.1915

The ivory ground molded to depict a floral design, *unmarked*

8.7in. high

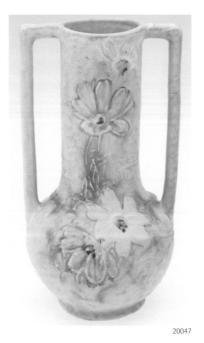

20047

A SILVERTONE AMERICAN POTTERY VASE

Weller, c.1915

The pastel textured glazed ground molded with purple and white flowers, elongated handles, stamped with signature *Weller/Pottery*

9.7in. high

20049

A SILVERTONE AMERICAN POTTERY VASE

Weller, c.1900

The pastel colored matte ground molded with a floral design, stamped signature *Weller Pottery*

8.3in. high

20050

A HUDSON STYLE AMERICAN POTTERY VASE

Weller, c.1900

Of conical form, the white ground decorated in the Hudson style with burgundy and mauve flowers against a geometric design, incised signature *Weller*

6.5in. high

20051

A SILVERTONE AMERICAN POTTERY VASE

Weller, c.1915

The pastel textured ground molded with pink flowers on a brown tree branch, crimped rim, stamped signature *Weller Pottery*

8.7in. high

20052

A COPPERTONE AMERICAN POTTERY CENTER BOWL

Weller, c.1900

Molded to resemble a pond, the copper underglaze stained with vibrant green coloration and decorated with frog and a lily pad, stamped signature *Weller Pottery*

15.5in. across

20053

A SILVERTONE AMERICAN POTTERY VASE

Weller, c.1900

The pastel matte glaze molded with flowers and butterflies, crimped rim, stamped signature *Weller Pottery*

12in. high

20054

20054
A SILVERTONE AMERICAN POTTERY VASE
Weller, c.1900

The pastel blue textured ground molded with a floral design and green leaves, with ribbed rim, stamped signature *Weller Pottery*
10in. high

20056

20056
AN AMERICAN POTTERY VASE
Newcomb, c.1900

The Spanish moss and moon design highlighted by rare colorations in pink to peach, the best of color, incised signature
7in. high

20055

20055
AN AMERICAN POTTERY JARDINAIRE
Weller, c.1900

The forest scene highlighted by strong colors in brown, yellow, green and blue, unsigned
8in. high

20057

AN AMERICAN POTTERY COVERED DISH

Fulper, c.1920

Molded to depict a pink basket full of pastel colored flowers, incised signature *Fulper*

8.5in. high

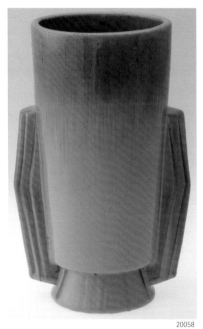

20058

AN ART DECO AMERICAN POTTERY VASE

Fulper, c.1915

Of slightly flaring cylindrical form, drip glaze, stylized handles, strong color

9in. high

20059

AN AMERICAN POTTERY SCENIC TILE

Rookwood, c.1930

The matte glaze depicts a Dutch scene with mother and daughter at lake side, stamped with insignia

6in. square

20060

A PAIR OF AMERICAN POTTERY BOOKENDS

Rookwood, c.1928

The Dutch man and woman face each other behind a brown brick wall with mauve colored tulips, stamped with insignia and date *XXVIII*

6.5in. high

20061

AN AMERICAN POTTERY BOWL

Rookwood, c.1957

The mottled blue, green and white high gloss glazed ground molded in the shape of a flowering lotus, stamped with insignia and date *Rookwood*

3.7in. high

20063

AN AMERICAN POTTERY VASE

Rookwood, c.1919

The blue and green matte finish molded with three symmetrical floral designs, stamped with insignia and date *XIX 2141*

6.5in. high

20062

AN AMERICAN POTTERY VASE

Rookwood, c.1920

The peach glaze with floral decorations on the base, stamped with insignia and date *XX 2477*

8in. high

20064

AN AMERICAN POTTERY VASE

Rookwood, c.1928

The pedestaled classical form decorated with art deco design over a light blue matte glazed ground, stamped with insignia and date on bottom *XXVIII 2799*

10.25in. high

20065

20065

A HIGH GLAZE AMERICAN POTTERY PITCHER

Rookwood, c.1890

The peach and cream ground with hand painted floral decorations, stamped with insignia and artist's initials *H.E.W 251*

6.75in. high

20066

20066

AN AMERICAN POTTERY VASE

Rookwood, c.1900

The standard glaze with a brown to green floral designs surrounds this piece, signed with artist initials *L A* and Rookwood mark

10.5in. high

20067

20067

AN AMERICAN POTTERY SHIRAYAMADANI VASE

Rookwood, c.1926

Elongated form, short collar, round spreading foot, the blue flowers on flaring burgundy and purple ground, impressed artist signature *Shirayamadani*

11in. high

Provenance: Harriman Judd collection, Sotheby's; exhibited Jordan-Volpe Gallery, New York, New York; Rookwood Pottery 100th Anniversary Exhibition, 1980

Visit <u>HeritageGalleries.com</u> to view scalable images and bid online.

Session Three, Auction #608 • Saturday, October 31, 2004 • 1:00 p.m.

269

20068

20068

AN AMERICAN POTTERY SHIRAYAMADANI VASE

Rookwood, c.1944

Of ovoid form, the purple and pink matte glazed ground with poppy plants executed by the artist "Shirayamadani," stamped insignia and date *XLIV 6184C S*

9.5in. high

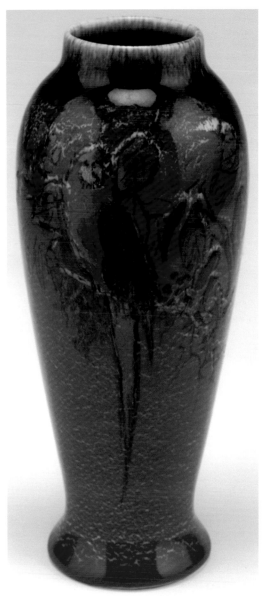

20070

20070

AN AMERICAN POTTERY VASE

Rookwood, c.1922

The high glazed brown ground with enamel decorations depicting a violet parrot on a branch with leaves and flowers, stamped with insignia and date *XXII 1667 E.T.H.*

11.25in. high

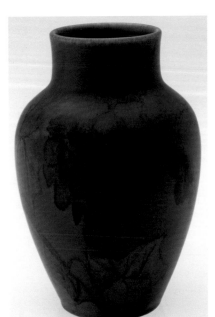

20069

AN AMERICAN POTTERY VASE

Rookwood, c.1926

The rich blue, green and orange glazed ground decorated with vines and grapes, signed under glaze *Able* and date *XXVI A 9270*

9.25in. high

20069

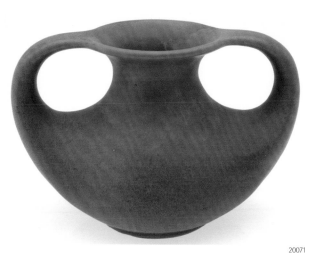

20071

20071

AN ARTS AND CRAFTS AMERICAN POTTERY VASE

Teco, c.1910

With looped handles and forest green matte glaze, stamped signature *Teco*
5.5in. high

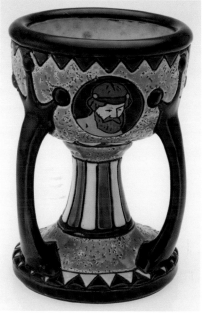

20073

20073

A THREE HANDLED AMPHORA CHALICE

Amphora, c.1910

The three panels depict gladiator faces with cobalt handles, stamped signature *Amphora*
7in. high

20072

20072

AN AMERICAN PRAIRIE SCHOOL ARTS AND CRAFTS POTTERY VASE

Teco, c.1910

Grooved cylindrical form with soft green matte glaze, stamped signature *Teco*
5in. high

20074

20074

AN AMPHORA TWO HANDLED VASE

Amphora, c.1910

The two decorative panels lined with red and white hearts and light blue textured ground with lid, stamped signature *Amphora*
8in. high

20075

20077

20075
A EUROPEAN POTTERY VASE
Gouda, c.1920

The classical urn shape with cobalt blue base followed by a multi-color floral design in the middle leading to a teal top, signed in enamel *Regina/Tagora/W.B/Gouda/Holland*
8in. high

20077
A EUROPEAN POTTERY VASE
Gouda, c.1920

The bulbous shaped vase fully decorated with purples, ivory, orange, teal and cobalt blue with enameled signature, *Gouda*
11.5in. high

20076

20078

20076
A EUROPEAN POTTERY VASE
Gouda, c.1920

The bulbous form fully decorated with black, cobalt blue, yellow, brown, and ivory, enameled signature *Gouda*
7in. high

20078
A EUROPEAN POTTERY VASE
Gouda, c.1920

The bulbous form fully decorated with blue, ivory, green and brown with enameled signature, *Gouda*
8.5in. high

20079

20081

20079
AN AMERICAN POTTERY WALL POCKET

Rookwood, c.1921

With leaves and floral designs in a charcoal to light grey coloration,
Rookwood mark

8in. high

20081
AN EBBTIDE AMERICAN POTTERY VASE

Hull, c.1940

With high glaze finish, the mold depicts a conch shell form vase with a fish
form handle and a base formed of seaweed and a swimming fish, stamped
signature *Hull USA*

14in. high

20080

20082

20082
AN EBBTIDE AMERICAN POTTERY BASKET

Hull, c.1940

Molded to depict an open conch shell covered in olive green and magenta
high glaze, incised signature *Hull/USA*

10in. high, 17in. diameter

20080
A FISH FORM AMERICAN POTTERY VASE

Hull, c.1940

The dorsal fin opening to comprise the vase, incised signature *Hull USA*

9.5in. high

20083

A PEACOCK FANNED AMERICAN POTTERY VASE

Haeger, c.1930

The high glazed pink ground molded to depict a peacock with blue and green pastel colorations on the feathers, raised signature *Haeger*

15.5in. high

20084

A FIGURAL AMERICAN POTTERY CENTER BOWL

Haeger, c.1930

The rose colored high glazed ground with aqua overspray highlights, frog molded to depict nude lady riding a fish, raised signature *Haeger*

11in. high

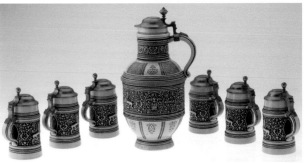

20085

A GERMAN BEER STEIN AND PITCHER SET

Mettloch c.1890

The set comprising six steins and a pitcher, each etched green on ivory depicting mythological creatures, fleur de lis motif, hinged pewter lids, impressed on bottom

Pitcher 14.5in., Steins 7.5in. high (Total: 7 Items)

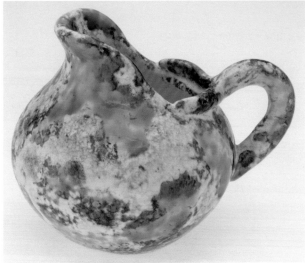

20086

A CONTINENTAL EARTHENWARE PITCHER

Jerome Massier, c.1900

With turquoise high glaze on a black, gray and white matte ground, incised signature *Massier/Vallauris*

6in. high

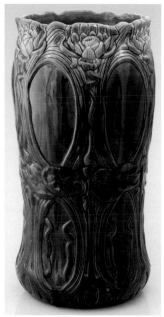

20087

20087

A EUROPEAN MAJOLICA UMBRELLA STAND

c.1880

The cobalt blue streaked emerald green, molded with lilypads and yellow lilies

21in. high

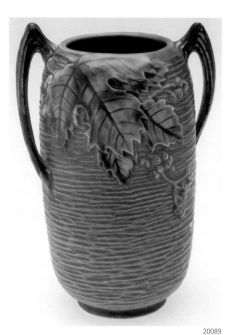

20089

20089

A BUSHBERRY GREEN AMERICAN POTTERY HANDLED VASE

Roseville, c.1900

The green textured ground molded leaves and brown berries, tree branch form handles, raised signature *Roseville/U.S.A.*

8in. high

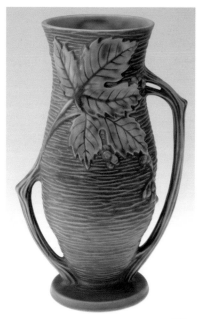

20091

20091

A BUSHBERRY BLUE AMERICAN POTTERY VASE

Roseville, c.1941

With twisted handles, strong mold and color, signed underside

10in. high

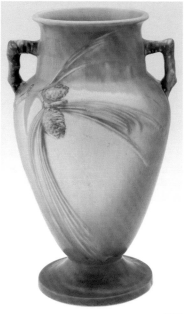

20088

20088

A PINE CONE AMERICAN POTTERY VASE

Roseville, c.1931

The matte ground molded with pine cone design, pine branch handles, incised signature *Roseville*

15in. high

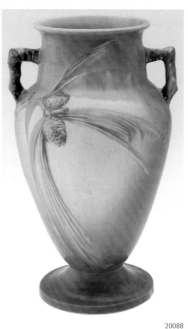

20090

20090

A MORNING GLORY WHITE AMERICAN POTTERY VASE

Roseville, c.1935

The flaring classical shape with handles, molded with pastel floral design, strong drip glaze to the bottom, marked with the original silver retailer tag *Roseville/Pottery*

14in. high

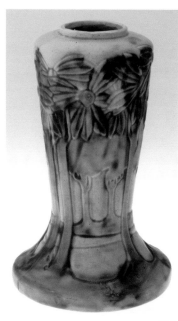

20092

20092

A VISTA AMERICAN POTTERY VASE

Roseville, c.1900

On spreading foot, the vase molded with green, lavender and burgundy flowers on a grey ground

10in. high

20093

20095

20093

A PINE CONE GREEN AMERICAN POTTERY VASE

Roseville, c.1931

Baluster form on spreading foot, the molded pine cone design with pine branch handles, strong color and mold, incised signature on bottom, *Roseville*

15in. high

20095

A BANEDA GREEN AMERICAN POTTERY VASE

Roseville, c.1930

Spherical, the forest green matte glaze molded to depict pumpkins and vines with cream colored flowers, *unmarked*

5.7in. high

20094

20096

20094

A WISTERIA BLUE AMERICAN POTTERY VASE

Roseville. c.1937

Spherical form with strong mold and color, dark blue base shaded to light blue with lavender wisteria and green vines

5.5in. high

20096

A BLACKBERRY AMERICAN POTTERY VASE

Roseville, c.1932

Spherical, the textured ground transitions from green to russet brown molded with leaves and blackberries, two handles, strong color and mold, *unmarked*

6in. high, 8.6in. across

20097

20097

A WISTERIA BLUE AMERICAN POTTERY VASE

Roseville, c.1937

With strong mold and color and handles on top, the textured blue and tan matte ground molded with purple flowers on a leafy green vine, marked with original silver retail tag *Roseville/Pottery*

4in. high

20099

20099

A CARNELIAN II AMERICAN POTTERY VASE

Roseville, c.1930

Of baluster form with frothy turquoise and mauve glaze, two shaped handles, unsigned

20098

20098

A BANEDA PINK AMERICAN POTTERY MILK-CAN SHAPED VASE

Roseville, c.1931

The pink matte ground with a sky blue foot, molded with pumpkins and vine design, *unmarked*

7.5in. high

20100

20100

A WISTERIA BLUE AMERICAN POTTERY VESSEL

Roseville, c.1937

The spherical form with handles, the blue matte ground molded with purple flowers on a leafy green vine, *unmarked*

5.5in. high

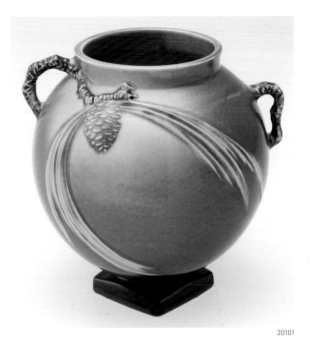

20101

A PINE CONE BLUE AMERICAN POTTERY VASE

Roseville, c.1931

Spherical on square foot, the blue matte ground with pine cone design and branch form handles, *unmarked*

7.5in. high

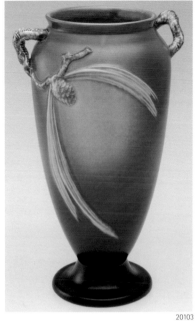

20103

A PINE CONE BLUE AMERICAN POTTERY VASE

Roseville, c.1931

The blue matte ground with pine cone design and pine branch handles, *unmarked*

15in. high

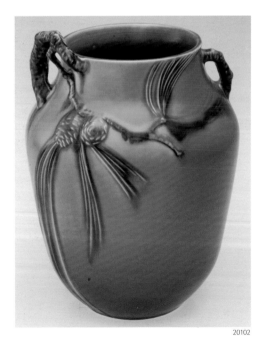

20102

A PINE CONE BROWN AMERICAN POTTERY VASE

Roseville, c.1931

With strong mold and color, the brown matte ground with molded pine cone design and pine branch handle, incised signature *Roseville*

11in. high

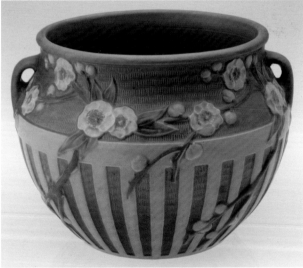

20104

A CHERRY BLOSSOM PINK AMERICAN POTTERY JARDINIERE

Roseville, c.1931

The teal matte glaze with molded branches of cherry blossoms and light green leaves, *unmarked*

9.5in. high

20105

A PINE CONE BLUE AMERICAN POTTERY EWER

Roseville, c.1931

The blue matte ground with molded pine cone design and pine branch handle, incised signature *Roseville*

15.7in. high

20106

A BANEDA PINK AMERICAN POTTERY BULBOUS URN

Roseville, c.1931

The rose matte glaze molded with pumpkins and vines, retains original silver retail tag *Roseville/Pottery*

9.5in. high

20107

20107

A PAIR OF PINE CONE BROWN AMERICAN POTTERY BOOKENDS

Roseville, c.1931

Each with brown matte ground molded with pine cone design to depict an open book, raised signature *Roseville/U.S.A.*

4.8in. high

(Total: 2 Items)

20108

20108

A PINE CONE BROWN AMERICAN POTTERY VESSEL

Roseville, c.1931

Of spherical form on square footed base, the brown matte ground with molded pine cone design and pine branch handles, with original silver label *Roseville/Pottery*

7.5in. high

20109

A BANEDA PINK AMERICAN POTTERY VASE

Roseville, c.1932

The rose pink matte ground molded with pumpkins and vines, *unmarked*

6.5in. high

20111

A PINE CONE GREEN AMERICAN POTTERY PITCHER

Roseville, c.1931

The forest green matte ground with pine cone design and pine branch handle, incised signature *Roseville*

10in. high

20110

A MORNING GLORY GREEN AMERICAN POTTERY VASE

Roseville, c.1935

The green ground molded with purple and yellow floral design, with original silver retail tag marked *Roseville/Pottery*

8.5in. high

20112

A PINE CONE BROWN AMERICAN POTTERY PITCHER

Roseville, c.1931

Of bulbous form, the brown matte ground with pine cone design and pine branch handle, *unmarked*

10.3in. high

20113
A PINE CONE BLUE AMERICAN POTTERY CONSOLE SET
Roseville, c.1931

Comprising a centerbowl and two single candlesticks, blue matte ground molded pine cone design, raised signature on the bowl *Roseville* and incised signature on candlesticks *Roseville/1123*

bowl 14in. across, candlesticks 2.5in. high (Total: 3)

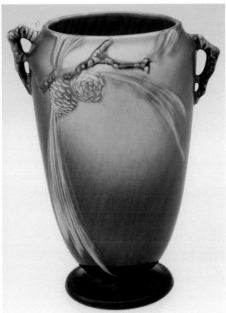

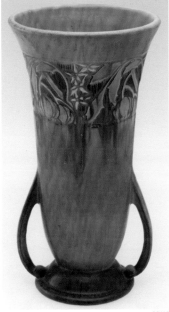

20114
A PINE CONE BLUE FOOTED AMERICAN POTTERY VASE
Roseville, c.1931

Of elongated form, the blue matte ground with molded pine cone design and pine branch handles, interior burnt orange glaze, *unmarked*
10.7in. high

20115
A BANEDA GREEN AMERICAN POTTERY FLARED VASE
Roseville, c.1932

The forest green matte ground molded with pumpkins and vines over dark blue drip glaze, *unmarked*
12.3in. high

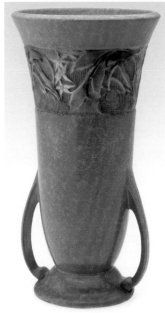

20116
A BANEDA PINK AMERICAN POTTERY FLARED VASE
Roseville, c.1931

The pink textured matte ground molded to depict pumpkins and vines, handles at the base, marked with original silver retail tag *Roseville/Pottery*
12.4in. high

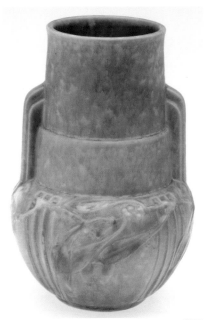

20117
A LAUREL GREEN AMERICAN POTTERY VASE
Roseville, c.1934

The mottled green stepped form, the base with molded tree branch and lavender berries, marked with original silver label *Roseville/Pottery*
9.5in. high

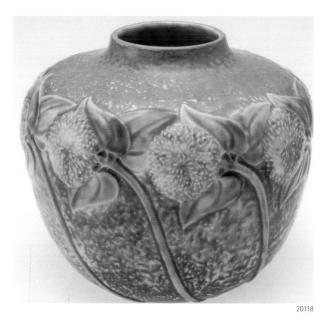

20118

20118

A SUNFLOWER AMERICAN POTTERY VASE

Roseville, c.1930

With strong mold and color, the dark blue, forest green, and russet brown textured ground molded to depict yellow sunflowers, *unmarked*

6.5in. high

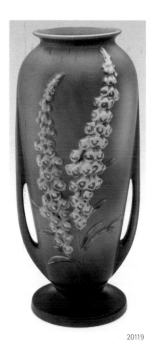

20119

20119

A FOXGLOVE BLUE AMERICAN POTTERY VASE

Roseville, c.1942

The deep blue matte glaze molded with yellow and pink bell shaped flowers on green stems with leaves, raised signature *Roseville/U.S.A.*

18.5in. high

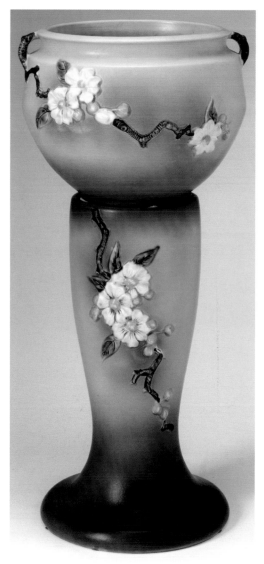

20120

20120

AN APPLE BLOSSOM BLUE JARDINIERE AND PEDESTAL

Roseville, c.1948

With strong mold and color, the blue matte ground molded with light pink flowers and berries on brown tree branches, raised signature *Roseville/U.S.A.*

31in. high (Total: 2)

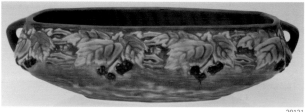

20121

20121

A BLACKBERRY AMERICAN POTTERY FACETED LOW BOWL

Roseville, c.1932

The two-handled elongated bowl decorated with a band of russet and green foliage, blackberries, the ground a textured medley of green and brown, with original retail label

13.5in. across

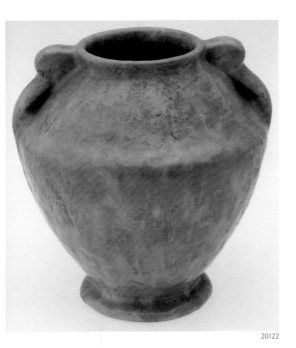

20122

A CARNELIAN II AMERICAN POTTERY VASE

Roseville, c.1915

Covered in a frothy periwinkle and mauve matte glaze, marked with the original silver retailer tag, *Roseville Pottery*

7.5in. high

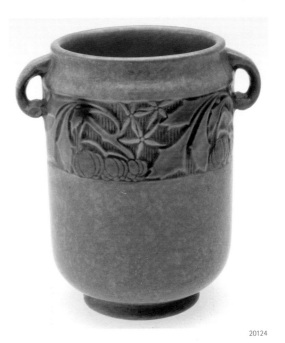

20124

A BANEDA PINK AMERICAN POTTERY VASE

Roseville, c.1932

The rose matte ground with strong color, molded with pumpkins and vines, *unmarked*

7.3in. high

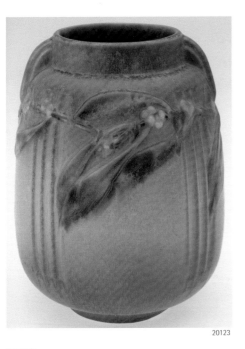

20123

A LAUREL GREEN AMERICAN POTTERY VASE

Roseville, c.1934

The forest green and light brown matte glaze molded to depict laurel branches with lavender berries, *unmarked*

8.7in. high

20125

A WISTERIA BROWN AMERICAN POTTERY JARDINIERE

Roseville, c.1937

The brown textured ground molded with lavender wisteria flowers on a green vine, *unmarked*

6.3in. high

Visit HeritageGalleries.com to view scalable images and bid online.

Session Three, Auction #608 • Saturday, October 31, 2004 • 1:00 p.m.

283

20126

A DONATELLO AMERICAN POTTERY JARDINIERE AND PEDESTAL

Roseville, c.1915

The green, brown and white matte glazed jardiniere and pedestal in classical style with mythological figures, *unmarked*

34in. high

(Total: 2 items)

20128

A PINE CONE GREEN AMERICAN POTTERY JARDINIERE AND PEDESTAL

Roseville, c.1931

Strong mold and color, the forest green ground with molded pine cone design and pine branch handles, raised signature *Roseville/U.S.A.*

25in. high

(Total: 2)

20127

A SUNFLOWER AMERICAN POTTERY VASE

Roseville, c.1930

The textured dark blue, forest green and brown matte ground molded to depict yellow sunflowers, *unmarked*

10.5in. high

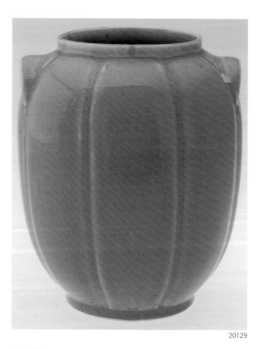

20129

AN ARTS AND CRAFTS POTTERY VASE

Unknown, c.1900

The paneled form with high glaze colored in mauve and yellow, prunt handles, unsigned

8in. high

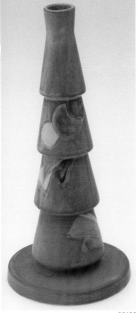

20130

20130

A FUTURA AMERICAN POTTERY TAPERING STACKED VASE

Roseville, c.1924

With geometric patterns in pastel tones on a burnt orange ground, *unmarked*

10.7in. high

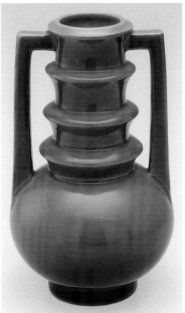

20132

20132

A FUTURA AMERICAN POTTERY TWO-HANDLED VASE

Roseville, c.1924

The bulbous base and stacked neck covered in a bright green high glaze, *unmarked*

9in. high

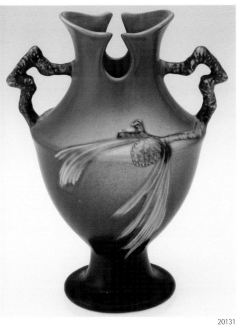

20131

20131

A PINE CONE BLUE AMERICAN POTTERY URN

Roseville, c.1930

With crisp mold and scissor cut rim, the blue matte ground molded with pine cone design and pine tree branch handles, incised signature *Roseville*

10.4in. high

20133

20133

A FUTURA AMERICAN POTTERY VASE

Roseville, c.1924

The stepped neck with soft green overspray subtly covering the brown matte ground, with an original silver retail tag *Roseville/Pottery* and an original brown label

10.7in. high

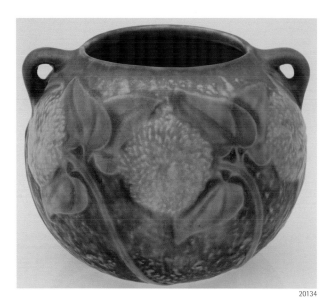

20134

A SUNFLOWER AMERICAN POTTERY VASE

Roseville, c.1930

Of bulbous form, the textured tan and green matte ground molded with sunflowers, strong mold and color, *unmarked*

4.5in. high

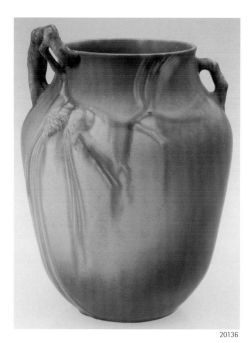

20136

A PINE CONE GREEN AMERICAN POTTERY VASE

Roseville, c.1931

The forest green drip glaze molded with pine cone design and pine branch handles, incised signature *Roseville/ 711-10*

10.5in. high

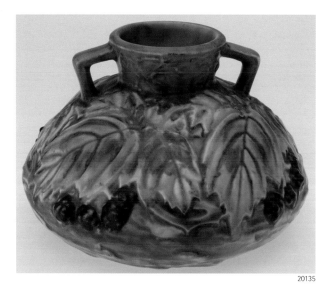

20135

A BLACKBERRY AMERICAN POTTERY BULBOUS SQUAT VASE

Roseville, c.1932

Two handled, with strong mold and color, the textured green and brown matte ground molded with foliage and blackberries, original silver retail tag *unmarked*

4.5in. high

20137

A BUSHBERRY BLUE AMERICAN POTTERY JARDINIERE

Roseville, c.1941

With scissor cut top and stylized branch handles, the textured blue matte glaze ground with molded berries and foliage, incised signature *Roseville*

10.5in. high

20138

A WISTERIA BLUE AMERICAN POTTERY VASE

Roseville, c.1937

The textured blue, burnt orange and cream ground molded with purple flowers on a leafy green vine, with strong mold and color *unmarked*

4in. high

20139

A FUTURA AMERICAN POTTERY FOUR-SIDED VASE

Roseville, c.1924

The art deco design with layered pastel coloration and a frosted glaze, strong mold and color, marked with original black label *Roseville*

6.5in. high

20140

A SUNFLOWER AMERICAN POTTERY BULBOUS VASE

Roseville, c.1930

The textured tan, blue and green matte ground molded with yellow sunflowers *unmarked*

5.5in. high

20141

A FUTURA PINK AMERICAN POTTERY PILLOW PLANTER

Roseville, c.1924

With strong mold and color, the two-toned pink ground molded with blossoms *unmarked*

4in. high

20142

A CARNELIAN II AMERICAN POTTERY BULBOUS TWO-HANDLED VASE

Roseville, c.1900

The pink dripped glaze mottled with olive green, caramel, and purple, *unmarked*

8.1in. high

20144

A PINE CONE BLUE AMERICAN POTTERY VASE

Roseville, c.1931

The circular foot supporting a globular shaped body, blue and white matte ground with molded pine cone design and pine branch handle, incised signature *Roseville/261-6*

6.5in. high

20143

A CARNELIAN II AMERICAN POTTERY BULBOUS VASE

Roseville, c.1915

The two handled form with strong drip glaze in pink, caramel and burgundy colors, signed with *R* ink stamp under glaze

8.5in. high

20145

A POPPY GREEN AMERICAN POTTERY EWER

Roseville, c.1938

The slender form with scissor cut spout and single handle, decorated with canary yellow poppies, signed underside *Roseville*

18.5in. high

20146

A JONQUIL AMERICAN POTTERY VASE

Roseville, c.1931

Of bulbous form, with strong mold and color, the textured tan and green matte ground molded with white flowers with yellow centers, *unmarked*

8.5in. high

20148

A PINE CONE GREEN AMERICAN POTTERY VASE

Roseville, c.1931

The forest green drip glaze with molded pine cone design and pine branch handles, incised signature *Roseville*

9.5in. high

20147

A FUCHSIA BLUE AMERICAN POTTERY BULBOUS VASE

Roseville, c.1938

With strong mold and color, the blue matte ground molded with peach bell-shaped flowers on green leafy vines, *unmarked*

8.5in. high

20149

A FUCHSIA BLUE AMERICAN POTTERY VASE

Roseville, c.1938

The textured blue matte glaze molded to depict peach fuchsia on a green leafed vine, incised signature *Roseville*

12.5in. high

20150

20150

A SUNFLOWER AMERICAN POTTERY VASE

Roseville, c.1930

The textured fading green matte ground molded yellow sunflowers, strong mold and color *unmarked*

5.25in. high

20152

20152

A JONQUIL AMERICAN POTTERY VASE

Roseville, c.1931

The flaring form with handles dropping to base and brown matte glaze textured and molded to depict white flowers with yellow centers, *unmarked*

7.25in. high

20151

20151

A JONQUIL AMERICAN POTTERY VASE

Roseville, c.1930

The textured brown matte glaze ground molded to depict white flowers with yellow centers, with strong mold and color, *unmarked*

8.5in. high

20153

20153

A VISTA AMERICAN POTTERY BULBOUS VASE

Roseville, c.1930

With buttressed handles at rim, the light green matte ground with molded large purple and olive flowers, *unmarked*

9.75in. high

20154

AN EARLAM AMERICAN POTTERY VASE

Roseville, c.1930

The bulbous form mottled with different shades of green, *unmarked*

7.5in. high

20156

A PINE CONE GREEN AMERICAN POTTERY VASE

Roseville, c.1932

Of bulbous form, forest green drip glaze decorated with pine cone design and details on the handles, with impressed signature *Roseville*

10in. high

20155

A BUSHBERRY GREEN AMERICAN POTTERY WATER PITCHER

Roseville, c.1941

The green matte ground molded with leafy tree branches and berries, strong mold and color, raised signature *Roseville/USA*

9in. high

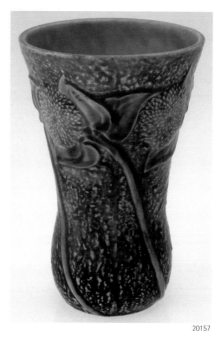

20157

A SUNFLOWER AMERICAN POTTERY FLARED VASE

Roseville, c.1930

The dark green textured form flares into a burnt orange at the rim, molded with yellow sunflowers, *unmarked*

7.4in. high

Visit HeritageGalleries.com to view scalable images and bid online.

Session Three, Auction #608 • Saturday, October 31, 2004 • 1:00 p.m.

291

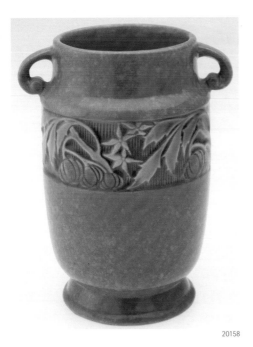

20158

A BANEDA PINK AMERICAN POTTERY VASE

Roseville, c.1932

The footed form with handles and rose colored ground molded to depict pumpkins and vines, *unmarked*

7.25in. high

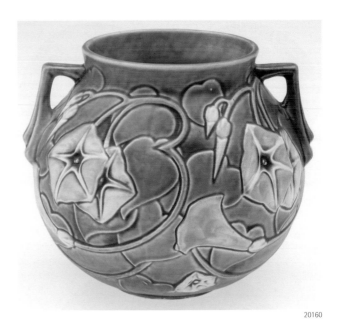

20160

20160

A MORNING GLORY AMERICAN POTTERY VASE

Roseville, c.1935

Of bulbous form, the color begins blue and fades into soft green, molded with pastel colored morning glories, *unmarked*

6in. high

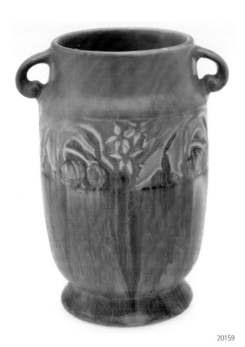

20159

20159

A BANEDA GREEN AMERICAN POTTERY VASE

Roseville, c.1932

The footed tapering form with handles begins with soft green fading to a blue drip glaze that extends to base, *unmarked*

7.5in. high

20161

20161

A ROZANE AMERICAN POTTERY JARDINIERE

Roseville, c.1917

The cream colored jardiniere has heavy floral and leaf pattern on a textured body, stamped under glaze on bottom, good color and mold

9in. high

20162

20164

20164
A WISTERIA BROWN AMERICAN POTTERY SMALL PLANTER
Roseville, c.1931

The brown textured matte glaze with molded purple wisteria on a green leafy vine, *unmarked*
4.3in. high

20162
A WATER LILY PINK AMERICAN POTTERY VASE
Roseville, c.1943

Circular foot supporting a stylized baluster form with two handles, molded with pink lilies and green lilypads, raised signature *Roseville/USA/78-9"*
9.5in. high

20165

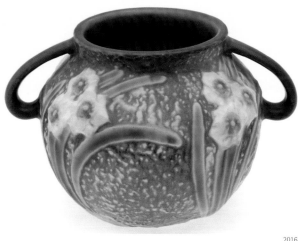

20163

20163
A JONQUIL AMERICAN POTTERY VASE
Roseville, c.1931

Of bulbous form, the brown textured matte glaze molded with white and yellow floral design and two handles, *unmarked*
4.5in. high

20165
A PINE CONE GREEN AMERICAN POTTERY VASE
Roseville, c.1931

The forest green matte glaze molded pine cone design and pine branch handles, incised signature *Roseville*
3.5in. high

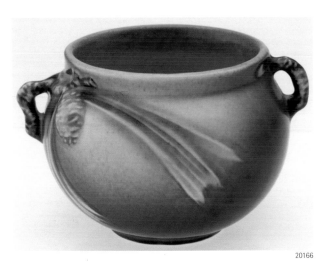

20166

A PINE CONE BLUE AMERICAN POTTERY BOWL

Roseville, c.1931

The blue matte glaze molded with pine cone design and pine branch handles, *unmarked*

3.5in. high

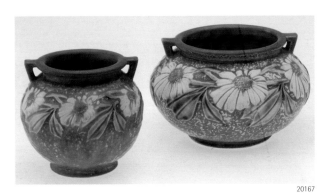

20167

A DAHLROSE AMERICAN POTTERY SPHERICAL VASE AND PLANTER

Roseville, c.1920

Each brown textured ground with molded white flowers, the planted marked with the original silver label *Roseville/Pottery* and the vase *unmarked*

4.5in. high

(Total: 2 Items)

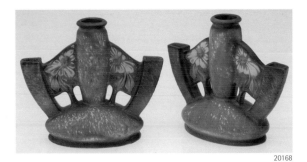

20168

A PAIR OF DAHLROSE TRIPLE BUD AMERICAN POTTERY VASES

Roseville, c.1930

The textured form with brown and green matte glaze, decorated with floral design, marked with original black paper label *Roseville/Pottery*

6.5in. high

(Total: 2 pieces)

20169

A FOXGLOVE AMERICAN POTTERY JARDENAIRE

Roseville, c.1942

The green and pink pastel ground molded with pink and white flowers and elongated handles, with raised signature *Roseville/U.S.A. 659-6"*

6.25in. high

20170

A LUFFA BROWN AMERICAN POTTERY BOWL

Roseville, c.1951

The brown matte glaze with forest green coating on the inside, molded to depict leaves and small yellow flowers, marked with original silver label *Roseville/Pottery*

4.5in. high

20171

20171
A BLACKBERRY AMERICAN POTTERY VESSEL
Roseville, c.1932

Squat form, the brown and forest green textured ground with molded blackberries and multicolored leaves, marked with original silver label *Roseville/Pottery*
4.7in. high

20172

20172
A WHITE ROSE AMERICAN POTTERY JARDINIERE
Roseville, c.1940

Spherical, with opposing lines to rim and handles near top, molded with a floral design, raised signature *Roseville*
7.5in. high

20173

20173
A LUFFA FOOTED AMERICAN POTTERY VASE
Roseville, c.1934

With strong mold and color, the green ground contains a hint of blue, *unmarked*
12.5in. high

20174

20174
A GREEN LUFFA AMERICAN POTTERY VASE
Roseville, c.1924

The tapered collar shape with blue hue on a green ground, two handles near top, decorated with floral design and foliage, *unmarked*
8.5in. high

20175

A PINE CONE BLUE AMERICAN POTTERY BUD VASE

Roseville, c.1931

The matte glaze varying from strong blue to light, pine cone form handle, with impressed signature *Roseville*

7.75in. high

20177

A WHITE ROSE PINK AMERICAN POTTERY PILLOW VASE

Roseville, c.1940

The forest green textured glaze shades into a blush pink, molded with white roses and green leaves, raised signature *Roseville/U.S.A.*

8.4in. high

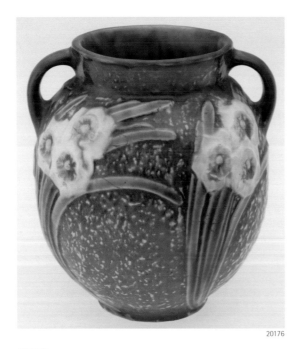

20176

A JONQUIL AMERICAN POTTERY VASE

Roseville, c.1931

Of bulbous form, the brown textured ground molded with white flowers, *unmarked*

6.5in. high

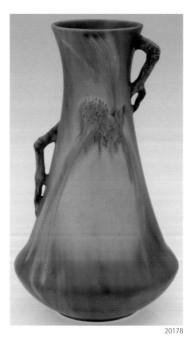

20178

A PINE CONE GREEN AMERICAN POTTERY VASE

Roseville, c.1931

The forest green matte ground molded with pine cone design and tree branch handles, incised signature *Roseville* and marked with original silver sticker

12.5in. high

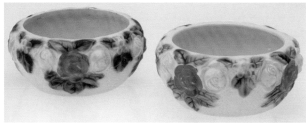

20179

A PAIR OF ROZANE LINE AMERICAN POTTERY BOWLS

Roseville, c.1917

Cream textured ground with multi-colored flowers, *unmarked*

3in. high

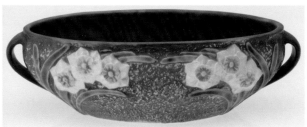

20180

A JONQUIL AMERICAN POTTERY CENTER BOWL

Roseville, c.1931

The brown and cream textured ground with forest green glaze on the interior, two looping handles, decorated with white flowers, *unmarked*

12in. high

20181

A PINE CONE GREEN AMERICAN POTTERY URN

Roseville, c.1931

With a scissor cut top, the forest green matte ground molded with pine cone design and tree branch handles, incised signature *Roseville*

10.5in. high

20182

A BANEDA PINK AMERICAN POTTERY VASE

Roseville, c.1931

Pear shaped, the pink matte ground textured with light blue and molded with pumpkins on the vine, *unmarked*

6.5in. high

20183

AN APPLE BLOSSOM PINK AMERICAN POTTERY PLANTER

Roseville, c.1948

The rose matte ground molded with white flowers and soft pink berries, branch form handles, raised signature *Roseville/U.S.A.*

6.5in. high

Visit HeritageGalleries.com to view scalable images and bid online.

Session Three, Auction #608 • Saturday, October 31, 2004 • 1:00 p.m.

297

20184
A PINE CONE BLUE AMERICAN POTTERY BOWL
Roseville, c.1931

A low bowl with pine branch handles, signed *Roseville USA 354-6"*
7in. across

20185
A PAIR OF PINE CONE GREEN AMERICAN POTTERY BOOKENDS
Roseville, c.1930

In the shape of an open book, the forest green matte ground with molded pine cone design, *unmarked*
each 4.8in. high

(Total: 2 pieces)

20186
A FUCHSIA BLUE AMERICAN POTTERY VASE
Roseville, c.1938

The slender cylindrical form with slightly flaring lip, strong mold and color
9in. high

20187
A PINE CONE GREEN AMERICAN POTTERY VASE
Roseville, c.1930

The forest green matte ground with molded pine cone design and pine tree handles, incised signature *Roseville*
7.5in. high

20188

A PINE CONE BLUE AMERICAN POTTERY EWER

Roseville, c.1931

The blue matte glaze ground molded pine cone design and pine branch handle, incised signature *Roseville*

10.5in. high

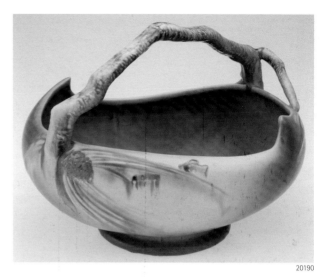

20190

A PINE CONE GREEN AMERICAN POTTERY BASKET

Roseville, c.1931

The bowl molded to resemble a basket with forest green matte ground with pine cone design and tree branch handle, *unmarked*

11in. high

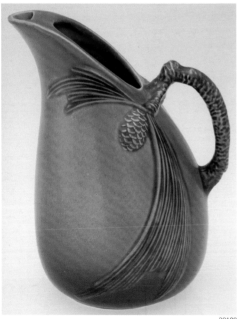

20189

A PINE CONE BROWN AMERICAN POTTERY PITCHER

Roseville, c.1931

The brown matte ground molded with pine cone design and tree branch handle, raised signature *Roseville/U.S.A.*

9.3in. high

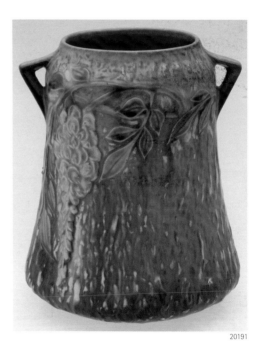

20191

A WISTERIA BLUE AMERICAN POTTERY CYLINDRICAL TWO-HANDLED VASE

Roseville, c.1931

With blue and burnt orange textured matte ground, molded purple wisteria on a leafy vine, marked with the original silver label *Roseville/Pottery*

8.3in. high

Visit HeritageGalleries.com to view scalable images and bid online.

Session Three, Auction #608 • Saturday, October 31, 2004 • 1:00 p.m.

299

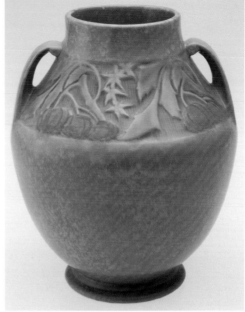

20193

A BANEDA PINK AMERICAN POTTERY BULBOUS URN

Roseville, c.1932

The rose matte ground molded with pumpkins and vines, *unmarked*

10.5in. high

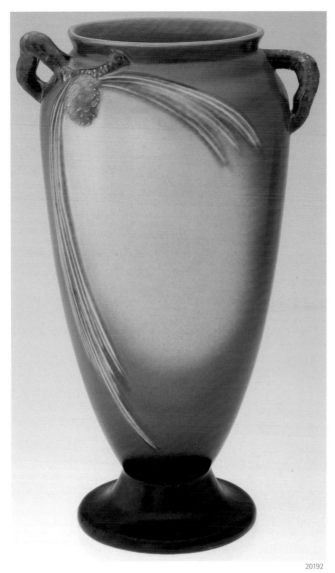

20192

A PINE CONE BLUE AMERICAN POTTERY VASE

Roseville, c.1931

Pine cone blue vase with good mold and color, impressed mark

15in. high

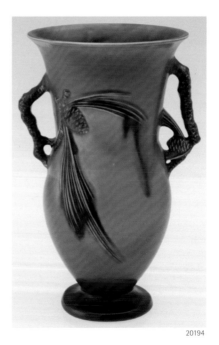

20194

A PINE CONE BROWN AMERICAN POTTERY VASE

Roseville, c.1931

Baluster form, the brown matte ground molded pine cone design and pine branch handles, incised signature *Roseville* with the original brown retail tag

12.5in. high

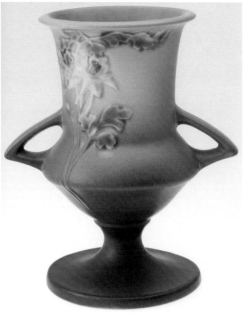

20195
A COLUMBINE BLUE AMERICAN POTTERY URN
Roseville, c.1941

Handled, with rich mold and color
8in. high

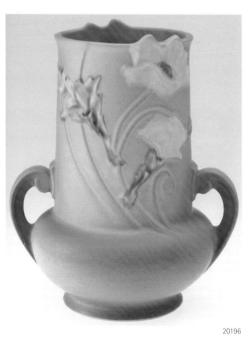

20196
A POPPY GREEN AMERICAN POTTERY VASE
Roseville, c.1938

Baluster form, the molded yellow poppies peeking out beyond the rim
10in. high

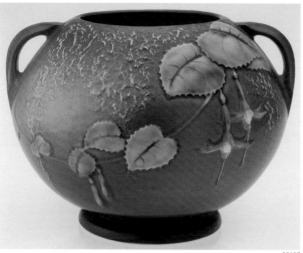

20197

20197
A FUCHSIA BLUE AMERICAN POTTERY PLANTER
Roseville, c.1930

Spherical, the textured blue matte ground decorated with light green leaves and peach fuchsia flowers, incised signature *Roseville/347-6*
6.5in. high

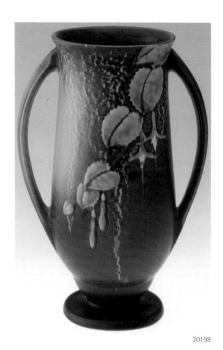

20198

20198
A FUCHSIA BLUE AMERICAN POTTERY VASE
Roseville, c.1938

Elongated cylindrical form with flaring lip, good mold and color, large looping handles
12in. high

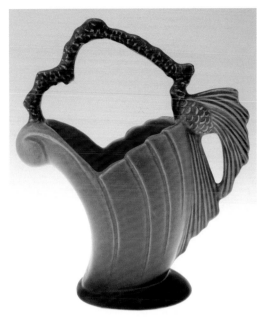

20199

A PINE CONE BROWN AMERICAN POTTERY BASKET

Roseville, c.1931

The rare basket with art deco body and pine branch handle, strong mold and color

7in. high

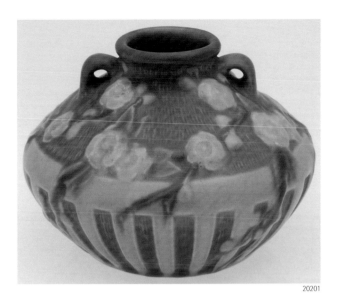

20201

20201

A CHERRY BLOSSOM PINK AMERICAN POTTERY SQUAT VESSEL

Roseville, c.1933

With rose matte glaze over a teal ground, molded cherry blossom branches, *unmarked*

4.7in. high

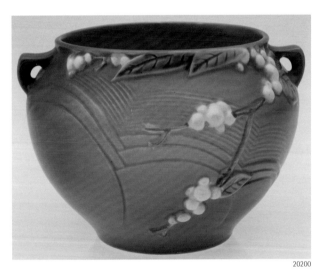

20200

20200

A SNOWBERRY BLUE AMERICAN POTTERY JARDINIERE

Roseville, c.1947

The sky blue matte ground with light pink overspray molded with white berries on a leafy tree branch, raised signature *Roseville/U.S.A.*

6.5in. high

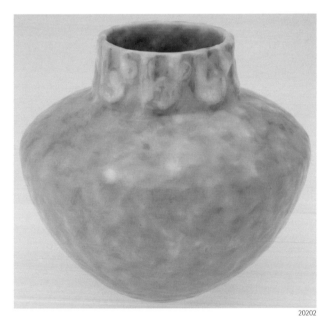

20202

20202

AN IMPERIAL II AMERICAN POTTERY VASE

Roseville, c.1920

Covered in a frothy turquoise glaze with yellow band at rim, *unmarked*

7.7in. high

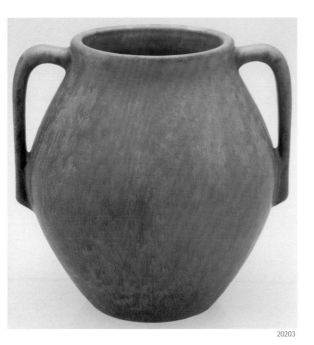

20203

AN EARLAM GREEN AMERICAN POTTERY VASE

Roseville, c.1930

The blue base transitions to a forest green matte glaze and then to caramel, *unmarked*

7.7in. high

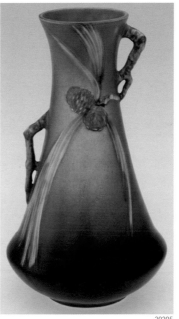

20205

A PINE CONE BLUE AMERICAN POTTERY CORSETED VASE

Roseville, c.1931

With a squat base, the blue matte ground with molded pine cone design and pine tree handles, incised signature *Roseville*

12.5in. high

20204

A CARNELIAN II AMERICAN POTTERY VASE

Roseville, c.1915

Covered in a mottled pink glaze with purple and olive drippings around rim, *unmarked*

8.7in. high

20206

AN AMERICAN CARNELIAN II POTTERY VASE

Roseville, c.1915

The blue, mauve and green frothy glaze covers a classical urn shape with long handles extending to base, best of color, silver retail tag on bottom

9in. high

20207

AN ORMOLU MOUNTED PORCELAIN URN

Sevres, c.1890

The cobalt blue base with intricate gilt design supporting a bulbous porcelain vase and two bronze handles, the wooded lake scene depicting a maiden in flowing gown sitting on a bench with a cherub, reverse side depicting a cherub writing in a forest, cobalt blue rim and covered lid, artist signed *Lucot* in design, also signed with *Sevres* mark under glaze in lid

18in. high

20209

A FRENCH BRONZE AND PORCELAIN BASKET

Sevres, c.1890

The intricately designed dore bronze mesh basket with soft paste porcelain insert depicting floral design in traditional Sevres manner with gold gilt and pastel colorations

6.25in. diameter

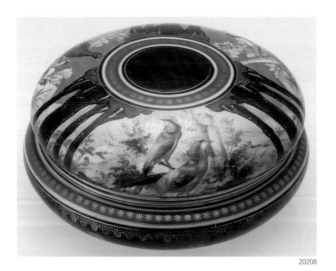

20208

AN ART NOUVEAU PORCELAIN COVERED DISH

Sevres, c.1900

The cobalt blue ground decorated with enamel hand painted exotic game birds and trees in an art nouveau style, gilt highlights, stamped with the *Sevres* mark in blue

4in. high, 8.5in. across

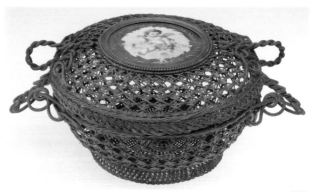

20210

A FRENCH BRONZE AND PORCELAIN BASKET

Sevres, c.1890

The intricately designed dore bronze mesh covered basket with soft paste porcelain insert depicting a cherub in traditional Sevres manner with gold gilt and pastel colorations

8in. diameter

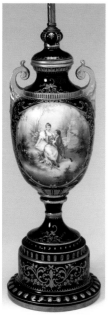

20211

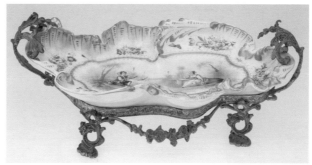

20213

20213
A FRENCH ORMOLU MOUNTED PORCELAIN CENTERPIECE
Sevres, c.1880

Enameled and gilt to depict a girl and boy in a garden, with an elaborately sculpted bronze rim, the dore bronze base with floral garlands and vines extending up into handles, artist signed *P. Roche*, stamped under glaze with *Sevres*

15in. across

20211
A FRENCH ARTIST SIGNED LAMP
Sevres, c.1880

The cobalt blue ground with gilt decorations and a hand painted central cartouche depicting a Victorian man and woman, artist signed

38in. high

20212

20214

20215

20212
AN ORMOLU MOUNTED PORCELAIN VASE
Sevres, c.1900

The pedestaled vase enameled in pink with gilt and enamel design featuring a woman in a forest scene in art nouveau style, floral and gilt design throughout, the vase with bronze handles, rim and pedestal

12in. high

20214
A FRENCH ORMOLU MOUNTED PORCELAIN VASE
Sevres, c.1890

The porcelain and brass vase with a man and woman sitting in a garden, gilt designs on the side, the base and top enameled in a floral design of vibrant color and highlighted with gilt, signed *Sevres*

9.5in. high

20215
A FRENCH ORMOLU MOUNTED PORCELAIN VASE
Sevres, c.1890

The bronze and enameled base and pedestal supporting a porcelain urn form body, hand painted scene of a Victorian man and woman, gilt designs on sides, bronze top with enameled floral design, signed *Sevres*

11in. high

20216

AN ORMOLU MOUNTED PORCELAIN CENTERBOWL

Sevres, c.1880

The dore bronze base supports an elongated porcelain tray hand painted over pink borders with four floral design panels, bottom of tray depicts a couple near a boat on a lake, signed *Binet* and Sevres mark under glaze

14in. high

20218

A BRONZE MOUNTED PORCELAIN VASE

Sevres, c.1890

Bronze footed base with champleve borders, body depicts a lady and cherub in a forest setting, engraved signature *France*

12in. high

20217

A PAIR OF BRASS MOUNTED PORCELAIN LAMP BASES

Sevres, c.1900

The pedestals with brass griffins supporting pink porcelain globes depicting scenes of enameled cherubs and a goat on one side, a detailed floral design on the other, brass flowers applied to sides

27in. high

20219

A BISQUE SEASHELL FIGURAL GROUP

Royal Dux, c.1940

The matte finish fashioned as a giant seashell with two women sitting on and standing by it, the base richly detailed with waves and water lilies, pink triangle, insignia *Royal Dux*

17in. high

20220

A CONTINENTAL PORCELAIN FIGURAL ELEPHANT

Royal Dux, c.1940

The white high glazed finish with brown and golden colorations, curled and raised trunk, marked with pink triangle

13in. high

20222

20222

A CONTINENTAL PORCELAIN FIGURAL GROUP

Royal Dux, c.1900

The bisque finish highlighted in green, brown and mauve colors depicts a lady carrying a water pitcher and a man sitting on rocks giving lady a rose, pink triangle mark

11.5in. high

20221

20221

A CONTINENTAL PORCELAIN FIGURAL GROUP

Royal Dux, 20th Century

The circular foot supporting a masked and cloaked man holding a lantern next to a similarly dressed woman, the high glazed cobalt blue and white clothing consistent with Mardi Gras motif, stamped signature *Royal Dux*

20in. high

20223

20223

A CONTINENTAL PORCELAIN STATUE

Royal Dux, c.1900

The soft paste porcelain in ivory and matte gold molded to depict a lady peering into a pond from a rocky ledge, stamped with the applied pink triangle insignia *Royal Dux*

11.2in. high

20224
A CONTINENTAL PORCELAIN FIGURINE
Royal Dux, c.1900

On circular base, the soft paste porcelain lady in a green dress with a rose colored cloak and a gold gilt necklace carrying an amphora whilst standing on rocks, stamped with an applied pink triangle insignia *Royal Dux*
11.5in. high

20226
A CONTINENTAL PORCELAIN FIGURAL CENTERPIECE
Royal Dux, c.1890

Two porcelain bowls molded to depict wicker baskets with a figurine of a young windswept girl clutching a bonnet, her dress billowing in the wind, stamped with applied pink triangle insignia *Royal Dux*
9.7in. high

20225
A CONTINENTAL PORCELAIN FIGURAL SHELL BOWL
Royal Dux, c.1890

The soft paste porcelain molded to depict a classical lady wearing a green and gold toga lounging on rocks, two white doves on top of a sea shell shaped bowl, stamped with an applied pink triangle insignia *Royal Dux*
9in. high

20227
A CONTINENTAL PORCELAIN FIGURAL VASE
Royal Dux, c.1900

The pale green finish decorated with carved shepherdess and sheep

20228

AN AUSTRIAN PORCELAIN FIGURE

EW Vienna Austria, c.1890

Lady draped in russet brown with gilt highlights holding a jewel box, a cherub at her feet, bisque finish, stamped *EW Vienna Austria*

16in. high

20229

A EUROPEAN CERAMIC PLAQUE

c.1890

In gilt frame with blue velvet and painted blue mattes, the enameling depicts a woman dressed in oriental style dress with heavy Egyptian necklace and earrings in gilt, signed on back, *Figueunerin after N. Lichel*

12in. high with frame

20230

A FRENCH PORCELAIN VASE

Limoges, c.1900

The spreading foot supporting a slightly flared cylindrical form, high glaze with rich burgundy and gilt borders and fully decorated with a classical design of a female in rose garden, best of color and quality, artist signed *Kryba*

15in. high

20231

A GROUP OF SIX PORCELAIN CUPS

Limoges, c.1890

With heavy gold gilt around the rim, the ivory soft paste porcelain hand painted with green and purple grapes on leafy vines, stamped signature under glaze *T&V/Limoges/France*

4in. high (Total: 6 Items)

20232

A FRENCH PORCELAIN TEA SET

Limoges, c.1900

The black ground fully decorated with heavy gold gilt and an oriental motif with multi-colored hand painted fans, buddas, French soldiers, geisha girls and tea pots, each piece individually stamped *Limoges France*

14in. diameter (Total: 6)

20233

A FRENCH PORCELAIN PLATE

Limoges, c.1900

The cobalt blue ground with elaborate gold gilt border and a center panel with pastel colorations depicting two Victorian ladies and a gentleman, enamel signature *Dubois* and stamped under glaze *Wm Guerin & Co./ Limoges/France*

12.5in. diameter

20234

AN ENAMEL ON COPPER PLAQUE

Limoges, c.1900

The elaborate dore frame with felt border holds a hand painted artist signed portrait of an art nouveau lady, signed in enamel

7in. across

20235

20235

AN ENAMEL FRENCH LIDDED BOX

Limoges, c.1890

The dore bronze with enamel on copper panel depicting a lady and man sitting on a brick wall in a forest setting, signed in enamel in the design *Gamet*

2.5in. high

20237

20237

A FRENCH PORCELAIN PLAQUE

Limoges c.1890

Hand painted, a nude stepping into a bath, pastel coloration with scenic columns

9.25in

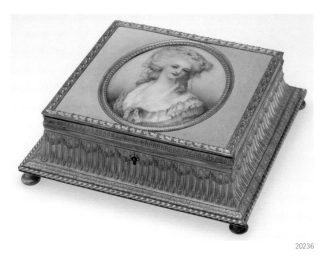

20236

20236

A FRENCH DORE BRONZE AND ENAMEL BOX

Limoges, c.1900

On four bun feet, the top with an oval portrait of a victorian lady enameled on copper, artist signed

7in. across

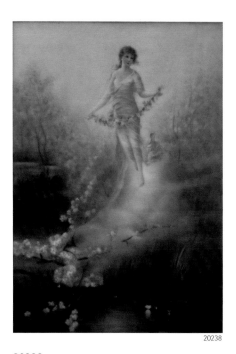

20238

20238

A FRENCH PORCELAIN PLAQUE

Limoges c.1890

The dore bronze framed plaque depicts a maiden flying above a pond with garlands of flowers, mist rising from water, pastel colorations in art nouveau style, bordered in rose colored silk material

7.25in. high

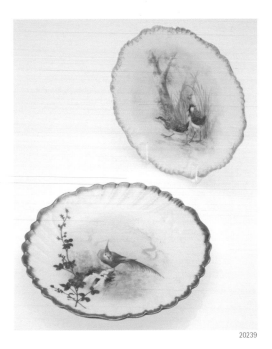

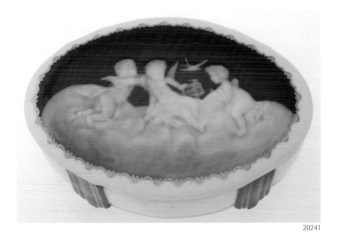

20241
A FRENCH PORCELAIN COVERED BOX
Limoges, c.1900

The footed pate sur pate white oval body with white on blue design depicting cherubs and birds, gilt rimmed, signature stamped, *Limoges, France*

7in. across

20239
TWO FRENCH PORCELAIN PLATES
Limoges, c.1900

Hand painted over a white ground with birds depicted in a wooded scene, stamped with signature *Limoges*

8.5in. and 9in. diameters (Total: 2 Items)

20242
A FRENCH PORCELAIN COVERED BOX
Limoges, c.1900

A pate sur pate blue round on porcelain body rimmed with a white, blue and gilt design, the lid depicting a woman and cherub on a cloud, stamped signature, *Limoges, France*

7.5in. across

20240
A FRENCH PORCELAIN COVERED BOX
Limoges, c.1900

A pate sur pate white square porcelain body with white on blue design depicting cherubs, gilt rimmed, signature stamped, *Limoges, France*

5in. diameter

20243
A FRENCH FRAMED PORCELAIN PLAQUE
Limoges, c.1900

The black wood frame surrounds a pate sur pate cherub scene, signed *Limoges* under glaze
3.75in. diameter sight size

20245
A FRENCH PORCELAIN COVERED BOX
Limoges, c.1900

A pate sur pate white oval porcelain body with white on blue design depicting cherubs and birds, gilt rimmed, signature stamped, *Limoges, France*
7.5in. across

20244
A FRENCH PORCELAIN COVERED BOX
Limoges, c.1900

The pate sur pate white domed body with a cobalt blue border rimmed in gilt, and a white on blue scene depicting a cherub standing by a tree, signature stamped, *Limoges, France*
8in. diameter

20246
A FRENCH PORCELAIN PLATTER
Limoges, c.1890

The green ground with gilt, the center with pastel floral design, signed *Limoges, France*
14in. across

20247

A FRENCH PORCELAIN FOOTED VASE

Limoges, c.1890

The cobalt blue glazed ground with gold gilt trim and center panel hand painted to depict a Victorian lady and gentleman in a garden setting, signed *Dubois*

13in. high

20249

A EUROPEAN CERAMIC VASE

Royal Bonn, c.1890

Mottled green, lavender and yellow ground with hand painted floral design, handles and mouth of vase decorated with gilt leaf design, stamped underside *Royal Bonn Germany*

12in. high

20248

A STRAWBERRY MOTIF PORCELAIN PLATE

Limoges, c.1900

The white ground edged in green with a strawberry motif

11in. diameter

20250

A EUROPEAN CERAMIC PITCHER

Royal Bonn, c.1890

The cream colored water pitcher fully decorated with hand painted floral designs, heavy gold gilt decorates a twisting tree limb design from bottom to top, stamped *Royal Bonn Germany*

11in. high

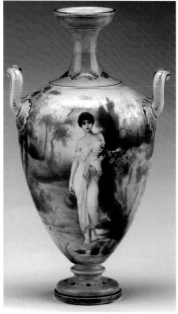

20251

A CONTINENTAL PORCELAIN HANDLED VASE

Royal Bonn, c.1890

The white soft paste porcelain with gold gilt highlights on handles and hand painted with classical lady holding a water pitcher in a forest setting, stamped with signature under glaze *Royal/Bonn/Germany* and engraved artist's initials *CT*

13.3in. high

20253

TWO CONTINENTAL PORCELAIN BOWLS

R.S. Prussia, c.1890

The first, of petal shape with sculpted rim on yellow ground and enamel pink wild roses; the second, ovoid with sculpted floral border, the white ground with enamel lily pads over teal water, stamped with enamel insignia *Prussia*

11in. diameter and 13in. long, respectively (Total: 2 Items)

20252

A CONTINENTAL PORCELAIN PLATE AND LIDDED CHOCOLATE POT

R. S. Prussia, c.1890

The porcelain plate, sculpted to resemble a flower, with a floral border on a cream ground hand painted with pink, purple and white flowers; the chocolate pot with hand painted floral design and subtle gold gilt on a light green ground, stamped with insignia *R.S/Prussia*

8.5in. diameter and 9.7in. high (Total: 2 items)

20254

A FRENCH PORCELAIN TWO-HANDLED VASE

Old Paris, c.1880

The deep rose colored ground with two hand painted chateaux on a lake, gold gilt highlights on handles, *unmarked*

15in. high

20254

20255

20255

A FRENCH PORCELAIN HANDLED VASE

Old Paris, c.1890

The cobalt blue ground with heavy gold gilt leaves and berries, applique handles, the center panel hand painted with multi-colored floral design, *unmarked*

19.3in. high

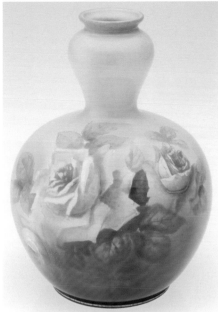

20257

20257

A GERMAN PORCELAIN VASE

Royal Bonn, c.1890

The soft past porcelain with hand painted grey and pink roses with green leaves, stamped under glaze with insignia *Royal/Bonn/Germany* and artist's initials *DG*

11in. high

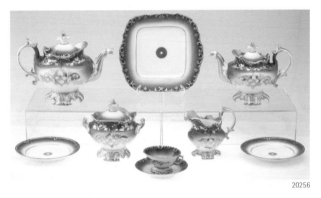

20256

20256

A FORTY-PIECE FRENCH PORCELAIN TEA AND DESSERT SET

Old Paris, c.1880

The high glazed white ground graduates to a burgundy finish accented with heavy gold decorations, *unmarked*

7in. high (Total: 40)

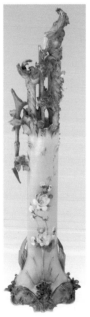

20258

20258

AN ENAMELED AND CARVED EWER

Carlsbad, Austria, c.1890

The elaborately sculpted and decorated enameling depicts flowers with vines and leaves sculpted out of top of sides, gilt accents, stamped under glaze *Carlsbad Austria*

20in. high

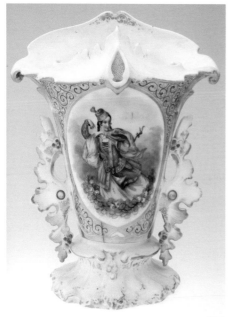

20259

20261

20259
A LARGE PORCELAIN VASE
Old Paris, c.1880

The large vase with elaborate handles and rim, the base in gilt, a woman with flower garland on the front with gilt and blue designs around picture over surface

15in. high

20261
A FLORAL MOTIF PORCELAIN EWER
Teplitz, c.1890

The cream colored soft paste porcelain with art nouveau floral decorations rising up to the sea shell top with elaborate handle, stamped mark

16in. high

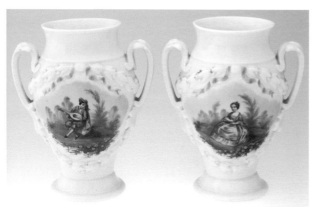

20260

20262

20260
A PAIR OF PORCELAIN VASES
Old Paris, c.1880

The pedestaled high glaze and handled vase with a woman sitting in a garden and a man playing a lyre on the reverse side, the other vase depicts a man sitting in a garden on one side and a woman sitting in a garden on the other

10in. high

(Total: 2)

20262
A PAIR OF PORCELAIN TRUMPET VASES
Old Paris, c.1900

The art nouveau design over soft paste porcelain with gold gilt highlights, hand painted pink roses and two multi-colored butterflies, unmarked

(Total: 2 items)

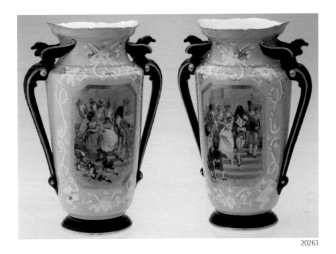

20263
A PAIR OF FRENCH HANDLED PORCELAIN VASES
Old Paris, c.1890

Each, the soft pink ground with black, white and gold gilt handles ending in winged mythological joins, center panel depicting Victorian ladies and gentlemen, *unmarked*
14.3in. high
(Total: 2)

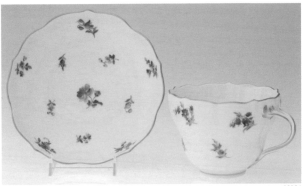

20264
A GERMAN PORCELAIN CUP AND SAUCER
Meissen, c.1880

The white high glaze hand painted with flowers, signed with crossed swords under glaze
the cup 3in. high
(Total: 2 Items)

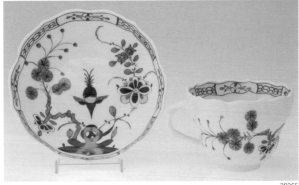

20265
A GERMAN PORCELAIN CUP AND SAUCER
Meissen, c.1880

The white high glaze with hand painted oriental designs, signed with crossed swords under glaze
the cup 3in. high
(Total: 2 Items)

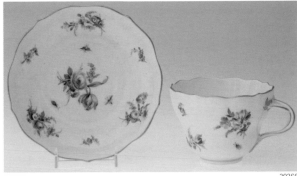

20266
A GERMAN PORCELAIN CUP AND SAUCER
Meissen, c.1880

The white high glaze with hand painted flowers and insects, signed with crossed swords under glaze
the cup 3in. high
(Total: 2 Items)

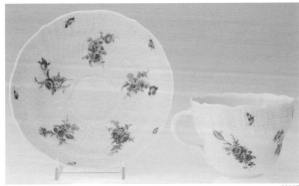

20267
A GERMAN PORCELAIN CUP AND SAUCER
Meissen, c.1880

The white high glaze hand painted with flowers and insects, raised molding, signed with crossed swords under glaze
the cup 3in. high
(Total: 2 Items)

20268
A GERMAN PORCELAIN CUP AND SAUCER
Meissen, c.1880

The white high glaze with hand painted flowers, signed with crossed swords under glaze

the cup 3in. high (Total: 2 Items)

20269
A GERMAN PORCELAIN CUP AND SAUCER
Meissen, c.1880

The white high glaze ground hand painted with flowers, signed with crossed swords under glaze

the cup 3in. high (Total: 2 Items)

20270
A GERMAN PORCELAIN CUP AND SAUCER
Meissen, c.1880

The white high glaze hand painted with flowers and a butterfly, signed with crossed swords under glaze

the cup 3in. high (Total: 2 Items)

20271
A GERMAN PORCELAIN PLATE
Meissen, c.1880

The cobalt blue trim intricately decorated with gold gilt design, leading to a white ground with hand painted birds and flowers with baby birds in a nest, signed with crossed swords under glaze

10in. diameter

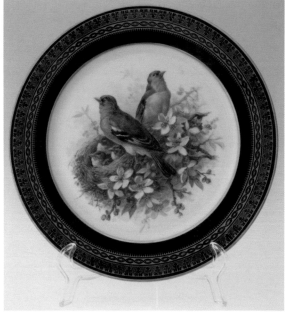

20272
A GERMAN PORCELAIN PLATE
Meissen, c.1880

The cobalt blue trim intricately decorated with gold gilt design, leading to a white ground with hand painted birds and flowers and baby birds in a nest, signed with crossed swords under glaze

10in. diameter

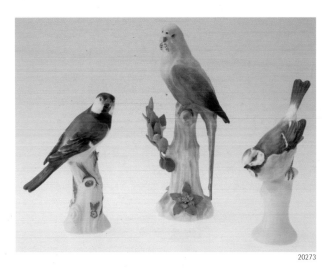

20273

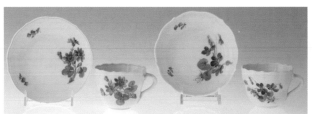

20274

20274

A PAIR OF GERMAN PORCELAIN DEMI CUPS AND SAUCERS

Meissen, c.1880

The white high glaze hand painted with pansies, signed with crossed swords under glaze

3in. high

(Total: 4 Items)

20273

A GROUP OF THREE GERMAN PORCELAIN BIRDS

Meissen, c.1890

Hand painted in pastel colors with white high glaze bases, two marked with crossed swords, tallest marked with faint script under glaze

the tallest 9in. high

(Total: 3 Items)

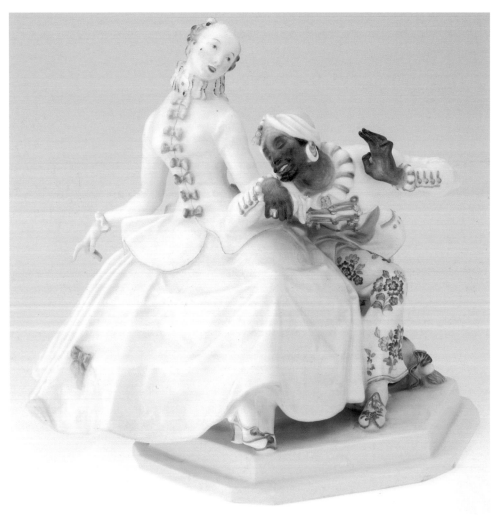

20275

A 'LADY AND THE MOOR' GERMAN PORCELAIN FIGURINE

Meissen, c.1890

In high glaze white with vibrant colors, the Moor in turban and sash outfit serving the Lady, signed crossed swords on side of base

11in. high

20275

20276

A GERMAN PORCELAIN BOWL

Meissen, c.1890

The filigree and white soft paste porcelain hand painted with a floral design and gold gilt, stamped with crossed swords

5.5in. high

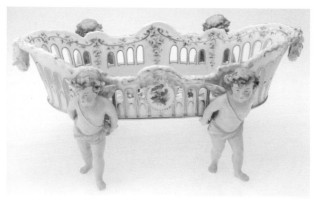

20277

A PORCELAIN CENTER BOWL

Meissen, c.1880

The variegated soft paste porcelain suspended by four bisque cherubs, and decorated with gold gilt and hand painted floral design, stamped with the Meissen crossed swords

6.5in. high

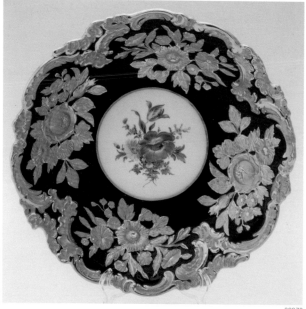

20278

A PORCELAIN CENTER BOWL

Meissen, c.1890

The cobalt blue high glazed ground fully decorated with an elaborate gilt rococo design, the center white panel hand painted with multi-colored flowers, stamped with the Meissen crossed swords

12in. across

20279

A ROYAL DOULTON MONUMENTAL VASE

Florence Barlow, c.1880

The high glazed ground with art nouveau design rising from bottom to top and three white trimmed butterflies circling border, three panels with birds and roses done in pate sur pate technique, inscribed signature *FEB*

19.7in. high

20280
AN ENGLISH PORCELAIN WATER PITCHER
Royal Doulton, c.1900

The pastel blue ocean ground with peach colored sky, highlighted by hand painted sail boats in a harbor scene, stamped underside

12in. high

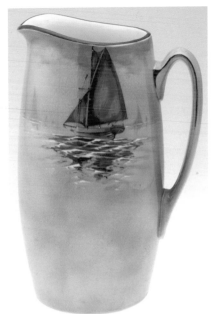

20280

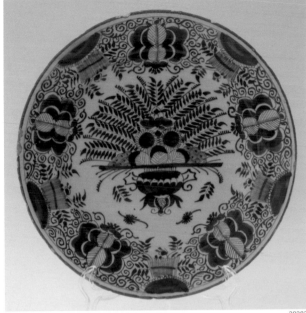

20282

20282
AN ORIENTAL POTTERY PLATE
Unknown, c.1900

The blue and white floral design fully decorates the plate, unknown mark under glaze

10in. across

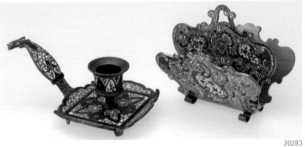

20283

20283
A BRONZE AND CHAMPLEVE LETTER HOLDER AND CANDLE HOLDER
c.1880

The footed trifold bronze and enamel letter holder, the single candle holder footed with classical design, *unmarked*

4.5in. high and 2in. high (Total: 2 items)

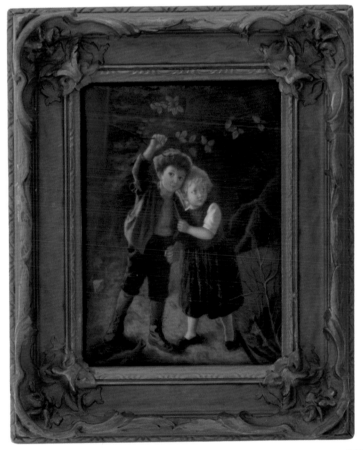

20281

20281
A GERMAN PORCELAIN PLAQUE
KPM, c.1890

The hand painted forest scene with two children, best of color and detail, original gold leaf frame, mint condition

11in. high

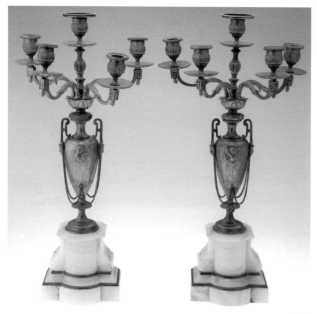

20284

**A PAIR OF EMPIRE STYLE MARBLE AND
BRONZE FIVE-LIGHT CANDELABRAS**

c.1880

The marble with gold dore bronze trim at base rises to support urn shape
body with classical designs of angels, *unsigned*

22in. high (Total: 2 Items)

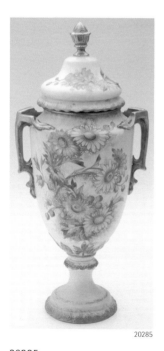

20285

A GERMAN PORCELAIN COVERED URN

Royal Bonn, c.1880

Double handled, gilt and decorated with hand painted daisies, stamped
signature *Royal Bonn GERMANY*

16.5in. high

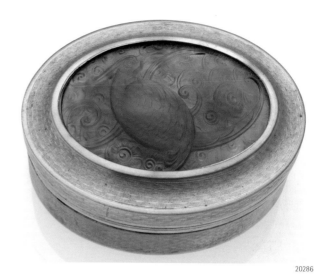

20286

20286

AN ART DECO BRONZE AND GLASS LIDDED BOX

Robert, c.1920

The oval bronze box with art deco style turquoise glass depicting a peacock,
with a raised signature *Robert*

1.7in. high

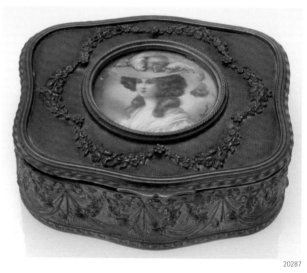

20287

20287

AN IVORY AND BRONZE HINGED BOX

French, c.1880

Lined with velvet, the dore bronze with hand painted ivory inserted panel
depicting a Victorian lady with a feathered hat, signed in enamel *Ragnol*

1in. high, 4.5in. across

20288
A BRONZE AND IVORY HINGED BOX

French, c.1880

Lined with dark green velvet, the dore bronze with a hand painted ivory panel depicting a Victorian lady surrounded in green enamel, incised signature *France*

1in. high, 6in. across

20291
A PAIR OF CIRCULAR FRAMED FRENCH PORCELAIN PLAQUES

c.1880

The soft paste porcelain plaques depict a Victorian man and lady framed in metal with classical designs, artist marks on both, black underglaze

17in. diameter (Total: 2 Items)

20289
A PORCELAIN AND BRONZE CLOCK

Royal Vienna, c.1880

The pink soft paste porcelain base decorated with gold gilt panels depicting putti at play, cobalt blue pillars with gold gilt designs surrounding bronze clock, dome shaped top with panels depicting putti in clouds, signed in enamel under glaze *Beehive*

11in. high

20290
A PORCELAIN VASE

Unknown, c.1890

The light green high glazed ground with center panel depicting a classical lady in a pink dress, *unmarked*

10.5in. high

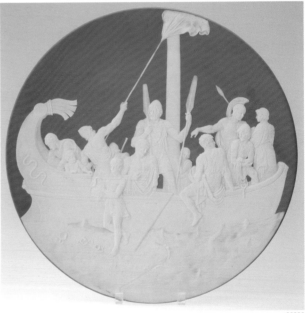

20292
A GERMAN PORCELAIN CHARGER

Mettlach, c.1890

The soft green ground with an ivory pate sur pate mythological motif depicting twelve classical figures in a boat, artist signed *J.Stahl 15* within design

18in. diameter

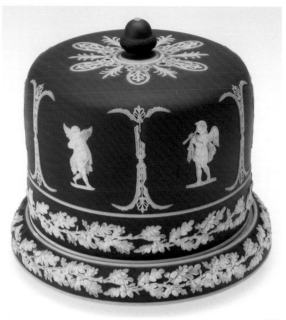

20293

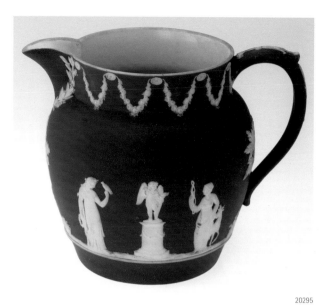

20295

20293

A PORCELAIN CHEESE PLATE

Wedgwood, c.1880

The cobalt blue bisque ground with ivory pate sur pate floral designs and medallion incised signature *Wedgewood*

10.3in. diameter

20295

AN OVERLAID AND ETCHED PITCHER

Wedgwood, c.1900

The deep cobalt blue ground overlaid and etched in ivory pate sur pate depicting four women and an angel, rimmed in ivory draped floral design

6in. high

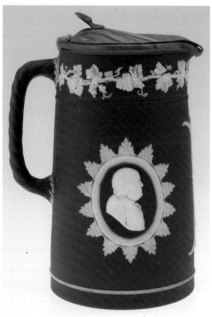

20294

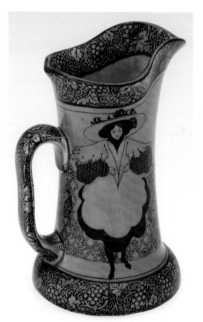

20296

20294

A PORCELAIN PITCHER

Wedgwood, c.1890

The cobalt blue bisque ground with ivory pate sur pate floral design with Benjamin Franklin on one side and George Washington on the other, incised signature *Wedgewood*

10.3in. high

20296

AN EDWARDIAN CERAMIC PITCHER

Royal Doulton, c.1905

The high glazed black over a golden yellow ground depicting two Gibson girls in front of a rose bush fence, stamped with signature *Morrisian* and the *English Crown and Lion*

7.5in. high

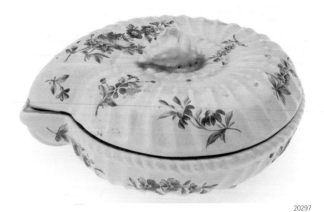

20297

20297

A FRENCH FAIENCE EARTHENWARE COVERED DISH

Emile Gallé, c.1890

Molded in the shape of a seashell with a conch shell applique finial on the lid, decorated with enamel flowers, signed in enamel *E. Gallé/Nancy* and with the original retail label

5.5in. diameter

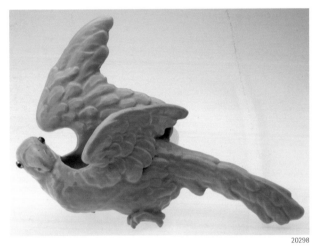

20298

20298

A FRENCH FAIENCE EARTHENWARE FIGURAL VASE

Emile Gallé, c.1890

The sculpted parrot with light blue glaze and applied glass eyes, signed in enamel *E. Gallé/Nancy*

17in. high

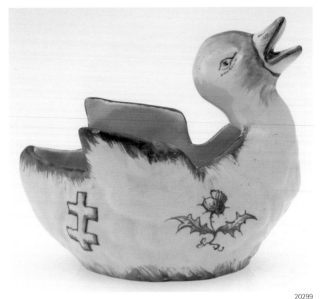

20299

20299

A FRENCH FAIENCE EARTHENWARE DUCK

Emile Gallé, c.1890

The light blue high glazed ground decorated with thistles and the *Cross of Lorraine* on both sides, signed in enamel *E. Gallé/Nancy*

4.7in. high

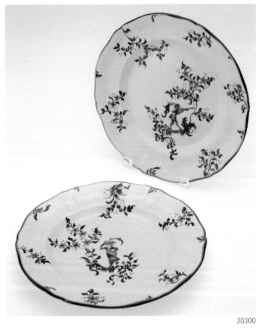

20300

20300

A PAIR OF FRENCH FAIENCE EARTHENWARE PLATES

Emile Gallé, c.1890

The white glazed ground with art nouveau floral design and enamel knight firing a gun, edged in gold gilt, signed in enamel *E. Gallé Nancy/Deposi*

10.3in. diameter (Total: 2 Items)

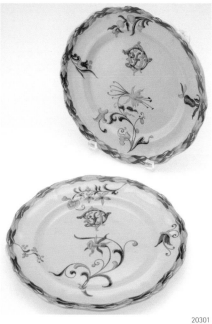

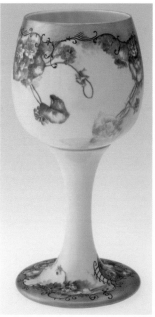

20301

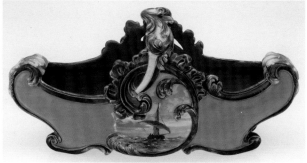

20302

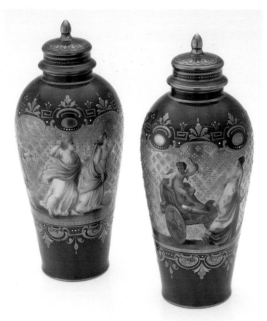

20301
A PAIR OF FRENCH FAIENCE EARTHENWARE PLATES
Emile Gallé, c.1890

The soft blue glaze decorated with a yellow art nouveau floral design in yellow and dark blue, monogrammed "D" into motif, signed in enamel *E. Gallé Nancy*

10in. diameter (Total: 2 Items)

20302
A FRENCH FAIENCE EARTHENWARE BASKET
Emile Gallé, c.1890

The high glazed basket shape with two hand painted enamel scenic panels depicting sailboats on the ocean, trimmed in gold gilt, inscribed signature under glaze *Emile Gallé/Nancy*

6.5in. high

20303
A EUROPEAN PORCELAIN CHALICE
Belleek, c.1890

The high glaze soft paste white with foliate and floral design along foot and rim, trimmed in gold gilt, hand painted, red maker's mark under glaze

11in. high

20304
A PAIR OF PORCELAIN COVERED URNS
Royal Vienna, c.1890

The high glazed green grounds highlighted with heavy gold gilt and hand painted with finely detailed classical figures, signed in enamel *Die Schule der Liebe* with stamped *Beehive Mark*

8in. high (Total: 2 items)

20305

A ROYAL DOULTON VASE

c.1896

The cobalt blue drip glaze covering a tan swirling grooved ground, stamped with the *English Crown and Lion*

8.5in. high

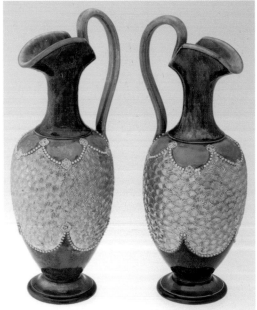

20306

A PAIR OF ENGLISH PORCELAIN EWERS

Royal Doulton, c.1920

The cobalt blue ground highlighted by green borders and gold, looping handles and beaded borders, stamped with the *English Crown and Lion*

15in. high

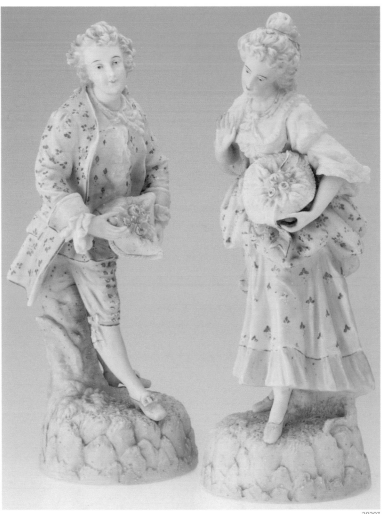

20307

A PAIR OF FRENCH BISQUE FIGURINES

Unknown, c.1890

The Victorian man and woman rendered in cream bisque and decorated in multi-colored enamels, unsigned

14in. high

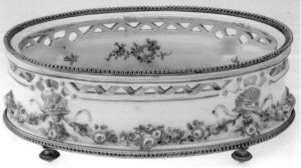

20308

A BRONZE MOUNTED PORCELAIN CENTER BOWL

A. Padin France, c.1880

The dore bronze feet support a high glaze white porcelain center bowl with rosettes and four lion faces, inside and out with multi floral design, rim with beaded dore bronze

14in. across

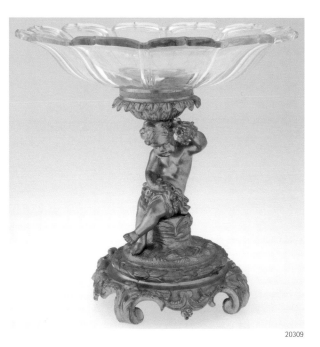

20309
A BRONZE AND CRYSTAL CENTERPIECE
Unknown, c.1900

The dore bronze footed platform supporting a cherub, rising to hold a crystal bowl, unsigned
10in. across

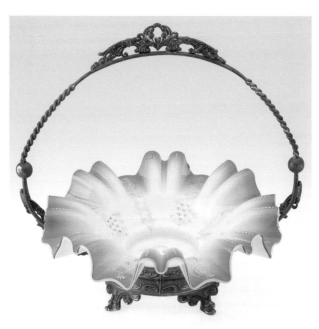

20310
A GLASS AND METAL BRIDE'S BASKET
Stevens and Willams, c.1880

The white and red cased bowl with blue, yellow, and white enamel in a floral design, unsigned
10in. across

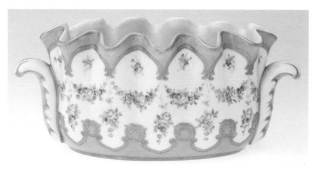

20311

20311
A FRENCH PORCELAIN PLANTER
Porcelain de Pares France, c.1890

Enameled floral garland with roses and a pink base and rim edged in gilt, stamped under glaze
12in. high

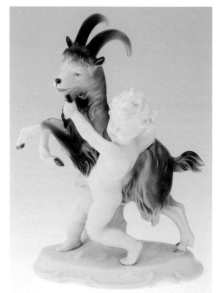

20312

20312
A PORCELAIN FIGURE
Unknown, c.1900

A child with billygoat, stamped underglaze with anchor mark
6in. high

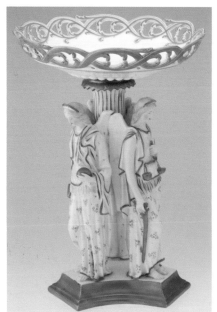

20313

20313
A GERMAN PORCELAIN CENTERPIECE
Unknown, c.1890

The base surrounded by three figures supporting a column and center bowl, unsigned
16.25in. high

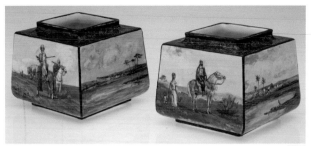

20314

A PAIR OF PORCELAIN PLANTER BOXES

c.1880

Of slightly tapering box form with short box collar, the hand painted panels depict different Arabic desert scenes with towns, temples, an oasis and warriors riding horses, signed in enamel with artist's initials and dated *R.S.N/1880*

7.5in. high

20315

AN ASSORTED GROUP OF CERAMIC TABLEWARE

Various makers

The group including two sets of eight teacups with matching saucers; eleven octagon shaped plates marked Rosenthal Bavaria on reverse; ten matching plates stamped England on reverse; four matching plates of harbor scenes; five unmatching plates of varying sizes; some chips and losses throughout

(Total: 46)

20316

AN ASSORTED GROUP OF STRAWBERRY MOTIF CERAMIC TABLEWARE

Various makers

The group consisting of fifty-nine items, including hand painted Bavarian and French strawberry motif dessert bowls, and a Limoges France hand painted grape motif circular tray

the largest 11.5in. diameter

(Total: 59)

20317

AN ASSORTED GROUP OF FRENCH, BAVARIAN, AND UNMARKED CERAMIC TABLEWARE

Various makers

Each with fruit and berry decoration, the group includes three different serving bowls with berries, two marked Bavaria; twenty-two dessert bowls in three different patterns hand painted with berries and blossoms, marked T&V France; thirteen plates of varying sizes and makers, some pieces with chips,

the largest serving bowl 10in. diameter

(Total: 47)

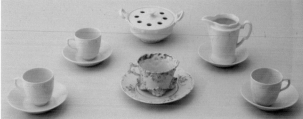

20318

A GROUP OF ELEVEN PORCELAIN TABLEWARE

Unknown, c.1900

The three cups with saucers, creamer with saucer, bowl with slotted lid, gilded and enamel cup and saucer, signed with unknown marks

4in. high

(Total: 11 Items)

20319

A PORCELAIN TRAY

Unknown, c.1880

The soft paste feather design with elaborate hand painted enamel and gold gilt trim, the center with crest of facing lions, unknown mark of crossed arrows under glaze

14.5in. across

20320

A GROUP OF NINE ASSORTED EUROPEAN PORCELAINS

Various makers, c.1900

Four high glaze, soft paste figures, four with bisque finishes, one with multi-colored enamel, two pieces damaged, assorted marks

tallest 6in. high

(Total: 9 Items)

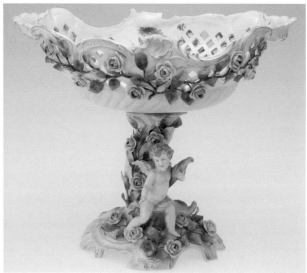

20321

A CONTINENTAL PORCELAIN CENTERPIECE

Dresden, c.1930

The soft paste porcelain platform bowl with domed foot with a seated putti resting against the floral pedestal, applique roses with gold gilt highlights throughout, stamped with *Dresden* mark

11in. high

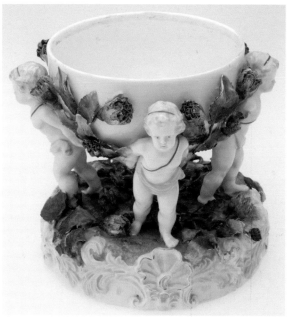

20323

A PEDESTALED PORCELAIN CENTER BOWL

Dresden, c.1890

The white soft paste porcelain bowl suspended by four cherubs and molded with applique green leaves and purple flowers, stamped with the *Dresden* mark

8.5in. high

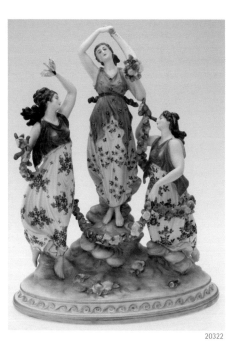

20322

A PORCELAIN FIGURAL GROUP

Alensia, c.1880

Three maidens wearing colorful classical gowns with garlands and bouquets, gold gilt elaborate enameling around base, signed under glaze

13in. high

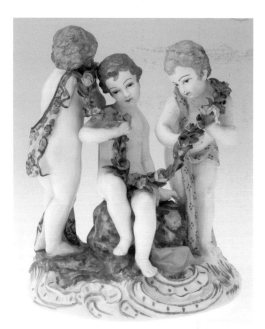

20324

A PORCELAIN FIGURAL GROUP

Dresden, c.1890

Featuring three putti holding a floral garland, highlighted with gilt, stamped on bottom

7in. high

Visit HeritageGalleries.com to view scalable images and bid online.

Session Three, Auction #608 • Saturday, October 31, 2004 • 1:00 p.m.　　331

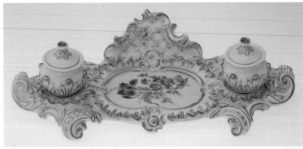

20325

A GERMAN PORCELAIN INKWELL

Dresden, c.1890

The white high glaze with rococo style gilding, hand painted floral bouquet in center, signed *Dresden Germany*

14in. across

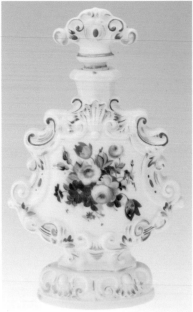

20327

A FRENCH PORCELAIN DECANTER

Old Paris, c.1880

With richly colored floral design, the base, sides and top in blue and gilt rococo style

12in. high

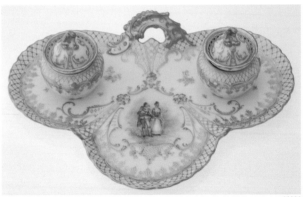

20326

A GERMAN PORCELAIN INKWELL

Dresden, c.1880

Trefoil form, the white high glaze heavily decorated in gold leaf design, with center scene of a Victorian man serenading a woman, signed *Dresden* under glaze

11in. across

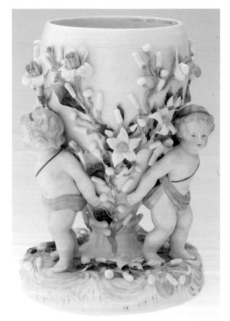

20328

A GERMAN PORCELAIN EGG

Sitzendorf, c.1880

The pedestaled egg supported by three cherubs, intricate applique floral designs, white ground transitions to teal, yellow, green and purple

10in. high

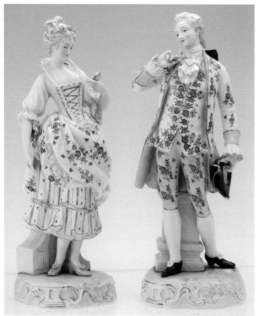

20329

A PAIR OF FRENCH PORCELAIN BISQUE FIGURINES

Unknown, c.1890

The Victorian lady posed holding a gold compact and the Victorian gentleman posed holding a flower; both figures decorated with hand painted multi-colored floral design and gold gilt highlights, *unmarked*

16in. high (Total: 2)

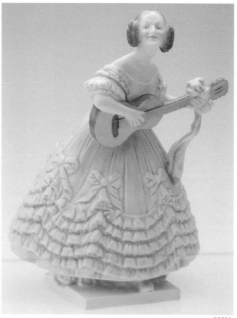

20331

A PORCELAIN PEDESTALED FIGURINE

Herend, c.1900

The soft paste porcelain molded to depict a Victorian lady in a light pink frilly dress playing a guitar, incised signature *Herend*

14.7in. high

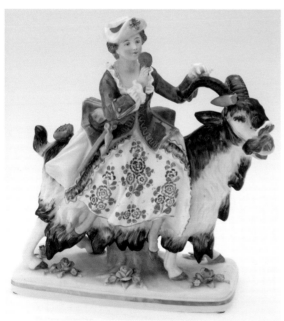

20330

A GERMAN PORCELAIN FIGURINE

Sitzendorf, c.1890

The soft paste porcelain lady riding a horned goat, sporting spectacles, stamped with artist's mark under glaze

10in. high

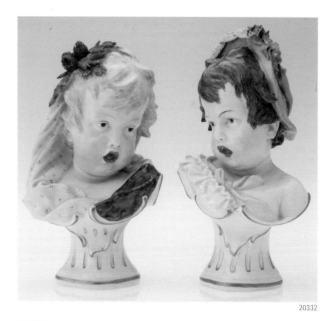

20332

A PAIR OF FRENCH PORCELAIN BUSTS

Unknown, c.1890

Molded to depict two children, one blonde and one brunette, with heads tilted towards opposite sides and gold gilt highlights on the base, unknown mark

11.2in. high (Total: 2)

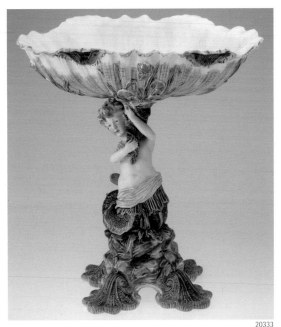

20333

AN ITALIAN MAJOLICA CENTERPIECE

Unknown, c.1890

High glaze, a quatrefoil base surmounted by a mer-child holding a seashell shaped bowl decorated with gold gilt highlights, *unmarked*

17.5in. high

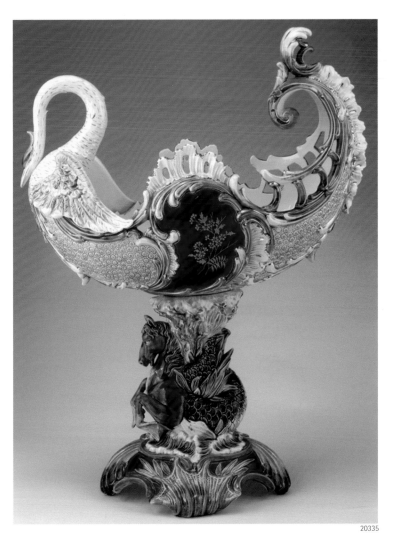

20335

AN ITALIAN MAJOLICA CENTERPIECE

Unknown, c.1890

The domed pedestal supporting a fantastical pedestal formed of cascading waves, shells, and a half-horse, half-fish creature with webbed hooves, surmounted by an ovoid bowl shaped as a swan-like bird emerging from elaborately decorated rocaille shells and scrolls reminiscent of a ship, hand painted, *unmarked*

24in. high

20334

A FLORAL MOTIF FAIENCE EARTHENWARE EPERGNE

D'Onnaing, c.1910

Molded in soft paste porcelain, the trefoil pond lily base supporting radiating yellow and magenta tipped tulips, purple irises encircling the rim of the vase, stamped signature under glaze *Faience RD'onnaing(Nord)/France*

18in. high

20336

A PORCELAIN COVERED TUREEN

Sevres, c.1890

The soft paste porcelain with white ground hand painted with colorful butterflies and decorated with applique fruits and flowers, enamel insignia under glaze

9in. high

20337
**A PORCELAIN ART
DECO FIGURINE**
Herend, c.1920

The high glazed white soft
paste porcelain molded to
depict a nude with a draped
cloak looking into a hand
mirror, incised signature
15.5in. high

20337

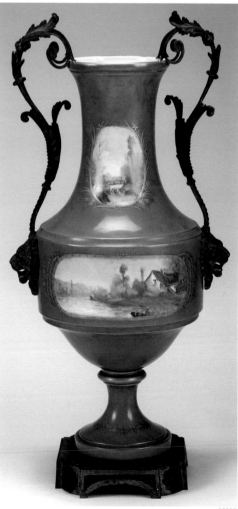

20338
**A PAIR OF BRONZE MOUNTED
PORCELAIN URNS**
Sevres, c.1890

The sky blue ground has four enameled
panels, two depicting pastoral scenes, two
with men and women in Victorian style,
elaborate bronze handles with foliate scrolls
terminating into lion heads
30in. high (Total: 2)

20338

END OF AUCTION